A SOUTHERN MADAM AND HER MAN

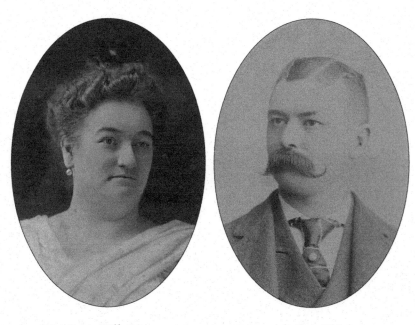

Susie Tillett Arthur Jack

A Southern Madam and Her Man

DAVID B. DEARINGER

WHITE POPPY PRESS
An imprint of Modern Memoirs, Inc.
Amherst, Massachusetts

All photographs are from the author's collection, unless otherwise noted.
Cover image: Susie Tillett, about 1896 (detail). Photograph by Granert, Chattanooga,
Tennessee
Frontispiece, left: Emily Susan Tillett á la grecque, about 1896. Photograph by Louis
Granert, Chattanooga; *right:* William Arthur Jack as the Don Juan of Chattanooga,
about 1892. Photograph by M. E. Schmedling, Chattanooga
Dustjacket design by Nicole Miller
Printed and bound in the United States of America

ISBN: 979-8-9875878-4-3

WHITE POPPY PRESS
An imprint of Modern Memoirs, Inc.
417 West Street, Suite 104
Amherst, MA 01002
www.modernmemoirs.com

To Pam and Kevin
with love and gratitude,
and
To Darrell,
who makes me smile with my heart.

Mary Magdalene was a Megowan Street woman,
and she got there all the same.

—Charles C. Moore, editor, *Bluegrass
Blade*, Lexington, Kentucky, Feb. 7, 1891

We were driven here by man and have been driven out by man.
Perhaps man will find some way to teach us a better mode of life.
If not, we can live in defiance of man-made laws.

—Madam Elizabeth English, quoted in
Chattanooga Daily Times, Feb. 6, 1915

CONTENTS

PREFACE

People who undertake genealogical research are inevitably cautioned, usually by a rib-poking relative who has little or no evidence to support the claim, that looking into the family's history will reveal "skeletons." It is true that, if excavations are deep enough, unusual personalities, odd doings, and more, will be uncovered, no matter the origins, social status, ethnicity, or pretensions of any family or its individual members. But anxiety about what we might uncover should not keep us from examining our ancestors' lives with as much intelligence and diligence as we can. And once we have made discoveries of things mundane or otherwise, we should not hesitate to investigate them as far as sources allow and with the rigor and intensity of true historians. Based on the experience of researching and writing this book, I can attest that, as it turns out, learning of a forebear's transgressions, disconcerting as they may be, can humanize history and, if one keeps an open mind, heighten our awareness of our own eccentricities. (Before I began this project, neither I nor anyone in my immediate family knew anything about most of the events that I describe here.) Honest historians set politics and ideologies aside and document people as they were—and are. Otherwise, we might ask, what is the point? With that in mind, the histories of two of my own ancestors, Emily Susan Tillett (1859–1922) and William Arthur Jack (1861–1944), are worth telling.

By the time they met, probably in the early 1890s, Susie Tillett and Arthur Jack, as they were known by their contemporaries, had independently embraced unconventional lifestyles. Arthur had abandoned a wife, a child, and the security of a respected Atlanta family to pursue a hedonistic career as a saloonist, gambler, and general raconteur. Susie had left her girlhood home in rural Fayette County, Kentucky, moved to Lexington, the county seat, and by the mid-1880s had become the manager of one of the town's most successful houses of prostitution. In 1889, she left Kentucky for Chattanooga, Tennessee, where she established another brothel and, as she had done in Lexington, became one of that city's leading madams, a profession that she pursued until she, along with most of her colleagues, was forced out of business by typically hypocritical Americans

who decided to wage a cultural war moments before the United States joined the real battles of World War I.

Be that as it may, it was probably in Chattanooga that Susie met Arthur Jack, who had also recently come to town. The two established a relationship that was both romantic and professional: with Susie's financial backing, Arthur opened a saloon just steps from her house, thereby shocking the folks back home. The American Gilded Age was at its peak, and we can imagine this pair, consciously or not, opting to participate in the era's extravagances in a place where they would be relatively free of family scrutiny and obligations.

Given the less-than-conventional paths that they chose, it was inevitable that Susie and Arthur, like most of their professional colleagues, would draw the attention of the press and the courts. Being scandalous, their activities often resulted in court documents and newspaper accounts that give us more information about the couple than we would otherwise have and allow us to gain a tantalizing sense of their complicated characters. Primary sources unequivocally describe Susie as "a lady of the town" and Arthur as "a young Don Juan," among other things, and they certainly dressed the parts. Extant photographs suggest that they were individually striking and, as a duo, stunning. Susie had dark auburn hair, flawless skin, and a figure that, in keeping with the taste of the time, grew increasingly Rubenesque as the years passed. She wore fashionable, elegant clothes, many of her own making, and accessorized with feathered hats, parasols with beautifully carved handles, ribbons, and (real) jewels. Arthur was the height of male fashion, dapper in richly tailored three-piece suits enhanced by silk ties, diamond stickpins, and a gold watch and chain. He sported an ivory-headed cane and wore a well-waxed, trimmed moustache. His hair was oiled and carefully combed with a prominent, rakish part; he wore bowlers and boaters as fashion dictated. No wonder they caused a stir.

The couple's circumstances would change with the coming of a new century and maturity. In 1902, by which time they were both over forty years old, they altruistically—and by their own choice—took on the responsibilities of parenthood. This new role came with the arrival of a child, Winnie Grace Jack, who immediately brought them grace in both name and spirit. Their decision to take this step required quotidian changes

that they may not have fully predicted but quickly embraced. The most significant of these, forced by circumstances that will be made clear here, was to establish a more traditional home in Susie's hometown of Lexington. There, in a newly developed part of that expanding city, they bought a substantial property with a large house in which to live happily ever after. Without totally abandoning their usual scandalous activities, they did their best to create socially acceptable lives for themselves, their daughter, and by extension, their descendants—of which I happen to be the fifth of their twelve great-grandchildren.

This is their story.[1]

David B. Dearinger
Richmond, Virginia, 2023

Chapter 1

Susie Tillett

Fayette County lies in the center of the state of Kentucky and is the de facto capital of the storied section of that commonwealth known as the Bluegrass. Lexington, the county seat, was established in 1775 on a branch of Elkhorn Creek, which, with its tributaries, irrigates and drains the region. The founders of the town, white men of European descent who typically disregarded any claim to the land made by Native people, thought that this would be a good spot for a settlement, not only because of the immediate, practical uses to which the waters of the creek, which they called Town Branch (or Town Fork), could be put, but because of the possibilities for future businesses and industries that the creek's adjacency suggested. Sure enough, by the middle of the nineteenth century Lexington was home to a number of mills, foundries, distilleries, and other entities that depended on the power of water for success. That water, running as it does through the thick layer of limestone that is the bedrock of the Bluegrass, also turned out to be rich in nutrients needed by horses and cattle, which were eventually raised in abundance in the county for profit. Fayette County thrived, and by the middle of the century Lexington was the most important town in the state. In 1860, when the subject of this chapter was a year old, the county had a population of nearly 23,000 people, over 9,300 of whom lived in the county seat.[2]

Emily Susan Tillett, known as Susie, spent most of her life in Lexington, but she was born—on August 1, 1859—in or near a rural Fayette County hamlet known as East Hickman, named for a nearby tributary of the

Kentucky River. Susie was the fourth of fourteen children born to Samuel W. and America Susan (Lanham) Tillett, natives of neighboring Madison County.[3] Samuel (ca. 1833–1887) was probably a descendant of John Tillett (died 1812), who had come to Kentucky from Virginia in about 1790 and operated a distillery on Stoner Creek in Bourbon County.[4] Samuel's father, John W. Tillett, was born around 1795 in Kentucky, probably in Bourbon County. By 1818, he had moved to Madison County where, on October 3, 1820, he married sixteen-year-old Sophia Bratton.[5] They had at least six children, one of whom, Samuel, would be Susie's father. In August 1841, when the youngest of those children was barely a year old, John Tillett died, in debt and intestate.[6] His possessions were quickly sold at auction to settle his debts, although the local court in Richmond, the seat of Madison County, magnanimously allowed the widowed Sophia to keep "the few pieces of bacon now on hand, three sows, two shoats, 8 pigs, & two milk cows, one bull calf, and about four & a half acres of corn, being all the corn in the field in which the house is located, and the few garden vegetables in the garden."[7]

Despite that largesse, Sophie was compelled to take a job as housekeeper to a local carpenter and farmer named Joseph S. Parks (or Parke). She also borrowed money from Parks and, in October 1848, was compelled to sell her few material possessions to him to settle the debt. That settlement, it turned out, was prelude to Sophie's marriage to Parks, which happened on January 10, 1849.[8] They spent the next three decades living off whatever the land of northwestern Madison County could produce, but financial troubles eventually caught up with them. By 1880, with Sophie's children grown and apparently without the means to help them, she and Joseph were living in the Fayette County Poor House, which is probably where they died.[9]

Susie Tillett's mother, America Lanham (ca. 1827–1883), also had roots in Madison County. She was a granddaughter of Stephen and Eleanor (Selby) Lanham, who had come to Kentucky from Prince George's County, Maryland, in about 1790.[10] America's father, John Lanham, was born in about 1810 and trained as a stonemason, a common profession in the limestone-rich Bluegrass.[11] He married about 1836 to Mary Grizard (born ca. 1811)[12] and they had at least three children: America Susan (born ca. 1837), Leah P. (ca. 1839), and William L. Lanham (ca. 1845).[13] Mary died, probably in the early 1850s, and John Lanham eventually remarried.[14]

The Tilletts and the Lanhams lived in northern Madison County near where Jack's and Hind's creeks empty into the Kentucky River. The local village was Valley View, the site of a ferry, still in operation today, that links Madison to Fayette County and provides access to Lexington. Samuel Tillett and America Lanham were both born and raised in the area and likely knew each other from childhood. While no record of a marriage between them has been found, they were presumably acquainted by the spring of 1854 when America gave birth to a child whom they named Charles Selby Tillett in honor of her ancestors.[15] The following year, shortly after their second child, Mary Belle, was born, they took the Valley View Ferry across the river and settled about nine miles south of Lexington in or near East Hickman. The surrounding countryside was dominated by horse and cattle farms, some of which were extensive. The village, which actually straddled the line between Fayette and Jessamine counties, consisted of a church, a schoolhouse, a general store, a blacksmith shop, a post office, and a handful of houses.[16] It was here that the rest of Samuel and America's children were born: Nancy (1858); Susie (1859); Annie B. (1860); William Colby (1862); Marshall (1864); John Samuel (1865); Lillie M. (1867); Mollie G. (1869); Nettie America (1871); Florence (1873); Waller Bullock (1875); and Abner Oldham (1877). East Hickman was also the site of the previously mentioned Fayette County Poor House, which may explain why, within a few years, Samuel's mother, Sophie, and stepfather, Joseph Parks, would come to live, and probably die, in that place.[17]

Samuel Tillett was a wagon-maker, an occupation that required expertise in carpentry (for the body of the wagon), blacksmithing (for its chassis and wheels), and painting (for its preservation and decoration). America Tillett worked in the home and, according to family tradition, was an accomplished seamstress and cook.[18] Whatever education her and Samuel's children had would have taken place in one or more of Fayette County's small rural schools, including the one at East Hickman.[19] The children's respective levels of education varied from very little to at least a few years of high school.[20] There is no direct evidence of how far Susie herself got in school, but the nature of some of the objects she later owned—books, a piano, sheet music—suggests that she had at least an average education.[21] Her writing style, of which we have a few examples, was no better than it should have been for someone

3

with a limited education, but as an adult she had enough knowledge of mathematics, accounting, and the management of human resources to run a successful business, as will be seen. She also learned how to turn a house into a home and, not incidentally, became an excellent seamstress and a fine cook.

In 1875, Samuel and America and their children, some of whom were by then approaching maturity, moved to Lexington. If the move was related to Samuel's employment, which seems likely, Lexington was a logical destination. It was hardly a metropolis, but besides being the county seat, it was the unofficial capital of Kentucky's most prosperous region and home to a population that had been steadily increasing since Kentucky became a state in 1792. By the mid-1870s, when the Tilletts moved there, Lexington was home to about 16,000 people. It had eight banks and eighteen churches; over twenty elementary schools, colleges, and seminaries, including the oldest college west of the Appalachian Mountains; eight newspapers; a library, a theater, four bookstores, and five literary societies; at least seven distilleries, as many liquor stores, and over one hundred groceries; eight restaurants, thirty-seven saloons, and ten hotels of various sizes and levels of respectability. It was also home to thirteen carriage and wagon makers, one of which may have employed Samuel Tillett.[22] The 1877 Lexington city directory, the only one in which his name appears, identifies him as a wagon-maker living at 243 North Broadway.[23]

During the Tilletts' time in Lexington, several events significant to their lives took place. In July 1876, their oldest daughter, Mary Belle (known as Mamie), married Manlius V. Thompson, an agent for the Lexington streetcar system; two months later Mamie gave birth to a son, Vertner Matlock Thompson.[24] The following year, Samuel and America had a child of their own—their last—whom they named after a Madison County physician, Abner Oldham.[25] But these presumably happy events were soon marred by an unpleasant and even dangerous one. In 1880, the Tilletts' sixteen-year-old son, Marshall, was arrested after he and an accomplice, Hamilton Atchison, age 13, broke into Charlie Foushee's saloon on West Short Street and stole tobacco, knives, and cash. Atchison made a deal with the prosecuting attorney in exchange for testimony against Marshall Tillett, who was subsequently found guilty and sentenced to a year in the state penitentiary.[26] As this family drama was playing out, Samuel and America took their younger children and

moved back to rural Fayette County. By June 1880, they were again living in the East Hickman precinct.[27]

Meanwhile, the older Tillett siblings had begun to leave home and find their own ways. As of 1880, the two oldest boys, Charles and William, were employed as farm laborers in nearby Jessamine County, while the oldest girls, Mamie, Annie, and Susie, remained in Lexington. Annie, who was working as a seamstress, lived with Mamie's small family until she herself married around 1881.[28]

Susie chose a less conventional path.

On June 8, 1880, Susie Tillett made her first appearance as an adult in the U.S. federal census, enumerated there as E. S. Tillett, a single twenty-one-year-old female living in the Spring Street home of Robert P. Geers, a Lexington grocer and saloonist, his wife, and their three children.[29] Susie was not the only boarder in the house: one R. O'Connor, a single, twenty-year-old male store clerk, and M. E. O'Connor, single, female, age fourteen, presumably a close relation of R. O'Connor, were also in residence.[30] The nature of Susie's relationships to the Geerses and the O'Connors, assuming there were any, is unknown. Nor is it clear as to how she was supporting herself at that time. It is unlikely that her parents, who still had seven children at home, could have offered any assistance. The census did not assign her an occupation but instead, stated simply that she was "at home," a designation that generally implied that the subject was not earning wages elsewhere.[31] Susie might have worked at one of the few, low-paying, more-or-less dead-end jobs that were available to women at the time—housekeeper, teacher, governess, milliner, seamstress, servant—but there is no evidence that she did. Instead, given her later history, we can reasonably conclude that it was at about this time that Susie Tillett embarked upon what would be her nearly lifelong career as a prostitute.

Her reasons for taking this step are unknown, but they were probably both economic and personal. She would have needed an income in any event, and perhaps she had fallen into the classic pattern of involvement with an unreliable man with its ensuing cycle of passion, promises, pregnancy, and

abandonment. But putting too much faith in that theory would be stereo-typing in hindsight. Historians who have studied the period argue that most prostitutes of the time were not forced into the profession but entered it voluntarily and rationally, choosing it as "an 'easier' and more lucrative means of survival than the other kinds of jobs open to them."[32] We may never know exactly why Susie Tillett became a prostitute, but we can make a reasonable guess as to when she did so. Two cabinet photographs taken of her when she was in her late teens, provide clues.

The earlier of these was taken by an unknown photographer, probably in Lexington, in 1877 or 1878 when Susie was eighteen.[33] It shows an attractive, rather sad-eyed young woman with carefully styled curls, wearing a dark, beautifully made dress with a high collar adorned with a black bar-shaped pin. In the other image, taken a year later by Lexington's leading studio photographer, W. Eugene Johns, Susie is in another stylish dress, buttoned to the neck, a lace collar, and another bar-shaped pin, this one silver and engraved with a geometric pattern.[34] Her curled hair is piled and netted. Her mode of dress in both of these images and the fact that they were professionally made suggests that Susie or someone close to her had enough disposable income to pay for such things, not a great deal, perhaps, but more than one might expect the daughter of a wagonmaker, especially one with more than a dozen children, to have on hand.

This remains conjecture, but perhaps by the time these images were made, Susie was already on a trajectory that had or soon would lead to prostitution. If not, the death of her mother in 1883 may have put her there.[35] That event would certainly have given Susie new responsibilities and, as tragic as the death might have been for her, new social freedoms. Given that, the photograph, and the 1880 census, we can estimate, then, that Susie Tillett, a member of an otherwise traditional family, became a prostitute at some time between 1877 and the early 1880s.

By the time Susie Tillett joined the ranks, prostitution had been well-established in Lexington for decades. The federal census of 1850, the first to record the occupation of each adult citizen, identified five Lexington women

as prostitutes. The censuses of 1860 and 1870 each named over twenty.[36] (The legal status of prostitution fluctuated in Kentucky, as it did in most states, until after World War I. The choice of whether to identify persons enumerated in the decennial censuses as such seems to have been left up to the individual census takers. In any event, there was no consistency in the practice or in the terminology used to identify the profession—"prostitute," "madam," "inmate," etc.—from year to year or from locale to locale.) These women were living and working in pairs or small groups and do not appear to have been concentrated in any specific part of town. It was only in the second half of the 1870s that the city's prostitutes began to come together in larger, presumably more business-like residences that could properly be called brothels.[37] Each of these would have been managed by an experienced, usually older woman who, with intentional irony, bore the title of "Madam." One of Lexington's earliest and best-known madams was Jennie Hill, who, as local historians enjoy pointing out, ran her business out of the house on West Main Street that had been the girlhood home of Mary (Todd) Lincoln.[38] Madam Hill's place seems to have been something of a training center for future brothel keepers, and it was not long before these next-generation women were giving Hill some stiff competition, as it were. In the late 1870s, a cluster of brothels opened along North Upper Street, within blocks of the all-male campus of Transylvania College and its neighboring Gratz Park, a convenient spot for assignations, and just far enough—but not too far—from Lexington's posh neighborhoods on and to the west of North Broadway. At about the same time, another clutch of brothels was emerging at the eastern end of Water Street, which ran parallel to and just south of Main Street. The Water Street houses were literally on the wrong side of the tracks and fronted on an exposed section of the by-then heavily polluted Town Branch.[39] In 1880, three houses were operating on East Water Street, one of which employed at least six women. Within a decade, others had been established at the western end of that street and in nearby Ayres and Branch alleys, which became notorious venues of "sin."[40] This heralded a surge in prostitution (or at least in its visibility) in Lexington during the 1880s, so that by November 1892, when the police made a sweeping raid of the city's more notorious neighborhoods, they easily rounded up no fewer than forty madams, each of whom was, with impunity, keeping a "bawdy house."[41]

It is likely that Susie Tillett apprenticed in one or more of these neighborhoods during the late 1870s or early 1880s, but wherever she had her training, it was completed by 1885 when she opened her own house and installed herself as its madam. Coincidentally or not, her timing anticipated a push by local politicians and concerned citizens to shut down the North Upper Street brothels, which were too close for comfort to Lexington's "better" neighborhoods, and banish all such establishments to a less obvious area of the city.[42] According to historian Ruth Rosen, the concept of "the red-light district," a socially segregated part of a city where what was considered to be the necessary evil of prostitution and all its attendant vices could be monitored and controlled, was an invention, strictly American, of the late 1880s.[43] It was believed that this sort of "reputational segregation," as Rosen calls it, would decrease the impact of unfortunate but unavoidable vices on the city as a whole.[44] If Lexington must have such a thing, the logic ran, it might as well be in a place where property values were unpromising and residents politically negligible. Thus, the place chosen for this civic project was a predominantly African American neighborhood at the eastern end of Main Street, just inside the city limits. It centered on an unpaved track that was originally called Grant Street but that had recently been renamed Megowan Street. One contemporary source referred to it, accurately or not, as "the most obscure street of the city."[45] From its start at Main Street, Megowan ran north, intersected Wilson and Corral (or Correll) Streets, and terminated at Constitution Street.[46] Several large but unglamorous businesses—a hemp warehouse, brass and copper foundries, a lock factory, and a steam laundry—were clustered around the intersection of Megowan and Main, while a few smaller ones—a grocery store, a saloon, a barber shop—were scattered along the otherwise residential street.[47] In 1885, when the city-fathers decided to change Megowan Street's destiny and demographics, its residents included two blacksmiths, a carpenter, a cook, three drivers, a grocer, a horseman, a pension agent, a Baptist preacher, a jockey, and four common laborers, almost all of whom were Black.[48] Immediately to the east of Megowan was Race Street and, beyond that, Town Branch. That sadly polluted creek bordered the tracks of the L. & N. and C. & O. railroads, several coal yards, a large lumber company, and the lock factory. The property adjacent to or behind these businesses had long been an open

dumping ground for "offensive garbage," all of which would have made the neighborhood, including Megowan Street, both noisy and noisome.[49]

Despite these drawbacks and the alleged obscurity of their neighborhood, the residents of Megowan Street were not totally isolated from the rest of the city. The entrance to the Kentucky Association Racetrack at the eastern end of Sixth Street, for example, was only a few blocks from Megowan. This nationally known venue for horse racing and gambling attracted owners, trainers, jockeys, breeders, animals, and an enthusiastic crowd eager to participate in and lose money on the races that were held there.[50] The track's proximity to Megowan Street was obviously good for business at both sites.[51]

In the other direction, to the west, Megowan was within walking distance of the political, economic, and social center of Lexington, with its passenger and freight depots, courthouse, marketplaces, hotels, and other urban attractions. There were perhaps as many as one hundred saloons in Lexington at any given time during the 1880s and 1890s, many of them along Limestone (formerly Mulberry) Street and South Broadway.[52] Some saloon keepers improved their offerings by installing a lunch counter or café at the front of their premises while promoting gambling and other shady doings in back rooms. Some installed slot machines and roulette wheels, hosted craps and card games, or set up bowling alleys and billiard tables, all in the service of gambling and profit. For the uninitiated, proprietors and employees of these places were more than happy to provide directions to Megowan Street and offer advice about the best or cheapest brothels that could be found there, just a quick trolley or carriage ride away. Between the horse people, the boozers, and the gamblers, Megowan Street's reputation was bound to spread both locally and nationally. Indeed, by 1890, "Megowan Street" had become synonymous with "prostitution," and, in Kentucky at any rate, the term "Megowan Street girl" was widely understood to mean "prostitute."[53]

In its role as the main, if unpaved, artery of Lexington's red-light district, Megowan Street also had promoters closer to home. One of these was Mike Foley (1852–1924), a native of Ireland who immigrated to the United States in 1869. By 1877, Foley was operating a grocery store and saloon at the corner of Megowan and Corral streets and was busy buying up other properties in the area.[54] In all his guises—saloonist, liquor salesman, landlord, and real-estate dealer—Foley counted the city's brothel keepers among his most

reliable clients. One of these was Susie Tillett, who, in the spring of 1885, leased a house, number 41 Megowan Street, from Foley.[55] Insurance maps of the period show that this, the first of several houses in which Susie would live and work, was a moderately sized, two-story brick affair. It had three or four rooms and a long service porch on the first floor, with as many bedrooms as could be squeezed into the floor above.[56] The house was probably similar in appearance and layout to the one across the street at number 38 Megowan, which would soon become a brothel under the direction of Mollie Kennedy. In 1889, that house was described as a "two-story building, of modern style, containing thirteen rooms (eight bedrooms, four halls, parlor, store-room, bathroom, and kitchen)."[57] What worked for Madam Kennedy presumably worked for Madam Tillett.

When Mike Foley rented 41 Megowan to Susie Tillett in 1885, he was fully aware of how she intended to use it. An indictment brought against him the following year identified him as "the owner and controller [of] certain houses" that he knowingly rented to prostitutes.[58] One of these was 41 Megowan where, the indictment stated, Susie Tillett was not only Foley's tenant but his collaborator in using the house as a bordello.[59] For his role in these doings, Foley was found guilty of abetting criminal activity and fined accordingly. Not that this did anything to discourage either him or Susie: he continued to rent and sell his properties to madams for many years, and Susie carried on her career with aplomb—and increasing success. Indeed, by establishing a brothel on Megowan Street in 1885, Susie was something of an urban pioneer, a distinction that she shared with two other local madams, Fannie Arnold and Sue Green, both of whose long histories in the profession make them worth pausing to consider.

Fannie Arnold was born into slavery in Woodford County, Kentucky, in about 1852.[60] After the Civil War, she moved to Lexington, where, during the late 1870s, she worked in a brothel on North Upper Street. She was successful enough that by 1882 she was able to buy two contiguous lots, numbers 52 and 54, on what would become Megowan Street and build a "brick cottage," as deeds called it, on the former.[61] The combination of her race and her status

as a madam made her unusual and, for a time, unique in Lexington. Most of the town's Black-run bordellos were located, or soon would be, in a shallow urban valley just to the west of Megowan Street known as Chicago Bottoms. Bordered by Walnut, Dewees, Barr, and Third streets, the neighborhood was depressed not only geographically but also economically, a separate but unequal red-light district whose bawdy houses were populated by African American madams and prostitutes. Chicago Bottoms' streets—Bradley, Clark, Edwards, Sowards, Spruce, and Wickliffe—were lined with places of assignation, some of which were little more than one- or two-room shacks with only one or two inhabitants, each on fifty-cent duty. Because some of these streets were short and could not have qualified as thoroughfares, the area presented as being sealed off from the surrounding areas. Undoubtedly, this contributed to Chicago Bottoms' success as a red-light district, in terms of quantity if not quality, and by 1901 there were no fewer than twenty-five mostly low-rent brothels there.[62]

Meanwhile, back up the hill on Megowan Street, Fannie Arnold's occupation kept her name in the papers. During the 1880s and 1890s, she was in and out of court on a regular basis, usually charged with minor offenses— running a tippling house, using profane language, selling liquor on Sundays, or simply creating a nuisance.[63] But these legal irritants did not cramp her style. On the contrary, when she died in June 1904, she was memorialized as the successful owner "of several houses on Megowan street [who] had been generally known to frequenters of that notorious thoroughfare for a quarter of a century."[64]

The other pioneering Megowan Street madam was Sue Green, who moved to the street at about the same time as did Susie Tillett (and, coin- cidentally or not, would eventually relocate to Chattanooga, Tennessee, as did Madam Tillett). Green was born in Kentucky in 1861 and had become a prostitute by 1880 when she was one of at least nine women working in a brothel on Water Street.[65] She advanced to madam and in about 1882 opened her own house on North Upper Street. When the official push came to rid that area of prostitution, she was compelled to move, "at great sacrifice" (her words), to Megowan Street.[66] In 1884 or 1885, she bought 35 Megowan Street, a substantial brick-and-frame house that was said to contain fourteen rooms, most of which were probably small bedrooms in which her employees

could accommodate their clients.[67]

Like most of her colleagues, Sue Green had her share of legal problems; but she was luckier than most in having powerful supporters who came to her aid when things got tough. In 1888, for example, she was arrested for running a disorderly house, found guilty, and fined $300 plus costs. Several of her clients defended her to no less a personage than Kentucky's governor Simon Buckner. They protested that the fine was exorbitant, especially since Madam Green had "two children, a boy 11 years old, that is off at school, and a daughter at the convent, being educated." "I am reliably informed," one correspondent wrote Buckner, "that she is raising them as they should be."[68] Swayed by these pleas—and by several visits that Madam Green herself made to the governor's office in the state capitol in Frankfort—the Honorable Buckner issued a pardon.[69]

For the next five or six years, Sue Green was "one of the leading lights of Lexington's half world." But by the mid-1890s, she was in financial trouble and struggling with an addiction to morphine. On one particularly dreadful day in early February 1895, she "became enraged," so the papers said, when her dressmaker confronted her with an overdue bill. She ran the unpaid woman out of her house, but then went across the street and took her anger out on her neighbor and fellow madam Mollie Kennedy. She accused Kennedy of "making divers remarks about her" and stealing her "girls." Things got so out of hand that Kennedy called the police. Green was arrested for using insulting language and disturbing the peace, charges that were leveled at Kennedy herself on more than one occasion. Green posted bail and returned home where, undone by the day's events, she overdosed on morphine. After "hours of hard work with electric batteries," several doctors managed to revive her.[70] But her financial situation did not revive, and in early 1896 she defaulted on her home mortgage.[71] She managed to stave off the worst for a while but in July 1899, the house at 35 Megowan Street, "formerly owned by Susie Green," was sold at auction by the Union Building and Loan Association.[72] By that time, Green had left town for Chattanooga where, by 1898, she opened a house on Helen Street, Chattanooga's answer to Lexington's Megowan Street. In making the move, she undoubtedly had been inspired and perhaps even advised by her former Lexington colleague, Susie Tillett, who, as we will see in a later chapter, had by then moved to

Chattanooga herself. As for Sue Green, Chattanooga would do better by her than had Lexington, and her house there quickly become one of that city's most successful.[73]

It is likely that Susie Tillett got her Megowan Street business up and running by combining personal savings with funding from friends and patrons of one sort or another. There can be little doubt that the brothels in which she worked throughout her lengthy career, whether as an employee or as a madam, were all "parlor houses." This type of house was understood to be "an entire building devoted to the business of prostitution," one that offered clients a full range of pleasures that began as soon as they entered its parlor, thus the name.[74] Perquisites included watered-down alcoholic beverages, priced for profit and served by the house's female employees under the strict supervision of the madam.[75] Music was usually on offer, emanating from a piano, sometimes with a hired musician at the keyboard, or later, from a Victrola on which the madam would play the latest phonographic records.[76]

Furnishing such a house in a manner appropriate to its intended use would have been a priority for its madam. As it happened, local merchants were willing to let Susie Tillett buy on credit, presumably because they trusted her to pay. In August 1887, she was approved for a personalty mortgage (a loan collateralized with personal property) with Smith & Nixon, Lexington's leading dealer in pianos and organs.[77] The following January, she made a similar deal with Charles F. Brower & Company, one of the city's early department stores. Bower sold a wide range of merchandise that included carpets, wallpaper, draperies and, in a recently established "art goods" department, "bronzes, bisques, vases, figures, busts" and the like.[78] It is easy enough to imagine Susie Tillett, by this time a successful madam, browsing among and making purchases from many of these offerings.

This shopping spree—and the fact that local merchants were willing to give Susie credit based on her personal assets—suggests that by 1887 she was financially successful. By that year, too, her name had begun to appear in Lexington's city directories as Madam Susie Tillett of Megowan Street and in local newspapers in a way that makes it clear that her professional status

was a matter of common knowledge.[79] A gossipy article published that year in the *Richmond Climax*, a weekly newspaper out of Richmond, Kentucky, suggests as much. It concerns a young woman named Belle Braxton who had come to Lexington from Madison County in about 1885 to work for Sue Green at 35 Megowan Street. By 1887 she had moved to Sue Tillett's house a few doors away.[80] On a June evening that year, the *Climax* reported, Belle "went to the house of a negro voodooist, 'Aunt Eliza', on Jefferson street, for the purpose of getting medicine which would give her power to see into the future and be able to retain the love of her paramour." Eliza allegedly gave the girl a glass of green liquid that was later identified as "Paris green," an arsenic-based pigment used for dying cloth and tinting wallpaper that was thought to have aphrodisiacal powers. Belle drank it, immediately became ill, and "while going home to *a place kept by Susie Tillett*, grew worse" [italics added]. There, she began "hemorrhaging from the lungs" and lost nearly a half-gallon of blood before "four physicians were called in" and determined that she had been poisoned.[81] The story ends there: the press made no follow-up reports, and nothing further is known of the unfortunate Belle. But the article is of interest here because of the coy way the writer refers to Belle's final destination and by the coincident fact that it aligned Susie Tillett with other shady characters, in this case the racially stereotyped Eliza. The reader is left to speculate about Belle Braxton's relationship with Susie, but the inference is that she was one of Susie's cohorts, providing more titillation for the reader and perhaps implying that she got exactly what she deserved.

About a year after the Braxton affair, Susie's name again appeared in the press in a way that leaves little doubt that she had achieved local infamy. In July 1888, the *Lexington Daily Leader* reported that Walter Meenach, a twenty-three-year-old farm laborer from Jessamine County, used his brother-in-law's wagon and horses to steal twenty-nine sacks of grain from another farmer. The morning after the theft, Meenach, who was described as not having "the countenance of a thief," brought the stolen goods to Lexington and sold them to a local grain dealer for $33.80.[82] Newly flush, Meenach went on a shopping spree that took him to Gus and Louis Straus' clothing store and to the "bagnios of Misses Belle Breezing and Tillett, where he made away with a considerable portion of his stolen wealth." With his assets spent, Meenach was spotted wandering around downtown Lexington and arrested.[83] While

Susie Tillett probably did not know or care about the source of Meenach's money, the casual reference to her in this sordid tale again implies the level of notoriety to which she had risen.

This begs the question of just how aware Susie's relatives, of whom she had many, were of her career. While it is not possible to answer that question with any certainty, we can note that, with a population of fewer than 20,000 people, Lexington was still a small city in the late 1880s.[84] The chances of Susie's activities going unnoticed were close to zero, even if she had made some attempt at secrecy, which she did not. As far as is known, she rarely if ever used an alias, as did many of her colleagues, and whenever the quotidian facts of her life appeared in print, they did so under her own name.[85] When profit was promised, she even went out of her way to call attention to herself. In 1890, for example, she paid a fee to have her (real) name, title, and address printed in large, bold-faced type in Lexington's city directory, a convenient way to advertise that was used by all manner of businesses at the time. Naturally, in many of these alphabetical directories, at least in Lexington, Susie's name appeared on the same page as those of some of her Tillett relatives, guaranteeing that they would see her name and occupation. In the 1890 directory, for example, the names of her brother Charles Tillett and her cousin William Tillett are adjacent to hers, as she must have known they would be when she chose to have herself listed in large, bold-faced type.[86]

Printed proximity is one thing, physical proximity another. During the late 1880s, Susie's older sister Annie, Annie's husband, David W. Warnock, and their young son lived only a block from Susie at 70 Megowan Street; and her brother Sam Tillett lived just around the corner at 122 Corral Street.[87] In fact, family was even closer to Susie than that. In the late 1880s, two of her younger sisters, Lillie and Nettie, joined her in the house on Megowan Street—and in the profession of prostitution.

Born in 1867, Lillie Marshall Tillett, Samuel and America Tillett's ninth child and fifth daughter, was eight years younger than her sister Susie.[88] "My mother was a middle child in a family of 13 [sic] children," Lillie's daughter later wrote.

She went to a country school in Fayette County, Kentucky, near Lexington; but she was a self-educated lady who had a thirst for education and learned by reading everything she could get her hands on. Up until the day she died she read six or seven books a week... everything from Dickens, Shakespeare, H. G. Wells, Jules Verne, and the Bible, to Zane Grey. Her formal education did not go beyond the fourth grade when she became ill and had to drop out of school due to pneumonia all one winter and a scalded ankle onto which she had dropped a large pot of coffee.[89]

With her mother's death in 1883, sixteen-year-old Lillie, like her older siblings, was obliged to find a way to support herself. She took a job as housekeeper for Claude Carr, a forty-two-year-old Lexington mill worker, and his wife, Laura.[90] According to later press accounts, Carr was overcome by Lillie's beauty and seduced her. Laura Carr discovered the infidelity and immediately left her husband. Apparently ignoring the gossip that was already abroad in the town, Lillie moved in with Carr and lived with him as his mistress.[91]

At about this same time, Carr learned from local newspapers that federal authorities were offering a twenty-thousand-dollar reward for information leading to the arrest and conviction of a notorious counterfeiter named Alonzo Fuget (or Fugate) who was thought to be operating his scam in central Kentucky.[92] Intrigued, Carr recruited two friends, the brothers John and Wilson Rose of nearby Woodford County, to help him trap Fuget and collect the reward. They tracked the man to a house in Jessamine County and, with promises to underwrite his criminal activities, convinced him to return with them to Lexington. With Fuget temporarily stowed in Carr's house, Carr and the Roses began looking for a secluded farm—the press called it a "blind preparatory"—where Fuget could set up his money-making machinery. After a few false starts, they found a place in Woodford County where, according to Fuget's later testimony, they forced him to print bogus currency. Carr and the Rose brothers took turns guarding their captive, but bored with his share of the duty, Carr announced that he was going to bring his mistress, Lillie Tillett, to the farm to keep him company. Fearing that Lillie's presence would pose a security risk, the Roses objected, and Fuget, claiming moral indignation, announced that he would not share a house with a "woman of ill-fame." With his captors distracted and arguing among

themselves, Fuget escaped, only to be apprehended and forced by Carr and the Roses to return to the Woodford County farm.

Meanwhile, someone tipped off the police as to what was going on. The farm was raided, and Fuget was caught in the act. "A complete counterfeiter's outfit was found," one reporter punned, "and the officers didn't *Fuget* to note the fact."[93] Carr told the police that he had planned the whole thing with this precise outcome in mind. At the subsequent trial, Fuget's attorney countered by claiming that Carr and the Roses had set up the partnership so that they could blackmail Fuget into printing fake money for their own benefit. The trio turned on Fuget, his lawyer claimed, only after they realized that he was about to name them as his accomplices. The court rejected that defense, ruled that Fuget was the sole perpetrator, and found him guilty on all counts. Carr eventually collected his share of the reward in the amount of five thousand dollars.[94]

Given Lillie Tillett's presence in Carr's house in Lexington and then on the farm in Woodford County, it is likely that she was fully aware of what was going on. By the summer of 1886, though, she had had enough of Carr and had left him. Perhaps she felt he had cheated her out of what she thought was her rightful share of the profits from the Fuget case; or maybe the strain of the whole thing was simply too much for her. Whatever the case, Carr, who had "given up his wife for the embraces of a beautiful house girl," was despondent.[95] The *Louisville Courier-Journal* brought the story to its dramatic conclusion. On August 1, the paper said, Carr locked himself in his house,

> nailed up the windows and doors and put an end to his existence with morphine. As usual, there was a woman at the bottom of it. Two years ago, he employed a beautiful girl, by name Lillian Tillett, to do his housework, and while in his employ he seduced her. He then procured a divorce from his wife and took the wronged girl to live with him as his mistress. Their association soon led to quarrels and blows. A few days since, the girl went to the house and moved away all the furniture. He caused her arrest on the charge of grand larceny, but the court dismissed the charge and gave her the furniture. When Carr's body was examined, a note to his mother was found, instructing her to bury him where no man's foot had ever trodden. Also a note to the woman he had wronged, begging her farewell, and saying his blood would be on her head.[96]

Luckily for Lillie—and her furniture—she had a place to go. With the press already reviling her as a "woman of ill-repute," a "soiled dove" beyond redemption, she took refuge in her sister Susie's house on Megowan Street.

Nettie Tillett's early history paralleled those of her older sisters. She was born near East Hickman in rural Fayette County in 1871, Samuel and America Tillett's eleventh child. According to the 1940 census, she completed eighth grade. Her father's death in 1887 left her and her three younger siblings, all still under the age of eighteen, legally orphaned. But on February 27, 1888, Nettie became the ward of David Wesley Warnock, a Lexington wood-turner (carpenter), who had married her sister Annie a few years earlier.[97] Warnock's primary function as guardian was to give permission for the under-aged Nettie to marry Daniel Reed, a man whom Nettie had recently met and about whom her family knew little or nothing. The marriage was performed on March 21, 1888; it lasted just over a week. By April Fool's Day, Reed had abandoned Nettie and vanished.[98]

Having been wronged, Nettie moved into Susie's house at 41 Megowan Street where, like Lillie, she became both resident and employee. She delayed divorcing Reed, who in any event never resurfaced, until 1892, by which time she was firmly ensconced in her new profession and had a steady income. Lawyers in her divorce case, which was heard in Fayette County court, were unable to locate Reed, but it was believed that he was living in Ontario, Canada, of which he was a native. They discovered that when Reed married Nettie, he already had a wife in Canada, adding bigamy to the charges. Nettie's brother-in-law David Warnock and her brother Sam Tillett were deposed. Both stated that they had been present at Nettie's wedding and that they had first-hand knowledge of Reed's mistreatment and abandonment of her. The divorce was granted in late December 1892 and Nettie was given "all the rights of an unmarried woman" and restored to her birth name.[99]

Soon after Nettie moved into her sister's place, Susie decided it was time to own, rather than rent, a house.[100] In September 1889, acting as Emma S. Tillett, "a single woman of the city of Lexington," she paid John J. Murray, a Lexington horseman, two-thousand-five-hundred dollars for the lot and

house at 54 Megowan, which was across the street from the house that she had been renting. In selling it to Susie, Murray was "flipping" it: he had just bought it from Robert Arnold who had acquired it from his mother, Madam Fannie Arnold, in 1886.[101] An insurance map of the period shows that, although it was of frame construction, it was comparable in size and plan to the brick house Susie had been renting from Mike Foley. It was large enough to accommodate a reception area, dining room, and staircase on the first floor, with a one-story extension to house the kitchen at the rear. The second floor would have been divided into as many bedrooms as needed to accommodate Susie's boarders and clients.[102]

With Fannie Arnold, Sue Green, and Susie Tillett established on Megowan Street, other madams soon followed. By 1887 Mollie Kennedy, who would live on the street for years, was at number 38; Frances Marshall, who had previously run a house just south of Main on Grant Street, was at number 48; and Nellie Abrams was at number 52. A year later Mary Oliver was at number 31 and, after Susie Tillett moved across the street, Ella Childers became Mike Foley's latest tenant at number 41.[103] The street also got its second African American madam at about this time in the form of Mollie Irvine, who had been in business around the corner on Dewees Street but was now at 66 Megowan. Irvine was popular and proved a worthy rival to the other Megowan Street madams, including the most famous of them, Belle Brezing, of whom more shortly. Mollie was later remembered by an unidentified local historian who seems to have been writing from personal experience (and in unfortunate racial terms common to the period). "The two outstanding houses of ill-fame in Lexington for more than a generation," he wrote,

> were Belle Breezing's and Mollie Irvine's, which stood across the red-light street, Megowan, from each other, Belle's being tall and white and handsome, and Mollie's a squat red brick cottage.... Mollie—and this may shock you—was a negress, a full-lipped African who had a keen head for business and an equally keen eye for what white men like in their screw-ladies. Mollie knew how to pick them better than Belle,

or so the rich and aristocratic gentlemen of the Blue Grass country held for thirty years or more; and so they, the rich and aristocratic gentlemen, would start getting drunk at the old Phoenix Hotel [on Main Street], slide, stumble and half-fall down the front steps into the arms of Ambrose, noted negro nigh[t] hawk, and, after being bundled up in his hack, he would look around at them for orders: "Mollie Irvine's," the drunks would mutter in unison, and old Ambrose, who hitched his carriage to a reformed race horse, Harry New, would smile and bow and say: "Yes, suh, yes suh, boss."[104]

But neither Mollie Irvine nor any other recent arrival on Megowan Street made as big a splash there as did Belle Brezing, who, thanks to the success of houses she had run on North Upper, was, by the late 1880s, Lexington's best-known madam.[105] The story of her life has been told a number of times, including in two full-length biographies, and need not be detailed here.[106] Suffice it to say that in 1889, she sold her Upper Street property and bought 59 Megowan Street from the ubiquitous Mike Foley.[107] She proceeded to enlarge and generally improve the house, eventually turning it into a showplace, at least by local standards. More than anyone else, she made the street famous. She even achieved international stardom—albeit by proxy—as the presumed inspiration for the fictional Belle Watling, the good-hearted madam in Margaret Mitchell's 1936 novel, *Gone with the Wind*.[108] Brezing's fame was (and is) such that one might conclude she was the only successful madam who ever ran a house in Lexington. That was far from the case.

By 1892, over forty madams were documented as working in Lexington, most of them on Megowan and surrounding streets. Judging by city directories and census records, each of these women employed between one and ten others, meaning that during the 1890s there may have been as many as one hundred prostitutes working on Megowan Street alone.[109] As for Susie Tillett, she had at least four boarders in her house (in addition to her sisters) in 1888: Goldie Cameron, Nora Courtney, Pearl Crawford, and Nora Kelley.[110] The only one of these women about whom much is known is Pearl Crawford. Her story, like those of Susie Tillett, Fannie Arnold, Sue Green, and Mollie Irvine, proves that Belle Brezing's was hardly the only game in town. Pearl's tale is a classic one, and again, worth a pause to tell here.

In 1887, when she was fifteen, Pearl Crawford was lured to Lexington from her home in rural Kentucky by a so-called traveling man who promised

to marry her. "They met," a Lexington paper reported, "but there was no marriage." As a "soiled dove" with nowhere else to turn, Pearl became a prostitute. She worked for Susie Tillett at 54 Megowan from about 1888 to 1890, moved around the corner to Fanny Jackson's place on Dewees Street, and then to Mollie Irvine's at 66 Megowan.[111] By 1895, she had her own brothel at 63 Dewees Street and apparently made a good job of it.[112] Over the next several years, she managed to accumulate a small fortune in cash, bonds, and diamonds. Her life changed in 1898 when she met Lieutenant Cullen Calhoon Mitchell, who was stationed at a U.S. Army encampment near Lexington awaiting deployment to the Philippines.[113] The son of a respected physician in Jackson, Mississippi, Mitchell probably met Pearl at her house on Megowan Street. The two fell in love, became engaged, and Pearl announced her plans to retire and await Mitchell's return from duty. When that finally happened in 1901, she met him as he stepped off the ship in Oakland, California, and the two were married, or so they claimed. Pearl returned to Kentucky while Mitchell went home to Mississippi to break the news to his widowed father. Suspecting that Pearl was less than genteel, the elder man refused to recognize the union and declared that the woman would never be received in Jackson. When Mitchell did not rejoin Pearl in Kentucky, she despaired and, on January 12, 1902, died by suicide after overdosing on morphine. The resulting controversy over the status of her money and jewels brought forth a widowed mother and a former husband to lay claim to them. At this point, some newspapers began to portray Pearl as an innocent, victimized Southern belle from a distinguished family. But others correctly identified her for what she was: a former resident of Lexington's Megowan Street and colleague of its notorious madams, including Susie Tillett.[114]

For a woman in her profession, it is predictable that Susie Tillett was party to a variety of shady doings and linked, directly or not, to scandalous characters such as Pearl Crawford. Consequently, her name appeared in the papers on a regular basis. It was the price of doing business in the demimonde, especially in a small Southern city like Lexington, which, by the late nineteenth century, had its share of madams, saloonists, gamblers,

and con artists. Most of these characters, male and female, managed to get themselves arrested, alone or with others, with some frequency.[115] It is easy enough to construct a rap sheet for Susie since, as we have seen, she rarely if ever used an alias.

One of the more interesting cases in which Susie was involved occurred within months of her move to Megowan Street. In December 1886, she was arrested for "suffering a nuisance," a standard charge that covered a host of transgressions, each of which, according to the legalese of the time, somehow managed to offend "the citizens of the Commonwealth," i.e., the entire population of the state. On this occasion Susie's specific offense was abetting the criminal activity of one Kitty Ramsey who had already been indicted for living with a man, Layton Ramsey by name, to whom she was not married. When the relationship ended, Kitty simply moved on to a new lover, in this case Broad Keith, the higher-profile son of a respected Lexington doctor. The authorities noticed and a new indictment was quickly issued. Kitty and Keith, it stated,

> did habitually cohabit and live together as man and wife and did openly habitually, & notoriously have carnal knowledge of and sexual intercourse with each other to the common nuisance and annoyance of all good citizens…especially those living in the neighborhood of the house so occupied by them and passing and repassing the same.

The neighborhood in question was Megowan Street and the house was Susie Tillett's. The indictment named Susie as an accomplice to the crime, a nuisance, and an offense to the citizenry.[116] There is evidence to suggest, and no reason to doubt it, that Kitty Ramsey was in reality Susie's sister Nettie, operating for these purposes under an alias.[117]

A year after the Ramsey affair, Susie was again in court, this time for keeping a tippling house and promoting various unnamed illicit activities. For these offenses, she was found guilty and fined three hundred dollars.[118] Similar charges were brought against her at least three times in 1888—in January, June, and November that year—with varying results.[119] The pattern continued into 1889 when, in January, she was again arrested, but this time the indictment was more specific. In "a certain house," it read,

> Susie Tillett did unlawfully suffer and permit divers persons, men as well as women, of evil name & fame, to habitually frequent said

house for purposes of prostitution, and did suffer them there to be and remain habitually engaging in prostitution, drinking, carousing, dancing, fighting, using obscene & profane language, making indecent exposure of their persons, & loud noises, to the common nuisance and annoyance of all citizens of the Commonwealth of Kentucky & especially those living in the neighborhood of said house.[120]

There is no evidence that Susie ever spent any extended time in jail for these offenses. Typically, she posted bail, was released, made a brief court appearance, was found guilty or not, and paid fines and court costs as required. But whatever the outcome of these cases, their regularity must have grated, or at least been inconvenient, not to mention expensive. Meanwhile, professional competition on Megowan Street was rapidly increasing, with no end in sight. It was probably not a coincidence that just as the news of the great Belle Brezing's intended move to Megowan Street was announced, Susie Tillett decided it was time to move on. In September 1889, she took out a mortgage on her Megowan Street property and used the money to relocate to Chattanooga, Tennessee.[121] She and her sisters had settled there by the fall of 1890. She continued to manage her Lexington property for a few years from afar.[122] Soon though, she began leasing it to other madams and turned her full attention to the business in Chattanooga. It was a change that had a profound impact, not only on her professional life, but on her emotional one as well.

Chapter 2

Arthur Jack

The city that would become Atlanta, Georgia, began life in 1837 as a town called Terminus, a reference to its position at the southern end of the newly established, state-sponsored Western & Atlantic Railroad, which connected it to points north. Six years later, the place, which was little more than a dusty crossroads, was given its own post office and the new, higher sounding name of Marthasville, in honor of the daughter of the then governor of Georgia. Politics changed, that name fell out of favor, and in 1845 the town took its final designation as Atlanta, which was thought to be the feminization of "Atlantic"— "a coined term," as one historian put it, "emblematic of its reach toward an oceanic future."[123] This time the name stuck and the place grew.[124] By 1860, Atlanta was the meeting point of three major rail lines, had a population of just under 10,000 people, and was on its way to becoming an economic and social hub, not only of a state but, soon, of a treasonous confederacy. Its strategic position was such that, despite its having been the jumping-off place for Sherman's March to the Sea in 1864, it not only survived the Civil War but thrived during the decades that followed it. Within fifteen years of the war's end, Atlanta's population had quadrupled from its pre-war peak to about 40,000 people, white and Black, free and subjugated, diverse but hardly integrated.[125] In 1868, it became the capital of Georgia.

Among the city's early (white) settlers was the newly widowed Malinda Jack—future grandmother of this chapter's subject—who, with her six sons, arrived in the city in 1850.[126] Malinda's husband and the father of her children,

William Jack (1813–1848), had died two years earlier.[127] Thought to have been a descendant of the Revolutionary War patriot Patrick Jack (ca. 1700–1780) of Charlotte, North Carolina, William married Malinda, née Davis (1815–1889), in 1833 in Fayette County, Georgia.[128] She was a daughter of John Timothy and Sarah (Russell) Davis and a presumed descendant of Morgan Davis (or David) who, according to one undocumented but impressively produced genealogy, came to America from Wales in about 1686.[129] William and Malinda lived in Carroll County, Georgia, where they had about 500 acres of land adjacent to a similarly sized farm owned by Malinda's parents. Presumably that is where their six children, all male, were born: James Russell, known as Jim, in about 1836; William F. in 1838; Francis Marion and his fraternal twin George Washington, sometimes known as F. M. and Wash, respectively, in 1840; Doctor Franklin, known as Frank or Doc, in 1843; and Columbus Lafayette in about 1844.[130]

Malinda Jack was said to have "reared, and…trained [her sons] in the ways of truth and manhood."[131] An important step in that training, it seems, was to move the fatherless sons to Atlanta. Undoubtedly, she thought that Atlanta, which was booming by then, was a good place for the boys to mature, find work, and, with luck, establish lucrative careers. And that is more-or-less what happened. In 1857, the eighteen-year-old twins, Francis and George, opened a grocery, bakery, and confectionery on Whitehall Street in the heart of the city. Their brother William soon followed with his own, similar business.[132] Over the next few years, the trio, sometimes working together, sometimes separately, expanded their inventory beyond baked goods to include a wide range of products: fruit, candy, and pickles; rope, nails, and twine; baskets and toys; wines, liquors, and tobacco. By the time the war came, the Jacks had cornered the local market for many of these commodities.[133]

In 1858, with a chronological rhythm that suggests calculation, three of the Jack brothers married in quick succession. In May, William married Angeline de la Perrière (1837–1860), daughter of a French-born Atlanta physician; the following month, George married Josephine A. Wall (1840–1886), a native of Augusta, Georgia; and in July, Francis married Sophia W. Rucker (1840–1873), daughter of Gideon Pope and Elizabeth (Callaway) Rucker of Wilkes County, Georgia.[134]

Francis and Sophia had five children, all born in Atlanta: Tallulah H.,

known as Lula, born in 1859; our subject, William Arthur Jack, born in 1861; Wade Hampton Jack, born in 1863; Roberta Lee Jack, known as Lee, born in 1865; and James Russell Jack, known as Jim, born in 1867.[135] During the Civil War, Francis Jack and all but the youngest of his brothers served in the Confederate army: Jim, William, George, and Doc enlisted in Cobb's Legion, the famed division of Longstreet's Corps, and Francis joined the Georgia State Militia, all in 1861.[136] Needing some of the products and services that the Jacks' businesses provided to fuel its forces, the Confederate government recognized Francis Jack's work as essential. He was removed from active duty and placed under contract to the rebel government. While continuing to market his bread and other products to the civilian citizenry of Atlanta, Francis made huge quantities of hardtack (or "Confederate pilot bread," as he called it), a nearly tasteless flour-and-cornmeal cracker that was easy to transport, had a long shelf-life, and became a staple of the Confederate soldier's diet.[137] To meet the demand, Francis operated five brick ovens between Broad and Forsyth streets and another on Whitehall.[138] At the peak of production, he employed as many as ten salaried workers and twelve enslaved persons.[139] One of his employees, a thirteen-year-old boy named James Bell, later recalled how he and his older brother William had performed "a variety of tasks" at Jack's bakery during the war, including "stoking the furnace with wood, 'peeling' the crackers out of the moulds, and delivering them to hospitals and local camps."[140]

Francis Jack's ability to stay in Atlanta and personally manage his business ensured that he and his family survived the war, physically and economically. Although they were forced to evacuate Atlanta when Union troops arrived in the fall of 1864, they had returned by the time of Robert E. Lee's surrender the following spring. On April 8, 1865, the day before Lee met Grant at Appomattox, Francis and Sophia Jack's fourth child was born. They named her Roberta Lee.[141]

With the war over and Atlanta experiencing a postbellum boom, the Jack brothers set about upgrading, diversifying, and marketing their businesses. By the end of the 1860s, they had built solid reputations throughout the South as Atlanta's best bakers and purveyors of crackers, candies, flavored sodas, and ice cream, the latter being a delicacy that Francis had introduced to the city as early as 1861.[142] In 1869, the *Atlanta Constitution* reported that

Francis and George Jack were among only 400 Atlantans who had earned more than one-thousand dollars the previous year.[143] In 1873, George Jack reported annual sales in the amount of two-hundred-ten-thousand dollars, a substantial increase over his previous record of thirty-thousand dollars in 1868.[144] This good fortune continued through the 1870s and into the 1880s as the Jacks catered to their gentlemen clientele by stocking fine cigars and liquors, and appealed to the leisure market by selling non-comestibles such as willowware (a popular blue-and-white porcelain), fancy baskets, and toys, the last of which they heavily advertised during the Thanksgiving and Christmas seasons.[145] To keep their inventory fresh, they made promotional tours of the South and took buying trips to New York, Washington, D.C., and elsewhere.[146] In 1882, Francis Jack expanded his by then independent operation to include a well-stocked refreshment counter, the central feature of which was an elaborate fountain, fourteen feet high and eight feet wide, constructed of several types of marble trimmed with gold. The *Atlanta Constitution* marveled at its "fifteen different draughts by which many drinks of soda and mineral waters [could] be dispensed over the counters." The faucets "are beautifully chased," the description continued, "silver mounted with arched necks that pour out the refreshing beverages to thirsty mortals."[147] An ice-cream counter was conveniently located near the front of the store, Jack advertised, so that ladies could enjoy a refreshment while keeping an eye out for their carriages.

Francis and Sophia Jack's second child and first son, William Arthur Jack, was born on October 13, 1861, at his parents' home at the corner of Pryor and Mitchell streets in Atlanta.[148] He was known in his youth as Willie or Will and, later, as Arthur. Having been born six months after the start of the war, Will Jack's earliest memories were of the city during the conflict. His recollections of both significant and arcane details of the 1864 siege of Atlanta remained clear to the end of his long life. "When Sherman came shootin' his bum [bomb] shells," he told his grandchildren seventy years after the fact, "we refugeed from Atlanta to Augusta in a covered wagon. I looked through a hole in the floor and saw a big frog sittin' in a mud puddle."[149] He

remembered, too, the death of his infant brother, Hampton Jack, a month before the fall of Atlanta; his mother's grief and frequent illnesses in the years after the war; and her death from "a painful illness of some duration" in 1873 when Will was only eleven. His solid memories of her love and fortitude were corroborated by eulogies delivered at her death. "Her course was like that of a sequestered stream," one of her sisters said, "noiseless and unpretending, yet bearing life, verdure, and sad beauty wherever its silent waters flowed."[150]

Despite these disruptive events, each of the four surviving Jack children—Lula, Will, Lee, and James—graduated from high school, a better-than-average education at the time.[151] Will also participated in extracurricular activities, especially sports, in which he had a keen interest. In the spring of 1878, he joined one of Atlanta's first baseball clubs, the Blue Belts, the members of which were between the ages of fourteen and eighteen.[152] He and his fourteen-year-old friend Carl Mitchell were the Blue Belts' star players, and Will was elected team captain.[153] Their main competition was the Atlanta Alerts, which, thanks to the batting skills of "Captain Jack and Carl Mitchell," the Belts defeated in their first outing that June with a score of 29–27.[154]

Unfortunately, the sport was not always fun. On July 8, 1878, a crowd of about forty young men ranging in age from fourteen to twenty-five gathered on a baseball field near McPherson Barracks (later Fort McPherson) in southwest Atlanta to play and watch baseball. As the teams assembled, Will, in his role as captain of the Blue Belts, asked one of his teammates Charles Venable, age fourteen, to prepare the team's bats for use. As Venable was doing so, an older boy named Will Lawshe, age twenty-two, made disparaging remarks to Venable, who responded in kind. The conflict turned physical and Lawshe soon had the much younger boy penned to the ground. Carl Mitchell came to Venable's defense, but when Lawshe proved too strong for them, Mitchell picked up one of the bats that Venable had been cleaning and hit Lawshe in the back of the head with it. Will Jack and some of the other boys carried the severely injured Lawshe to his family's house, which was nearby. A doctor was called but Lawshe died the next day.[155]

Mitchell was arrested, released on a five-thousand-dollar bail, and in December 1878 was put on trial for murder. Will Jack was among those called as character witnesses in Mitchell's defense. Testimony confirmed that

the accused was from a respected Atlanta family—his father was principal of the Marietta Street Grammar School—and that he had a good reputation among his teachers and peers. "He was an excellent student, standing with the foremost," one of his teachers at Atlanta's Boys' High School wrote. "I never saw a more quiet, gentle or peaceable boy. He was a model of uprightness and propriety in the school room, respected and loved by his teacher and his class."[156] Lawshe's death was eventually judged to have been the result of an unpremeditated act, and Mitchell was acquitted.[157] As we will see, for Will Jack, this was only the first of several well-publicized incidents in which he would be involved during his life.

It was probably not long after the baseball tragedy that Will completed his education, possibly, like his friend Carl Mitchell, at Atlanta Boys' High School. Following graduation, he worked as a clerk in his father's business, and that is how he is recorded in the 1880 Atlanta city directory, the first in which his name appears. He is shown there as living with his father, his younger siblings, Lee and James (their older sister, Lula, had married in 1876), his uncles George and William, and their wives at 285 Whitehall Street.[158] That same year, he joined Smith's Light Infantry, a recently formed militia unit that was made up of lawyers, clerks, and other young Atlanta professionals. The organization was probably more social than military in purpose, although its members were assigned ranks—Will was a third sergeant—and probably spent some time drilling, marching, and discussing ways to express their civic, if not necessarily national, pride.[159]

By that time, too, Will had become a devotee of the newly popular sport of roller skating.[160] He became so proficient that he decided to try to make some money from it. In 1881, he became manager of two commercial rinks, one at 15 East Hunter Street in Atlanta and the other in Milledgeville, Georgia, about one hundred miles southeast of Atlanta.[161] (In hot and humid Georgia, an indoor entertainment such as roller skating was understood to be seasonal, with rinks open only from late fall to early spring.) For the Milledgeville rink, Will partnered with a friend George P. Lawshe who worked as a baker for Will's uncle W. F. Jack and happened to be

an accomplished skater (as well as the brother of Will Lawshe whose mortal injury Will Jack had witnessed in 1878).[162] Jack and Lawshe rented space in Milledgeville, paid the city council five dollars for a monthly business license, and in late March 1881, opened their rink.[163] It was a sensation. "A skating rink is in full blast in Brake's building," Milledgeville's *Union & Recorder* reported on April 5, "under the control of Mr. Jack. The young people of both sexes are having some rare fun while trying to learn the graceful art. A visitor is well repaid by looking at the ludicrous mishaps that happen all along the line."[164] The public came to the rink to skate as amateurs but also to watch professionals perform and compete. "Mr. Jack's skating rink was the centre of attraction last Tuesday evening," the paper noted in April 1881. "The House was full of anxious young men and their friends who sought the prizes of the tournament." Jack himself was declared "the most accomplished skater," deservedly winning the first prize medal that night. "FUN was the presiding genius," the paper gushed in all-caps, "LAUGHTER was also there...LOVE was very prominent as a factor, and General Satisfaction kept the peace."[165] Ultimately, Jack's and Lawshe's rink was a popular but, alas, not financial success. Ticket sales and skate-rental fees were insufficient to keep the thing rolling, and the partners were forced to give it up. R. L. Brake, owner of the building in which the rink was located, told the newspapers that Mr. W. A. Jack had been called home and that he (Brake) intended to carry on the business himself but, he promised, "at reduced prices."[166]

The call that Will received from Atlanta in April 1881 might have been from his father, instructing him to come home and focus on a more viable business career; but it is just as likely to have had something to do with romance. By the time he opened the Milledgeville rink, Will had met and presumably begun courting Isabella Harvill, the sixteen-year-old daughter of Lucinda and the late William Henry Harvill, a respected Atlanta druggist.[167] On Christmas Day, 1881, at the bride's family home on Pratt Street, Will and Belle, as she was known, were married. After a honeymoon at the posh Duval Hotel in Jacksonville, Florida, the happy couple returned to Atlanta to live with her widowed mother on Pratt Street.[168] And that is where, on September 19, 1882, almost exactly nine months to the day after their marriage, their son, Francis Marion Jack II, was born.[169]

As far as is known, no images of Belle have survived, but, referring to

both her appearance and her talents, the Atlanta press called her "one of Atlanta's jewels." She was an accomplished singer, a talent she developed while a student at Atlanta's Girls' High School, from which she graduated in 1880.[170] After her marriage, she studied with Otto Spahr, a popular Atlanta musician, and was a featured singer in concerts held at Atlanta's Concordia Hall during the 1880s. Each time she appeared, Belle was singled out by the press for special praise. In June 1886, she sang two romantic songs, "in costume," the *Atlanta Evening Capitol* reported, "and captivated the whole audience by her bewitching grace in action and by her beautiful rendition of the songs. We understand that this lady...suffered a little from hoarseness last night, but we certainly could not detect it nor anybody else, as was evidence by the perfect storm of applause that greeted her performance."[171] For the following summer's concert, Belle sang three solos and, with Mrs. Julia Inez Deas, a duet. Again, her performance was highlighted by the press. "Where all did so well it is needless to draw any invidious comparisons," the *Atlanta Constitution* stated, but "the reporter will be pardoned for bestowing upon Mrs. Belle Jack a word of praise...Her singing was much complimented and she was the recipient of several bouquets of flowers."[172]

In 1884, possibly prompted by the responsibilities of marriage and fatherhood, Will Jack opened his own business, W. A. Jack & Co., a grocery store at 84 Peachtree Street.[173] The "& Co." part of the business was Will's twenty-year-old friend Noble P. Beall.[174] Unfortunately, it was not a good time to start a business, even with Will's family connections. A decrease in construction of new railroads sparked a nationwide recession that culminated with a bank panic in May 1884.[175] The elder Jacks' long-established firms were hit hard by the downturn but, with some reorganization, survived. Will's fledgling business, on the other hand, was dealt a lethal blow. Beall pulled out of the partnership, and in the summer of 1884 W. A. Jack & Co. declared bankruptcy. By the end of the year, it had ceased to exist.[176] Will went back to work for his father and uncles.

Meanwhile, his interest in sports, especially skating, was undiminished. By the early 1880s, skating was not only a craze on the national level but, according to the *Atlanta Constitution*, had reached "epidemic" proportions locally.[177] Eighteen-year-old Jim Jack joined his brother Will in the sport, and in November 1885 he, Will, and their friend George Lawshe joined the

Atlanta Polo Club, the members of which played competitive roller hockey, a version of ice hockey. The club was a branch of the Southern Polo League, a recently founded entity that had teams in several Southern cities. Although the Atlanta club's membership changed during its first year, Lawshe was its original "second rush," Jim Jack its "half hocks," and Will its manager and "goal tend."[178] The Atlantans put on exhibition games in their home city and travelled to compete against other league teams. In January 1886, for example, they went to Birmingham for a serial competition against that city's Globe and Shinney clubs. For his performance in the first game of the series, which was held at the Casino Rink, Will Jack earned praise from the *Atlanta Constitution* for his "fine playing" as goalkeeper.[179] Later in the series, though, the coverage was not as flattering. "After fifty-five minutes hard slugging on the Birmingham side, Ham, of the Birminghams, sent the ball flying between Will Jack's legs." The Atlantans persevered and despite being "fouled four times by the goal tender [Jack], who prevented the ball from going through by picking it up with his hands," they won the match.[180]

Later that same year, Jim Jack and an otherwise unidentified friend named Chase—"pioneers of roller skating," as they claimed to be— opened their own rink in Atlanta; Jim's brother Will became one of its star attractions.[181] "The Metropolitan skating rink will be thrown open tonight," the *Constitution* reported on October 20, "and a carnival of roller amusement never before equaled will be inaugurated in Atlanta." Jim Jack and Chase had leased a large hall in the Austell Building on Forsyth Street and upgraded it with a new floor, specially designed for skating, fresh plaster and paint for the walls and ceiling, and "two large electric lights [to] make the place as bright as day and give a pleasing effect to the artistic work what has been done." They furnished an "elegant waiting room for ladies" and hired a pianist to provide music. New skates "of the most approved design" were ordered and made available for rental. "Messrs. Jack & Chase are both gentlemen who know how to manage a rink," the newspaper said.

> Mr. Jack—James R. Jack—is well-known in Atlanta, and needs no introduction, while Mr. Chase's ten years' residence in Atlanta gives him a wide acquaintance. An expert skater will be employed in the person of Mr. Will Jack, than whom there is no better skater in the south. The proprietors will see that the best order is maintained, and

that no one who should not be present shall cross the threshold.[182]

The rink enjoyed some success through the holiday season of 1886 but closed by spring of the following year.[183]

By the time of his involvement with the Metropolitan Rink, Will Jack was in his mid-twenties and had yet to establish himself in a permanent or promising career. This probably did not please his business-oriented relatives, especially his father, or inspire confidence for a bright future in his young wife. It is little wonder then that by the mid-1880s, his marriage was in trouble. In 1883, he and Belle were still living with her mother on Pratt Street, but by 1886, Will had left her and their four-year-old son and was living with his uncle William.[184] As it turned out, Will and Belle's separation was permanent, though there is no evidence that they ever legally divorced. In fact, Belle continued to be known as Mrs. Belle Jack or Mrs. W. A. Jack for the rest of her life.[185]

As for Will, he spent at least part of 1885–86 as a clerk and driver of a bread-delivery wagon for Jack, Ward & Co., the business that his uncle William and William's son-in-law, John W. Ward, had formed a few years earlier.[186] In 1887, Will was again living with and working for his father.[187] He made his last appearance in an Atlanta city directory in 1888 when he was listed as a traveling salesman, living in rented rooms at 34-1/2 West Alabama Street.[188] The identity of his employer is unknown, although an advertisement in the *Atlanta Constitution* in May 1888 suggests that he was working, possibly as a bartender, for Randolph Taurman, an Atlanta merchant. Taurman had taken over one of Francis Jack's old "stands" at 43 Peachtree Street and was running it as a confectionary and soda shop that he called the Empire Baking Company.[189] A simple advertisement, which was part of a scattering of small, creative ads taken out in the Atlanta papers by Taurman, is the last known documentation of Will Jack's residency in Atlanta. After this, his name disappears from the records until 1893 when he resurfaces, now decidedly known as Arthur Jack, in Chattanooga, Tennessee.[190]

Chapter 3

Chattanooga

Chattanooga, the seat of Hamilton County, Tennessee, is near the state's southern border, only a few miles north of the Georgia state line. In 1890, its population was just over 29,000, making it somewhat larger than Lexington, Kentucky, but less than half the size of Atlanta, Georgia.[191] Geographically, it lies between those two cities. At about 130 miles north of Atlanta and 280 miles southwest of Lexington it would make a reasonable meeting point, if one were needed, for persons living in those cities, and travel, even regular commuting, between them would have been relatively easy. Direct rail service had connected Chattanooga to Atlanta since the 1850s and to Lexington since the mid-1870s.

Chattanooga's location determined its destiny, sitting as it does on the Tennessee River, which makes several wide bends around the city as it encounters and navigates the impressive wall of Lookout Mountain to the southwest. The site, which would in 1838 become Chattanooga, had been a natural one for Native American encampments. Later, during the Civil War, the river and the railroads that by then connected it to other Southern cities sealed Chattanooga's latest fate, as one of its mayors wrote, as the "scene of the bloodiest battles of that sanguinary struggle to possess this key to the South."[192]

Like Atlanta, Chattanooga survived the war, renewed itself, resumed its growth, and, thanks to the mining and milling of local mineral deposits, prospered. By the end of the century, authorities agreed, hubristically or

not, that the city possessed "every essential to future greatness" including a "healthful location, fertile soil, prosperous surrounds, abundant mineral and timber wealth, beautiful scenic attractions, rich historic associations, unsurpassed transportation facilities, a salubrious clime, and a progressive and enlightened citizenship."[193] A less prudish person might have amended this boosterish gush, written in 1897, by touting Chattanooga's red-light district, its longevity, and durability.

According to the modern historian James B. Jones Jr., who has studied the history of prostitution in Tennessee, Chattanooga's first brothels were established during the Civil War.[194] Most of these were (and would continue to be) located on the west side of town, in a swampy part of the Third Ward, just to the west of the city's main railroad terminal and the tangle of tracks that ran into and out of it, and only a few blocks east of the Tennessee River. According to one of the city's older residents, the neighborhood already had a bad name in 1861 and by the end of the war, had become infamous as Chattanooga's tenderloin district. The area was more-or-less defined by the adjacent, parallel streets of Penelope, Florence, and Helen, with Ninth Street to the north and Leonard (later Eighth) Street to the south.[195] Before the Civil War, this area was one of many properties in and around the city owned by James A. Whiteside, a lawyer and real-estate speculator who had been instrumental in making Chattanooga a railroad hub.[196] Whiteside developed this parcel, known as Whiteside's Addition, by dividing the land into narrow town lots fronting on short streets that he named for three of his children, Florence, Helen, and James Leonard Whiteside. His plan was to populate the lots with small one-room houses and sheds that he—and after his death in 1861, his widow, Harriet—could rent out at "a dollar to a dollar and a half per week" to "negroes and some low class of white people." Whiteside's son James later remembered that "the first house built there for improper uses was erected [in 1866] by a woman whose husband had been sent to the penitentiary of an adjoining state."[197]

Other such establishments "just gradually sprang up," and by the 1870s Chattanooga's tenderloin was set for the next fifty years.[198] By the early 1890s, when Susie Tillett moved there, the unpaved, undrained streets of the neighborhood were crowded with houses of various sizes, some of which covered the entire lot on which they stood and had entrances at

front and back. "The houses [at] nos. 11, 15, 17, 19 and 21 Helen St.," one account has it,

> are on the west side of the Street and fronting on Helen St. These lots extend across to Florence Street, and the houses also have frontage and entrance from Florence Street at their rear. They all adjoin each other. No. 8 Florence Street adjoins No. 11 Helen Street but fronts on Florence Street. Just across the street from these houses are the houses [at] 9, 11, 15, 17 and 19 Florence Street all adjoining each other and being directly across the street from the houses herein before described on Helen Street and all fronting on Florence Street. These last named lots and houses extend to Penelope Street and have rear entrances from that street. These houses…make up what is called the "Red Light District" in the Third Ward of Chattanooga, Tennessee.[199]

For business purposes, if for no others, the district was well sited. Ninth Street, its northern border and a major east-west thoroughfare in the city, was lined with saloons and gambling dens. One resident recalled that most of these establishments consisted of "close rooms…nearly suffocating with tobacco smoke…where card and dice reigned supreme."[200] The saloons were frequented by "white sporting women," a type that had begun to move into the district in the 1860s "by first renting…then buying a little piece of property, and putting up a little shanty of their own, until they [had] quite a settlement of sporting persons."[201] In 1885, the city's *Daily Times* reported that there were over 200 prostitutes operating in the city, most of them within or on the edges of the Helen-Florence-Penelope grid.[202] The publication of this sort of statistic, accurate or not, inspired the *Times* and other local papers to begin decrying the district and its inhabitants vociferously and more frequently. Some claimed that the district's streets were swarming with "crowds of debauched men and women [who] block the way till 11 o'clock" and that "the police have reason to believe all murders, highway robberies, etc., are planned" there.[203] The main streets of the district, as well as any number of nearby alleys, were lined with "long rows of baudy [*sic*] houses of the lowest character" where every night, "fights take place among the drunken inmates and visitors." These places were not raided with any consistency or sincerity, the paper noted, hinting at payoffs and corruption: "It is wonderful how rich some of the most degraded landladies have become. One of this class of Florence Street has over $5,000 of diamonds alone."[204]

By the time Susie Tillett and her sisters arrived in Chattanooga, the neighborhood into which they moved was considered to be of ill-repute. The city government occasionally tried to "clean it up," evict its madams, and reform its clients, but the results were invariably temporary. The first of these short-lived diasporas came in 1885 when pressure was put on the area's madams, via their landlords, to find lodgings elsewhere. The women scattered, but it was not long before the heat was off and they drifted back. Their speedy return was facilitated by a tacit agreement whereby the city's police would conduct occasional raids and roundups, usually charging lewdness, and judges would levy small fines that the madams would pay without fuss. As the historian Thomas Jones has wryly observed, the city was soon reporting "tumescent municipal revenues," and by 1887, the geography of Chattanooga's red-light district was solidified both on maps and in the consciences of its citizens. Now unofficially official, the place "became an outlet for the satisfaction of the prurient interests of a substantial community of Chattanooga men, including at least some of Chattanooga's officials."[205]

The district thrived, and the government would not seriously threaten it again for twenty years. Records indicate that Chattanooga's brothels were more numerous, employed more women, and in several cases, were managed by madams of greater longevity than ever was the case in, say, Lexington. The 1890 Chattanooga city directory, for example, may have located only five madams in the city; but contemporary newspapers make it clear that there were three or four times that number working there, each employing anywhere from two to twelve "soiled doves," as the press liked to call them.[206] During the 1880s and the early 1890s the city's reigning madams included Alice Cooper, who had been operating a brothel in Chattanooga since shortly after the Civil War; Maud Bell, who ran a house on Chestnut Street; and Mary Morris and Lizzie Davis, who had been in the business since at least the mid-1870s.[207] Newer entrants in the field included, or soon would include, Kate Cowan, Mollie Hicks, and Mattie Schultz, all of whom established houses in Chattanooga during the late 1880s or early 1890s. A few years later, the same Sue Green who had been a resident of Lexington's Megowan Street, moved to town. Like Susie Tillett, Green established a business in Chattanooga that was both more successful and longer-lived than what she had had in Kentucky. She quickly became one of the city's leading madams,

operating a house on Helen Street that employed as many as twelve women at a time for over twenty years.[208]

These women, and plenty others, would be competition for Susie Tillett when she, age thirty-one, and her sisters Lillie and Nettie, aged twenty-three and nineteen respectively, moved to the city. Lillie may have arrived first, possibly on a sort of scouting expedition. In 1890, "Miss Lillie Tillett" was listed in Chattanooga's city directory, living at 207 East Center Street in a somewhat seedy part of town. She would still be there a year later, by then living and working as Madam Lillie Raymond, one of several aliases she used during these years.[209] In 1891, Susie Tillett made the first of many appearances in the city's directory as "Mad Susie Tillett" of 113 Tenth Street.[210] She and Lillie also debuted in the local newspapers that year. On June 24, the *Chattanooga Times* reported that warrants had been sworn out "against Lillie Raymond and her sister, Sue Tillett," charging them with selling beer without a license and conducting a house of ill repute.[211] As for their sister Nettie, her presence in the city at this time is verified by several contemporary photographs of her that bear the stamps of local photographic studios.[212]

As it turned out, Nettie and her sisters may not have been the only members of the Tillett family to come to Chattanooga at this time. Several notices in the local press suggest that their two young brothers, Waller and Abner, accompanied them. When America and Samuel Tillett died—she in 1883 and he four years later—they left four children under the age of eighteen, "infants" according to the law: Nettie, Florence, Waller, and Abner. We have already seen what happened to Nettie in the years immediately following these deaths. At the same time, Florence, the next youngest of the Tillett "infants," went to live with her older sister Annie Warnock's family and may have continued to do so until 1892, when she married and began a family of her own in Lexington.[213] That left the two youngest siblings: Waller, who was about fifteen years old when his sisters moved to Chattanooga, and Abner, who was then about thirteen.

In August 1890, the *Times* published a list of letters left unclaimed at the post office that included one for an Abner Tillett.[214] The following month, in what seems to have been part of an unfortunate family pattern, Walter Tillet [*sic*], age fourteen, was arrested for disturbing the peace outside the Grand

View Hotel on Montgomery Street in downtown Chattanooga. "He was one of a party of boys who have been making things warm in that neighborhood with their profanity and obscenity. Two dollars and costs is what it cost Walter."[215] The names of the two boys, which are not especially common ones, and the coincidence of their appearance in Chattanooga papers at just this time, suggests that these were Susie, Lillie, and Nettie's brothers. The length of the boys' stay in Chattanooga is not known, but it was probably short. Waller was back in Kentucky by the fall of 1896, when he married his first-cousin Mary Edna Tillett.[216] Abner had returned to Lexington by 1898, when he was working as a sign painter and living with his sister Annie Warnock and her family.[217]

Susie Tillett's residency in Chattanooga is well documented, thanks to the city's newspapers and directories. We have already seen her presence there as it was noted by the Chattanooga directory of 1891, which put her at 113 Tenth Street.[218] That turned out to be a temporary address, though, and within a year she had moved to the other side of the railroad tracks, just south of Ninth Street, and into the heart of the red-light district. This would be her neighborhood for the next twenty-five years. Her first address in the district was 8 Florence Street, a two-story brick house that was clearly marked on contemporary insurance maps as a "female boarding house." It was only a few steps from the city's saloons and other dives along West Ninth Street and directly across the street from a coal yard, one of several in the area that fed the dozens of trains that daily arrived and departed from the nearby terminal.[219] After about a year in that location, Susie moved a block away to 11 Helen Street.[220] It was a deep, two-story brick building with a wing that extended through to Florence Street, placing that part of the house next door to her former residence on that street. It may also have been interiorly connected to number 13 Helen, with which it shared a wall. The configuration of these two houses, then, provided clients with discrete and easy access to and from both Helen and Florence streets, the district's two busiest thoroughfares.[221] The double building was already infamous when Susie moved in. During the early 1890s, it had been the center of operations for Fannie Ford and

Alice Cooper, two of Chattanooga's senior madams. It was there, in fact, in November 1893, that the latter inflicted a "horrible butchery" on herself by "cutting her throat from ear to ear," a deed that was afforded no dignity, much less remorse, by the press.[222]

But it was Madam Susie Tillett's house at 11 Helen Street that gained lasting fame and where she earned her reputation as a "denizen of Chattanooga's tenderloin," a notorious and highly successful businesswoman who gave her customers what they wanted. Consequently, she was subject to the same sort of harassment in Chattanooga that she had experienced in Lexington, regularly charged with lewdness, selling liquor to the wrong people, at the wrong time, or without a license, and operating a house-of-ill-repute. As we have seen, the trouble began, in Chattanooga, in June 1891 when Susie and her sister Lillie were arrested for violating the liquor laws.[223] A year later, Susie and two other madams, Fannie Ford and Mary Morris, were charged with lewdness, found guilty, and each fined five dollars plus costs.[224] Similar minor charges would be leveled against Susie a number of times over the coming years, each dutifully chronicled by the local press.[225] But her name also appeared in the papers for more scandalous reasons, sometimes as a witness of or even a participant in whatever tale of lust, jealousy, adultery, drugs, suicide, or murder was making the news at the time. The most infamous of these, perpetrated by her lover and future spouse, Arthur Jack, in the spring of 1894, will be discussed below; but there were others. In 1892, for example, she was said to be in "the lover business" with a handsome, "elegantly dressed man" named L. B. Moore. Moore was arrested for frequenting Susie's house "by night and day," and, the *Chattanooga Times* claimed, he was not alone in his shame. "There are a number of other men in Chattanooga in the same line of work" with Sue Tillett, the paper sniped, "and the [police] force has instructions to run them in regardless of dress."[226]

As a madam, Susie occasionally had trouble not only with her patrons but with some of her employees. In the spring of 1893, one of these, Zella Young, née Randall, came to Chattanooga from her home in Hill City, a suburb of Chattanooga. Supposedly possessed of "an abnormally passionate nature," she took a job in Sue Tillett's house. She soon regretted her choice to live among "the depraved inmates" of that place and, desperate to escape, began plotting suicide by drowning herself in the Tennessee River. She lost

her nerve and instead took to carousing around town dressed like a man. When she allegedly tried to kill her own mother, a writ *de lunatico inquirendo* (insanity) was taken out against her.[227] In April 1893, she was diagnosed as suffering from "suicidal melancholia brought on by the life that she had been leading" and was threatened with incarceration in the state asylum in Knoxville.[228] But if she did go to Knoxville, her stay there was brief, and by that summer she was back on the streets of Chattanooga.[229] A little later, she got a job in one of Nashville's houses of ill-fame, and it was there, in July 1895, that she finally succeeded in doing what she had long contemplated, with an overdose of laudanum.[230]

At about the time that the Randall affair was unwinding, Susie Tillett's name was attached to another mini scandal in Chattanooga, this one involving two other women, one of whom called herself Callie Ferguson, the other the wife of Levi "Cap" Elliott, an erstwhile Chattanooga lawyer, gambler, and saloon keeper.[231] The former had come to Chattanooga from Knoxville, so she said, to secure Cap Elliott's help in getting her a divorce from her husband, Will P. Ferguson, "a plumber and tin horn sport." On September 18, 1894, as Callie was leaving the Wisdom House Hotel on Market Street, where she had rendezvoused "for professional reasons" with Cap Elliott, Elliott's wife assaulted her. Mrs. Elliott accused Callie of plotting to destroy her family relations, and then pistol-whipped her.[232] Initial reports said that Callie had been murdered, but these proved false. As was soon realized, she had taken refuge, first, in Madam Lena Carmichael's house on Porter Street and then in Susie Tillett's place on Helen Street.[233] Reporters tried to catch up with her there, but to no avail. Madam Tillett, the *Chattanooga Press* reported, "stated that the woman was not in her house and has never been there," a dodge contradicted by Susie's neighbors who had seen Callie coming and going from the house.[234] Callie eventually returned to Knoxville, but a few months later it was discovered that she was in fact a prostitute named Callie Hyde who had gotten her start in the Carmichael and Tillett bordellos in Chattanooga. She went on to an infamous career as the madam of her own house in Knoxville, but after attempting suicide with morphine, she found religion and went into a presumably blessed retirement.[235]

These squalid incidents, which surely titillated the good citizens of Chattanooga, suggest that it did not take long for Susie Tillett's new house

to become a recognized destination on Chattanooga's pleasure circuit. Judging by photographs taken during these years, her success was such that she could well have been the bejeweled madam described in 1894 by the *Chattanooga Press*, as cited above.[236] She was soon known for her "fine horse and rig," which were tended and driven by her own personal hostler, and her luxurious house—a "gilded den," as one paper called it.[237] When local authorities, led by Chief of Police Fred Hill and the unfortunately named Police Commissioner Erhart Heiny, made a biannual tour of inspection of the city's houses of prostitution in the spring of 1896, Susie's place was on the list. A reporter for the *Chattanooga News* went along for the ride and subsequently produced a comparatively detailed front-page article about the inspection.[238]

Traveling from house to house in a "sumptuous landau," lent for the occasion by Harry Chapman, a Chattanooga undertaker and livery stable owner, the men stopped first at Madam Maggie Crow's place, but the only person they found there was the housekeeper, who successfully put them off. No one was home, she told them, because business was slow. In fact, she added, the number of bawdy houses and women who worked in them were decreasing in general. "Everything…is dead as it can be," she claimed. This statement was somewhat belied by what the commissioners saw at the next house on their itinerary, Mattie Shultz's at 31 Clift Street, near seedy Foundry Alley. It was reputed to be the most palatial bawdy house in the city, and the madam herself greeted the officials, sporting "a flowing robe of richest silk." She graciously introduced them to a bevy of her employees, each dressed as stylishly as their boss. Less glamorous but perhaps more interesting, not to say intimidating for these strait-laced inspectors, was Madam Mary West's place at 11 Florence Street. In contrast to the "ladies" at Shultz's, the young women at West's were scantily clad and inappropriately friendly with the commissioners. The madam herself, the *News* reporter wrote, came across as "not particularly tough—just common."

A few doors on, at Madam Mary Morris' house at 15 Florence, the visitors were met with "a wave of perfume [that] came out heavy as the odors that scented the apartments of Sappho." The only person in residence, or so the men were told, was one Ada Gibbs who was "gorgeously attired [with] pearls, gray china silk with vast quantities of lace and pink rosettes

and ribbons. A diamond necklace rose and fell upon her large, broad chest." She was a sharp contrast to Mary E. Hicks, widely known as "Irish Moll," whom the men met on their next stop. Hicks' house was known as one of the toughest in town, and Moll welcomed the unwanted inspectors with "a voice that sounded like a cracked clarinet."[239] Her place was more in keeping with some of the sadder stops on that evening's tour, those of Sallie Davis and Kate Baxter. These were small and rough in construction, closer to the river and in a neighborhood even "lower" than where the men had already been. Baxter's place, for one, was described as a "tumble-down, two-room shanty, surrounded by a stout, solid board fence [with] tawdrily furnished rooms."

Possibly looking for an antidote to what they had seen at the Davis and Baxter houses, the men returned to the heart of the district south of Ninth Street where, finally, they came to Sue Tillett's place. In contrast to some of the other bordellos, 18 Helen Street was "luxurious,…rich,…and comfortable," and it proved the most fruitful stop on the tour. In a section of the article subtitled "Rainbow-Hued Visions," the *News* described the Tillett house in more personal terms than it had the others. As the inspectors approached the place, "the girl already had the door open," the reporter noted. She invited them to walk down a long hall and into

> the luxurious parlor…and past the rich portieres where they sank into such comfortable seats that it was with difficulty Commissioner Williams could later be persuaded to move. When the girl at the door had given the command mentioned, she pulled a cord at the side of the wall and a bell rang three times, the signal that there was company in the parlor. Presently the girls began to float in like rainbow-hued visions in pink and purple and yellow. Jessie, a magnificent blonde came to the door and vanished. Nettie, a quiet, richly dressed, fine-looking woman, sat at the piano. Sue Tillett wore a cloud of white silk and lace. She had her hair powdered and looked for all the world as though she was going to a bal pudre [a costume ball].
>
> Commissioner Heiny explained the reason and purpose of the visit, as he had done at every other place, and then Commissioner Thomas took up his theme again. He directed the most of his remarks to Nettie. She seemed to be nearer what a woman should be. An interesting conversation ensued.

This young woman at the piano, who was almost certainly Susie's sister

Nettie Tillett, was more than willing to speak frankly with the men. Based on what she and Susie told them, the visitors drew a pessimistic conclusion. The women "did not try to defend their position," the reporter noted. Instead,

> they seemed more to regret it. But what were they to do? they asked. If they went out in the world and tried to live the right kind of lives, men who knew them would try to pull them down again, and women who knew them would not try to help them up. Many a woman had gone out resolved to be better and she had kept her resolve for months and months. Then one day she had met a woman, an old-time friend, and, forgetting what she had been, she had rushed up to greet her. But the friend had drawn her skirts aside and raised her hand as if to say, "Don't touch me!" A woman could stand anything but that. To ostracize them from society was to doom them.[240]

The account rings of personal experiences and memories of painful social rejections. Perhaps that is why Susie, for one, decided to change, or at least to adjust, her situation by becoming involved with a man on something more than a strictly professional basis. In fact, by the time of the commissioners' visit, she had already embarked on such a relationship.

It is not known exactly when Susie met Arthur Jack. In 1910, Susie told the U.S. census taker that she and Arthur had been married for twenty-two years, which was not technically true: they never married. It seems more likely that by "twenty-two years" Susie meant the length of time that she and Arthur had known each other, which would put the date of their first meeting at 1888 or 1889. This more-or-less coincides with the date of Susie's decision to move to Chattanooga, which is the most probable place for her fateful meeting with Arthur.[241] But whenever and wherever they first met, Susie and Arthur had unquestionably developed a relationship by 1893 when she leased a building at 11 West Ninth Street, between Broad and Market, and gave Arthur start-up money to open a saloon there.[242] It was a prime location for such an establishment, half a block from the Union Passenger Depot, close to three major hotels, next door to a wholesale liquor store, and within strolling distance of Susie's house.[243] Arthur would manage the

place and his brother, Jim Jack, who had worked in various Atlanta hotels and saloons as an experienced "mixologist," came up from Atlanta to be its chief bartender. With the brothers thus reunited, they named their place "The Two Jacks Saloon." As sons and nephews of men who had been in the business of providing the public with good food and drink for nearly four decades, they had the means and the genes to make their new saloon a success. And having the imprimatur, in the form of financial backing, from "the most notorious prostitute in the city" would certainly have helped in terms of publicity.[244]

It did not take long after his arrival in Chattanooga for Arthur Jack's presence in the city to become newsworthy. In the fall of 1893, the *Chattanooga Press* published a front-page story about "a local sport giving his name as Arthur Jack [who] was caught in a carriage with a lady of the town, Emma Olden, alias a number of names." Allegedly, Jack was trying to prevent the lady from leaving the vehicle, and the argument that ensued attracted the attention of a police officer who charged them both with disorderly conduct.[245] The press was soon referring to Arthur in terms meant to appeal to its readers' romantic or prurient sides, calling him "a dashing young Don Juan," "a handsome fellow," "a fine dresser [who] drives the most stylish turnout in the city," and, most titillating of all, "a masher of other men's wives."[246]

Within months of the minor dustup in the carriage, Arthur and Susie were each, in differing ways, party to a certifiable scandal that, in March 1894, brought them local and even national notoriety. Whether this publicity was welcome or not, the affair that generated it unfolded with all the melodrama of the age, involving as it did "a handkerchief at the window, a kiss thrown to a lover; a meeting and ride; a running fight with pistols; a ruined family, a divorce."[247] For weeks, it was front-page fodder for newspapers all over the South, making a splash in papers in Cincinnati, Louisville, and St. Louis, and even catching the attention of one of the great gossip sheets of the day, *The Police Gazette*.

The incident centered on an alleged adulterous affair between Arthur Jack, the "well-known West Ninth Street saloonist," and Nellie Spencer, the thirty-three-year-old wife of Ed Spencer, a grocer and liquor dealer. At the time of the scandal, the Spencers had been married for over nineteen years and had seven children ranging in age from two to eighteen.[248] They lived

above the family business on Market Street in Chattanooga and, according to people who knew them, were happy. Mrs. Spencer was described, probably with some post-facto exaggeration, as "the personification of prudence" and "an angel of virtue."[249] But her reputation began to crumble when she was observed openly flirting with several men of questionable character and using one of her daughters to deliver messages, oral and written, between her and them.[250] In the weeks leading up to the scandal, neighbors noticed growing tension between the Spencers and heard them hurling insults and jealous accusations at each other. The immediate cause of this turmoil, it turned out, was Arthur Jack.[251]

According to Nellie Spencer's later testimony, she first met Arthur Jack "by accident a long time ago" but had not actually spoken to him until February 28, the day on which they had an ill-fated meeting. Nellie admitted to having seen Arthur pass her house many times in his buggy—his saloon was about four blocks from where she and her family lived—but that was all.[252] But according to Jack, she had not only seen him, but had blown kisses, waved her handkerchief at him, and sent him amorous notes, care of his saloon. Nellie later denied all this, saying that it was Jack who had sent her notes. In one of these, dated the morning of February 28, she claimed, he had asked her to join him in a buggy ride into the country. She answered him:

> Your note received. I will not pass your saloon this afternoon but will go to [Missionary Ridge]. Meet me at the first house on top of the ridge after you cross the bridge, to the right. We can have a long drive towards Bird's mill. No one will know me. We can have some fun. This must be kept quiet. Be sure and come and come alone. Excuse writing. With love. Burn this.[253]

Jack's version of the events of that day was somewhat different and almost as implausible as Nellie's claim not to have had prior contact with him. "I don't know who the woman is at all," he told a reporter later that night.

> All I know is that she told me today that her name was Nellie Spencer. I called her Miss Spencer and she told me not to call her Miss Spencer, but to call her Nellie; then I called her Miss Nellie. I am on watch at the saloon from 10 to 2 o'clock in the day. Today, between 12 and 1 o'clock, I received a note signed N., which requested me to go to the second house on the right of the electric railway bridge on Missionary Ridge, and stating that a lady would meet me there. I did not know

who the note was from and I do not know now whether the woman is married or single or, with the exception of what she told me today, what her name is. When I got to the house on Missionary Ridge, she was there and got into the buggy.... We drove about five miles, in the direction of Bird's mill, and then came back. We never got out of the buggy and I never said a word to her that any gentleman should not say to a lady.[254]

Meanwhile, Ed Spencer had become worried about his wife's behavior, as had his brother Si Spencer, who did what he could to heighten Ed's suspicions. Arthur Jack was the perpetrator of the Spencers' domestic troubles, Si told Ed, and he insisted that they do something about it. The two men had already, in early February, begun tracking Nellie's movements. They had seen her with Jack, first near the Hamilton House Hotel on Market Street and then at Riverview, across the river from Chattanooga. Si discovered that Nellie was using one of her daughters to deliver love notes to the Two Jacks Saloon, as she allegedly had done with other men.[255] It remained unclear as to who had initiated the affair, but contrary to Arthur's later protestations, it was obvious that it had been going on for some time. Now, on the last day of February, things came to a head.

Early that morning, February 28, 1894, Nellie told her husband that she was going to spend the day with her mother, who lived in the Chattanooga suburb of Missionary Ridge. She took a streetcar to the neighborhood but disembarked before reaching her mother's house. There, as prearranged in her "burn this" note, Jack picked her up in his carriage, and they proceeded to drive out Bird's Mill Road. About five miles into the country, they stopped, did whatever unspecified thing they had gone there to do, and then turned around and headed back to town. They had not gotten far when Ed and Si Spencer ambushed them. The angry brothers leapt from behind a fence where they had been lying in wait and began waving guns and shouting for Jack to stop the buggy. He immediately complied, he said later, but they opened fire anyway. The *Chattanooga Daily Times* described what happened next.

[Jack] dodged down behind Mrs. Spencer but the latter jumped to the ground and then Ed fired. The bullet from his pistol struck Jack in the left arm and flattened against the bone but did not break it. At this, Jack rolled from the buggy and Ed continued to shoot at him. One of [the] balls grazed his right arm and another passed through his hat.

There was a moment's cessation in the firing during which Jack called to them not to shoot any more as he was already killed…While Si was endeavoring to turn the cylinder of his pistol, Jack, who was still on the ground from his fall from the buggy, jumped to his feet and ran for his life in the direction opposite from which he had come. Both of the brothers ran in pursuit. The horse, freed from the grasp of Si, ran away toward the city, and in a moment, Mrs. Spencer was the only person left upon the scene of the trouble.[256]

The Spencers chased Jack but were unable to catch him. "He's a good runner," Si Spencer told a reporter. "We ran him about two miles and finally came to John Emory Conner's place. There I tried to get a horse to overtake the scoundrel, and could not, but finally got a farm hand to go after him on horseback."[257] They gave the man a pistol and, dishonestly, told him Jack was an escaped convict. "[He] at once started in pursuit on horseback," the *Chattanooga Press* reported, "and soon caught his man." He brought Jack back to the Conner place where Ed Spencer tried again to attack him. But Conner "held him and prevented further trouble." He then took the alleged culprit "to the city in his buggy and [Jack] is now at the county jail for his protection as he believes the brothers will kill him at the first opportunity."[258]

From his jail cell, Jack told the press that he did not "care a snap" for Mrs. Spencer and insisted, "I have a woman that I would not give for a dozen of her."[259] That woman, who now flew to Jack's wounded side— "in a landau," no less—was "Sue Tillett, the proprietress of one of the noted bagnios of the city." She "hastened into the sheriff's office," the *Daily Times* reported,

> and was conducted to the hospital cell. Then there was a scene of much emotion. The woman threw her arms about her prostrate lover and wept profusely, and he, although he could not return the embrace, because he could not raise his wounded arms, wept also. And thus they remained for some time, the tears flowing copiously, as they might flow from the eyes of two children, and then, her eyes red with weeping, she arose, kissed him tenderly and returned to her home of infamy and sin.[260]

Meanwhile, the Spencer brothers told the press that their only regret was that they had not killed Jack, "and if the pistol had not failed to work we would have done so."[261] Two days later, the Spencers were arrested for attempted murder, weapon possession, and disturbing the peace.[262] By that

time, the victim's condition had improved, and he was moved to rooms not far from his doctor's office. He was visited there by a repentant Nellie Spencer who vowed to help him out of the mess that, she confessed, she had caused. There, too, Nellie encountered Sue Tillett, with whom she exchanged "warm words."[263] Arthur continued to deny having ever met or communicated with Mrs. Spencer before the day of the shooting and claimed to have been misquoted in the press. "Whether these quotations are the work of some secret enemy, or the mutterings of a man under the influence of chloroform," he told the *Times*, "I am unable to judge."[264]

Within days, Ed Spencer sued his wife for divorce on grounds of adultery. She had been unfaithful, he claimed, with multiple men over a long period of time, which was probably an exaggeration: Arthur Jack was the only co-respondent named in the complaint. Nellie Spencer was so "steeped in sin," the suit charged, that she had gone so far as to encourage her daughters to flirt with Arthur Jack as well as other men and had attempted to "prostitute" them.[265] Nellie counter-sued, claiming that her husband was violent, unreasonably jealous, an adulterer, and "a confirmed drunkard." She admitted that she had flirted with Jack and that her meeting with him had been indiscreet; but she insisted that she had never committed adultery with him or anyone else and that the sole purpose of her actions was to get her husband's attention.[266] This riled the Spencer brothers to further action, and they again went in search of Arthur Jack. On March 9, the day that Mrs. Spencer filed her counter suit, they followed Jack to his doctor's office, and as he emerged from there, chased him through the streets of the city. Jack's friends "hustled him through a store, out the back way and into a closed cab, from whence he was driven to his room," unharmed.[267] Several weeks later, Jack was arrested for carrying a pistol, which he said he was compelled to do in order to protect himself from the Spencers.[268] But no further attacks were made and that seems to have been the end of his connection with any of the Spencers.

Ed Spencer soon got his divorce and custody of his and Nellie's children.[269] Calling it "one of the most unfortunate [scandals] that has ever occurred in the city," the *Chattanooga Times* gave the affair the following postmortem: "Luckily no one was killed, but the name of a wife and mother which heretofore has been above reproach has had a stain placed upon it that

can never be removed. The worst feature of the affair is that the happiness of an entire family has been blasted."[270] Henceforth identifying himself as "widowed," Ed Spencer continued to live with his children in Chattanooga until his death in 1918.[271] Nellie fled the city, probably for Michigan, her mother's home state, where, it is thought, she lived until her death in 1907.[272]

Arthur Jack bore the physical scars of the Spencer assault for the rest of his life, at least those on his arm. Years later, he would proudly display them for his grandchildren, without, it should be noted, telling them the whole truth about their acquisition. As for his "shattered" hand, it apparently healed quickly: within eighteen months of the shooting, he was playing baseball again, this time for the Chattanooga Baseball Club, for which he served as pitcher.[273] He and his brother managed to hold on to the Two Jacks Saloon during and immediately after the Spencer episode, but not without the usual financial and legal troubles attached to such places. In March 1894, for example, they had to close for a few weeks due to non-payment of debt.[274] Susie probably paid the bill, and the saloon soon reopened. It was popular enough to be one of only a handful of venues in the city selected for the posting of bulletins about the November 1894 mid-term elections.[275] In April 1895, the police raided the Two Jacks "and confiscated a large amount of gambling paraphernalia," including some suspicious-feeling dice. "This morning," the *News* reported, "Chief [of Police] Hill had some of the dice broken and found all of them loaded. That is, so filed with quicksilver that a man playing in the house could not possibly win." The Jacks were obviously running a "skin game."[276]

Perhaps this was too much, if not for Arthur, then for his family back in Atlanta. Not long after the saloon was raided, the *Chattanooga News* identified him as "a son of F. M. Jack, the well-known manufacturer at Atlanta," and reported that "his people are anxious that he leave the [saloon] work he is now in."[277] This seems to have been the impetus for Arthur's next professional step. In July 1895, the papers noted with some inaccuracy, that "a deal is now pending by which Arthur Jack, who has been in the saloon business here, will purchase the farm now occupied by Esq. Joe Dobbs. The farm is one of the best in the county."[278] On August 1, Arthur signed a five-year lease (not a deed of purchase) on a twenty-acre farm owned by Mrs. Thomas McKee of Columbus, Ohio. It was located on Missionary Ridge, just across the state line

and about a mile east of the town of Rossville in Walker County, Georgia; the rent was twelve dollars and fifty cents a month. According to the lease, the farm was planted with orchards, shade trees, and grape arbors, none of which were to be disturbed during the term of the lease.[279] This was not a problem as Arthur's reasons for renting the place were aviary, not arboreal. "Arthur Jack is purchasing a large number of live pigeons," the *News* reported, "and a party of well-known local experts with a shotgun will go out…some day in the near future and have a grand shoot." In place of the clay pigeons with which these sportsmen had contented themselves on earlier shoots, "the real article is to be substituted. Prizes will be offered for the best shots."[280] Given Arthur's history, it is safe to conclude that the sport, played on his own leased property and under his direction, involved participation fees and gambling.

Susie Tillett lent Arthur twelve-hundred dollars to get the farm going and took delivery at her own house in town of nearly 300 "extra fine" pigeons. She told one visitor, who later claimed to have seen "a great number of pigeons in a box" at her house, that "she was going to send them out to her farm in Georgia to her honey Arthur Jack."[281] Arthur also bought "110 chickens (extra fine), one wire pigeon house, 2 breed houses, 8 chicken houses, 10 chicken yards & walks, one Milburn wagon and…household and kitchen furniture."[282] Other than possible pressure from his family back in Atlanta, the reason for Arthur's sudden interest in all this is unclear; after all, he was a creature of the city who, as far as is known, had no experience in agriculture or husbandry. Pressing debts may have required him to find an additional income stream, one that he could manage with at least some independence. The same might be said for his romantic antics, which, after the Spencer affair, were probably under closer societal scrutiny. The farm would have provided a place where he and Susie could spend extended periods away from gossips, the police, the gun-happy Spencers, and others of their ilk.

However, the idyll, if that is what it was, did not last. Arthur soon began covering day-to-day expenses at the farm with cash from the tills of the Two Jacks Saloon, which, as we have seen, was owned and funded by Susie. Apparently, she knew nothing of Arthur's misuse of the saloon's moneys until 1896 when she, not Arthur, was sued for his debts. Between August and December 1895, it seems, he had run up charges with Thomas Richardson's livery stable for the maintenance of several horses and at least one buggy. As

plaintiff in the suit, Richardson told the court that he understood that the charges were being made on behalf of Sue Tillett who, he said, ran "a house of prostitution at No. 1 [*sic*] Helen St. in rear of my stable. She also run[s] a Bar at No. 11 9th St Chattanooga in the name of Arthur Jack Agent." When presented with the bill, Susie questioned its accuracy. Although the amount in contention was only ninety-one dollars, plus interest, which hardly seems worth the fuss, she refused to pay it and insisted that the case go to trial, which it did in February 1897.[283]

When Susie was deposed in the case, she claimed, under oath, that she knew nothing of the charges; that Arthur had not made them as her agent; and that she had her own horse and buggy and paid her own bills at Richardson's. "Arthur Jack took a lease on the farm out in Georgia and attended that place for himself," she testified, "and I had nothing whatever to do with it." When witnesses for the prosecution implied that the farm was being used as a place of assignation, she claimed that she rarely went there and certainly had never spent a night there. "I am a single woman," she said, "and Arthur Jack is a single man." Her denial of moral turpitude was contradicted by several witnesses, including Richardson, who told the court that she had often ordered a carriage from him and driven herself out to the farm, too late in the afternoon, in his opinion, for her to have returned to town that same day. Indeed, her presence at the farm was noticed often enough and by enough people that it was assumed, even by the financially offended Richardson, that she owned it and had hired "her honey," Arthur Jack, to manage it for her.[284]

As all this was going on, in the fall of 1895, Susie visited Lexington to tend to her property there. She was then taken ill by an unidentified affliction and, with her sister Nettie as companion, retreated to Hot Springs, Arkansas, where she spent six weeks in search of a cure.[285] The only surviving letters (brief and unfortunately undated) from her to Arthur were written there. She began each with the salutation "My darling Boy" or "My darling Arthur" and ended them with love, "Susie" or even "Susie Jack." She wrote briefly of her own health and his and expressed concerns typical of love letters. "This makes Five letters I have received from you and five I have wrote you," she

wrote on November 11. "Am all most crazy to see you. I am just counting the minutes when I can get to see you. God in heaven knows I would not mistreat you for no one on this earth." She said she was getting better in Hot Springs and that she could not stay longer unless he joined her. "Honey can't you get money from Charley Rief [a business acquaintance] to pay your rail road fare out here," she pleaded, "I must see you."[286] But she was still lonesome in Hot Springs two weeks later. "I am all alone," she wrote on the 18th. "Nettie went to the show to night so I thought I would write to you. I have got my Arthur's picture setting by me now and I am loving it so much I can't think of anything too write." She had heard rumors that he was "running around," but did not believe it. "I don't think my Arthur would treat me wrong and God knows I won't treat you wrong." On the 21st she wrote that she would be home the following week. "Write just as soon you get this so I will get it before I leave here. Good bye with love and kisses your loving wife."[287]

Contending with an illness and a lawsuit simultaneously was too much, even for a seasoned professional like Susie. On her return to Chattanooga, she cut her losses and closed the Two Jacks for good.[288] Jim Jack returned to Atlanta, where he continued to work in the hotel and saloon business. Arthur turned over the physical assets of the farm to Susie in payment of the loan she had made him to set it up and began to look for new work. He found it, but not in Chattanooga.

With the closing of the Two Jacks Saloon and the failure of the farm, Arthur went to Nashville.[289] The reason is unknown, but it is not a stretch to think that maybe he and Susie had a spat (who could blame her?) and he left town to look for work, peace, romance, or all three. Whatever the case, his stay there was brief, and by the fall of 1897 he had moved on to Montgomery, Alabama, where he got a job as chief barkeeper at the popular saloon of Isadore Brickman, "purveyor of fine liquors, wines, and cigars."[290] It is not known how Arthur got the job, but apparently his reputation as an expert mixologist preceded him, and Brickman brought him in as part of a general upgrading of the place.[291] The saloon was prominently located on the first floor of Mabson's Hotel on Montgomery's Commerce Street

between a wholesale grocery and a funeral parlor. Brickman prided himself on running a full-service establishment offering popular beers, imported brandies, cordials, scotches, whiskies, wine, fine tobacco products, a free lunch, a wholesale package liquor and grocery store, and, with the promise of gambling opportunities, a "pool and billiard room furnished in the most modern manner."[292] For the hedonist, other earthly pleasures could be had around the corner at McDonald's Opera House and, within a block or two, at several bordellos.[293]

It could not have been coincidental that one of the latter was under the new, if temporary, management of Susie Tillett. If Susie did not follow Arthur to Nashville, she certainly did to Montgomery. Lacking any legal documentation of a marriage between them, we might take this joint move as a de facto commitment, a definitive act that cemented their relationship and, for them, put it on the level of marriage. While maintaining her business in Chattanooga and continuing to manage her Lexington property from afar, Susie was the madam, first of a house on Bell Street, and then of one on North Lawrence in Montgomery. These places were not far from where Arthur worked and from the Merchant's Hotel on Bibb Street, where he rented a room for at least part of his stay in the city.[294]

Little else is known of their time in Montgomery. They were there long enough to be listed in the city's directory, he once (in 1897), and she twice (in 1897 and 1898), but not long enough to leave any other trace. By the summer of 1898, they were back in Chattanooga, and Arthur had turned to a new and exciting professional pursuit: horse racing.

The Grand Circuit was a national network of tracks that joined forces in 1871 to organize annual stakes races of standardbreds, meaning horses trained to run at a trot, in harness, pulling a light carriage and driver. Arthur Jack became a professional competitor in the sport in 1898 when, with financial support from his father, he bought a trotter named Dick Ferguson for $1,700.[295] His plan to turn the horse "into a world-beater" began to pay off when Dick Ferguson won the featured race at the Rockwood, Tennessee, Fair in September 1898 and, the following month, ran in a series of well-publicized

races sponsored by the Chattanooga Driving Club.[296] By the following year Jack had added three other horses to his stable, each named for a loved one: Susie T. and Susie J. (for Susie Tillett, a.k.a. Susie Jack) and J.R.J. (for his brother, James R. Jack).

Judging by the sports pages of contemporary newspapers, 1900 was Arthur Jack's most active year in the sport. In June of that year, he ran J.R.J. at tracks in Akron, Cleveland, and Newburg, Ohio, to good public response and lucrative results. Even when the horse placed (came in second) in Newburg, J.R.J. was praised for giving "a lively chase" and performing "far better…than in any other start he has made this season."[297] Both that horse and Dick Ferguson ran at tracks in Canton, Ohio, and Rockport, Illinois, with some success that summer. J.R.J. may have been Jack's most popular and successful horse: in addition to the races already named, in the fall of 1900, he ran several times in Cleveland and Salem, Ohio, and in races held in conjunction with the Interstate Fair in Atlanta.[298] That October, Susie J., whom Arthur owned in partnership with the Lexington horse trainer Fred D. McKee, placed in one of the biggest races of the season, the Kentucky Futurity in Lexington.[299] The 1900 edition of *Wallace's Year-Book of Trotting and Pacing*, the bible of the sport, includes multiple listings for Susie T., Susie J., and Dick Ferguson, and no fewer than seventeen for J.R.J.[300]

Given his history it is no surprise to learn that Arthur Jack's horses, circa 1900, were not the only things he was running. Apparently, he took advantage of the traveling that racing required to pursue more libidinous interests. Predictably, these pursuits landed him, by now an aging but not yet pastured Don Juan, in trouble. On July 31, 1900, the Canton, Ohio, *Stark County Democrat* stated that one Lillie M. Fulk, age sixteen, had been reported missing by her parents. A friend of the girl told the police that Lillie had told her that she had recently met Arthur Jack of Tennessee, "a well-known horseman who had several entries in the races." Jack allegedly showed Lillie a roll of bills thought to be in the amount of five-thousand dollars and asked her to meet him in the nearby town of Warren for "a good time." Jack "is known to have considerable money with him," the paper reported, "but as to his connection with the story, the police are unable to state further than the statement made by the girl to a friend before she left."[301] The story was complicated by the fact that Lillie was the product of a troubled home—a

few years earlier, her mother had sued her father for cruelty and failure to provide for his family—and the case against Arthur Jack apparently went no further.[302]

Despite the quantity of races in which Arthur ran his horses, the payoff was not enough to meet expenses, and he was soon forced to quit the business.[303] Although his participation had lasted only a few years—1898 to 1901—he had managed to make a name for himself among horse people and had hob-knobbed with a few prominent ones. Among these were well-known owners and trainers, such as Fred McKee and the famous rider-turned-owner Seth Marvin "Marv" Beardsley.[304] Arthur's last known professional connection to the field occurred late in 1902 when he sold a horse named Fearna N. at Trantor-Kenney's summer sales in Lexington.[305] After that, his equestrian connections were limited to ownership of several carriage horses, a pony he eventually bought for his daughter, and a twenty-five-year-old jockey named Thomas McElhinney, who boarded with and worked for Arthur and Susie for a short time around 1910.[306]

In the fall of 1900, as Arthur was running horses on the Grand Circuit and Susie was continuing to manage her business in Chattanooga, they took a step that would change their lives forever: They adopted a child. No official documentation has been found to mark the event, but Susie dutifully inscribed the child's name and birthdate in her bible: "Winnie Grace Jack / Born Saturday / March. 31st 1900." Several contemporary newspapers stated that the child was born in Knoxville, and Susie later made the unlikely claim that she had been born in Lexington.[307] But she and Arthur always told Gracie, as the child was known, that she was born in Chattanooga, and she accepted that as fact for the rest of her long life.[308] Wherever she was born, Gracie was in Chattanooga by the time she was six months old when Louis Granert, Chattanooga's and, by that time, Susie Tillett's photographer-of-choice, made several cabinet photographs of her. They show a richly dressed, happy, healthy child, one who is obviously cherished by people who love her.

Unfortunately, at least one of Chattanooga's residents would have taken exception to that assessment. On March 26, 1902, the *Chattanooga*

News received an anonymous—and somewhat outlandish—letter from "A Citizen." "There is an infant about 3 years of age [*sic*] at the house of Susie Tillett, on Florence street," the apparently ill-informed correspondent wrote, continuing:

> From what I can learn she adopted it from some party in Knoxville. This is a crying shame and some steps should be taken to put it under the care of a decent home. I am told that it is already cursing [!]. Here is a chance for some more humane work. I hope to hear good results through the columns of the news.[309]

The "Tillett woman," the paper clarified, was "of questionable character" and was rearing the child, "amid surroundings that are anything but conducive to morality and uprightness."[310] Thus alerted, the city's so-called humane officer, Thomas M. Rowden, and its chief of police, Fred Hill (the same man who had interviewed Susie and Nettie Tillett in their home a few years earlier) dispatched a policeman to investigate. The officer confirmed the child's presence in the house and reported that she was only about a year old, which at least was closer to the truth. Rowden and Hill immediately began efforts to "rescue" the child and place her in an orphanage or an industrial school. "Under no circumstances would the woman be allowed to retain possession of the child," Hill told the *News*. But when no institution could be found to accept an infant as young as this one, an appeal was made for private adoption. "Unless some kind-hearted person offers to take the little outcast," the paper said, "it will have to remain in its recent surroundings, which will result in the blasting of its life."[311] Two women came to police headquarters and expressed interest in the baby, the paper reported on March 28, but when nothing came of that, a frustrated Rowden complained,

> this is not the only sad case of this kind that I have on hand. There are others, many others. So far I have been unable to secure a home for this little one, and would certainly be glad if some respectable person would take it. Such a person would be doing a thing that would meet the commendation of both God and man.[312]

Susie had every reason to be alarmed by these threats and no reason to doubt that the authorities would act on them. Various do-gooders had been abducting children, natural or otherwise, from prostitutes in the city for years. In 1883, a judge ordered the removal of three children from "the

bawdy house" of a certain Mrs. Ellis, and a group of "ladies from the orphan's home" took a five-year-old girl away from Babe Butler, alias Georgia Smith, an "inmate" of Madam Alice Cooper's house. A few days later, Butler "kidnapped the child from the Home and boasted to it in a card to the *Times*."[313] In 1885, a "beautiful nine-year old boy" was taken from his mother, who was working in Maud Bell's house; the police tried to get a "bright little girl of four or five" away from Madam Mollie Massie, against the woman's violent protests; and an eight-year-old boy was taken from another prostitute and left at the county hospital awaiting relocation in "the home."[314] Lieutenant Arthur Doty, who was leading the official charge against the maternal residents of the city's red-light district, claimed to have "the names of quite a number of prostitutes who," he promised, "will be deprived of their young children."[315] In 1895, two such cases made the news. In April, Mamie Jones, the inmate of a disorderly house, had her four-year-old child taken from her and placed in "the hands of the ladies at the Vine street orphanage."[316] That summer, a woman named Dinah Pattron, widowed and the mother of five children between the ages of five and eighteen, was accused of running a disorderly on Grove Street where she and her eldest daughter "were engaged in highly immoral practices." Mrs. Pattron was arrested for prostitution, and her three youngest children taken from home and placed in an orphans' home. She protested fiercely, to no avail.[317]

Occasionally, a madam managed to keep her children, probably by paying off the authorities. This was the case for Hattie Fowler, a madam with three small children. When she was arrested and fined for keeping a disorderly house, she was told that the local orphanage was ready to take her children at any time. She declined the kind offer and that seems to have been the end of it. But this sort of official interference rarely worked to any madam's advantage and sometimes even had disastrous consequences.[318] In 1893, for example, a Chattanooga woman of ill-repute named Manda Sauceman committed suicide after it became clear that the authorities were about to abduct her four-year-old "blue eyed girl baby" and place her in an orphanage.[319]

Susie and Arthur would almost certainly have heard of these and similar stories, and they quickly reacted to the situation in which they now found themselves. Within a month of the publication of the articles about "the little

outcast" in Susie's place, they acquired a new home, at some distance (but not too far) from Chattanooga, where they could raise their child in safety and with at least a modicum of respectability. That home was in Lexington, Kentucky.

Chapter 4

Lexington

Almost exactly one month after the *Chattanooga News* broke the story about a child living in the house of the notorious Susie Tillett, Arthur Jack signed the deed on a large piece of property in Lexington, Kentucky. Given the explicit threats that the Chattanooga officials had leveled at Susie's, and now Arthur's, child, it would be hard to interpret this action and the Jacks' hurried move to Lexington as anything other than a last-minute effort to save Gracie and provide her with a safer and perhaps more respectable home than she was likely to have in Chattanooga. Geographically, anyway, it was a logical move. After all, Susie had been born in Fayette County, she considered Lexington her hometown, and she had relatives there. Given her affiliation with the city's most notorious neighborhood, though, it must have taken some nerve, or at least a hope that memories were short, in proposing the town as a family refuge. In any event, the move proved to be surprisingly successful.

On April 29, 1902, Arthur Jack gave Ellen McCormick, a real-estate dealer and investor, fifteen-hundred dollars in cash for six contiguous city lots on Chestnut and Ohio streets just south of Seventh Street in Lexington.[320] The property, which was three-hundred feet deep and fronted sixty-five feet on Chestnut Street and seventy on Ohio, was in an expanding neighborhood in the northeast quadrant of the city that would have been familiar to Arthur Jack, as the Kentucky Association Track was only a block or two to the east. For the first time, upgrades to the city's streetcar and interurban

transportation systems were making this and other new sections of the city, as well as the smaller Bluegrass towns that surrounded Lexington, easily accessible to the city.[321] And as a newly domesticated neighborhood, it had amenities that would have appealed to any couple with a child, even a couple as unconventional as Mr. and Mrs. Arthur Jack, as they would now be known. For a city of its size, Lexington had an impressive number of schools—public and private, elementary through college—that Susie and Arthur could and would explore for Gracie's sake. As for the immediate future, Lexington had an active cultural life (both high- and lowbrow), as well as its own brand of café society, which presented possibilities for the professionally flexible and gregarious Arthur.

The Jacks' newly acquired property included a large house, to which the city had only recently assigned the address 647 Chestnut Street. It had been built in 1901–02 by the Combs Lumber Company, one of Lexington's leading contracting and construction firms, and the Jacks were its first residents. A barn and a stable, survivors from the land's former life as part of a farm, were also on the property. To this, the Jacks soon added a large poultry coop, a rabbit hutch, an extensive kitchen garden, an orchard, a grape arbor, picket fences, and concrete walkways.[322] The house was described in the Lexington papers as "a two-story, 8-room residence with bath, gas, electric lights, the finest cabinet mantles in the city, elegant electric fixtures, with cut glass and hand-painted globes, stone foundation, concrete cellar and porch."[323] The first floor consisted of a reception hall and parlor, living and dining rooms, a kitchen, and a large pantry with a wide, deep porch behind. A staircase that turned at a landing halfway up, led to a large upper hall, three bedrooms, and a modern bathroom on the second floor. Above this was a full attic with dormer windows. The front, main bedroom opened onto an ell-shaped, covered balcony. The roof of the house was covered with slate, the floors were hardwood, and the basement housed the latest-model furnace. It was hardly a mansion, but it was "a modern home in every particular."[324] Its style might be called Queen Anne, an eclectic branch of late-Victorian architecture, with that style's asymmetrical, vertical profile countered by the horizontals of board-and-batten siding. Classicism in the form of pure Doric columns on the first floor and hybrid, fluted ones on the second, contrasted with elements of modern, arts-and-crafts tastes, such as stained-glass, turned-wood, patterned

tiling, and decorative bracketing. It was the sort of house that would have appealed to a successful, middle-class family. Despite the means by which they got there, the Jacks were certainly that. In the summer of 1902, they moved in; it was to be their home for the next twenty years.

The size of the Chestnut Street property, the amenities of the house, and the comparative respectability of the neighborhood, all spoke of permanency, if not of exclusivity. Despite the move, Susie had no intention of giving up or even downsizing her interests in Chattanooga. After all, hers was the most— and sometimes only—reliable income for her new family. Apparently, she did not consider the distance between Chattanooga and Lexington to be an impediment to this arrangement. With Gracie safe from the sanctimonious crusaders of Chattanooga and a new home fitted out in the latest style in Lexington, Susie could comfortably commute between the two cities.[325] In fact, between 1902 and 1917, when she finally retired, she truly lived a double existence, with the details of her life in Lexington known by few people in Chattanooga and almost nothing of her Chattanooga life known in Lexington, especially not by her daughter.

This obfuscation was made easier when, in 1904, Susie divested herself of the most tangible evidence of her former life in Lexington. In December 1904, "Emma S. Jack, wife of Arthur Jack" sold the house and lot at 54 Megowan Street, which she had owned since 1889. The price was fifteen-hundred dollars, and the buyer was Dr. James T. Shannon, a Lexington horse doctor.[326] Thus the woman who continued to be known in Chattanooga as Susie Tillett, madam of a "home of infamy and sin," was now, and at the same time, Mrs. Emma S. Jack, wife and mother, in Lexington.

For Arthur, ever in search of income, the move to Lexington meant a return to the saloon business. His first stop was the Criterion Bar & Café where he started working as a bartender in May or June 1902, within a month or so of his purchase of the Chestnut Street property. The Criterion was at 13 North Limestone, a few doors from Main Street. Under various names, it had been a part of Lexington's entertainment scene since at least the mid-1890s. In the spring of 1902, two of Lexington's best-known saloonists, James E. Kearns and Frank Brandt, took over the management of what was then Asa McGinniss' Saloon and renamed it the Criterion. They spent as much as ten-thousand dollars, or so they said, to renovate it with the goal of turning

it into "one of the finest places of the kind in the South."[327] It opened to the public on May 18, and within weeks, the well-known former horseman and experienced barkeep, Arthur Jack, began working there, as Kearns and Brandt made sure the press knew.[328] Apparently these successful businessmen were not above staging at least one publicity stunt, which is what the following absurd notice, published in the *Lexington Leader* in February 1903, seems to have been: "Arthur Jack, bar tender at the Criterion saloon, will leave in a few days for Germany, his old home, for a visit of two years. Mr. Jack came to the United States about five years ago and has not been home in that time." The only accurate part of this notice is that Arthur Jack was a bartender at the Criterion. He was not from Germany, nor is there any evidence that he ever went there. Besides whatever publicity this oddity gave the bar and its bartender, I suspect that it also gave Arthur an alibi for not appearing in court in Chattanooga pursuant to a bankruptcy proceeding that was underway there.[329]

After a year at the Criterion, Arthur Jack decided to open his own saloon. For once, it was a good decision. He had enough experience in the business, and thanks to his extroverted personality, he had already become a popular figure in Lexington. In terms of real estate, there were plenty of opportunities in the city. Lexington was known throughout the South for the quantity and quality of its saloons and, with a steady influx of people in town for its farmers' markets, tobacco and horse sales, agricultural fairs, and horse races, investing in a saloon would not have been an unreasonable gamble. By 1900, there were over 125 saloons in the city, most of them clustered along Limestone and Mill streets and on Broadway, although Short and Water streets had their share of watering holes.[330] Those that aspired to full-service had the added attraction of a "club room" where patrons could play nickel and quarter slot machines and participate in poker and crap games.[331] In fact, almost any activity on which one could bet—racing, prizefighting, bowling—were promoted in these places. In recalling the era, one local paper later bragged that, during the early years of the twentieth-century, Lexington "had some of the most luxurious bars in the country, far surpassing those of any other city of similar size."[332]

Since the managerial turnover of Lexington's saloons was fairly regular, Arthur Jack had no trouble finding a prime location that he could manage

independently. In June 1903, he signed a five-year lease on a saloon at 12–14 North Limestone Street, almost directly across the street from the Criterion. He bought the inventory and various licenses that were attached to the business from his landlord, Claude S. Brownell, a local "turfman" and professional gambler.[333] Brownell had only recently acquired the place from Anthony Meiler, who had run it as Tony's Manhattan Café & Bowling Alley.[334] Arthur Jack renamed it the Majestic Café & Saloon, making certain that "café" retained its precedence over "saloon" in order to give the place a veneer of respectability.[335] He brought in contractors from Cincinnati to remodel the joint inside and out. They renovated the lower part of the façade, where they installed cut-glass windows, to make it more inviting from the street.[336] The lunch counter was expanded to accommodate more patrons, several small, private dining rooms were created, and the spaces that made up the café and saloon were better integrated. Jack announced his intention to serve "the very best drinks," and the press, acknowledging the many friends that he had made while at the Criterion, predicted success.[337]

The Majestic Café & Saloon opened on the evening of October 5, 1903. With typical boosterish hyperbole, the press called it "one of the handsomest saloons in the South." A reporter for the *Lexington Leader*, apparently enamored of glass, marveled at the café's "elegant mahogany and cut-glass alcove front, mosaic floors, metallic ceiling, porcelain wainscoting, and specially designed furniture and fixtures." Attention was called to "the handsome bar upon which is a lavish display of beautiful cut glass, reflected by the long, heavy French plate glass mirrors." Opposite the bar was more mahogany in the form of a lunch counter where "all the delicacies of the season are to be served." A new, modern kitchen was outfitted with "a costly range and every other convenience" for the use of a newly hired professional cook who, Arthur promised, "will make a specialty of game in season and will fix it to suit the most fastidious of trade."[338] The *Herald* predicted that the Majestic would be "one of the best short order and chop houses in Central Kentucky."[339] At the café's gala opening, guests dined on "sliced tomatoes, ham, shoat, mutton, beef, chicken salad, slaw, spaghetti and many other tempting delicacies," all served "in great profusion…and much lavishness." The "jovial proprietor added to the geniality of the gathering," it was reported, and his success was "repeatedly drunk by his many friends and patrons."[340]

As he had done in Chattanooga almost a decade earlier, Arthur invited his brother, Jim, to come up from Atlanta to be the Majestic's chief bartender.[341] In the years since the Two Jacks had closed, Jim had made a name for himself in the saloon business and, as the Lexington papers noted, was "an accomplished caterer." In another bit of nepotism, Arthur hired his own son, nineteen-year-old Francis Marion Jack II, to work as a waiter in the café.[342] Marion, as the young man was known, had been raised in Atlanta by his mother, from whom, as we have seen, Arthur had been separated since the late 1880s. Now, Marion was on the run from his own marital problems. In July 1901, he had secretly married Hazel Madeline Crutcher, the fifteen-year-old daughter of an Atlanta merchant.[343] Predictably, the marriage quickly disintegrated. According to Hazel's later testimony, Marion abused her, told her he had married her only to spite another woman (who turned out to be a prostitute), and abandoned her. Hazel sued for divorce, claiming desertion, cruelty, and infidelity, and Marion fled to whatever refuge his father could provide in Chattanooga.[344] When Arthur and Susie moved to Lexington, Marion went with them. Arthur got him a job waiting tables at the Criterion and then, when he opened the Majestic in 1903, hired him to work there.[345]

One of the attractions of the building in which the Majestic was located—and something that set it off from other buildings in the area—was its depth: it extended about 163 feet back from the street, fully covering the lot on which it stood.[346] Around 1897, the original inhabitants of the building, a local lodge of the Knights of Pythias, moved out.[347] The following year, Tony Meiler refurbished it as the Manhattan Saloon and turned the extended space into a four-lane bowling alley, one of Lexington's first.[348] Once he bought the place, Arthur Jack, who already had an interest in bowling as he did in all sports, legal and otherwise, took advantage of this amenity to promote the game in Lexington. Between 1904 and 1907, he sponsored and played with a team of five or six men that he called "The Majestic Bowling Club."[349] He installed fans in the alley so that competitions could continue through the summer, sponsored contests with prizes, invited teams from Chattanooga and elsewhere to compete at the Majestic, and participated in tournaments in Danville, Louisville, Nicholasville, and Paris, Kentucky, and in Cincinnati, Ohio.[350] He even provided team uniforms that included sweaters "of extra fine quality, white with the word 'Majestic' in green letters woven into them,"

and bowling shoes "of the usual form, canvas tops and rubber soles."[351] "Mr. A. Jack, manager of the Majestics," one Lexington paper reported," is to be congratulated on getting together so strong an aggregation of players [and he] hereby issues a challenge to any amateur five-man team in the State."[352]

At the same time, Jack thought of other ways to monetize the Majestic while boosting its reputation as one of Lexington's most comprehensive resorts, one where patrons could find a variety of fine drink, food, and entertainment. He sometimes provided live music, and when the bowling alley was not being used for that sport, he transformed it into a shooting gallery, charging admission and undoubtedly encouraging patrons to bet on competitions, with the house taking a cut.[353] On at least one occasion, in August 1904, he ran a Western Union wire into the saloon so that a blow-by-blow description of the World Heavyweight Championship boxing match in San Francisco between James "The Boilermaker" Jeffries and "Fighting Jack" Munroe could be read on the telegraph wire and "called off" (announced) in what today would be identified as "real time." "Fifty cents admission will be charged," the *Leader* announced. "Perfect wire service is assured, and the description will be the next thing to actually seeing the great contest. Interest in the outcome here is keen and a large crowd will doubtless take advantage of the opportunity."[354] Again, betting was encouraged—and closely managed— by the Majestic's jovial host.

If the purpose of all this was to increase profits, which it certainly would have been, it worked, at least for a time. Arthur Jack ran the Majestic for over four years—June 1903 to October 1907—making it the longest-running of his several professional and semi-professional gambits. The nature of the business, though, assured that it would have legal problems, the first of which came even before the place opened. In August 1903, Louis H. Ramsey, who had for some time been leasing the second floor of 12–14 North Limestone for his sign-painting business, sued Jack and the building's owner for removing his signs from the façade of the building, "interfering with the passage" that led to the stairway that gave him and his customers access to his offices and workrooms, and razing an interior wall, thereby depriving him of "any means of opening and closing the entrance to his place of business."[355] The case went to trial the following month and was decided for the defendants.[356] Understandably frustrated, Ramsey moved, first to an

address further up Limestone and then to one on South Mill Street, where his business thrived.[357]

But troubles of a more serious (i.e., criminal) nature were ahead. Whenever local law enforcement cracked down on Lexington's saloons, cafés, and restaurants, which they did on a regular basis, the Majestic was on their hit list. The most common accusations made during these raids related to saloons staying open past the legally mandated closing time of midnight, violating the sacrosanct Sunday "blue laws," selling liquor to minors, and "suffering gaming." Jack was indicted for each of these violations on more than one occasion, as were most of his fellow saloonists. Like the tactics used against Chattanooga's madams, charges might be filed against individuals or against groups of perpetrators. One of the most publicized of the latter type occurred in October 1904 when Arthur and four other of Lexington's leading saloon owners, all of whom ran businesses on Limestone Street, were arrested during a midnight raid. They were charged "with violating city ordinance 148, which provides that all saloons must not only be closed on Sunday but on each week day night at 12 o'clock and remain closed until 4 o'clock the next morning." Jack testified that on the night in question he had locked the door of the Majestic "promptly at 12 o'clock, but that there were five gentlemen in the restaurant department finishing supper and he did not want to eject them before completing their meal." Several other defendants in the case gave similar reasons for having closed their establishments after midnight that night. Among them was James Kearns, Arthur's old boss at the Criterion, who asked the judge to read the applicable statute aloud in court. In complying with his request, the judge realized that the law pertained only to saloons, not to restaurants. Since all five men had restaurant as well as saloon licenses, the charges were dismissed.[358]

The following year, 1905, Arthur was one of more than a dozen Lexington bar owners, including Kearns, John W. Ecton, Nick Ryan, and Matt Sauer, who were indicted multiple times and over several months for selling liquor to minors.[359] These actions were prelude to a sweeping raid that was timed to coincide with the Christmas-New Year's holidays, one of the saloons' busiest times of the year. In late December, the court handed down two group-indictments that involved almost every saloon keeper and restaurant owner in the city—a total of ninety-six people in one case and eighty-six in

the other. Arthur Jack was included in both groups. The main charge was, again, violating the Sunday closing laws, hardly a major transgression, but enough to make political points (as well as revenue in the way of fines) for the city's administrators.[360] The extent of these holiday raids and the growing frequency of arrests and indictments in general, all of which were widely publicized, worried Lexington's saloon and restaurant owners that the city would gain the reputation of being a "tight town," that is, a place where the police kept an especially close watch on the entertainment and hospitality industries. The saloonists complained to the press that this repeated intimidation would scare off potential customers, including those from out of town, thereby harming not only their businesses but the economy of the entire city.

Things came to a head in May 1906, when Lexington's mayor closed down James Scott's saloon on Water Street for operating without a license. Fed up with the harassment, the saloonists joined forces in protest. "[They] are saying little," the *Lexington Herald* reported,

> but there is an undercurrent that argues that a move will be made by them before long. It was hinted yesterday that a test case will be made by one opening his place next Sunday, and when arrested, he will carry the case from court to court until the constitutionality of the closing law is thoroughly tested.[361]

A reporter for the *Herald* interviewed several of the businessmen, including Arthur Jack who summarized the party line. "There is nothing here now on Sunday for the people," Jack said. "I think that they will now go and spend their money in towns where the law is not in effect, which money would otherwise be spent here."[362] It is difficult to know if these protests had the desired effect of reducing raids, arrests, and fines—there is no evidence that the saloonists made good on their threat of court action—but the whole affair was the talk of the town for several weeks and gave the affected businesses some free publicity.

The other most common legal problem encountered by the saloon men was gambling, which many of them not only suffered (allowed) but promoted and managed. The fact that Arthur Jack had already faced such charges in Chattanooga did nothing to discourage him from ignoring similar laws in Lexington. As they did for violations of blue laws, the police often applied

the anti-gaming law to groups of operators in the form of raids. At the end of March 1906, just as local papers were railing against all manner of moral corruption in the town, Arthur and eleven other saloonists were rounded up and charged with promoting gambling. Most of the accused were found guilty and fined two-hundred dollars each, a not inconsiderable sum at the time. Arthur was accused of the same and similar crimes on other occasions that year and the next, although he was not always found guilty.[363]

There is every indication that, despite (or perhaps because of) these problems, Arthur Jack's Majestic Café & Saloon was a popular success.[364] Unfortunately, it was not a financial one. Perhaps Arthur simply lacked the talent for managing budgets and had run up debts, financial and otherwise, through his unconventional activities, especially gambling. What may have been the deathblow for the business came on October 2, 1907, when the saloon was burglarized: two-hundred-fifty dollars was taken from the safe, which, Arthur told the newspapers, he had forgotten to lock when he closed up the previous evening.[365] The culprit or culprits were never caught, nor were the missing funds ever recouped, and by the end of the month Arthur decided to cash out. On October 25, he sold his liquor and tobacco licenses, as well as the Majestic's inventory, to fellow saloon keeper Michael Sullivan.[366] Although Arthur would later give the restaurant business one more go, this was the last time he would run a saloon. But his association with the Majestic would be remembered as late as 1930, when the *Lexington Leader* published a brief history of the city's saloons as they had been at the turn of the century. The Majestic, the article stated, was "opened by Arthur Jack [and was] one of the brightest of the Limestone street bars," thanks in part to a room in the back "where bets were made on horse races."[367]

As Arthur Jack's affiliation with the Majestic Café was nearing its end, two would-be entrepreneurs named Thomas J. Steeves and Jefferson Bratt were refitting a building on Upper Street as a 500-seat theater.[368] One block west of Jack's saloon, a few doors north of Main Street, and immediately across the street from the Fayette County courthouse, the building had been constructed around 1874 by Col. Robert R. Stone as the headquarters of

a private banking firm that he had founded. After that firm closed in the early 1880s, various tenants including, in succession, two newspapers, the *Observer and Reporter* and the *Lexington Leader*, Chinn & Todd's dry goods emporium, and the Rudolph Wurlitzer Piano Store had occupied the building. When Wurlitzer moved out in 1907, Steeves and Bratt took over the lease.[369] In converting the building to a theater, they declared their intent to fill it with "the most up-to-date shows," by which they meant vaudeville, a relatively new and wildly popular form of American theatre that sparked something of a boom in theater construction in Lexington.[370] Without necessarily referencing Arthur Jack's saloon, they named their new business the Majestic Vaudeville Theater. They equipped it with "the latest devices to please the public [including] plenty of seats, commodious aisles, good fire exits," and a large stage with "a full set of scenery to play the best class of acts."[371] It would be a venue, they promised, for "polite" and "progressive" vaudeville acts suitable for the entire family.[372]

The Majestic opened "in royal style" to a packed house on the evening of December 2, 1907.[373] The premier bill was typical for vaudeville presentations, which were usually a mixed bag of five or six short acts—melodramatic, musical, comedic, and acrobatic—that ran for a total of about ninety minutes. On opening night, the theater presented several vocalists, a yodeler, a team of slackwire "equilibrists," a pair of jugglers, a "trick" violinist, a German comedian, and the latest "motion picture productions" shown on a projector that Steeves and Bratt called "The Kinetograph."[374] The acts were supported by a five-piece orchestra under the direction of Prof. C. W. Munnell who had been brought to Lexington from Milwaukee's Empire Theatre at great expense. Apparently, the professor had left Milwaukee with some reluctance, but he was pleased with what he found in Lexington. "Very much surprised when I landed here," he wrote to friends back home, "to find a strictly modern city of 50,000 population. I have my orchestra all engaged and ready to do business."[375] Over the next two weeks, the theater's program featured self-proclaimed vaudeville royalty such as Noodles Fagan, the "king of newsboys," and Frank Cushman, "the king of minstrel stars." Fagan was a singer and impersonator known for his charity performances in aid of newsboys, who Fagan, having been one himself, saw as exemplars of American get-up-and-go. The less charitable Cushman performed in

blackface, a regrettably popular branch of vaudeville.[376]

With these bookings, a warm initial reception, and a "fashionable and high-class" audience, the press predicted success.[377] But it was not to be, at least not for Bratt and Steeves. Within days, they were in trouble. Unpaid performers took legal action, and bilked creditors put liens on scenery, props, and furnishings. Bratt quickly withdrew from the partnership and, less than two weeks after it had opened, the theater closed.[378] Steeves regrouped and, on December 15, brought in a new partner: Arthur Jack. Under this arrangement, Steeves and Jack would be equal investors in the business with Jack, who had no known previous theatrical experience, as its manager. To help with bookings, they hired William M. Pollard of the Cincinnati Theatrical Agency.[379] Pollard's connections, they promised the press, would allow them to change the program weekly while continuing to feature Prof. Munnell's orchestra and show the latest moving pictures on what they now called "The Majestiscope."[380]

The refreshed theater, with Arthur Jack in charge, opened on December 16, 1907, with four shows a day—at 2:30, 4:00, 7:30, and 9:00 p.m.—and an admission price of ten cents.[381] That first week, the acts included the brother-sister duo of Wiley & Wiley who performed "The New Recruit," a skit in which Mr. Wiley "proved himself a laugh producer" and Miss Wiley displayed "a very captivating appearance." The Musical Primroses presented "a pleasing novelty act" starring "one of the best" female coronet players in the country. Frances Swartz, "an accomplished actress and a beautiful woman whose seductive manner and high class acting gains for her much praise," led her company in "The End," a one-act drama described as "a startling, realistic portrayal of a class [of women] who lure young men to destruction and the sufferings of all."[382] Two weeks later, the blackface duo of Lambert & Pierce shared the stage with seven other acts, including Jean Beaugere, a female impersonator and "European lightning change artist."[383] It was standing-room-only throughout the Christmas holidays and the year closed with a full bill of singing and dancing comedians, a "renowned educated dog," and the rising star Violet Dale, "the most popular and up-to-date soubrette in vaudeville."[384] These were the earliest of over one hundred acts that would play the Majestic during Arthur Jack's management, a role that was about to become his alone.

By the end of January 1908, Steeves had decided to leave the theater business altogether. Jack bought him out and became the sole proprietor of the Majestic.[385] He hired W. H. Browne, formerly of the Lexington Opera House, as the Majestic's stage manager, and began advertising in the town's leading papers on an almost daily basis. In consideration of customer satisfaction (and prompted by a recent, much-publicized fire in a theater in Pennsylvania), he assured the public that the Majestic was the safest entertainment venue in the city. Its staff was thoroughly trained in emergency procedures and the building had enough red-lit exits to facilitate a full evacuation in three minutes.[386] For the audience's comfort and edification, Arthur oversaw the installation of fans that had been specially designed for theater interiors by the Scott Electric Company and continued to book the best and most varied acts he could get.[387] During the spring of 1908, headliners included the singer and actor Marie Jansen; comedians Fred and Dolley Carpenter, whose popular sketches "Sally's Revenge" and "Crazy Land" were held over for a second week; professional whistlers Hank and Lottie Whitcomb; Coy "The American Beauty" DeTrickey; aerialist Frank La Rose, who hung from a wire by his teeth; the Santfords, whose act starred a female coronet player in the skit "Too Late for the Beat"; Moreland & Lee, a.k.a. "The Sweet Singer & the Big-Mouthed Man"; the popular female impersonator Louis Bates; and the contortionist Zaletta, a.k.a. "The Human Corkscrew." Racist acts—comedians and singers in blackface—continued as standard parts of the programs and included groups such as "The Gold Dust Pickaninnies," who were said to do "something sensational."

Several national touring groups, including the Monarch and the Lenox vaudeville companies, were brought to the Majestic "at an enormous expense," fresh from successful runs in New York and Chicago.[388] Each presented a bill of five acts and was booked for one week. A highlight was the comedian Louis Chevalier's latest skit, "A Lucky Liar." Its plot was typical: a young couple has "a tiff," the wife goes home to her mother while the husband goes out on the town, gets drunk, and "meets a song-and-dance soubrette, whereby hangs a tale." "The totally unexpected denouement of the affair," the *Lexington Leader* reported, "keeps the audience in laughter from start to finish."[389]

Perhaps closer to home for Arthur Jack, given his Chattanooga adventures, was the sharp-shooting pair known as "The Two Vivians." Touted

as "one of the highest priced acts in vaudeville," they had recently returned from a European tour where, they claimed, they had given a command performance for the king of England, for which they received a gold medal. Miss Vivian, the star of the show, demonstrated her talents with a variety of tricks, the most famous of which involved igniting matches and candles on stage by firing at them from the back of the theater. For an encore, she sang "My Old Kentucky Home" while Mr. Vivian "played the chorus with a rifle." As reported by the *Leader*, the pair wowed audiences at "that beautiful little play house," the Majestic Theater, for several weeks in May 1908.[390]

At most performances throughout that season, homegrown talents such as Joe Dunlap and Herbert Cox filled gaps between shows by singing ballads and performing song cycles illustrated with lantern slides and moving pictures. "The Passion Play" and "The Holy City," for example, were shown during Easter week and promoted as family-friendly entertainments while someone named Shorty "manipulated" the Majestiscope "with such precision that the picture…[is] so lifelike that everyone…applauds so loudly that he [is] obliged to do an encore."[391]

Among the bigger hits that spring were "The Great Lester, King of Ventriloquists" and "The Great Zartoons," a husband-and-wife mind-reading duo. The former was Harry Lester, born Maryan Czajkowski in Poland in 1878. He was one of the best-known vaudevillian ventriloquists (or "vents," as they called themselves), famous for conducting a conversation on the telephone while his beloved wooden sidekick, Frank Byron Jr., carried on a quick banter of his own. They were so popular in Lexington that they were held over at the Majestic for a second week, during which they debuted a whole new act.[392] With the Great Lester in mind, and with references that would have been familiar to vaudeville aficionados, Arthur Jack bragged to the *Lexington Herald* that "the management of the Majestic does not rely upon hot-air critics, Keith & Proctor dollar-and-a-half shows for a dime, famous airship productions and the like to secure a few patrons." As manager of the Majestic, the only thing that he asked was that "the public come and see for themselves."[393]

The other most popular act at the Majestic that season, 1908, consisted of Harry S. and Alice Zartoon, known as The Great Zartoons, presumably to distinguish them from some lesser theatrical Zartoons. They performed

a mind-reading act—they preferred to be called psychics rather than clairvoyants—for two weeks in April and were a popular and critical success. They had come to town, Lexington's papers crowed, directly from New York where they had succeeded in "startling the whole city" with their "mediumistic power." The *Herald* thought they were one of the best attractions to have visited Lexington for a long time and praised Arthur Jack for going out of his way, again at great expense, to secure the act so that local theater goers could see "something that is out of the ordinary attraction showing in the vaudeville line."[394] Go to the Majestic, the paper urged its readers, and "see the spirit of your dear ones that have past [*sic*] out of the world." Merely ask the Zartoons, "Does Death End All?", and they "will mystify you by their wonderful answers from the spirit world."[395]

Arthur Jack took advantage of the Zartoons' popularity by orchestrating a publicity stunt to show off their talents and pull in business for the Majestic. A gold watch, lent for the occasion by the horseman John Spain, was hidden at an undisclosed location in the city. The plan was for Harry Zartoon, allegedly ignorant of the details of the concealment, to use his mediumistic powers to find it. "Blindfolded and with no one to guide or direct him," the papers said, "Prof. Zartoon drove a pair of spirited horses hitched to an open carriage in which he was seated, through the crowded streets, starting from the Majestic Theatre and winding up at the Model Clothing store, at the corner of Main and Limestone streets."[396] As a crowd formed, Zartoon, with dramatic flair, inspected the buildings around the store and then declared that he would wager one-thousand dollars that the watch would be found in the clothing store itself. To the thrill of the crowd, he entered Model's and, probably after some melodramatic carrying-on, found the watch in a sealed box at the back of the store. Asked how he did it, Zartoon gave credit to the fact that he was "the seventh son of the seventh son" and as such, had been endowed with a "wonderful necromancy, or telepathic power." Prof. Zartoon, the papers helpfully added, could be seen that week "daily and nightly in his wonderful performances at the Majestic."[397]

In April, as the Zartoons were finishing up their two-week run at the Majestic, Arthur offered Harry the job of business manager for the theater, presumably to take advantage of the Zartoons' vaudeville connections to drum up further publicity for the place.[398] Harry took the job. But as with

most of Arthur's other professional partnerships, this one did not last long. Within a month, the Zartoons quit the Majestic and left town, ostensibly to take over the management of Luna Park in Pittsburgh.[399] Their departure coincided with the first of a series of lawsuits brought against the theater, mostly by disgruntled actors. Probably in anticipation of financial problems and to keep his personal assets out of creditors' hands, Arthur transferred the deed to the Chestnut Street property to Susie by selling it to her for one dollar.[400] It was a timely move. In May 1908, Mary Marlowe and Mary Maddox, comedians billed as "The Two Marys," sued Arthur for non-payment of salary, breach of contract, and unlawfully canceling their week-long booking at the Majestic after only one performance. Arthur claimed that he was contractually allowed to do this because he was dissatisfied with their performance. The case dragged on for months, even after the two women had left town to perform elsewhere.[401]

With these and other troubles brewing, Arthur brought in several investors to help reorganize his theater. Under the slightly grander name of The Majestic Opera Company, the business was incorporated and went public with a capital stock of five-thousand dollars to be divided into fifty shares of one-hundred dollars each. The company was to have three partners, none of whom, as far as is known, had any experience as theater owners. Edward J. Linnig, who ran several tobacco and coal companies in Lexington, bought twenty-four shares in the Majestic and was named its president. John D. McRohan, the manager of a local employment agency, bought one share and, on that basis, was made the Majestic's secretary-treasurer. Arthur Jack retained control with twenty-five shares and, for what it was worth, became the new company's vice-president.[402]

If these steps inspired any public confidence in the Majestic, it soon dissipated. By the middle of August, McRohan had sold his single share and pulled out of the business. On September 1, the theater closed, this time at the behest of the building's owner, Judge George B. Kinkead, who claimed non-payment of rent and went so far as to padlock the theater's doors.[403] Performances were cancelled until further notice and Kinkead began looking for a new tenant. Arthur Jack, who was in Chattanooga when these calamities occurred, rushed back to town. "I was in Tennessee attending to some private business when the theater was closed," he told the press, "and its affairs have

been in a tangle ever since." He assured the public that "the necessary legal steps are now being taken to dissolve the partnership between Mr. Linning [*sic*] and myself and as soon as this is done, I will re-open the theater as sole proprietor."[404] In truth, Lining had incited the trouble by taking advantage of Arthur's absence to criticize him to Judge Kinkead. The manner in which Jack was running the theater did not suit him, he told Kinkead, and he did not believe the business could survive without new management.[405] Arthur found out about this betrayal and publicly defended himself. "The venture has been a financial success from the start," he told the press, probably with some exaggeration, "and I do not intend to abandon it."[406]

His optimism, if that is what it was, was ill-placed. The day after Kinkead locked the Majestic's doors, its management was again sued for breach of contract and non-payment of wages. The new plaintiffs—Arthur Yule, a popular Canadian-born comedian, Robert Nome, "a trick whistler and instrumentalist," and the family act of B. H., Jessie, and Nellie Russell—had been slated to open at the Majestic the following week. With the theater's closure, they were facing loss of wages.[407] Lining immediately distanced himself from his partner and tried to stave off the litigants by promising to see that they got paid. The situation worsened with the reappearance of the Two Marys, whose suit of four months earlier was finally coming to trial, and an attempt by the other disgruntled actors to get the court to put the Majestic's assets into receivership.[408] Other nervous creditors, including the Combs Lumber Company, which had renovated and repaired the theater when Jack took it over, added their own suits to the pile.[409]

Thus ended Arthur Jack's career as a theatrical impresario. He relinquished his lease on the Majestic and by the beginning of 1909 was out of the business for good. The Majestic itself was taken over by a more experienced manager, John B. Elliott, who renamed it "The Star," the title under which it continued to operate through the 1910s.[410]

Chapter 5

Helen Street

Whatever income Arthur was able to make from his saloons and theater in Lexington, the reputable life that Mr. and Mrs. Arthur Jack established in that city in 1902 was, at all times, underwritten by the less reputable one that Madam Susie Tillett continued to live in Chattanooga. And she was not about to abandon it, despite the inconveniences that might result from such a double existence. Presumably her income made the challenge worthwhile. It has been estimated that during this period, madams of first-class parlor houses of the sort that Susie ran could easily clear as much as $50,000 a year.[411] And there can be little doubt that Susie, now at the top of her game, was making at least that. Photographs taken of her by Marcus E. Schmedling and Louis Granert, Chattanooga's leading studio photographers during these years, show Susie decked out in long, beautifully made gowns, diamond earrings, bejeweled pins, and fashionable hats.[412] Such attire could not have come cheap, even if Susie did make some of her own clothes, as her daughter later recalled. There are no surviving photographs of the interiors of any of Susie's houses, but she probably spent similar funds on these, furnishing and decorating them in a manner suitable for her top-paying clientele. So, as Arthur remained in Lexington with Gracie, who grew from infancy to young adulthood during these years, Susie retained her status as a leading lady of Chattanooga's pleasure district, madam of the notorious house at 11 Helen Street.

By this time, Susie's sisters' professional situations had changed. In the

mid-1890s, Lillie met George Goggan, a native of Alabama who worked for the railroads. She retired from the Chattanooga business and, in 1898 in Atlanta, she and Goggan were married.[413] They lived for a short time in St. Louis before moving to San Antonio, Texas, where they lived for the rest of their long lives, George dying there in 1941 and Lillie two years later. Nettie Tillett continued to work in Chattanooga where, around 1900, she opened her own brothel on Penelope Street, two blocks from her sister Susie's house. She sometimes worked under the alias Nettie Peyser (or Piser), and it was under that name that, in April 1900, she and a colleague, one Willie Belmont, were arrested "for parading up and down West Ninth street in men's clothes." They were found guilty and fined $3 each.[414] That June, Nettie, again as Peyser, was identified in the federal census as a madam living at 12-1/2 Penelope Street with three "inmates."[415] Later that year, this time as Nettie Tillett, she was the target of a home burglary. At four o'clock in the morning of November 3, a man named John Street broke into Nettie's place on Penelope Street and attempted to enter her bedroom. She was ready for him. Woken by the noise, she jumped out of bed, grabbed a pistol from her bedside table, and opened the door "full in the face" of the thief. Street ran down the hall and made a frantic effort to escape through a rear door; but when he found it locked, he turned and made "threatening gestures" at Nettie. She screamed and, as he ran toward the front door of the house, she shot him three times. He managed to make it about a block down the street before he fainted from loss of blood, which is how the police found him. He survived and, when arraigned in court several days later, was identified by Madam Tillett and several other victims of recent burglaries as the culprit.[416] Not long after this, Nettie returned to Lexington where, in 1907, she married Frank Brandt, the saloonist who five years earlier had given Arthur Jack a job at the Criterion.[417]

No deeds or mortgages for Susie Tillett (or Arthur Jack, for that matter) have been found in Hamilton County records. The U.S. censuses of 1900 and 1910 clearly indicate that, in those years, she was renting the Helen Street property just as she must have done for the nearly twenty years that she lived there.[418] Several madams—Sue Green and Blanche Harris, for example— owned houses in the district and sometimes rented them to other madams. But it is more likely that Susie Tillett's landlord was one of the several men

who, as owners, dealers, and lessors, specialized in red-light properties. The most active of these was Otis E. "Dick" Pooler, a native of Ohio who had moved to Chattanooga in 1887. Pooler initially worked as a cooper but began dealing in real estate in the late 1890s. By 1910, he owned or controlled more properties in the city's red-light district than did any other landlord. Apropos of nothing other than human interest, he is said to have weighed 300 pounds and, coincidentally, was an associate of Si Spencer, who figured in the Jack-Spencer scandal of 1894, described above.[419]

We know something about Pooler's character and business strategy, which were probably typical for men of his profession, thanks to statements made by witnesses in a 1908–12 lawsuit in which Susie Tillett was a defendant and that will be discussed below. The testimony of one of the more vocal of these witnesses, Mrs. Ed Whittenberg (alias Laura Hines, alias Mamie Crow), provides a vivid portrait of the sort of person (in this case, Pooler) that the madams of Chattanooga were forced to accommodate. A longtime Chattanooga madam and therefore in a position to know, Whittenberg testified that by 1910 Pooler had gained control of many of the houses in the red-light district and was basically calling the shots about what happened there, not only in terms of rents but also in the manner and vehemence with which the police patrolled the district. In the summer of 1910, Whittenberg stated, Pooler offered her the house at 11 Florence Street for the bargain rate of thirty-seven dollars and fifty cents a month, providing she ran it as a bawdy house. She moved in but had been there for only a few weeks when the place was raided. Pooler, who probably instigated the raid, used it as an excuse to raise Whittenberg's rent, telling her that the increase was to pay for the protection that he would now give her against future raids. "He said, 'I will stand between you and all suits,'" Whittenberg recalled, "'I will keep you out of jail...I will be your "Jesus" as long as you stay in this district and you look to me for protection.'" Hardly an absentee landlord, Pooler was "around the places most every day," Whittenberg said, "and meddling more or less into the business of the Madams and at times all the inmates." He treated all his tenants poorly. "When he found out they were making a little money," she said, "he would raise the rent, giving as his excuse...that it was costing him a great deal to fight the cases in Court, and that he had to pay officials to get to run the houses in that territory as sporting houses." He would even snoop

around outside the houses early in the morning and count empty beer bottles to get an idea of how much business the madams had done the night before. He cursed at the women and insisted they run their businesses according to his rules. "The women are afraid of him," Whittenberg testified. "Pooler treats them like slaves and very few ever make any more money there in that business than it takes to live on after all rents and expenses are paid." When Pooler raised Whittenberg's rent to fifty dollars a month, she moved out, only to be replaced by Madam Bert Hall who, it was rumored, was paying Pooler an exorbitant two-hundred dollars a month.[420]

Whatever the vicissitudes of their professional relationships, the district's landlords and tenants were parties in a mutual if uneven bargain that was bound to lead to trouble. Indeed, they often found themselves as concurrent targets of social protests and, more seriously, as co-defendants in legal actions aimed at controlling the city's brothels. A suggestion of future difficulties came in the summer of 1904 when Chattanooga's City Council passed several ordinances that, for the first time in the city's history, recognized an official prostitution district, which they defined as the long-infamous blocks of Helen, Florence, and Penelope streets between Ninth and Leonard (soon to be renamed Tenth) streets. As part of the deal, disorderly houses were henceforth required to be at least "forty feet from any public highway and… to display in front a red light." They were prohibited from operating close to "any church or institution of learning." Nearby saloons were closed and the sale of all "intoxicating spirits" was prohibited in the district. To balance the equation, at least from the city's point of view, well-behaved inmates of notorious houses would be allowed access to the rest of the city, free of police harassment, between the hours 7:00 a.m. and 7:00 p.m.[421] All of this was designed to segregate prostitution and to prevent it from spreading to other neighborhoods, a futile effort as it turned out. The regulations do not seem to have been enforced with any consistency, although from time to time one authority or another felt compelled to reiterate them and threatened to close houses operating outside the "sharply defined" borders of the district.

The situation remained more-or-less stable for the next two years, but

on September 1, 1906, the papers announced that a new regime at the Chattanooga police department intended to prosecute the women of the tenderloin with renewed energy. At the same time, the city's new chief sheriff announced that, under his leadership, all constables (as opposed to members of the city-paid police force) would work under a fee system whereby they would receive a cash bonus for each arrest they made, a license for corruption if ever there was one. Three deputies immediately descended on the city's red-light district and served warrants to thirteen madams, including Susie Tillett. The women were ordered to appear before a magistrate the following day, each to answer the charge of running a house of ill fame. Not fooled by the timing of the raid, Magistrate Joseph J. Bork, who also had recently taken office, dismissed the case as a blatant example of "fee grabbing," an unethical practice that, Bork noted, had been a problem for the city for some years and one that he would not tolerate.[422]

The harassment did not end there, of course, and after another pause, the sheriff and his minions tried again. In July 1907, no fewer than 106 women—"practically all keepers and inmates of immoral resorts," the press said—were swept up in a major raid. But most of the charges were minor and as one judge pointed out, the cumulative fines subsequently levied on the women were barely enough to cover the expense of planning and executing the raid. The whole affair was widely mocked as a political stunt that had little or no effect on the day-to-day operation of the district.[423]

Frustrated by these failures, a grassroots movement took form, led by a recently established organization called the Third Ward Business League, which would prove to be the most formidable of the madams' many foes. Comprised of businessmen and property owners, the League first met in the summer of 1908 in James McMahon's tin shop on Carter Street, which ran along the east side of the district. The group's immediate goal—and perhaps its only one—was to convince the city to abandon attempts to contain and control brothels in the Third Ward and, instead, to rid the city of them altogether.[424] These houses, McMahon summarized,

> do their business thru all hours of the night...Lewd and lascivious music is constantly heard...Drunken men were constantly going to and from these houses, and constantly using loud and vulgar language and oaths unfit to be heard by decent people. The women themselves

81

constantly appeared, day and night, on the street in front of these houses in a partially disrobed condition, constantly using vulgar language and oaths, smoking cigarettes and otherwise misbehaving themselves.[425]

Members of the League pledged to help the police identify and indict "every woman who keeps or inhabits a disorderly house" and, if called on, to testify in any case that might be brought against them.[426] But not everyone thought the plan would work. James L. Whiteside, whose family, starting fifty years earlier, had developed the land on which the district was now located, believed that pushing the madams out would simply cause them to relocate to other neighborhoods. Nor would the change do anything to improve the ward. Decent people, Whiteside wrote in a letter to the *Times*, would not move into them since they had been "built for [prostitution] alone and cannot be used as residences." Adjacent properties would become equally undesirable, he said, which would lead to an even worse outcome: an increase in the number of "negroes" in the area.[427]

Whiteside's warning (and race-baiting) went unheeded, and at the urging of the League the city ordered the miscreant residents to vacate the district by the first of September.[428] According to the *Times*, few if any of the madams complied. They "are uncertain," the paper said, "and, as they take every issue in life, laugh the danger away and seem to be making no preparation whatever to meet the critical emergency." Most of the women were thought to have large enough bankrolls that they did not feel the need to face this or any other problem until it was "upon them," at which time they would simply "depend on the inspiration of the moment to meet it."[429]

The *Times'* prediction was accurate. The deadline to vacate came and went with no meaningful movement. Employees at the city's railroad terminal claimed to have seen "ten of the women board trains for other places," but that seems to have been either an exaggeration or a presumption.[430] On September 11, frustrated by the nonchalance with which their orders had been met, the city issued arrest warrants for all owners and inhabitants of lewd houses in the district. "On the record of the transaction," the *Chattanooga News* reported, "names highly respectable in the community are alongside those of people whose names are unmentionable in the drawing room."[431] The list of "unmentionables" was led by Susie Tillett (identified here for the

first time as "alias Jack"), followed by Stella Armstrong, Edna Darnell, Irene Friedman, Mollie "Irish Moll" Hicks, Hallie Hood, Alice Lee, Lillian Sterling, and others. The supposedly "highly respectable" citizens, men "of wealth and prominence [who] are boldly renting their property for bawdy houses," were J. Walter Cummings, John C. Garner, Hosea J. Green, Perritt A. Smith, John Thompson, and W. H. Winshipp, as well as the tyrannical Pooler.[432]

Hearings were scheduled, and within days the case went to the grand jury—which ignored it.[433] In fact, when the city created a test case by threatening to prosecute Georgia Miller, one of the recalcitrant madams, for failing to follow the court order, it "created quite a stir." It was feared, the *Chattanooga Star* reported, that if the case went forward, "many habitués in the red-light district would cause trouble by moving into quiet resident sections and opening disorderly places." The prosecutor dropped the case.[434]

In their frustration, the League turned to the chancery court. On November 11, 1908, forty-two men and three women, all of whom lived, owned property, or ran businesses in the Third Ward, filed a suit against fourteen alleged madams, again including Susie Tillett, and six brothel owners.[435] (Officially, the case was known as *M. G. Weidner, et al., vs. Irene Friedman, et al.*, referencing the two names that happened to land at the top of the lists of plaintiffs and defendants, respectively.) In their lengthy petition, the plaintiffs complained that, although a few bawdy houses had "infected" Penelope, Florence, and Helen streets for years, their number was now growing at an alarming rate. "All this district has increased in its unsavory notoriety," the suit claimed, "and the adjacent property to the West has become less and less valuable, the respectable tenants having been driven further and further away."[436]

The defense lawyers' first ploy was to aver that the plaintiffs' only connection to each other was that they all lived in Chattanooga, which was not enough of a reason to give them legal standing to file the suit. Besides, they contended, it was the city itself that had set aside the area in question as "a proper place for carrying on and indulging in this social, necessary evil." The land on which the district was located, they argued, with a predictable racist reference,

> is hardly fit for anything else. It is a low, swampy, muddy section of the
> city which, before it was set apart as a suitable place for conducting

bawdy houses, was occupied by cheap shanties that were rented to negro tenants, and the reputation of the people who lived there was already bad.

Instead of expanding, the argument continued, the district had actually shrunk in size during the past three decades,

> until now it embraces only a few blocks lying in behind 9th St., and the houses are so built and so conducted as not to interfere with people who have occasion to travel and pass along 9th St. and not to impair the values of property or businesses on 9th St. or the other residence streets in the vicinity.[437]

The judge was not impressed, and on November 16 he handed down his ruling. "The court is of the opinion that the houses described in the bill," he stated, "are being maintained by defendants as houses of ill fame, and are nuisances injuriously affecting the property of the complainants and that the complainants are entitled to an injunction as prayed." The defendants were individually named and formulaically charged. Susie Tillett, for one, was

> enjoined and restrained from renting or leasing her property at No 11 Helen St. to person or persons to be used as a bawdy house or house of ill fame, and from permitting same to be occupied by lewd women and prostitutes and from permitting prostitution to be carried out upon said premises.[438]

She and all other "scarlet people," as the press called them, were again ordered to leave the area and to appear in court on December 19 with proof that they had done so.[439]

For the first time, most of the madams complied, although the red-light district was hardly "wiped out," as one paper claimed. Far from it. Madams and landlords alike saw this development as nothing more than a temporary interruption in the operation of their businesses. Some madams stayed put, stopped taking customers, and assumed a low profile. Others sublet their houses and, according to the *Times*, "scattered to almost every [other] part of the city," especially to "lower Pine street and the river front, Douglas street, between Ninth and Tenth, and Foster street, between Eleventh and Ninth streets" in the Seventh Ward.[440] Ada Culver went from 19 Florence Street to 8 Foster, and Alice Lee moved from 17 Helen to 135 Chestnut. At least three madams relocated to Pine Street, Marion Fulgham, with six inmates, to 108

Pine, Susie Green and four other women to 118 Pine, and Ida Miller and her four "girls" to 135 Pine.[441] Susie Tillett sublet 11 Helen Street to an African American madam named Eva Clark and made a longer-than-usual trip to Lexington, where Arthur's Majestic Theater was in full swing and Gracie was just starting school.[442] Within a few months, though, she was back in Chattanooga, running her business, for the time being, out of a two-story duplex at 1020 Douglas Street.[443] Like Pine Street, Douglas was a temporary, unofficial red-light district with at least six houses of prostitution clustered there during the hiatus. With five young women and an elderly servant working for her, Susie led the pack in terms of employment.[444]

As if things were not uncertain enough, at just this time, Susie, like other madams, was the victim of a type of extortion scheme at which landlords like Dick Pooler were expert. According to the May 30, 1909, edition of the *Chattanooga News*, the house in which "Sue Tillett, a noted woman of the underworld" was living (presumably 1020 Douglas Street) was owned by a local real-estate dealer (Pooler?) who was renting it to an unnamed "interested official." This "official" had sublet it to Ada Culver, another leading Chattanooga madam, who then sub-sublet it to Susie. "In this roundabout way," the *News* reported, Susie was "forced to pay double profit for the property," i.e., one-hundred-fifty dollars a month.[445] "It is said," the article continued,

> that some months ago the Tillett woman expressed the intention of leasing the property directly from the real estate firm but was promptly informed that in case she did this she would be arrested often enough to break up the nefarious business conducted by her. This had the effect of making the woman submit to the increased rental.[446]

Predictably, the residents of the areas into which Chattanooga's madams moved after the most recent edict—Douglas Street, Pine Street, etc.—were no happier to have them as neighbors than had been those who lived near the

old red-light district. Not necessarily by choice, Black people had been living near Chattanooga's bordellos for years. But when more than a few of the city's madams moved directly into one of the more respectable African American neighborhoods in the Seventh Ward, its inhabitants protested. The Douglas Street houses, such as Susie Tillett's, were especially offensive for being within a block of the First Baptist Church, an historic Black establishment, and not far from the all-Black high school on East Eighth Street. In March 1910, following a fiery sermon about prostitution by Rev. Charles A. Bell, the popular pastor of the church, a committee of one hundred Black business and property owners visited both the Chattanooga City Council and the Board of Safety to register their outrage. Their major complaint, they told the authorities, was that school children were being subjected to "scenes daily that were calculated to poison their minds."[447]

Unwilling to let "negroes" get a judgmental jump on them, and apparently too genteel to join the fray directly, a group of white church ladies quickly announced their intention to ask God to take charge. They called an emergency, ten-hour "prayer and fasting service" during which they tapped into their direct network to the deity to state their desire that all "houses of ill repute located in the neighborhood of the colored public school" be closed immediately. Ignoring the fact that the offending houses were, for the most part, owned by white men and run by white women, the do-gooders decided that the best solution was to establish a home for "young negro girls...where the environment would be conducive to good morals"—and where the girls could be trained for domestic service. The meeting reached a climax when the 250 ladies in attendance formed a circle, joined hands, and sang "Blest Be the Tie That Binds."[448]

That same month, May 1910, God, apparently being occupied elsewhere, sent his surrogate Thomas P. McMahon, Chattanooga's Chief of Police, to answer the ladies' prayers by ordering the closure of the city's brothels and the arrest of anyone who attempted to enter one. "The women of the demimonde of this city have had a hard road to travel," the *Times* reported, with a rare hint of sympathy, "and have been the recipients of much attention from the police department in the last twelve months." Thomas Latimore, a lawyer and chairman of the city's Board of Public Safety, took exception to McMahon's order and, like Whiteside before him, expressed the opinion

that the best way to control the problem was to continue to confine it to a proscribed neighborhood. Forcing the madams to move had proved ineffective and had only made matters worse. Moral segregation remained, he thought, the best solution.[449]

In July, after these various protests and decrees had failed to cleanse the city of sin, a group consisting of the "heads of thirty-five prominent families," most of whom had been plaintiffs in the 1908 suit, *Weidner vs. Friedman*, demanded a new criminal injunction against all the madams, wherever they might live. The most offensive of these, they claimed, were Mamie Crow, Ada Culver, Irene Friedman, Susie Green, and Susie Tillett. They explicitly accused the women and their employees of "appearing in the streets [of the Seventh Ward] dressed in wrappers" and entertaining noisy "bands of men and boys" at all hours of the day and night, charges with which the women were all too familiar.[450] The madams, who by now had been in exile for about a year and a half, obliged the complainants by leaving the Seventh Ward and, probably with some justifiable smugness, moving back to the old red-light district in the Third Ward. Among them was Susie Tillett who, later that month, July 1910, returned to her old house at 11 Helen Street. According to the press, it took more than thirty fully packed wagons to move the possessions of "the scarlet radiance" from their temporary homes back into the district. "Red lights were burning last night on Helen street after two years [*sic*] of darkness in that quarter," the *Times* reported, adding that "expulsion of the demi monde from one section of the city to another and then back again is proven to be a decidedly profitable thing to certain owners of real estate."[451] Indeed, it was widely believed that the big return was the direct result of payoffs made by the landlords, Pooler undoubtedly leading the pack, who were eager for the reinstatement of the exorbitant rents that they had been able to charge the (white) madams before they had moved.

Predictably, this rebirth of the red-light district put the anti-vice forces back on high-alert, and in October, Chancellor Thomas H. McConnell, judge of the Hamilton County Chancery Court, issued summonses to two brothel owners (Pooler and Garner) and eight madams (Bouley, Friedman, Fulgham, Green, Harris, Hines, Sterling, and Tillett), charging them with contempt of court for having violated his earlier injunction against maintaining disorderly houses on Helen and Florence streets.[452] In effect, this reopened the lawsuit

of *Weidner vs. Friedman*, which would now drag on until January 1912. The plaintiffs and the defendants were basically the same as in the original 1908 suit, although a few of the former, having realized the ineffectiveness of the earlier effort, withdrew.[453]

After several continuances, the defendants finally paraded before the court in March 1911, and, one by one, declared their innocence. First up, Susie Tillett stated, under oath, that although she was "keeping house at No 11 Helen Street," she was not a "so-called landlady" and was certainly not "maintaining any sort of nuisance at or about said place." She said, "Everything about [my] house is quiet and orderly; there is not and has not been in that place any drunkenness, noise or anything that is calculated to or does disturb or disquiet any one, not even the ones living next to [me]." Careful not to perjure herself by out-and-out denying that she was running a house of prostitution, she repudiated the claim "that her living in said house has in any wise injuriously affected the real or market value of any property in that locality." As for the contempt charge, she insisted that she had not "openly, notoriously and flagrantly violated the injunction, orders and decrees of this Court or…caused the power and authority of this Hon[orable] Court to become a jest and by word, in the community." Her accusers, she said, were clearly trying to arouse "the ire and indignation" of the court by deliberately attempting "to prejudice the respondents in their rights."[454]

The other madams, whom one local paper non-contextually called "the yoshiwari," a reference to Tokyo's ancient red-light district, followed suit.[455] Marion Fulghum, for example, admitted to the court that she had recently leased and moved into the house at 15 Helen Street. But she had done so, she said, not because she felt any contempt for the court's order but strictly for the "purposes of having a home and a rooming house." She was very poor, she said, but also "a human creature" and, as such, was "entitled to shelter and protection from the scorching summer sun and the blizzards and bleak winds of winter."[456]

This time around, the lawyers for the defense took a comparative approach. They called thirty witnesses, all of whom were white men who either worked or owned property in or near the old red-light district. The group included several policemen, a justice of the peace, a furniture salesman, an insurance agent, two livery stable owners, a pawn broker, several restaurant and saloon

workers, and, as if on cue, the manager of a sausage factory. In deposing these men, the lawyers sought to answer two basic questions: Was life, liberty, and the pursuit of property better in the district after the madams left it in 1908, or had it gotten worse? Would the future of the Third Ward be better without them, or would it deteriorate? As a visual aid, a color-coded map of the district was created and entered into evidence. It designated businesses in brown, saloons in green, Black people's residences in black, and houses of prostitution in red.

Witnesses for the defense unequivocally supported the madams, if not morally then certainly in the interest of profits and peace. Almost all of them testified that the old district had not been as seedy or disruptive as the plaintiffs in the 1908 case had charged and that it had noticeably declined as soon as the madams left. It had subsequently been overrun by "negroes of the lowest order," they claimed, and its streets and houses had become noisier, dirtier, and more dangerous. How much these professed views were based on reality and how much on racism cannot be known, but it is clear that the lawyers for the defense were playing to whatever of the latter might be present in the courtroom.[457]

At the same time, none of the witnesses expressed regret that the madams had since returned to the district. On the contrary, each of them testified that the women and their employees were making a decided effort to keep things quiet. There were no signs of open solicitation and no displays of scantily clad women on porches, in hammocks, or anywhere else. The madams kept their shades drawn and their houses quiet throughout the day and even at night. Despite predictions to the contrary, when the madams had moved out, several witnesses reiterated, landlords were unable to find decent clients and had been forced to rent their properties at greatly reduced rates to "undesirables." Now that the women were back, almost everyone agreed, rents and property values had returned to their former levels.[458]

In the end, none of this mattered, at least not for the defendants. In April 1911, Judge McConnell ruled that because they had violated the eviction decree of 1908, the defendants were guilty of contempt of court. On April 13 the *Times* declared, somewhat prematurely as it turned out, that "the long-drawn-out red-light district case was brought to a sudden termination yesterday afternoon in chancery court when Judge McConnell...sentenced

each of the defendants involved in the case to pay a fine of $50 and…to serve ten days in the county jail."[459] In stating his position, the judge claimed to be "very sorry for the women in the case and…would much rather sentence a man to the penitentiary than to be called upon to sentence a woman to the workhouse." Theatrics ensued. "For a time," one paper reported, "the entire third floor of the municipal building was in a state of excitement" and at least one of the defendants, Sue Green, was so overcome with the prospect of doing time that she collapsed and had to be carried from the courtroom.[460]

Histrionics aside, there was again no immediate change in the make-up or functioning of the red-light district. This prompted yet another wave of opposition. In September, thirteen former plaintiffs in *Weidner vs. Friedman* renewed their petition for action, and in October the court held more hearings. "It is reasonable to suppose," the *Times* predicted, "that they will continue until Judge McConnell enters another order ousting [the madams] from the district."[461] This proved to be accurate. In December, the judge handed down a new decree, the most serious to date. It went beyond the earlier contempt charges and addressed the larger question of whether the red-light district should continue to exist at all. "From all of which," McConnell concluded,

> it appears to the court [that the] defendants to this cause have been and are creating and maintaining a nuisance…repulsive to all ideas of decency, and shocking to all sense of morality, and to the irreparable injury and damage of complainants in the value of their property…
> It is therefore ordered, adjudged and decreed…that said defendants be forever enjoined and restrained from creating or maintaining said nuisance in said district, and to that end it is further ordered and decreed that all defendants, owners, lessors and lessees, of houses in the "Red Light District," of Chattanooga, Tennessee, being the houses located on Helen, Florence and Penelope Streets, between W 9th and W 10th Streets…remove within 40 days from the entry of this decree, all lewd women, prostitutes, or women of easy virtue, from any or all their houses owned, controlled or operated by them.[462]

Pursuant to this order, in late 1911 or early 1912, Susie Tillett again left Helen Street, this time moving to 132 Foundry Alley, an already notorious place that, with nearby Clift Street, had functioned as a seedier version of the Helen–Florence street district for some years.[463] It could not have been a pleasant place to live. Susie's house was wedged between the large

factory complexes of the Chattanooga Railway & Light Company and the Mountain City Mills & Chattanooga Bakery, and she and her colleagues were just as susceptible to police harassment there as they had been in their old neighborhood.[464] In April 1913 Susie was again cited for conducting a disorderly house, and in October her license and those of eighteen other "ladies of the night" to sell beer were revoked.[465] Meanwhile, the old red-light landlords were again busy bribing the authorities to reopen the district, and in 1914 Susie and several other madams brazenly moved back to it. Unfortunately, Susie's historic residence at 11 Helen Street was not available. Earlier that year, tenants of the house, which already "had an unsavory reputation," were diagnosed with smallpox and the place was put under quarantine. The scandal intensified when the inmates, unwilling to lose income, even temporarily, flaunted the quarantine by taking their clients to nearby hotels.[466] So, with 11 Helen no longer an option, Susie and the six women who worked for her moved to 8 Florence Street, bringing her life in Chattanooga full circle, as this was the same house in which she had lived in the early 1890s.[467]

Again, these events—part of the ongoing cycle of raids, evictions, payoffs, returns, and more raids, each dutifully chronicled in the local papers— guaranteed a renewal of civic action against the madams. This time, the order came from the city's sheriff who, in February 1915, decreed that all bawdy houses must close and stay closed. According to the press, the command affected no fewer than 123 women who lived and worked in the district. Calling the blow "heavy," the *Times* saw it as the end of "the music of nickel and dime pianos, the merry clink of beer glasses, and the laughter and dance of those who live in the bright glare of the red lights."[468] "What are we going to do?" Madam Elizabeth English asked. "We haven't got money enough to leave town. We can't get jobs." The sheriff claimed that he did not mean to drive them from their homes, but simply to force them to quit doing business in them. As the *Times* reported, however, this was not feasible: the women could not continue to live in the district without a steady income. With rents that ranged from fifty dollars a month for the smaller houses on Penelope Street to as much as two-hundred dollars for the fancy parlor houses, such as Susie Tillett's, on Florence and Helen, over twenty-one-hundred dollars was paid out each month, the *Times* estimated.[469] "We were driven here by man,"

Madam English told the paper, "and have been driven out by man. Perhaps man will find some way to teach us a better mode of life. If not, we can live in defiance of man-made laws."[470]

In the end, it took the federal government to do what Chattanooga's judges, magistrates, lawyers, sheriffs, and angry citizens could not. This time, the effect on Susie Tillett's business and those of her colleagues was profound, even fatal. The events that now transpired in Chattanooga were, wittingly or not, part of a national reform movement that would quickly lead not only to the dissolution of individual red-light districts in cities across the country, but the demise, for all intents and purposes, of the very idea of such semi-officially designated places. As historian Mara Keire has put it, the national movement marked the end of "reputational segregation" as it applied to prostitution and the demise of whatever "controlled toleration" of red-light districts still existed.[471] This historical moment has been documented elsewhere and need not be detailed here.[472] Suffice it to say that although Chattanooga did not establish a formal vice committee to eradicate prostitution, as did other cities, the aggregate of the various protests, legal actions, and decrees that culminated in the drawn-out action of *Weidner vs. Friedman*, in which Susie Tillett had been a prominent defendant, functioned as a surrogate for that brand of targeted attack.[473]

Instigated by the federal government, the national crusade had as its main targets all cities that were geographically close to armed-forces training centers and that were thought to be hotbeds of vice. Once it became clear that the United States would soon enter what would later be known as World War I, the movement became especially earnest. On May 24, 1917, Secretary of War Newton Baker sent an open letter to the states' governors demanding their cooperation "in keeping the army mobilization camps free from promiscuous influences."[474] "I am determined that our new training camps," he wrote, "as well as the surrounding zones, within an effective radius, shall not be places of temptation and peril." The inability of states to achieve this, the Secretary threatened, would force him to move camps away from the offending cities.[475] With the U.S. Army's Fort Oglethorpe, which

had a recruitment goal of 2,500 men, only ten miles south of Chattanooga, the city's authorities sprang into action.[476] As the historian James Jones has written, "Chattanooga and Hamilton County officials, with a hitherto unknown sense of urgency, had by the next day thrown down the gauntlet and inaugurated a strict eradication of prostitution."[477] Martin A. Fleming, judge of Chattanooga's city court, ordered all madams, inmates of disorderly houses, and street walkers to close up shop immediately and "leave the city—until the war is over at least." Thirty women were ordered to appear before the court and explain their intentions to comply. "Practically every one of them said they were willing to leave," reported the *Chattanooga News*, implying that the madams were just as patriotic as everyone else. "The exodus has begun."[478]

Nationwide, many madams simply abandoned their houses and rented space in a cheap hotel, or in a down-at-heel boarding house, or above a dancehall, café, or saloon.[479] Not quite yet ready to quit the business, this is what Susie Tillett did. In late 1916 or early 1917, she left the house on Florence Street, where she had lived for the previous three years, and took rooms over a saloon in one of the seedier blocks of Market Street, one of the city's major thoroughfares.[480] She was not the only madam to move to the neighborhood. In late December 1916, the *Times* noted that it had become a refuge for many of the women who had worked in the restricted district. "Some of the present vice resorts on lower Market street," the paper confirmed, "are said to be situated in rooms over business houses, liquor establishments and restaurants." The situation had deteriorated so rapidly and severely along this stretch of Market that "decent women" could no longer shop there and "school girls had to take an airship to pass over the prostitutes who infected the street."[481] The chief of police promised to clear the area, but everyone knew that the end was near. When in January, several women were arrested for "'seining' around the streets," their lawyer, Osceola G. Stone, who claimed Native-American ancestry, called for sympathy by playing on the stereotype of the vanishing Indian. "These women are the remnants of a fast perishing crowd," he told the court, "the last roses of summer, as it were, and like my tribe, they will soon have faded away. They are the last of [the] Mohicans."[482]

By the beginning of 1918, Susie Tillett, who had been engaged in prostitution for nearly forty of her fifty-eight years, decided it was time to retire. The political situation certainly played a role in her decision, but considerations of health and home were probably paramount. She was luckier than many of her professional colleagues who were being forced out of business with little hope of finding a place where they could continue to practice their professions at a profitable level. "What are we going to do?" Madam Elizabeth English had asked. Susie Tillett, at least, had an answer to that question—and a place to go.

Chapter 6

Chestnut Street

Neither the frequency of Susie's commutes between her business in Chattanooga and her home in Lexington, nor the typical length of her stay in each city is known. Her daughter would later recall that Susie often took the train to the former city to manage a "boarding house," but she never implied that her mother's absences were overly long or that they disrupted domestic arrangements at 647 Chestnut Street. The Jacks employed several servants to help with those arrangements, especially where Gracie was concerned. A young African American woman named Irene tended to Gracie during the first decade of her life, and an African American jockey, name unknown, taught her to ride and took care of the pony that her parents bought for her. In fact, Susie and Arthur did everything they could to see that Gracie's life was happy, that she remained untouched by and unaware of the unusual parts of their histories, and that she had whatever she needed to thrive and grow into an educated and respectable young woman. Against the odds, they succeeded.[483]

Gracie's formal education began in 1906 when she joined the kindergarten at Miss Ella Williams' School, a private, coeducational day school on North Broadway in Lexington.[484] The curriculum there gave Gracie the basics that she needed to transfer, as she did around 1909, to the Preparatory Department (elementary school) of Campbell-Hagerman College, a larger and comparatively advanced school on West Second Street. At Campbell-Hagerman, she had the opportunity to study English literature,

mathematics, the romance languages, elocution, art, and music.[485] When the college closed in 1912, she moved to Dudley City School on Maxwell Street, and then to Morton High School on Main Street.[486] She graduated from the latter in 1918.

This structured education was enhanced with private instruction in music, a subject for which Gracie showed a particular affinity. About the time she entered Miss Williams' School, she became a student of Frances McKenna, director of the Lexington Conservatory of Music, a long-running and respected organization adjacent to the Lexington Opera House on North Broadway. It was in the Conservatory's 1906 commencement exercises at the Woodland Park Auditorium on East High Street that Gracie, age six, made her stage debut in a choral ensemble of Miss McKenna's "enfants."[487] At the same time, she was learning to dance at Mrs. Melvina Hughes' School of Dancing that operated out of the Merrick Lodge Building at the corner of West Short and Limestone streets. She participated in several of Mrs. Hughes' recitals, including one in the spring of 1908 when she and her fellow students performed ensemble standards, including "The Merry Widow Waltz," "The Barn Dance," and "The Boston."[488]

But Gracie's real musical talent, one that would sustain her throughout her long life, was at the piano. The teacher who had the most impact on her in that regard was Mrs. Lilla Foster Ford, who had a popular piano studio in her home on North Mill Street, and with whom Gracie studied from around 1908 until at least 1918. Under Mrs. Ford's guidance, Gracie proved to be a keyboard prodigy. Her talent manifested itself so early, in fact, that her father proposed putting her on the stage of his Majestic Theater, a plan that her mother rejected out of hand. Happily, other, perhaps more appropriate venues were available for showcasing Gracie's talents. In the summer after her tenth birthday, she was featured in Mrs. Ford's biannual recital in which she played two challenging virtuoso pieces, Larche's "Schottische Militaire," performed as a duet with Mrs. Ford herself, and Paul Ducelle's "Viola Waltz," a solo that earned her a silver medal.[489] In 1913, at Curry Hall, the Y.M.C.A.'s auditorium on North Mill Street (and still in use today), she played a duet version of Bohn's "The Witches' Flight" with fellow student Mary Amato and, as a solo, Sidney Smith's "A Starry Night."[490] The following year, she won Mrs. Ford's coveted gold medal for her interpretation of Henri

Kowalski's "Hungarian March."[491]

Of course, none of these opportunities for Gracie came cheap; and in any case the Jacks were always on the lookout for new income streams, not so much from avarice as from necessity. Chestnut Street was the largest real-estate investment that, together or separately, they made in their lives, although Susie's Megowan Street property had certainly been significant. But on at least two occasions, Susie made additional forays into the real-estate market solely for investment purposes. In July 1903, she paid fourteen-hundred dollars for a comparatively large, square lot with a house at 142 Montmullin Street, a recently developed neighborhood on Lexington's south side near the campus of the Kentucky Agricultural & Mechanical College (later the University of Kentucky). There is no reason to believe that the acquisition was anything other than an investment or that she intended to operate the house as one of assignation. As far as is known, the place served strictly as a source of rental income (one-hundred-eighty dollars a month at its peak) and as equity for several mortgages that she and Arthur took out on it before she finally sold it in 1915.[492]

Her other attempt at making money from land had a less satisfactory outcome. In 1912, an entity calling itself the Oklahoma Guaranty Investment Company opened an office in Lexington and took out full-page ads in local papers offering land for sale in "Oklahoma's five growing cities."[493] Distance was not a problem, the company assured potential Kentucky investors: they would provide roundtrip train fare to Oklahoma so that interested parties could inspect the offerings first-hand. Whether or not Susie and Arthur made the trip, she took the bait. In the summer of 1912, she bought one of the company's lots in Poteau, a tiny town in eastern Oklahoma near the Arkansas border, for two-hundred-seventy-five dollars. She soon thought better of it, though, and within a year was running her own ads offering the property for resale for two-hundred-dollars cash.[494] What ultimately happened to the land is not known.

Whatever the financial advisability of these moves, the Jacks' focus, in terms of real estate, was naturally the comparatively large piece of land on which they lived. With Arthur's loss of the Majestic Theater in 1908 and, starting that same year, Susie's involvement in *Weidner vs. Friedman* in Chattanooga, there was a definite need for money. By 1910, they had figured out a way to monetize the Chestnut Street land, not by the usual means of leases and mortgages, but by using it for husbandry. Relying on whatever Arthur had picked up during his time on the north-Georgia farm a decade earlier and whatever experiences Susie might have had during her rural childhood, they decided to raise poultry for pleasure and profit. They made traditional White Plymouth Rock chickens a specialty and consequently called their new business Jack's White Poultry Yards.[495] Within a year, they had built a large coop and stocked it with incubators and other equipment that their flock needed to flourish.[496]

Acting against type, at least from a modern point of view, Susie took an avocational interest in the operation, possibly as much for the managerial and competitive opportunities that it provided as for an affection for chickens. Raising fine and diverse breeds of poultry in order to enter them in local, state, and national contests was all the rage in the early years of the twentieth century, and judging by the number of prizes that Susie won, she was good at it. In August 1910, her White Rocks won first place in all four categories of their class (hen, cock, cockerel, and pullet) at the Bluegrass Fair, Lexington's premier boosterish fête.[497] In January the following year, Mrs. E. S. Jack, as she always registered for these occasions, participated in the State Poultry Show at Lexington's Jackson Hall. It was billed as the largest display of its kind ever seen in the state.[498] And in July, she took first prizes for her White Rocks and her Black Langshan pullets at the Scott County Fair in nearby Georgetown.[499] In 1912, she won multiple cash prizes at both the Bluegrass Fair in Lexington and the Kentucky State Fair in Louisville, where one of her "feathered kings and queens," a cockerel in this case, took home a silver medal for best-in-show.[500] That same summer, her birds went to Paris,

Kentucky, for the Bourbon County Fair, where they were again among the winners of ribbons and cash prizes.[501]

While Mrs. E. S. Jack was achieving temporary renown as a breeder of champion poultry on her days off from being a madam—an interesting image to contemplate—Mr. Arthur Jack, retired theater impresario, maintained his visibility by participating in a local popularity contest being sponsored by the Ada Meade Theater, a major vaudeville house on Main Street. The terms of the contest permitted one vote per paid admission to the theater, with the latest election tally projected on the stage curtain each day until the contest ended. The prizes on offer were hardly frivolous. Second and third prizes were diamond rings, valued at $75 and $50 respectively; first prize was a new Ford Model T touring car "equipped with electric starter and lights." An avid press announced the results of each day's voting, which continued through the month. On April 10 the winners were announced: in first place with 78,455 votes, Arthur Jack ("who manages a poultry farm") won the automobile. Alza Stratton, an infant whose cuteness had been touted by her prize-seeking parents, came in second with 70,344 votes. Eulalia Tincher, the pretty sixteen-year-old daughter of a local policeman, ran a distant third with 23,600 votes.[502] (This at a time when the population of Lexington was only about 50,000 people).

As with so many things in Arthur Jack's singular life, this was not the end of the story. Apparently unable to believe that charisma could trump cuteness, Baby Alza's parents accused the contest's organizers of cheating. The affair wound up in court (*Alza Stratton vs. the Lexington Theatres Company and the Hippodrome Company*), and while Arthur Jack was not personally accused of malfeasance, the suit cast an after-the-fact pall over the proceedings.[503] Undaunted, Arthur and four friends piled into "Mr. Jack's new car" and took off for a few days' fishing on the Kentucky River, an event that the local papers duly reported.[504]

In 1915, as Susie was weathering serious threats to her business in Chattanooga, Arthur made another foray into the world of entertainment in Lexington. With Susie in her usual role of financial backer and co-signer

on accounts, Arthur leased the first floor of the Maguire Building, a late-Victorian structure that still stands at the northwest corner of Broadway and Main. The space had most recently been occupied by the Stag Café, but Arthur proposed to refit it as a first-class restaurant, suitable for ladies and gentlemen, under the more sophisticated name of the La Fayette Café.[505]

The La Fayette opened with fanfare and press-provided puffery on the evening of April 20, 1915. Not only was it "attractively decorated with flowers" but, as each guest entered the restaurant that first evening, they were given a souvenir bouquet of pink and white carnations.[506] With a staff of eighteen, the place could accommodate fifty diners at a time. "Mr. Jack says he intends to make it one of the best and cleanest eating houses in the city," the *Lexington Herald* noted, and "is putting on special Sunday night dinners at a popular price."[507]

Unfortunately, the La Fayette did not last long. Five months after it opened, Dr. John Maguire, who had inherited the eponymous building from his father, put it on the market.[508] Ernest March, a Lexington furniture dealer, bought it with the intention of using part of it for inventory storage. He raised the rent on the space that the restaurant occupied to a level that was unsustainable, and on October 21, the La Fayette closed. The Jacks offered to lease the restaurant's fixtures (tables, chairs, counters, kitchen equipment, etc.) to the next tenant, which turned out to be the Busy Bee Restaurant. When the Bee demurred, the Jacks worked out a deal whereby March would store the fixtures for a reasonable fee until they could dispose of them, a situation that again landed the Jacks in court. Five months into the arrangement, with the fixtures still in storage and no rent payments forthcoming, March sold the lot. In February 1917, the Jacks brought separate suits against him, seeking the value of the lost property.[509] March countered that, not only had the Jacks failed to pay the storage fees, but they owed him nearly one-thousand dollars for furnishings that he had sold to them on credit. When the case finally came to trial in early December, the jury determined that March had improperly sold the fixtures and ruled in favor of the plaintiffs, at least on that point.[510] Unfortunately, it was also determined that the Jacks owed March for the furniture. After the books were balanced, the court awarded Susie two-hundred-twenty dollars. Arthur got twenty cents.[511]

After the La Fayette closed, Arthur came up with one more money-making scheme for the Chestnut Street property, one that circled back to his Atlanta roots. He hired a young carpenter named Taylor "Nick" Nickoson, who lived in the neighborhood, to build a one-story, wood-frame structure on the northeast corner of the property; it would have the address of 651 Chestnut Street.[512] Completed by the winter of 1915–16, it was a long, narrow structure with a false front typical of small commercial buildings, a country store in the city. Under the name Jack's Staple & Fancy Grocery, it was a family affair, with Arthur and sometimes a teenaged Gracie and even Susie, when she was in town, tending the counter.[513] Offering not only groceries but also ice-cream, candies, and sodas, it was soon said to be "a thriving and paying business" and, with its certifiably popular owner in attendance, became a beloved feature of the neighborhood.[514]

The grocery undoubtedly helped with domestic finances, but the collapse of Susie's business in Chattanooga in 1917–18 meant troubles more serious and of greater longevity than the Jacks had yet experienced. Things got so bad, in fact, that in August 1919, they began running advertising for the sale of their home, apparently with the plan of packing up and returning to Chattanooga.[515] Either there were no takers or they weathered whatever crisis was at hand and withdrew the property from the market, if only temporarily. In December, the city included 647 Chestnut on a long list of properties that were about to be sold at public auction for non-payment of taxes. The Jacks owed the city one-hundred-eighty-seven dollars and fifty-three cents, but they settled that debt, and the sale was cancelled. The following April, though, they hired a local auctioneer to market and sell what they advertised as their "beautiful residence, store room and four building lots," including a "frame grocery building."[516] Again, disaster was averted and the auction cancelled, only to have the process repeat itself. In June 1921, the property appeared as lot number ten in another local auction house's "combination sale," but again, it was withdrawn at the last minute.[517] One can only imagine the pressure that this ongoing threat of being uprooted had

on the Jacks, especially on Gracie who had known nothing but security. This is not to say she was coddled: she was doing what she could to contribute to the family's finances by working as needed at the grocery and, following her graduation from high school, as a clerk at S. Bassett's & Sons, purveyors of fine shoes and boots on Main Street. Career-wise, she planned to attend business school—Lexington had an advanced and highly respected one. But fate had other plans.

In 1918, Gracie met June Dearinger, a young man whose family lived in the neighborhood. In fact, his parents, with five of their six children, had only recently returned to their native Kentucky after nearly two-decades of homesteading, first in northeastern Washington state and then on the southern plains of Alberta, Canada. They bought a house on Lexington's Breckinridge Street, just around the corner from the Jacks' house on Chestnut, and in the summer of 1917, the Dearingers moved in. The prairie sun had darkened the Dearinger children's complexions, and the younger ones spoke with a flat Canadian inflection. Gracie, who was intrigued by this exotic-looking family, met June's younger sister Rosalie at Morton High School, where they were both students, and the girls became great (and as it turned out, lifelong) friends. Rosalie soon introduced Gracie to her brother June and, as they would later insist, it was love at first sight.

In September 1918, the young couple began dating, which meant going to friends' parties and dances, attending concerts in nearby Duncan Park, going to the "picture shows" downtown, organizing picnics to scenic High Bridge in nearby Jessamine County, or taking the interurban cars out to Blue Grass Park, a pastoral amusement venue in rural Fayette County.[518] In an attempt to keep the nascent romance secret, at least at first, they began a frequent and sometimes steamy exchange of letters, which were hand-delivered by one or another of their friends. These letters paint an epistolary portrait of young romance, mostly innocent but highly charged. So charged, in fact, that it could not be kept quiet for long. Shortly before Christmas, June wrote Gracie, "My folks know that I love you and I believe they are glad that it [is] you that I love, for all of them believe that there was never such a

girl before as you." He continued, "One night, mother said real sudden like, 'June bug, you love that girl.' I said 'which girl' and you know which girl it was. I told her that I surely did, and she said that she was very glad that I did love a girl like you."[519]

The situation with Gracie's parents was more complicated. Despite, and probably because, of their comparative worldliness, Susie and Arthur were more protective of their daughter than June's were of him. (Homesteading evidently did not lend itself to overly cautious parenting.) Although they did not fully understand why this should be the case, June and Gracie were sensitive to it. "So your mother says that if she lives she'll see that you don't marry till you're thirty," June wrote in November 1918. "[She] says she's glad she has no boys and that she has tried to get girls (I don't know who she means) to leave boys alone, that she has had some experience with them and she would try to save some girls that shame. I'm heartily sorry, maybe she has been fooled once by someone and lost faith in men."[520]

None of this diminished the young couple's mutual attraction, which was intense—and physical. "Did it make you unhappy or angry for me to put my hand where I did last night and do the way I did?" June asked Gracie in early January. "That sure was my first time to ever touch a girl like I did you …. We just must not go much farther than we have." Their naïveté was palpable and, in light of Gracie's parents' experiences, poignant. "You are the only girl or woman I would want to (I don't know what to call it)," he continued, "but dear I believe it is the great love I have for you that makes me feel that way about it towards you."[521] But that very night, they went further. "Last night, dear, I was wild," he wrote her the next day. "My very soul seems to be on fire. I was wildly happy and miserable. If it makes you unhappy and afraid I won't ever do it again, but dear I find it harder and harder to keep from giving away altogether all the time."[522]

These physical experimentations continued, belying presumptions we might have about our ancestors' sexual timidity. But naturally there were other issues to be discussed, and as their intimacy grew, June became curious about Gracie's family. This intensified after he began hearing rumors about Arthur's and Susie's lives in Chattanooga and about the uncertain social status of some of their current friends. "Sweetheart, would you get angry at your Boy if I was to repeat some gossip that I've heard about you and your

folks?" he asked her in early 1919.

> Of course I don't believe a word of it, if I had or did, I would surely
> find out. I've heard it repeated, by the Glynn Stuarts [presumably
> neighbors] and those people that live just across the street from us.
> Nothing harmful about you. But touching hard on the character of
> some of the people you have had in your home. Forgive me, dearest.
> You know that if it had been about you, something would have
> happened. I'm just a bit curious you know and if you won't get angry,
> I'll tell you all about it when I feel like it.[523]

Whether he ever felt like it or not, a year later, he was still "hearing
things" and expressed some confusion about the Jacks' history. "I won't say
that I was surprised when you told me you were born in Ten[nessee]," he
wrote Gracie in March 1920,

> because I thought so and I've been wondering why your mother told
> me that you were born here in Lex[ington] on East Main. Can you
> explain? And dearest there are some other things that I want you to
> tell me some time about yourself and your folks. You see I have an
> old friend, he is also a distant relative, that has lived in Chattanooga
> and he says he knew of your folks there. I really don't want to make
> you curious dear and I can't tell you more what he has told me but I
> will one of these days.[524]

We do not know what June had heard or if he ever told Gracie more
about it, but whatever it was, it did not affect his feelings for her or, it seems,
lessen his desire for her parents' approbation. "I do believe your mother
stays up Sundays to watch us," he wrote at one point. "Your father gives me
quite a bit of encouragement [but] in my opinion it will be your mother that
we will have to deal with."[525] Forging ahead, on March 31, 1919, Gracie's
nineteenth birthday, he proposed to her. She accepted, but they hesitated
about approaching her parents.[526] "Gee, when I think of asking Papa Jack
for the only girl he has," June wrote in July, "it seems to me as if it were the
hardest job I have before me. Do you think he would throw things, dear, or
kick me out? I'm scared to death when I think of it."[527]

In fact, it wasn't until April 1921, that Arthur and Susie, who by then
could hardly have been ignorant of the situation, were asked for their
blessing, which they gave. The engagement was finally announced, and on
June 21 that year, in the front parlor of 647 Chestnut Street, June and Gracie

were married.[528] Almost exactly nine months to the day later, on March 15, 1922, in the main bedroom of the house, their first child was born. To honor his grandfathers, the boy was named John Arthur Dearinger. But Susie was not there to see it. Six days before the child's birth, in that same room, Mrs. Emma S. Jack, alias Madam Susie Tillett, age sixty-three, had died of a massive stroke.[529]

EPILOGUE

As devastating as Susie Jack's death must have been for her family, it could hardly have been a total surprise. Her health problems, which started as early as the mid-1890s, were serious enough that, as we have seen, she consulted doctors in Chattanooga, Lexington, and even Atlanta, and made at least one extended trip to Hot Springs in search of a cure. Her issues were probably multiple— "female trouble," as her daughter would later remember, for one—but it seems likely that there were other equally serious and ultimately incurable ones. We cannot rule out the possibility that at least some of her problems were related to her profession, a line of work rife with the horrors of venereal disease, chronic depression, and drug addiction. As anyone who has read nineteenth-century novels knows, a major culprit in the last category was laudanum. Prescriptions for this powerful opiate were freely given by doctors as a misguided treatment for just about anything that ailed their patients, especially the female ones. As a form of morphine, its use often led to an addiction that required increasingly stronger and more frequent doses. Its abuse was a common scourge among prostitutes and a known problem for some of those who worked for Susie, several of whom died of drug overdoses in her house, as they did in many brothels. Lexington's most famous madam, Belle Brezing, was an acknowledged morphine addict for her entire adult life and, as uncomfortable as it is to contemplate, the drug may have been a problem for Susie Tillett as well.[530]

But whatever the cause of her physical deterioration, it had started by the time she was fifty, as contemporary photographs clearly show. Somehow, through it all, she admirably took on motherhood at the late age of forty-one and, having done so, established and maintained a home that her daughter remembered as comfortable, happy, and loving. Gracie could easily have been a spoiled child and become a selfish adult, but she did not. As she later proved on many occasions—her mother's death, the Great Depression, World War II, her father's death in 1944, and that of her husband in 1955, to name the most challenging—she remained resolute, selfless, and caring throughout her long life. It is not unreasonable to

assume that she acquired many of these qualities from her mother.

Expected or not, Susie's death in 1922 had an immediate economic as well as emotional impact on the lives of her husband and daughter. We can only guess at the emotional side, but the economic one is documented and definable. The long-threatened forced sale of the Chestnut Street property was now put in motion and was completed by the end of that year, 1922. The process started within weeks of Susie's death with the sale of the grocery, which Arthur was unwilling to carry on without her. In June, he advertised the sale not only of the land on which the store stood but also its commercial furnishings, an "ice box, meat block, scales, three showcases, oil tank and meat tools."[531] In September, the rest of the Jacks' property was sold, including:

> the two-story frame, slate roof residence...two lots adjoining, one of which contains a frame store room...which has been and always will be a paying proposition ...six building lots on Ohio street...all of the household goods contained in the residence, consisting of a complete set of house furnishings, all of which are extra nice...[and] a lot of groceries and fixtures contained in store room.[532]

Several investors paid a total of just under ten-thousand dollars for it.[533] With part of the proceeds from the sale, Arthur, his daughter, and his son-in-law, bought a lot on Arceme Avenue, which, like Chestnut Street, was on Lexington's north end.[534] There, they built a house large enough for the growing family that June and Gracie planned. Their next two children, Emily Susan and Loralie Frances Dearinger, were born there in 1923 and 1925 respectively.[535]

June Dearinger was now the family's primary wage earner, working as a carpenter and building contractor with skills learned from his father. But Arthur Jack continued to contribute to the family's well-being as best he could. Within months of Susie's death, he was hired, presumably based on his reputation as a saloon and restaurant manager, as head clerk of the Leonard Hotel on West Main Street. The hotel's previous owners had been forced to relinquish management of the place after they were arrested for running a disorderly house.[536] The Leonard's new managers, James and George Collis, who had immigrated to Lexington from their native Greece some fifteen years earlier, now planned to renovate the hotel in both décor

and reputation.[537] With a restaurant on its first floor, the hotel would have been a good fit for Arthur, but his partnership with the Collis brothers did not work out. By the following year he was working as a cashier at Lexington's popular downtown Merchants' Lunch Counter.[538] In 1925, he opened his own business, a small confectionary, in a building (still standing) at the corner of West Second and Jefferson streets where, like his father and uncles, he sold bread, pastries, candy, and ice cream.[539] But again, the investment was short lived, and by the following year the shop had closed.

Luckily, at just this time, Arthur's brother-in-law Frank Brandt, who had married Susie's now-retired sister Nettie in 1907, hired him as desk clerk at the Savoy Hotel, which Brandt managed for a number of years in the late 1920s and early 1930s.[540] Arthur worked there on-and-off over the next decade, sometimes alternating as clerk and night-watchman at the Leland Hotel across the street.[541] He later told his grandson that the clientele at both places included "working girls" who, we might assume, would have been doing business on Megowan Street if that street's historic function had not ended in 1917 during the same progressive purge that killed off Chattanooga's red-light district.[542] Both the Savoy and the Leland were also popular with the racing crowd, enough so that each sponsored its own annual race, "The Savoy Hotel Handicap" and "The Leland Hotel Handicap" respectively, at the Kentucky Association Track.[543] Arthur's connections to these racier sides of Lexington society—in both senses of the word— coupled with his geniality, professional experiences, and ability to maintain good relationships with all manner of people made him a popular employee at the hotels.

By the late 1930s, as both Arthur's eightieth birthday and another world war approached, he finally retired. As he had done since Susie's death, he continued to live with Gracie and June, becoming a revered and, later, fondly remembered grandfather to their five children. It was the final and perhaps only role in the unlikely life of this one-time skating champion, confectioner, saloonist, expert mixologist, restaurant manager, vaudevillian,

poultry farmer, grocer—and pistol-packing Don Juan—that might have been predictable. But Susie, who had supported him, emotionally and otherwise, for so many years, was still much on his mind and in his heart. There is no evidence that he ever fell into self-pity or made his grief burdensome for his family, but in truth Arthur never recovered from her death. "He missed her a lot," his oldest grandson recalled.

> He would sit in front of *his* window—he had one in each of the fifteen-plus houses in which we lived during the Depression—and go through her alligator-skin purse—perfume bottles, a few pieces of jewelry—and talk about his beloved "Mama".... He was such a mild, gentle old guy...and lived a long and interesting life. I have only good memories of him.[544]

William Arthur Jack died at his daughter's home in Lexington on May 30, 1944, age 83. He and Susie are buried in the Lexington Cemetery. Their descendants—Gracie and June's children, grandchildren, great-, and great-great-grandchildren—include three veterans of World War II, a fireman, a police officer, several poets and writers, an artist and architect, a professional dancer, a Broadway actor, three college professors, an art-historian and museum curator, and several high-school teachers. This, it must be acknowledged, would be a respectable list of progeny for anyone. But especially for a Southern madam and her man.

ADDENDUM

As this book was going to press, a heretofore unknown event in Arthur Jack's life, a life already crowded with incident, came to light. Not only is this event interesting on its face, but its discovery partially fills a gap in Jack's chronology, that is, the years between his last appearance in Atlanta records in 1888, and his first in those of Chattanooga, five years later.

As mentioned at the end of Chapter 2, Jack left his hometown of Atlanta for good in or shortly after 1888. Although he may have made some stops along the way, by 1891, as is now known, he was in Birmingham, Alabama. Soon after his arrival there, he met twenty-seven-year-old Julia A. Bishoff. She had been born in Mobile, Alabama, in 1863, a daughter of George Bishoff (sometimes Bishop) and his wife Julia Anna Echmeyer, natives of Darmstadt, Germany, who immigrated to the United States probably just before the Civil War.[545] According to the 1870 U.S. census, George Bishoff worked as a laborer in Mobile, probably at a job or series of jobs that did not produce much income. While still in their teens, Julia and her younger sister Annie (1866–1928) were obliged to work as waitresses in a saloon run by one Silvester Festorazzi.[546] It may have been through Festorazzi that Annie Bishoff met Paul Gilardoni (1852–1905) who had come to the United States from his native Italy in the 1870s.[547] He settled in Mobile and worked there as a candy maker, a cook, and finally as the proprietor of his own saloon. In 1885, he and Annie Bishoff were married and, soon afterwards, moved to Birmingham, taking her sister Julia with them. In Birmingham, Girlandoni opened the first of a series of restaurants, which, over the next decade or so, made him one of that city's most successful and respected restauranteurs and caterers.[548] Julia lived with the Girlandonis and continued to work as a waitress, now for her new brother-in-law.

All of this put Julia Bishoff in a position to meet Arthur Jack, newly arrived in town and already familiar with the restaurant world. By the fall of 1891, they had begun a personal relationship, and on November 26 that year, in the rectory of the Catholic church of St. Mary's in Julia's hometown of Mobile, and with the bride's mother and brother Frank as witnesses, they

married.[549] Proof that this Arthur Jack, the man who married Julia Bishoff in Alabama in 1891, was the same Arthur Jack who had married Belle Harvill in Atlanta a decade earlier and who would soon become an intimate of Susie Tillett in Chattanooga, is found in a comparison of Jack's signature as it appears on his and Bishoff's marriage bond with a later one, known to be by him and in the author's possession.

Two examples of Arthur Jack's signature: above, from his marriage bond to Julia Bishoff (1891), and below, from a bank receipt (1923) in the Jack-Tillett Scrapbook

After the marriage ceremony, Julia and Arthur (or "Archie," as she called him) returned to Birmingham where, presumably, he worked in the restaurant or saloon business while Julia set up house.[550] In keeping with Arthur's history, the marriage was short lived. On April 13, 1892, he went to Memphis, Tennessee, or so he told Julia, to open a business. She never saw him again. By the following year, having despaired of his returning, she moved back to Mobile, where she lived with her mother and worked as a dressmaker. Although she did not hear from Arthur himself during this time, she certainly would have heard *of* him. In 1894, the Alabama papers covered the sordid details of Jack's involvement with Nellie Spencer in Chattanooga with as much interest and detail as did most other Southern papers.[551]

There is no telling what else Julia heard or read about Arthur, but

by 1896, she had decided to take steps finally to end this chapter in her otherwise quiet life. On February 26, in Mobile County Chancery Court, she filed for divorce, seeking to end a marriage that had, evidently unknown to her, been bigamist and illegal from the start.[552] "I gave him no cause whatever to leave me," she told the court. "I was as good as a wife could be." But he had "got to drinking & gambling," "voluntarily abandoned me," and thereafter "never rendered me any assistance." The last time she had heard anything about him, she testified, he was living in Chattanooga.[553] The judge ordered that a weekly notice be placed in the *Mobile Daily-Herald*, announcing proceedings against "Archie W. Jack" and giving him one month to enter a plea in the case. He failed to do so, and the court took that as an admission of guilt.[554] On April 30, 1896, Julia Jack was granted a divorce and proclaimed free to remarry at any time.

And so she did. On December 30, 1897, in Montgomery, she married Joseph Julius Farley, a thirty-three-year-old bartender and grocer.[555] Except for a brief period around 1900, when they were in New Orleans, the Farleys lived in Mobile for the rest of their lives. He died there in 1922, and she in 1939, with burial in the city's Catholic Cemetery. They did not have children.[556]

In the end, the facts of Arthur Jack's ill-fated and apparently soon forgotten Mobile marriage are significant for our story in that they pinpoint the time of Arthur's arrival in Chattanooga to the spring of 1892. And thus began the most active and infamous period of his life.

ABBREVIATIONS USED IN NOTES

AC *Atlanta Constitution*, Atlanta, Georgia.

CDT *Chattanooga Daily Times / Chattanooga Times*,
 Chattanooga, Tennessee.

CN *Chattanooga News*, Chattanooga, Tennessee.

CP *Chattanooga Press*, Chattanooga, Tennessee.

KDLA Kentucky Department of Library and Archives,
 Frankfort, Kentucky.

KL *Kentucky Leader*, Lexington, Kentucky.

LH *Lexington Herald / Lexington Morning Herald*,
 Lexington, Kentucky.

LL *Lexington Daily Leader / Lexington Leader*,
 Lexington, Kentucky.

micro. microfilm

NARA U.S. National Archives and Record
 Administration, Washington, DC.

Weidner vs. Friedman Hamilton County, Tennessee, Chancery
 Court file 11444, M. G. Weidner, et al., vs. Irene Friedman,
 et al., 1908–1912, Tennessee State Library and Archives,
 Nashville, TN, Manuscripts Division, Box 1184.

Unless otherwise noted, the census records cited here are federal
population schedules and were accessed via *Ancestry.com*. The desig-
nation "ED" that is used within these citations abbreviates the census's
accounting term "Enumeration District."

Sanborn Fire Insurance maps were accessed via the Library of Congress
website, *LOC.gov*.

All websites cited here were accessed in 2022 or 2023.

NOTES

Preface

1 My purpose here is not to shame or assign blame. On the contrary, in many ways I admire the two people whose lives this work documents, lives that fascinated me even before I knew any of the truly fascinating details of them. At the same time, I do not seek to glamorize or romanticize prostitution or the red-light districts that sheltered them. As historian Mara Keire has written, while "the tenderloin encouraged cultural creativity—jazz [for example] originated in these disreputable turn-of-the-century venues— . . . it also produced grotesque brutality and unabated ugliness. Drunken bums wallowed in district gutters, pimps beat their prostitutes to death, johns waited in line . . . and angry whites attacked more successful blacks. However brightly the lights shone in Pottersville, even its most avid advocates recognized its ugly side." Mara L. Keire, *For Business & Pleasure: Red-Light Districts and the Regulation of Vice in the United States, 1890–1933* (Baltimore, MD: Johns Hopkins University Press, 2010), 4.

Chapter 1

2 Two histories of Lexington and Fayette County were published in the nineteenth century: George W. Ranck, *History of Lexington, Kentucky: Its Early Annals and Recent Progress* (Cincinnati, OH: Robert Clarke & Co., 1872) and Robert Peter, *History of Fayette County, Kentucky,* William Henry Perrin, ed. (Chicago: O. L. Baskin & Co., 1882). Lewis Collins' *History of Kentucky* (rev. Richard H. Collins; 2 vols.; Covington, KY: Collins & Co., 1874) is also useful.

3 Kentucky Department of Health, death certificate 6046 (1922), Emma S. Jack Bureau of Vital Statistics, Frankfort, certified copy in author's files. America Tillett had some awareness of her ancestry. She named her oldest child, Charles Selby Tillett, after one of her mother's relatives and her daughters Emily Susan and Nettie America Tillett, in part, after herself. In turn, Susie Tillett's name, in part or whole, is reflected in those of her granddaughter Emily Susan Dearinger (1923–2009) and her great-granddaughter Emily Brook Howell (1980–2000).

4 Will of John Tillett, 1810, probated 1812, Bourbon County, Kentucky, Will Book D: 300–302, Kentucky Department of Library and Archives, Frankfort, Kentucky [hereafter KDLA], micro. no. 183133; William Henry Perrin, ed., *History of Bourbon, Scott, and Nicholas Counties, Kentucky* (Chicago: O. L. Baskin, 1882), 87.

5 Tax Assessments, Madison County, Kentucky, 1818, p. 72, KDLA micro. no. 008126, John Tillett; Annie Walker Burns, "Marriages in Madison County, Kentucky, 1788–1851" (typescript, 1932), Kentucky Historical Society, Frankfort, Kentucky; photocopy in author's files. Sophia Bratton was born in Kentucky around 1804; her parents have not been identified. 1850 U.S. census, Madison County, Kentucky,

district 2, p. 282 (stamped), p. 563 (penned), family 521, Sophia Parkes, U.S. National Archives and Records Administration, Washington, DC. [hereafter NARA], micro. publication M432, roll 211.

6 Settlement of the estate of John Tillett, 1841, Madison County, Kentucky, Circuit Court Records, case 17356, KDLA, micro. no. 7036858; Administrator Bond for the estate of John W. Tillett, Aug. 20, 1841, Madison County, Kentucky, Administrator Bond Book (1830–1844), naming William P. Moore as administrator, with Daniel Breck as surety.

7 Settlement of the estate of John Tillett, 1841, Madison County, Kentucky. During the 1830s, John Tillett owned eight acres on Tates Creek in Madison County. Since his estate papers do not mention any real estate, it is assumed that he had sold that land by the time of his death. Tax Assessments, Madison County, Kentucky, 1833, p. 76; 1834, p. 83; 1835, p. 82. KDLA micro. nos. 008126-008129, John Tillett.

8 Deed, Sophia Tillett to Joseph Parke [sic], Oct. 2, 1848, Madison County, Kentucky, Deed Book 4: 175, KDLA; Marriage of Joseph Parks to Sophia Tillett, 1849, Madison County, Kentucky, Marriage Records Book, p. 33, KDLA, micro. 183308.

9 1880 U.S. census, Fayette County, Kentucky, East Hickman precinct, County Poor House, Enumeration District [hereafter ED] 63, p. 5 (penned), p. 219A (stamped), dwelling 22, Joseph and Sophy [sic] Parks, NARA micro. publ. T9, roll 412. Joseph and Sophia are identified in this census as "paupers." Their names do not appear in records after 1880.

10 For the connection between the Lanham and the Selby families of Maryland and Kentucky, see Donna Valley Russell, Selby Families of Colonial America (Middletown, MD: Catoctin Press, 1990), 102.

11 1850 U.S. census, Madison County, Kentucky, district 2, sheet 285 (verso), dwell. 505, family 510, John Lanham; 1880 U.S. census, Madison County, Kentucky, Foxtown precinct, ED 72, p. 32, dwell. 294, fam. 320, John Lanham household, NARA micro. publ. T9, roll 431.

12 1850 U.S. census, Madison County, Kentucky, dist. 2, sheet 285 (verso), dwell. 505, fam. 510, Mary Lanham. No record of John Lanham and Mary Grizard's marriage has been found.

13 Ibid., John Lanham household.

14 Ibid., Mary Lanham. This page of the census is dated September 23, 1850. Presumably, Mary died between that date and 1857 when John Lanham remarried. He may have had a penchant for female members of the Grizard family. See Marriage of John Lanham to Polly Grizard, Nov. 18, 1857 (bond), Madison County, Kentucky, in "Kentucky, County Marriages, 1783–1965," frame 441, Ancestry. com; Marriage of John Lanham to Sarah Grizard, Nov. 20, 1873, Madison County, Kentucky, in "Madison County, Kentucky, Marriage Certificates, 1786–1877," Ancestry.com.

15 Kentucky Department of Health, death certificate 23279 (1940), Charles S. Tillett, Bureau of Vital Statistics, Frankfort, certified copy in author's files.

16 No deeds or other land records involving Samuel or America Tillett have been found.

The 1870 U.S. census (cited below) locates them in the sixth precinct of Fayette County. My conclusion that they lived in or near the village of East Hickman is based on a comparison of the names of their nearest neighbors in the census (e.g., Roland and Moses Young, Ellen and Nathaniel Berry) with the location of those same people as given in D. G. Beers, *Atlas of Bourbon, Clark, Fayette, Jessamine, and Woodford Counties, Kentucky* (1877).

17 For East Hickman, see Peter, *History of Fayette County, Kentucky*, 539–549. The village no longer exists.

18 A quilt, which family tradition says was pieced by America Tillett, survives and is in the author's possession (2023). As would have been the custom, America taught her daughters to sew. Susie Tillett's daughter later stated that Susie made all her own clothes as well as Gracie's. Gracie (Jack) Dearinger, Lexington, Kentucky, in conversations with the author, her grandson, 1970s. Alma O'Day, who had been one of Gracie's fellow students at Miss Williams' School in Lexington in 1906, remembered that Gracie was always the best-dressed student at the school. Alma O'Day, Lexington, as quoted to the author by his mother, Anna (Lane) Dearinger, 1970s.

19 Of the nine children born to Samuel and America Tillett by 1870, two—Mary Belle and Annie— attended school that year. Of the eight children still living at home in 1880, Lillie, Maud, and Nettie attended school that year. 1870 U.S. census, Fayette County, Kentucky, sixth precinct, East Hickman, p. 19 (penned), p. 135 (stamped), dwell. 125, fam. 123, Samuel Tillett household; 1880 U.S. census, Fayette County, Kentucky, ED 63, p. 31, dwell. 223, fam. 232, Samuel Tillett household.

20 The 1940 U.S. census, which was the first to record the level of each citizen's education, states that Charles Tillett, the oldest of the siblings, and Nettie, one of the younger ones, completed the eighth grade; John Samuel, Lillie, and Florence finished the 6th grade; and Waller graduated from high school. 1940 U.S. census, Fayette County, Kentucky, Lexington, ED 34-54, sheet 6A, household 139, Charles S. Tillett, NARA micro. publ. T627, roll 1303; Ibid., ED 34-21, sheet 13b, household 281, Nettie A. Brandt; 1940 U.S. census, Hamilton County, Ohio, Cincinnati, ED 91-438, sheet 5B, household 100, Samuel Tillet [sic], NARA micro. publ. T627, roll 3201; 1940 U.S. census, Bexar County, Texas, San Antonio, ED 20, p. 4A, household 80, Lillie Goggan, NARA micro. publ. T627, roll 4207; 1940 U.S. census., Hamilton County, Ohio, Cincinnati, ED 91-8, household 325, sheet 15A, Florence Stagg, NARA micro. publ. T627, roll 3198; 1940 U.S. census, Woodford County, Kentucky, Versailles, ED 120-4, sheet 13B, household 327, W. B. Tillett, NARA micro. publ. T627, roll 1364.

21 According to her grandson John A. Dearinger, who inherited several of these items, Susie owned an encyclopedia, an atlas, a Doré-illustrated *Divine Comedy*, several volumes of sentimental poetry, the complete works of Dickens, and several Bibles. Music was also an important part of her life. She bought a piano as soon as she could afford one, probably in the mid-1880s, and had a collection of sheet music. Around the turn of the century, she acquired a phonograph and eventually owned a considerable number of 78-rpm recordings. Judging by the few of these that survived into the later twentieth century, she preferred standard classical compositions,

operatic scores, and romantic songs.

22 Collins, *History of Kentucky*, 2: 169–170; *Lexington's City Directory and Gazetteer, 1877–78* (Lexington, KY: R. C. Hellrigle & County, 1877), passim, but especially 118, 127.

23 *Lexington's City Directory and Gazetteer* (1877), 105, Samuel Tillet [*sic*].

24 Marriage, M. V. Thompson and M. B. Tillett, Fayette County, Kentucky, Marriage Bonds (1871–1881): 214, July 19, 1876, County Courthouse, Lexington; *Lexington's City Directory and Gazetteer* (1877), 104, M. V. Thompson; "World War I Draft Registration Cards, 1917-1918," card for Vertner Matlock Thompson, serial number 3398, order number 2340, Sep. 11, 1918, Covington, Kenton County, Kentucky, *Ancestry.com*.

25 Ohio Department of Health, death certificate 70249 (1942) Abner O. Tillett, in "Ohio, U.S., Death Records, 1908–1932, 1938–2018," *Ancestry.com*.

26 *Commonwealth of Kentucky vs. Marshall Tillet* [*sic*], 1880, Fayette County, Kentucky, Circuit Court records (criminal), box 7, drawer 58–60, KDLA (A-48-E-0-E). Foushee & Brothers were "dealers in domestic liquor and jobbers in cigars and tobacco." *Williams' Lexington City Directory, for 1881–82* (Lexington, KY: Williams & County, 1881), 75. Marshall did not long survive his prison term. On March 17, 1882, the *Bourbon News* (Paris, Kentucky), reported that "the body of the man Tillett who was drowned in the Kentucky river near Boonesboro, has been recovered."

27 1880 U.S. census, Fayette County, Kentucky, East Hickman prec., ED 63, p. 31, dwell. 223, fam. 232, Samuel Tillett household.

28 1880 U.S. census, Jessamine County, Kentucky, Keene, ED 110, p. 35 (penned), p. 68C (stamped), dwell./fam. 313, Charley Tillett in household of George Cleveland, NARA micro. publ. T9, roll 425; Ibid., p. 2B (penned), dwell./fam. 15, William Tillett in household of Silas Wiggington. Annie Tillett married David W. Warnock, a Lexington carpenter, in about 1881. I have found no record of the marriage and it may have been of the common-law variety.

29 1880 U.S. census, Fayette County, Kentucky, Lexington, ED 64, p. 43, dwell. 418, fam. 421, E. S. Tillett in household of R. P. Geers. Robert Geers' house was on Spring between High and Maxwell streets. *William's Lexington City Directory for 1881–82* (1881), 78, Robert Geers.

30 1880 U.S. census, Fayette County, Kentucky, Lexington, ED 64, p. 43, dwell. 418, fam. 421, R. and M. E. O'Connor in household of R. P. Geers. This census registered Geers as "R. Geers," but *Williams' Lexington City Directory for 1881–82*, cited above, gives his full name as Robert Geers. While no R. O'Connor appears in that directory, a Mary O'Connor, who was working as a domestic at Dennis Mulligan's grocery and saloon at Vine and Limestone streets, does. The 1880 census gives the O'Connors' birthplace as Kentucky and that of their parents as Maryland. Nothing further is known of them.

31 1880 U.S. census, Fayette County, Kentucky, East Hickman precinct, ED 63, p. 31, dwell. 223, fam. 232, Samuel Tillett household.

32 Ruth Rosen, *The Lost Sisterhood: Prostitution in America, 1900–1918* (Baltimore, MD: Johns Hopkins University Press, 1982), xiv. Rosen posits that, to those who practiced it, "prostitution was neither a symbol of social disorder nor a symbol of female economic and sexual exploitation. Rather, it was simply a form of work: an obvious means of economic survival which occasionally even offered some small degree of upward mobility." She goes on to say that prostitutes did not "generally view themselves as morally 'lost,' as pathological or fallen victims of sinister forces."

33 Susie's daughter, Gracie (Jack) Dearinger, inscribed the back of this photograph, "My mother Susie Tillett at age of 18 years."

34 Johns began working as a clerk for the "artistic photographer" James Mullen in Lexington in 1870. Six years later, he took over the business and began expanding it. His studio was on the second and third floors of 56 East Main Street. *Lexington City Directory* (Lexington, KY: James H. Prather, 1875), 54, 128, 283; *Lexington's City Directory and Gazetteer* (1877), 62; 1880 U.S. census, Fayette County, Kentucky, Lexington, ED 65, dwell. 86, fam. 105, Eugene Johns. Also see "Lexington Photography," in Bettie L. Kerr and John D. Wright, Jr., *Lexington: A Century in Photographs* (Lexington: Lexington-Fayette County Historic Commission, 1984), 1-8.

35 Lexington Cemetery Office (Lexington, Kentucky), Index to Burials (card file), citing Mrs. America Tillett, age 65, section A, lot 48, grave 235N½, interred Jan. 8, 1883.

36 1850, 1860 and 1870 U.S. censuses, Fayette County, Kentucky, passim, searching "prostitute," "ill-fame," and "ill-repute." Of course, these sources and other such tabulations, e.g. city directories, include only those prostitutes who self-identified as such. There were almost certainly many others who did not do so and were working under cover.

37 Suggesting the importance and ubiquity of the phenomenon, synonyms for it were numerous in the late nineteenth and early twentieth centuries and include bordello, bagnio, bawdy house, cathouse, house of assignation, house of ill-fame, house of ill-repute, *maison de joie*, parlor house, resort, and sporting house. On the other hand, the term "whore house" was rarely used during this period.

38 Buddy Thompson, *Madame Belle Brezing* (Lexington, KY: Buggy Whip Press, 1983), 41–43; Maryjean Wall, *Madam Belle: Sex, Money, and Influence in a Southern Brothel* (Lexington: University Press of Kentucky, 2014), 45.

39 *Sanborn Fire Insurance Map for Lexington, Fayette County, Kentucky* (New York: Sanborn Map and Publishing Co., 1886), sheet 10, Library of Congress, Washington, DC, *www.loc.gov*. In 1892, a Lexington newspaper published a brief history of Town Branch that concluded with a statement about its sad deterioration. "Now Town Branch is a small affair," the paper reported, "a portion of the year going almost dry, and hardly sufficient to carry off the sewerage drained into it. This drainage is composed of the foul water of manufactories, the gas works, excreta from water closets, etc. Without a sufficient stream of water in the branch to carry off quickly this drainage, it must lodge and become a death-breeding menace to the public." "Town Branch," *Kentucky Leader* [hereafter *KL*], Lexington, Sep. 13, 1892.

40 1880 US census, Fayette County, Kentucky, Lexington, ED 64, p. 16B, dwellings 154, 155, and 156, households of Bessie Ward, Lizzie Gillum, and M. McCay. Newspaper notices of brothels in Ayres and Branch alleys increased during the late 1880s. See for example "A Cowardly Shooting," *KL*, Aug. 11, 1888, "A Water Street Rumpus," *LL*, Aug. 13, 1888, and "Branch Alley," *KL*, Aug. 14, 1888.

41 "A Good Long List," *KL*, Nov. 9, 1892; "One Hundred and One," *KL*, Nov. 16, 1892.

42 Thompson, *Madame Belle Brezing*, 57–58; "Petition of Citizens," *Lexington Daily Press*, Jan. 13, 1889.

43 Rosen, *The Lost Sisterhood*, 78–81. My use of the term "red-light district" at this point is *avant la lettre*. According to the *Oxford English Dictionary*, it was not coined until the 1890s.

44 Keire, *For Buisness & Pleasure*, 7–8.

45 C. J. Bronston to Gov. Simon B. Buckner, quoted in Thompson, *Madam Belle Brezing*, 60. In the 1870s, the street that would become Megowan was laid out as Grant Street. It was the de facto boundary between two African American neighborhoods, Gunntown and Goodloetown. There were few houses on it until about 1883 when it was renamed Megowan Street and, despite remaining unpaved, began to thrive. Ranck, *History of Lexington*, 47; "History Shines In and Around Lexington," *Lexington Leader* [hereafter *LL*], Dec 12, 1915; John Kellogg, "The Formation of Black Residential Areas, in Lexington, Kentucky, 1865–1887," *Journal of Southern History* 48 (Feb. 1982): 21–52.

46 Megowan Street originally extended to that part of Third Street that is now called Winchester Pike, but in the second half of the 1880s its northern-most section, between Constitution and Third streets, was renamed Vertner Avenue. Wilson Street, an extension of Short Street, was cut through to intersect with Megowan in 1890. "Working on Wilson Street," *KL*, Dec. 11, 1890. Because Megowan Street ran at an incline, the customers who frequented it for prurient purposes came to refer to it as "the Hill." Wall, *Madam Belle*, 85. Kentucky historian William H. Townsend (1890–1964) stated that college students of his generation (i.e., during the early twentieth century) favored that term. Townsend, *The Most Orderly of Disorderly Houses* (Lexington, KY: privately printed, 1966), 2. On the other hand, I have found no examples of its use during the nineteenth century.

47 *Sanborn Fire Insurance Map for Lexington, Fayette County, Kentucky* (1886), sheet 15. Contemporary deeds indicate that the lots on Megowan Street were typically about 30 feet wide and 125 feet deep.

48 *Shole's Directory of the City of Lexington* (Lexington: Sholes & County, 1885), passim.

49 "Column of Kicks," *LL*, Sep. 21, 1892. In 1915, the Lexington Vice Commission reported that the city's vice district "is generally understood to include Megowan Street and part of Wilson Street, or from 34 Wilson Street to E. Short Street Extended." *Report of the Vice Commission of Lexington, Kentucky* (2nd ed.; Lexington: J. L. Richardson & Co., 1915), 13. As Mara Keire has written, such "artificially sharp boundaries looked impressive on a map, but disreputable leisure did not abide by the limits set." Keire, *For Business & Pleasure*, 25.

50 Ranck, *History of Lexington, Kentucky*, 130–131, 134. Also see Gary A. O'Dell, "At the Starting Post: Racing Venues and the Origins of Thoroughbred Racing in Kentucky, 1783–1865," *Register of the Kentucky Historical Society* 116 (Winter 2018): 29–78.

51 For a discussion of the connections between the Association Track and Lexington's hotels, saloons, and brothels, see Wall, *Madam Belle*, passim, but especially chapter 5. For a contemporary take on the subject, see "Rev. J. W. McGarvey's Sermon on 'Horse-racing, the Liquor Traffic, Whoredom and Corruption,'" *Blue-Grass Blade*, Lexington, Dec. 19, 1891. McGarvey implied that traffic on Megowan Street had been so heavy during the recent racing season that its madams had to call for backup, creating "a very large influx of strumpets from Louisville and Cincinnati to accommodate our distinguished visitors."

52 Clay Lancaster, *Vestiges of the Venerable City: A Chronicle of Lexington, Kentucky* (Lexington, KY: Lexington-Fayette County Historic Commission, 1978), 124–126, 214.

53 Writing in 1891, Charles Chilton Moore (1837–1906), editor of Lexington's *Blue-Grass Blade*, gave hope to the fallen women of Lexington by noting that Mary Magdalene had been a prostitute. "Lexington Councilmen Indicted for Selling Whisky on Sunday," *Blue-Grass Blade*, Feb. 7, 1891. Moore is a fascinating character who deserves further study. See *The Kentucky Encyclopedia* (Lexington, KY: University Press of Kentucky, 1992), 647.

54 *Lexington's City Directory and Gazetteer, Cincinnati Southern Railway, 1877-78* (1877), 46, Michael Foley; 1900 U.S. census, Fayette County, Kentucky, Lexington, ED 18, sheet 12, dwell. 256, fam. 287, Michael Foley, NARA micro. publ. T623. According to Maryjean Wall, Mike Foley owned six properties on Megowan Street, ten on Dewees Street (which in the next century got a slight, cosmopolitan upgrade to "Deweese" Street), and two on Race Street. Wall, *Madame Belle*, 3. In 1913, Foley was renting at least four properties to madams: 161 Megowan to Margaret Hughes, 133 Megowan to Lillian Bowers, 167 Megowan to Lillian Vogt, and 165 Megowan to Sue Stern. The era's other most active Megowan Street landlord was the brewer Gustave Luigart, who in 1913, was renting at least ten properties to madams. "Grand Jury Advised Obliteration of Red-Light District," *LL*, Nov. 8, 1913.

55 *Shole's Directory of the City of Lexington* (1885), 265, Miss Susie Tillett. This was the first time Susie's name appeared in a city directory. She had at least one boarder that year, Lucy E. Cronin, widow of John Cronin. By 1890, Lucy was working for Susie's colleague Madam Sue Green at 35 Megowan. *City Directory of Lexington, Kentucky 1890* (Lexington: J. Prather, 1890), 93, Lucy E. Cronin.

56 *Sanborn Fire Insurance Map for Lexington, Fayette County, Kentucky* (New York: Sanborn Map Company, 1896), sheet 13, Library of Congress, Washington, DC. Insurance maps of this period, including this one, identified houses of prostitution as "female boarding houses" (or "f. b."). This map labels thirteen houses on or near Megowan Street as such. By 1901, that number had risen to about twenty. *Sanborn Fire Insurance Map for Lexington, Fayette County, Kentucky* (New York: Sanborn Map Company, 1901), sheet 9, Library of Congress. On the 1896 map, Megowan Street is given the additional name of "Trilby Avenue." This is the only instance that I have

found of its being called by that name. It may be a reference to the British writer George Du Maurier's popular novel *Trilby* (1895), which introduced the characters of Svengali and the eponymous Trilby who Svengali terrorized.

57 "For Sale Elegant Residence," *KL*, Lexington, Mar. 11, 1889.

58 See, for example, "Delinquent Tax Notice," *LH*, Sep. 22, 1905.

59 Quoted in Wall, *Madam Belle*, 65, citing *Commonwealth of Kentucky vs. Mike Foley*, Nov. 26, 1886. Wall misidentifies Susie Tillett, Foley's lessee, as "Susie Lillie." The documents for this case are listed in the KDLA's type-written inventory of Fayette County circuit court records that was made in 1972 when they were transferred to Frankfort, but as of 2022, they have not been located.

60 City of Lexington, Kentucky, death certificate 7774 (1904), Fannie Arnold, in "Kentucky Death Records, 1852–1965," *Ancestry.com*, citing KDLA, micro. 7011806. This may be the same Fanny Arnold who was born in Woodford County, Kentucky, June 10, 1852, as a slave of Wyatt Arnold. Woodford County, Kentucky, birth records (1852), Fanny Arnold, in "Kentucky Birth, Marriage, and Death Records (1852–1910)," *Ancestry.com*.

61 See Deed, Fannie Arnold to Robert Arnold, Jan. 23, 1889, Fayette County, Kentucky, Deed Book 82: 283–284.

62 *Sanborn Fire Insurance Map for Lexington, Fayette County, Kentucky* (1901), sheet 10. Although city directories of the 1880s and 1890s did not hesitate to list white madams as such, they generally declined to do so for African American madams, although there are exceptions. This makes it difficult to identify Black madams. It does not help the historian that the existence of Chicago Bottoms as a distinct neighborhood of Lexington seems to have been forgotten and plays little or no role in published histories of the city. Interestingly though, the popular author and newspaper man A. B. Guthrie did mention it in his memoir, *The Red Hen's Chick: A Life in Context* (New York: McGraw-Hill, 1965), 80. I am grateful to Mike Courtney of Black Swan Books, Lexington, for calling this reference to my attention. For contemporary mentions of the area see, for example, "Judge Jewell is Hot," *KL*, Aug. 7, 1894; "'Chicago Bottoms,'" *LH*, Apr. 15, 1899.

63 See for example "Another Megowan Muddle," *KL*, June 20, 1888; "Sunday Fight," *KL*, July 9, 1888; "Serious Charges," *LH*, Jan. 12, 1896; "Police Court," *LH*, Aug. 3, 1897; "Bud Horn," *LH*, June 24, 1899.

64 "Fannie Arnold Dies Suddenly," *LL*, June 22, 1904; "Dead on Knees," *LH*, June 22, 1904; City of Lexington, Kentucky, death certificate 7774 (1904), Fannie Arnold. According to her obituary, Fannie was survived by her son, Bob Arnold, who had been a jockey for the Fleetwood Stables.

65 1900 U.S. census, Hamilton County, Tennessee, Chattanooga, Ward 3, Helen Street, ED 59A, p. 47A, dwell./fam. 1, Sue Green, NARA micro. publ. T623; 1880 U.S. census, Fayette County, Kentucky, Lexington, Ward 1, Water Street, ED 64, p. 16, dwell. 154, fam. 157, Sue Green.

66 Letter, C. J. Bronston to Gov. Simon B. Buckner, 1888, quoted in Thompson, *Madam Belle Brezing*, 60; *City Directory of Lexington Kentucky 1887* (Chattanooga:

Norwood, Connelly & County, 1887), 131, 301, Mad. Susie Green.

67 "At Auction," *LH*, July 15, 1899. In 1885, Sue Green employed at least six women: Lillie Belmont, Belle Braxton, Alice Clark, Maud Durand, Belle Elvington, and Mamie Webber. *Shole's Directory of the City of Lexington* (1885), 89, 90, 105, 124, 126, and 275. Given the trajectories of their careers, which, as we will see, followed parallel tracks, there is a good chance that Sue Green and Susie Tillett were colleagues in their early days as prostitutes-in-training, perhaps even working in the same houses on Water and North Upper Streets during the first half of the 1880s.

68 Letter, Mat Walton to Gov. Simon B. Buckner, 1888, Simon B. Buckner Papers, Governors' Papers, Kentucky Historical Society, on deposit at KDLA, quoted in Thompson, *Madam Belle Brezing*, 60. Thompson cites several other letters written in support of Sue Green, some of which took a racist turn by implying that the sole reason for Green's indictment was that "certain Negroes" who lived in the neighborhood had complained about her.

69 Thompson, *Madam Belle Brezing*, 59–61.

70 "She Took Morphine," *KL*, Feb. 3, 1895.

71 "In the Courts," *LH*, Feb. 28, 1896; "Trial Docket," *LH*, May 3, 1896.

72 "At Auction," *LH*, July 15, 1899.

73 *City Directory of Chattanooga Tennessee 1898* (Chattanooga: G. M. Connelly & County, 1898), 308, Mad Susie Green; *City Directory of Chattanooga, Tennessee, and Suburbs 1899* (Chattanooga: G. M. Connelly & County, 1899), 296, Mad Susie Green; 1900 U.S. census, Hamilton County, Tennessee, Chattanooga, Ward 3, Helen Street, ED 59A, p. 47A, dwell./fam. 1, Sue Green. Green's Chattanooga business appears to have been successful: by 1900, she had as many as nine women living with and working for her.

74 *Report of the Vice Commission of Lexington, Kentucky*, 13.

75 Madams could buy a pint of beer for as little as five cents, for example, and then sell it to customers for one dollar or more. Keire, *For Business & Pleasure*, 156, n30.

76 Keire, 31. At the other end of the spectrum were "cribs," small houses with small rooms that opened directly on to the street and where clients paid as little as ten cents. Keire, *For Business & Pleasure*, 33.

77 Personalty Mortgage, Susie Tillett from Smith & Nixon, Aug. 30, 1887, Fayette County, Kentucky, Mortgage Book 16: 153. Smith & Nixon was founded in 1843, specialized in pianos, "with the famous Chickering as their leader," and had branches in Louisville and Cincinnati. "A Card of Thanks," *KL*, Sep. 26, 1889. A Chickering piano, once owned by Susie Tillett, descended in the family and survived well into the twentieth century.

78 Personalty Mortgage, Susie Tillett from C. F. Bower and Co., Jan. 25, 1888, Fayette County, Kentucky, Mortgage Book 17: 464. Brower and Co. occupied a large building at the southeast corner of Main and Broadway, which, as of 1923, became the site of Purcell's, Lexington's premier twentieth-century department store.

79 Her name made its first appearance in Lexington's city directories in 1885, when

she was listed as "Miss Susie Tillett," residing at 41 Megowan Street. In the town's subsequent nineteenth-century directories—those of 1887, 1888, and 1890— she was afforded the title "Mad" (Madam). *Shole's Directory of the City of Lexington,* (1885), 265; *City Directory of Lexington Kentucky 1887* (1887), 246; *City Directory of Lexington, Kentucky, Illustrated 1888* (Lexington: Prather & Snyder, 1888), 425; *City Directory of Lexington, Kentucky 1890* (1890), 372.

80 *Shole's Directory of the City of Lexington* (1885), 89, Belle Braxton.

81 "Poisoned," *Richmond Climax,* June 22, 1887. Voodoo was a popular subject in Kentucky newspapers during the 1880s and 1890s. The *Climax* alone published at least half a dozen articles on the subject during this period including "Charms and Philters," Aug. 21, 1889, and "Voodoo Worshipers," Apr. 30, 1890. These stereotypically identified voodoo artists as "superstitious negroes" said to be adept at concocting love charms and potions that led young women to commit illicit sexual acts.

82 Gus and Louis Straus advertised as Lexington's "leading clothiers and gents' furnishings." Their store was at 73–75 Main Street. *Williams' Lexington City Directory* (1881), 180.

83 "Chief Lusby's Haul," *LL,* July 19, 1888.

84 "Twelfth Census of the United States," *Census Bulletin,* no. 25 (Washington, DC: Dec. 29, 1900), 16, table 6.

85 According to historian Ruth Rosen, choosing a new name was part of the ritual of becoming a professional prostitute during the late nineteenth and early twentieth centuries. Using one's own name while doing business was considered bad luck. Apparently, Susie Tillett was unaffected by such traditions or superstitions. Rosen, *The Lost Sisterhood,* 102, 105.

86 *City Directory of Lexington, Kentucky* (1890), 372.

87 *City Directory of Lexington, Kentucky* (1888), 224 and 234.

88 Texas Department of Health, death certificate 528 (1943), Lillie Goggan, in "Texas, U.S., Death Certificates, 1903–1982," *Ancestry.com*; 1880 U.S. census, Fayette County, Kentucky, ED 63, p. 31, dwell. 223, fam. 232, Lillie Tillett.

89 Lillian (Goggan) Keller, "Autobiography of Lillian Olive Goggan Keller," ms, courtesy of Kenneth Andrew Keller, San Antonio, Texas.

90 Marriage, Claudius Carr and Laura B. Morgan, July 26, 1876 (certificate) Harrison County, Kentucky, Marriage Book: 324, in "Kentucky, County Marriage Records, 1783–1965," *Ancestry.com*; 1880 U.S. census, Fayette County, Kentucky, Lexington, ED 66, page 12, dwell. 429, fam. 556, Claude and Laura Carr.

91 "Lexington. Claude Carr Locks Himself in His Room," *Louisville Courier-Journal,* Aug. 2, 1886.

92 My account of the Fuget affair is taken from "Fuget Found Guilty," *Louisville Courier-Journal,* Oct. 22, 1885, and a juicy but unverifiable history of Fuget's family, "Criminal Romance. The Blue Brick House with Trap Door, Hidden Springs and Secret Apartments. Home of the Notorious Fuget Family," *Louisville Courier-Journal,*

Oct. 25, 1885.

93 "State News," *Herald*, Hazel Green, Kentucky, June 24, 1885. Fugate was sentenced in Federal Court, Louisville, to five years imprisonment. *Hartford Herald*, Hartford, Kentucky, Nov. 25, 1885.

94 *Louisville Courier-Journal*, July 17, 1885.

95 *Interior Standard*, Stanford, Kentucky, Aug. 24, 1886.

96 "Lexington. Claude Carr Locks Himself in His Room," *Louisville Courier-Journal*, Aug. 2, 1886.

97 Fayette County, Kentucky, Order Book 24: 545, Feb. 27, 1888, County Courthouse, Lexington.

98 Marriage, Daniel Reed and Nettie A. Tillett, 1888, Fayette County, Kentucky, Marriage Book 7: 393c. There is a chance that the marriage was prompted by an ill-timed pregnancy, but this is pure conjecture. In the 1910 census, Nettie, who was by then married, stated that she had had no children. 1910 U.S. census, Fayette County, Kentucky, Lexington, ED 23, sheet 1A, dwell./fam. 1, Nettie Brandt, NARA micro. publ. T624.

99 *Nettie A. Reed vs. Daniel Reed*, Fayette County, Kentucky, Circuit Court Cases, Civil, 1892, box 236, drawer 2042-4, KDLA, box A-48-A-2-C, including: "Petition in Equity," Sep. 9, 1892; "Warning Order," Dec. 17, 1892; "Report of Corresponding Attorney," Dec. 17, 1892; "Deposition of D. W. Warnick [sic]," Dec. 17, 1892; "Deposition of Samuel Tillett," Dec. 17, 1892; "Judgment," Dec. 21, 1892.

100 Mike Foley owned 41 Megowan Street until at least 1905. See "Delinquent Taxes," *LH*, Sep. 28, 1905.

101 Deed, Fannie Arnold to Robert Arnold, May 25, 1886, Fayette County, Kentucky, Deed Book 75: 197; Deed, Robert Arnold to J. J. Murray, Sep. 12, 1889, Fayette County, Kentucky, Deed Book 85: 229; Deed, J. J. Murray to Emma S. Tillett, Sep. 13, 1889, Fayette County, Kentucky, Deed Book T-Z: 101. Since Fannie continued to live at 52 Megowan until her death in 1904, she was, for a time, Susie Tillett's immediate neighbor. Fannie's heirs sold 52 Megowan in 1912 to Gus Luigart, one of Lexington's most active red-light landlords. Deed, Fannie Arnold's heirs, by commissioner, to Gus Luigart, Nov. 30, 1912, Fayette County, Kentucky, Deed Book 168: 437.

102 *Sanborn Fire Insurance Map for Lexington, Kentucky* (1896), sheet 13.

103 *City Directory of Lexington Kentucky* (1887), passim; *City Directory of Lexington, Kentucky* (1888), passim; *City Directory of Lexington, Kentucky* (1890), passim; "A Good Long List," *KL*, Lexington, Nov. 9, 1892; "One Hundred and One," *KL*, Nov. 16, 1892. Childers later bought number 33-34 Megowan where she lived and worked until her death in 1906. "Auction!" *LH*, June 23, 1907.

104 Typescript, 8 pages, inscribed in ink at the top of first page, "J. K. [?] T. original." Collection of Mike Courtney, Black Swan Books, Lexington, Kentucky (seen by the author May 3, 2022). I am grateful to Mr. Courtney for sharing this document with me.

105 After apprenticing at Madam Fannie Hill's house on West Main Street, Belle opened
her own place on North Upper Street in about 1881. Two years later, she bought a
two-story, fifteen-room house at 194 North Upper where she lived until the end of
the decade. "For Sale. Elegant Frame Residence," *KL*, Mar. 13, 1889.

106 See Thompson, *Madam Belle Brezing*; Wall, *Madam Belle*; Townsend, *The Most
Orderly of Disorderly Houses*.

107 Wall, *Madam Belle*, 50, 57, 81.

108 In addition to Brezing's two biographies, cited above, see Anne Edwards, *Road to
Tara: The Life of Margaret Mitchell* (Lanham, MD: Taylor Trade Publishing, 1983),
150. Edwards writes that Mitchell had learned about Brezing from her second
husband, John R. Marsh, and his younger sister, Frances, who was also a close
friend of Mitchell's. The Marsh siblings were natives of Maysville, Kentucky, and
had graduated from the University of Kentucky in Lexington, he in 1916 and she
in 1922. John Marsh was on the staff of the university's student newspaper, *The
Kentucky Kernal*, and worked for the *Lexington Leader*, connections that could have
alerted him to Belle Brezing's history. See the university's yearbook, *The Kentuckian*
(Lexington, KY: University of Kentucky, 1916), 249.

109 As mentioned above, city directories and census records rarely identified African
American madams as such, as they did for their white counterparts, making it
difficult to estimate the total number of prostitutes working in Lexington during
the 1880s and 1890s. However, in 1891, J. W. McGarvey, one of the town's popular
Christian preachers, reported that "men who are supposed to know…variously
estimate the number of [Lexington's] public strumpets at from four to six hundred,
besides a large number of private sluts which are kept by individuals." "Rev. J. W.
McGarvey's Sermon," *Blue-Grass Blade*, Dec. 19, 1891.

110 *City Directory of Lexington, Kentucky* (1888), passim.

111 *City Directory of Lexington, Kentucky* (1890), 92, Pearl Crawford; "Considerably
Worsted," *KL*, Sep. 28, 1890; *Lexington Directory* (Lexington: Emerson & Dark,
1898), 108, 403, Miss Pearl Crawford. Crawford's wanderings suggest that she was a
difficult person—or perhaps she incited jealousy among her fellow "doves." In 1891,
she was arrested for sending "through the mail" a threatening letter to Ella Childers,
another Megowan Street prostitute, the contents of which were "said to be of very
vile language." The case was dismissed when it was proved that Pearl could neither
read nor write. "Recorder's Court," *KL*, Mar. 17, 1891.

112 *Prather's Directory of the City of Lexington, Kentucky* (Lexington: J. Prather, 1895),
58, Mad. Pearl Crawford.

113 Mitchell was garrisoned at Camp Hamilton, a Division Camp established by the
US Army in 1898 on the outskirts of Lexington for the temporary housing of troops
being trained to fight in the Spanish-American War. The camp was named for Lt.
Col. John M. Hamilton who had recently fallen at the Battle of San Juan, Cuba.
"Named for a Hero," *LL*, Aug. 26, 1898.

114 Pearl's story is told in "Murder? Death Ends a Woman's Varied Career," *Louisville
Courier-Journal*, Jan. 13, 1902. Also see "Pearl Crawford," *LL*, Jan. 13, 1902; "Woman

Killed Herself," *LH*, Jan. 14, 1902; "Crawford Jewells," *LL*, Jan. 17, 1902; "Estate of Pearl Crawford," *LL*, June 12, 1902; "Thomas Stuart," *LL*, Feb. 12, 1903; "Stuart," *Louisville Courier-Journal*, Feb. 13, 1903. Despite Mitchell's claims and protests, the courts settled whatever was left of Pearl's estate on her Kentucky relatives.

115 The raids were often extensive. In November, 1888, for example, over seventy people were arrested and ordered to appear before the Grand Jury. Belle Brezing, Sue Green, and Susie Tillett were on the list, as were a number of Lexington's other prostitutes and madams (see Appendix A). Each was charged with creating a nuisance, running a tippling house, or both. "Did Any One Get Away? Grand Jury Indicts Nearly Everybody in Town," *KL*, Feb. 18, 1889.

116 *Commonwealth of Kentucky vs. Kitty Ramsey and Broad Keith*, Fayette County, Kentucky, Circuit Court Records (criminal), bundles, 1886, box 11, KDLA.

117 A clipping of an article about Kitty Ramsey that appeared in the *Lexington Leader* on May 28, 1901, is in a scrapbook kept by Susie and Arthur Jack beginning in the 1890s (collection of the author). Beside the clipping, written in ink, is the word "Nettie." The article reads: "Kitty Ramsey was arrested by Policeman Conlon and Police Lieutenant Marshall at her home on East Short street on charges of being drunk and abusive and insulting language. When the officers called at her home, she declined to join them, and excusing herself for a moment disrobed herself causing Donlon to blush. Maud Graves, who lives in Morton's Alley, alleged that the language used by Miss Ramsey was of such a nature as to shock her modesty in repetition, but she reeled off a few lines just to satisfy the court that a crime had been committed. A fine of $1 and costs was assessed for drunkenness and the same dose went for insulting language." Broadwell William Keith (b. 1848), known as Broad, was the son of Dr. Marville L. Keith (1822–1865). *Williams' Lexington City Directory for 1864–5* (Lexington: Williams & Co., 1864), 63, M. L. Keith; *FindAGrave.com*, meml. no. 162237386, Marville Louis Keith.

118 Fayette County, Kentucky, Circuit Court Order Book 67: 244 (Nov. term, Dec. 16, 1887), KDLA. In nineteenth-century legal terms, a tippling house was a place where liquor is sold without a license. See John Bouvier, *A Law Dictionary* (2 vols.; Philadelphia: Childs & Peterson, 1856), 2: 589.

119 Fayette County, Kentucky, Circuit Court Order Book 67: 336 (Jan. term, Feb. 4, 1888): 336, and 608 (May term; June 8, 1888); Fayette County, Kentucky, Circuit Court Order Book 68: 129 (Nov. term, Nov. 19, 1888), KDLA.

120 Fayette County, Kentucky, Circuit Court file 115, indictment of Sue Tillett, 1889, KDLA.

121 Mortgage, E. S. Tillett to Saturday Night Savings & Loan Association, Sep. 17, 1889, Fayette County, Kentucky, Mortgage Book 20: 371, County Clerk's office, Lexington.

122 "Mysterious Affair," *KL*, Feb. 23, 1891. This article makes specific reference to "the house of Sue Tillett, on Megowan street." Subsequent tax and other records continue to identify her as owner of the property until she sold it in 1904. See Fayette County, Kentucky, Tax Assessments,1890, Book 2, p. 87, line 40, Emma S. Tillett, Megow[an], value 2,000, KDLA; Ibid., 1891, Book 3, p. 98, line 19, "Emma

or Susie" Tillett, 54 Megow[an], value 2,000; Ibid., 1892, Book, 3, p. 105, line 24, Susan Tillett, 54 Megowan, value 2,000; "City and Vicinity," *LL*, Sep. 14, 1903; "Delinquent Tax Notice," *LH*, Sep. 28, 1905.

Chapter 2

123 Marc Wortman, *The Bonfire: The Siege and Burning of Atlanta* (New York: PublicAffairs, 2009), 43.

124 Franklin M. Garrett, *Yesterday's Atlanta* (Miami: E. A. Seeman, 1974), 11–13. Also see, by the same author, *Atlanta and Environs: A Chronicle of Its People and Events* (3 vols.; Athens: University of Georgia Press, 1954).

125 Andy Ambrose, "Atlanta," *New Georgia Encyclopedia* (Athens: Georgia Humanities and the University of Georgia Press, 2004–2021), *Georgiaenclylcopedia.com*.

126 The obituary of Malinda Jack's son William F. Jack states that he (and presumably his mother and brothers) moved to Atlanta in 1849 ("Mr. W. F. Jack Dead," *Atlanta Constitution* [hereafter *AC*], Apr. 7, 1885). But the 1850 U.S. census, cited above, has the family in Carroll County, Georgia, in that year. The major history of Atlanta, *Pioneer Citizens' History of Atlanta 1833–1902* (Atlanta: Byrd Printing County, 1902), 33, published a "List of Residents in 1851" which includes the names "F. Marvin [*sic*], G. Wash, and William F. Jack, candy and bakery."

127 William Jack is buried at the Providence Baptist Church Cemetery near Alpharetta, Georgia, *FindAGrave.com*, William Jack, meml. no. 29968350.

128 Marriage, William Jack and Malinda Davis, Fayette County, Georgia, Marriage Records, Book B: 29 (1833), in "Georgia Selected Marriage Records, 1828–1978," *Ancestry.com*. Information on the Jack family will be found in the following sources, none of which are adequately documented and should be used with caution: "The Jack Family," undated typescript, Library of the Genealogical Society of the Church of Jesus Christ of Latter-Day Saints, Salt Lake City, UT; C. L. Hunter, *Sketches of Western North Carolina* (Raleigh, NC, 1877; repr. Baltimore, MD, 1970), 61–84; Alethea Jane Macon, *Gideon Macon of Virginia and Some of His Descendants* (Macon, GA: J. W. Burke, 1956), 181–195. According to these sources, Patrick Jack and his wife Lillis McAdoo were born in Ireland and immigrated to the American colonies, settling first in Pennsylvania and then in Charlotte, Mecklenburg County, North Carolina. Tradition has it that in 1775, Patrick Jack's son James couriered a document that became known as the Mecklenburg Declaration of Independence, North Carolina's version of the more famous Declaration, to the Continental Congress in Philadelphia. Our William Jack's supposed descent from Patrick Jack served as the basis for admission to the Daughters of the American Revolution by several of William's descendants. See National Society of the Daughters of the American Revolution, *Lineage Book* (Washington, DC, 1927), 40: 165. Confirmation of the relationship between William Jack of Georgia and Patrick Jack of North Carolina, assuming there was one, awaits further research.

129 Harry Alexander Davis, *The Davis Family in Wales and America* (Washington, DC, 1927), 199–200. If this undocumented genealogy of the descendants of Morgan

David/Davis of Wales is accurate, Malinda (Davis) Jack was the fifth cousin of Jefferson Davis, president of the Confederacy (96–97).

130 1850 U.S. census, Carroll County, Georgia, 11th division, p. 134 (penned), dwell. 933, Melinda Jack household, NARA micro. publ. M432, roll 63. At the time of this census, Melinda's parents, John T. and Sarah Davis, were living adjacent to her and her sons. Also see 1850 U.S. census, Carroll County, Georgia, eleventh division, agricultural schedule, p. 283 (penned), line 28, Jno. T. Davis, line 29, Melinda Jack, NARA micro. publ. 1137.

131 "Mother," AC, Nov. 10, 1889.

132 Williams' Atlanta Directory (Atlanta, GA: M. Lynch, 1859), 106, Francis M. Jack, and 107, Geo. W. Jack, W. F. Jack.

133 Meanwhile, Malinda Jack took care of her own needs. On March 13, 1860, in Atlanta, she married William Nesbit, a widowed plantation owner from Gwinnett County, Georgia. Two years after his death, on Nov. 23, 1865, she married Mathias Bates, another widowed plantation owner from Cherokee County, Georgia. Marriage, William Nesbit and Malinda Jack, Fulton County, Georgia, Marriage Book A: 273; Marriage, Mathias Bates and Malinda Nesbit, Fulton County, Georgia, Marriage Bk. B: 373. Malinda died on Nov. 5, 1889, and is buried in the Jack family lot in Oakland Cemetery, Atlanta. "Jack," AC, Nov. 7, 1889; FindAGrave.com, meml. no. 69712941, Malinda Davis Bates.

134 Marriage, George W. Jack and Josephine A. Wall, Fulton County, Georgia, Marriage Book A:155, June 20, 1858; 1850 U.S. census, Richmond County, Georgia, division 73, p. 497 (penned), dwell. 895, Josephine A. Wall, NARA micro. publ. M432, roll 81; Marriage, Francis M. Jack and Sophia W. Rucker, July 15, 1858, Fulton County, Georgia, Marriage Book A, p. 157; "Married," Augusta Evening Dispatch, July 26, 1858; 1850 U.S. census 1850, Meriwether County, Georgia, division 59, p. 186 (penned), dwell./fam. 1303, Gideon Rucker household, NARA micro. publ. M432, roll 77.

135 Francis M. and Sophia (Rucker) Jack Family Bible Record, 1858–1944, written in various hands, Harper's Illuminated Bible (New York: Harper and Brothers, 1846). The provenance of this bible is as follows: Francis Marion Jack, Atlanta; [by bequest possibly to one of his daughters]; to his son William Arthur Jack, Atlanta and Lexington, Kentucky; by bequest to his daughter Grace (Jack) Dearinger, Lexington, 1944; by gift to her son, John Arthur Dearinger, Woodford County, Kentucky; by bequest to his widow Anna L. (Lane) Dearinger, 2006; by bequest to her children, 2015; by gift to their cousin Jesse Daniel Howell, great-great-great grandson of Francis Marion and Sophia (Rucker) Jack, Lexington, Kentucky, 2015.

136 Harriet Bey Mesic, Cobb's Legion Cavalry: A History and Roster of the Ninth Georgia Volunteers in the Civil War (Jefferson, NC: McFarland & Company, 2009), 245–46. James, the only Jack brother not to survive the war, was killed at the Battle of Monroe's Crossing, North Carolina, a month before the conflict ended. A fellow soldier who witnessed his death remembered him as "one of Atlanta's truest, best men." Wiley C. Howard, Sketch of Cobb Legion Cavalry and Some Incidents and Scenes Remembered (Atlanta, GA, 1901), 13, quoted in Mesic, 246. Also see "A Random

Talk with a Veteran," *AC,* June 3, 1900, in which an unidentified veteran recalled the battle at Monroe's Crossing. "Cobb's gallant soldiers," he told the reporter, "were driven back, but returned to the charge. In one of their charges Jim Jack, of Atlanta, was killed, and in another Colonel B. F. King of Roswell. All the same, these men made history. They did as much as Tennyson's men at Balaklava."

137 Deposition, Francis M. Jack, Claim of Thomas M. Bryson, Stone Mountain, Georgia, Feb. 12, 1875, in "U. S. Southern Claims Commission, Disallowed and Barred Claims, 1871–1880," National Archives Record Group RG233, M1407, *Ancestry.com.* Jack testified that Bryson was his business partner from 1861 to 1864. Also see Wallace P. Reed, "The Story of the City of the Siege," *AC,* July 20, 1898, in which the author states that "the Jack brothers furnished hardtack in large quanaities [*sic*]" to the Confederacy.

138 "F. M. Jack Died Yesterday," *AC,* Dec. 24, 1901.

139 Georgia, Property Tax Digest, 1864, Fulton County, Atlanta, p. 37, F. M. Jack. His total property, which included fourteen acres of land in Fulton County, was valued at ninety-one-thousand-seven-hundred dollars. Five years later, it was valued at twelve-thousand-sixty-one dollars. Ibid., 1869, Fulton County, Atlanta, n.p., F. M. Jack.

140 Wendy Hamand Venet, *A Changing Wind: Commerce and Conflict in Civil War Atlanta* (Athens, GA: University of Georgia Press, 2014), 87, citing "What James Bell Told Me about the Siege of Atlanta," July 11, 1935, Wilbur Kurtz Papers, MSS OS box 2.17.2, folder 14, "Siege of Atlanta—as told by James Bell to Wilbur G. Kurtz Sr. (exhibition of James Andrews)," 1935, Kenan Research Center, Atlanta History Center. The 1860 census states that the Bell boys' mother, Calender Bell, was a prostitute. 1860 U.S. census, Fulton County, Georgia, Atlanta, ward 5, p. 150, Calender Bell.

141 Francis M. and Sophia (Rucker) Jack Family Bible Record.

142 "Ice-Cream Saloon," *Southern Confederacy,* May 26, 1861.

143 "Annual Income in Atlanta," *AC,* Apr. 16, 1869.

144 "G. W. Jack," *AC,* Sep. 14, 1873.

145 Advertisement for Jack & Davis, *Atlanta Intelligencer,* Dec. 13, 1868; Advertisement for George W. Jack, *Atlanta Intelligencer,* Feb. 22, 1870.

146 See, for example, "Solid Enterprise. Improvements to Jack's Candy and Cracker Manufactory," *Daily Herald,* Atlanta, Sep. 7, 1873.

147 "A Beautiful Sight. The Largest and Most Exquisite Soda Fount Ever Brought to Atlanta," *AC,* May 22, 1882. The fountain was topped by a parian copy of the American sculptor Hiram Powers' *Greek Slave,* the most famous American sculpture of the nineteenth century.

148 Francis Marion and Sophia (Rucker) Jack Family Bible Record.

149 William Arthur Jack in conversation with his grandson John Arthur Dearinger, 1930s, and told by the latter to the author, 1990. The Jacks probably fled Atlanta in or shortly after July 1864, when the bombardment of the city began. For a summary of life in the city during this time, see Franklin M. Garrett, "Civilian Life in Atlanta,"

Civil War Times Illustrated (1964), 30–39.

150 "Obituary," *AC*, Sep. 19, 1873.

151 The Jacks' oldest child, Lula, graduated from John H. Logan's High School in Atlanta in 1876. Will and Lee also graduated high school. "Prof. Logan's School," *AC*, Dec. 24, 1875; 1940 U.S. census, Fayette County, Kentucky, Lexington, 4th Ward, ED 34-21, p. 17B, Will A. Jack; 1940 U.S. census, DeKalb County, Georgia, Atlanta, 6th Ward, ED 160–303, p. 61A, line 5, W. Pauline [*sic*] Weathers. No record of the youngest child, Jim Jack's, education has been found, but it was probably comparable to that of his siblings.

152 "Base Ball," *AC*, June 2, 1878.

153 Teammates included James Allensworth, son of a respected Atlanta surgeon; Morris Conley, whose father was a wealthy retired merchant; Sidney J. Rawson, also the son of an Atlanta merchant; Jeremiah "Jerry" Morton, son of a successful grocer; and Hampton Fitzsimmons, whose father, a federal marshall, had been an officer in the Union Army. "Base Ball," *AC*, June 2, 1878.

154 "The Blue Belts and the Alerts," *AC*, June 12, 1878.

155 "The Base Ball Tragedy," *AC*, July 10, 1878; "Not Guilty!" *AC*, Dec. 19, 1878. Carlton Mitchell (born 1862), known as Carl, was a son of Henry C. Mitchell (1832–1900), a teacher and eventually principal in Atlanta's city schools, and Rowena (Gunby) Mitchell. Carl became a physician and by 1900 was living in New Orleans. 1880 U.S. census, Fulton County, Georgia, Atlanta, ED 100, p. 7 (penned), p. 419 (stamped), dwell. 44, fam. 45, Henry C. Mitchell family, NARL micro. publ. T9, roll 148; U.S. Passport Application of Carleton Mitchell, Talladega, Alabama, appl. no. 2930, Aug. 5, 1895, in "U.S., Passport Applications, 1795–1925," *Ancestry. com*; "Professor Mitchell Dead," *AC*, Jan. 2, 1900.

156 W. A. Bass, "The Mitchell-Lawshe Tragedy," *AC*, July 12, 1878.

157 "Carl Mitchell's Case," *AC*, Dec. 18, 1878; "Not Guilty!" *AC*, Dec. 19, 1878. The proceedings of the Mitchell-Lawshe case are summarized in Robert M. Gorman and David Weeks, *Death at the Ballpark* (2nd ed.; Jefferson, NC: McFarland & Company, 2015), 110.

158 *Shole's Directory of the City of Atlanta for 1880* (Atlanta: Sholes & Co., 1880), 241, William A. Jack. Also see, 1880 U.S. census 1880, Fulton County, Georgia., Atlanta, ED 199, p. 521A, 43 Peachtree St., dwell. 263, fam. 350, Willie Jack.

159 "A New Military Company," *AC*, Jan. 28, 1880; "Smith's Light Infantry," *AC*, Jan. 29, 1880; "Smith's Light Infantry," *AC*, Feb. 13, 1880; "State News," *Athens Weekly Banner*, Athens, Georgia, Feb. 3, 1880. The unit was named for its founder, Joseph Smith, an Atlanta grocer.

160 Roller skating became widely popular with the invention, by the New-York businessman James L. Plimpton, of the "guidable parlor skate" in 1863. It was the first four-wheel skate with a pivoting device that allowed the user to turn by leaning from side to side. Atlanta joined the trend with its own roller-skating rink as early as 1869, but the entertainment does not seem to have become widely popular in the city until the early 1880s when its competitive possibilities were realized. This aspect

of roller-skating probably made it even more attractive to young men like Will Jack and his friends. See "A Skating Rink in Atlanta," *AC*, Dec. 6, 1869.

161 *Shole's Directory of the City of Atlanta, Georgia, for 1881* (Atlanta: H. H. Dickson, 1881), 320, William A. Jack; "The City," *Union and Recorder,* Milledgeville, Georgia., Apr. 5, 1881.

162 *Shole's Directory of the City of Atlanta for 1880,* 265, George Lawshe. Like his brother, George Lawshe died tragically when, in May 1887, he was struck by a train. His obituary said that he was "well-known throughout the country as the champion roller skater of the south." "George Lawshe Killed," *AC,* May 22, 1887.

163 "Council Proceedings," *Union and Recorder,* Milledgeville, Georgia., Apr. 5, 1881.

164 "The City," *Union and Recorder,* Apr. 5, 1881.

165 "Skating Tournament," *Union and Recorder,* Apr. 19, 1881.

166 Ibid.

167 1880 U.S. census Fulton County, Georgia, Atlanta, ED 99, sheet 2B, dwell. 19, fam. 27, William Harvill household. Belle Harvill's father had had at least a passing business relationship with Francis Jack to whom, in 1878, he sold "a fine milch cow, which is warranted to give 10 gallons of milk per day." *AC,* June 19, 1878. Perhaps Jack used the cow's milk to make the fresh ice-cream for which he was famous in Atlanta.

168 Marriage, W. A. Jack and Belle Harville [*sic*], Fulton County, Georgia, Marriage Bk. E (1880–1885): 238; "Hymeneal. Jack-Harville," *AC,* Dec. 26, 1881; " 'The Duval,' Jacksonville, Fla.," *AC,* Jan. 22, 1882; *Atlanta, Ga., City Directory 1883* (Atlanta: Judson, Dunlop, 1883), 335, William A. Jack.

169 1900 U.S. census, Fulton County, Georgia, Atlanta, Ward 2, ED 54, sheet 10B, dwell. 178, fam. 203, Francis M. Harvill, NARA micro. publ. T623, roll 1240198; World War I Draft Registration Card, Francis Marion Jack, serial no. 1804, order no. 3342, Sep. 12, 1918, Atlanta, Georgia, *Ancestry.com*.

170 Atlanta's Jewels," *AC,* June 25, 1880. Also see "Local Items. Our Public Schools," *Sunny South,* Atlanta, July 7, 1877.

171 "Prof. Spahr's Recital," *Atlanta Evening Capitol,* June 16, 1886. Belle sang Enrico Bevignani's "The Flower Girl" and Jacques Blumenthal's "The Venetian Boat Song" that evening.

172 "A Successful Entertainment," *AC,* June 10, 1887. The duet was of Luigi Arditi's "A Night in Venice." Belle's solos were George Schleiffarth's "Alone at Last" and Wilhelm Ganz's "Nightingale's Trill."

173 *Weatherbe's Atlanta. Ga. Duplex City Directory, 1884* (Atlanta: Ch. F. Weatherbe, 1884), 120, Noble P. Beall, and 221, W. A. Jack & Co., grocers.

174 Noble P. Beall, son of John S. and Sarah C. Beall, was a grocer (briefly), a barber, and, for many years, a clerk for a clothing store in Atlanta. See 1880 U.S. census, Fulton County, Georgia., Atlanta, 1st Ward, ED 90, p. 172A, dwell. 131, fam. 157, Noble Beall; *Weatherbe's Atlanta. Ga. Duplex City Directory, 1885* (Atlanta: Ch. F. Weatherbe, 1885), 129, Noble P. Beall; "Funeral of Noble P. Beall," *AC,* Aug. 13,

1899.

175 See Robert Sobel, *Panic on Wall Street: A History of America's Financial Disasters* (New York: Macmillan, 1968), chapter 6.

176 "Notice. N. P. Beall," *AC*, Jan. 20, 1884; "Trade Embarrassments," *Macon Telegraph*, June 10, 1884.

177 "Roller Skating," *AC*, Jan. 16, 1885.

178 "Polo Players," *AC*, Jan. 26, 1886. The league consisted of teams in Atlanta, Macon, Rome, and Thomasville, Georgia, Birmingham, Alabama, and Chattanooga, Tennessee.

179 "Atlantanians in Birmingham," *AC*, Jan. 26, 1886.

180 "The Polo Game," *AC*, Jan. 28, 1886. Besides the Shinneys and the Globes, Birmingham also had a women's team. "Polo Clubs," *AC*, Jan. 25, 1886.

181 "Roller Skates!" *AC*, Oct. 22, 1886.

182 "The Merry, Merry Skate," *AC*, Oct. 20, 1886; "Wanted," *AC*, Dec. 19, 1886. The Metropolitan Skating Rink lasted only a few months. Its advertisements ran in the *Constitution* for a few weeks in late October 1886 and then disappeared. Within a month or so, Chase left the business and Jim Jack took on another partner, named "Beal," possibly Noble P. Beall who had been Will Jack's partner in his grocery business in 1884.

183 In addition to baseball and roller-skating, Will Jack had a brief interest in another fad sport, walk-racing (a.k.a. pedestrianism), which was popular in America in the 1870s and 1880s. Participants ("walkists") competed by walking as fast and as far they could in a specified amount of time. Contests could go on for days and were typically held in skating rinks and public exhibition halls, most famously at Madison Square Garden in New York. Admission was charged for these events and betting on the outcome was common. The sport was as popular in Atlanta as it was anywhere, and the city's papers regularly covered both local and national matches. See for example, "Go As You Please," *AC*, May 3, 1884; "Scribes in the Ring," *AC*, May 10, 1884; "The Glorious Fourth," *AC*, June 29, 1884. There is no evidence that Will Jack competed in the sport, but on at least one occasion, he acted as a scorer and timekeeper for "a great state walking match." "Take Notice," *AC*, July 25, 1884; "Orr Takes the Cake," *AC*, July 26, 1884. For a history of the sport, see Matthew Algeo, *Pedestrianism: When Watching People Walk Was America's Favorite Spectator Sport* (Chicago: Chicago Review Press, 2014).

184 *Atlanta, Ga., City Directory* (1883), 335, William A. Jack; *Shole's Atlanta City Directory* (1882), 343, William A Jack; *Weatherbe's Atlanta, Ga., Duplex City Directory 1886* (Atlanta: Ch. F. Weatherbe, 1886), 229, William A. Jack.

185 Little is known of Belle's life after her separation from Will Jack. In May 1886, she was reported to be "critically ill at her mother's home, No. 10 Pratt Street." "Personal," *AC*, May 13, 1886. She had recovered by the following month when she participated in one of Spahr's concerts. The last time her name appeared in print as Belle Jack is her mother's 1902 obituary in which she is named as a survivor. "Mrs. Anna Harville Dies," *AC*, Jan. 10, 1902. Her son's 1929 obituary listed "his parents,

Mr. and Mrs. William Jack" as survivors. "Francis Jack Dies," *AC*, Sep. 20, 1929. But the accuracy of that statement, at least in reference to his mother, is questionable. Belle's name has not been found in the 1900, 1910, or 1920 censuses nor among the records of Oakland Cemetery, Atlanta, where many of her relatives and in-laws are buried. The date of her death is not known.

186 *Weatherbe's Atlanta, Ga., Duplex City Directory* (1885), 237, William A. Jack, and Jack, Ward & Co; *Weatherbe's Atlanta, Ga., Duplex City Directory* (1886), 229, William A. Jack.

187 *Directory of Atlanta, Georgia, 1887* (Atlanta: Norwood, Connelly & Co., 1887), 277, William A. Jack.

188 *Atlanta City Directory for 1888* (Atlanta: R. L. Polk & Co., 1888), 606, Wm. A. Jack.

189 *Directory of Atlanta, Georgia* (1887), 454, Randolph Taurman.

190 *City Directory of Chattanooga* (Chattanooga: Connelly & Fais, 1894), 308, Arthur Jack.

Chapter 3

191 According to statistics compiled by the U.S. census bureau, Atlanta's population in 1890 was 65,533, Chattanooga's was 29,100, and Lexington's was 26,369. *Historical Statistics of the United States: Colonial Times to 1970* (Washington, DC: Bureau of the Census, 1975), passim.

192 George W. Ochs, *Chattanooga and Hamilton County, Tennessee* (Chattanooga: Times Printing Co., 1897), 3.

193 Ibid.

194 James B. Jones Jr., "Municipal Vice: The Management of Prostitution in Tennessee's Urban Experience, Part II: The Examples of Chattanooga and Knoxville, 1838–1917," *Tennessee Historical Quarterly* 50 (Summer 1991), 110.

195 The boundaries of such districts were rarely strictly defined by city authorities. According to Mara Keire, "Informal methods worked just as well and caused significantly less controversy." Keire, *For Business & Pleasure*, 9.

196 Will T. Hale and Dixon L. Merritt, *A History of Tennessee and Tennesseans* (2 vols; Chicago: The Lewis Publishing Co., 1913), 1742–1744; "Mrs. Whiteside Passed Away Last Night," *Chattanooga News* [hereafter *CN*], Feb. 20, 1903.

197 Deposition, James L. Whiteside, Apr. 8, 1911, in Hamilton County, Tennessee, Chancery Court file 11444, *M. G. Weidner, et al., vs. Irene Friedman, et al., 1908–1912* [hereafter *Weidner vs. Friedman*], Tennessee State Library and Archives, Manuscripts Division, Box 1184; digital and hard copies in author's files. I learned of this lawsuit though James B. Jones Jr.'s excellent two-part article about prostitution in Tennessee, cited above, for which I am grateful.

198 "They Seek Injunction," *Chattanooga Daily Times* [hereafter *CDT*], Nov. 11, 1908.

199 *Weidner vs. Friedman*, 4.

200 "In the Slums," *Chattanooga Press* [hereafter *CP*], May 8, 1894.

201 Deposition, James L. Whiteside, Apr. 8, 1911, in *Weidner vs. Friedman*.

202 "'For Men Only,'" *CDT*, July 22, 1885.

203 "In the Slums," *CP*, May 8, 1894.

204 Ibid.

205 Jones, "Municipal Vice," *Tennessee Historical Quarterly*, 110–112.

206 *Directory of Chattanooga, Tennessee. 1890* (Chattanooga, Tennessee: Connelly & Fais, 1890), 138, Mad Emma Allen; 272, Mad Alice Cooper; 289, Mad Mattie Davis; 382, Mad Mollie Hicks; and 499, Mad Mary Morris.

207 "She Cut Her Throat from Ear to Ear," *CDT*, Nov. 29, 1893. Chestnut Street was at the eastern edge of Chattanooga's red-light district, between it and the main train station, and had its share of brothels. See, for example, "A Disorderly Institution," *CDT*, Aug. 9, 1889.

208 1900 U.S. census, Hamilton County, Tennessee, Chattanooga, Ward 3, Helen Street, ED 59A, p. 47A, dwell./fam. 1, Sue Green. See *Weidner vs. Friedman*, in which she was a defendant.

209 *Directory of Chattanooga, Tennessee*, (1890), 627, Miss Lillie Tillett; *City Directory of Chattanooga, Tennessee, 1892* (Chattanooga: Connelly & Fais, 1892), 587, Mad Lillie Raymond. Another of Lillie's aliases was Lillian Hamilton. See Ibid., 765, Mad Lillian Hamilton.

210 *Directory of Chattanooga, Tennessee*, (1890), 693, Mad Susie Tillett.

211 "Lewd Women in Trouble," *CDT*, June 25, 1891. Lillie Tillett, operating under an alias, may have been in Chattanooga even earlier than 1890. In October 1888, the *Chattanooga Daily Times* reported the arraignment of Laura Ellis, Alice Elliott, Annie Walsh, and Lillie Raymond, inmates of Mattie Schulz's house of ill-repute. A few months later, in February 1890, a Lil Raymond, presumably the same woman, was involved in a shooting at "the notorious" Nan Berry's house on East End Avenue. And the following July, a Lil Raymond was identified as the madam of her own disorderly house. "Justices' Court," *CDT*, Oct. 4, 1888; "Recorder's Court," *CDT*, July 18, 1890; "A Row on the Outskirts," *CDT*, Feb. 18, 1890.

212 The records of Nettie's 1892 divorce, cited above, also place her in Chattanooga in that year.

213 Marriage, John O'Hare and Florence Tillett, Lexington, Jessamine County, Kentucky, Marriage Licenses (loose), box 8, 1892, County Courthouse, Nicholasville, Kentucky.

214 "Letter List," *CDT*, Aug. 25, 1890.

215 "Another Youthful Offender," *CDT*, Sep. 5, 1890.

216 Marriage, Walter B. C. [*sic*] Tillett and Edna Tillett, Jessamine County, Kentucky, Marriage Book, in "Kentucky, U.S., Compiled Marriages, 1851–1900," *Ancestry.com*.

217 *Emerson & Dark's Lexington City* (1898), 719, Abner Tillett, 182, David W. and Annie B. Warnock.

218 *Directory of Chattanooga, Tennessee* (1891), 693, Mad Susie Tillett.

219 Numbers 11 and 15 Florence Street are likewise identified. *Sanborn Fire Insurance Map, Chattanooga, Hamilton County, Tennessee* (New York: Sanborn-Perris Map Company, 1889), sheet 11.

220 The house was described as such by Madam Mamie Crow (a.k.a. Mrs. Ed Whittenberg) in the affidavit she gave in *Weidman vs. Friedman*, 68–71.

221 The building, or at least part of it, was originally numbered 13 Helen Street and had previously been occupied by Madam Alice Cooper. During the years Susie lived there, her neighbors included, at different times, madams Mollie Lister, Lucy Jewell, Maggie Crow, Marion Fuller, Mary Fulton, and, across the street, Sue Green, formerly of Lexington.

222 "Fair But Frail," *CDT*, Jan. 18, 1891; "Bible in a Brothel," *CP*, Dec. 8, 1893. The latter article, a pseudo-obituary, states that Cooper was "notorious in Chattanooga for the past twenty years as the keeper of a brothel, who has figured in the courts as a shameless bawd and who has been accused of all the vileness of a hardened procuress."

223 "Lewd Women in Trouble," *CDT*, June 25, 1891.

224 Hamilton County, Tennessee, Circuit Court Records, vol. W (June 15, 1892, May Term): 514, case nos. 7788, 7691, and 7693. Chattanooga Public Library, micro. roll 10; *City Directory of Chattanooga, Tennessee* (1892), 345, Mad Fannie Ford, and 534, Mad Mary Morris.

225 See for example, "Grand Jury Discharged," *CP*, Sep. 20, 1894; "Circuit Court Term," *CDT*, Dec. 31, 1894; "Judge Moon's Court," *CDT*, Jan. 10, 1895; "Criminal Docket Assigned for Jan. Term of the Circuit Court," *CN*, Dec. 12, 1901.

226 "The Lover Business," *CDT*, Aug. 30, 1892; "A Day and Night Caller," *CDT*, Aug. 31, 1892.

227 "The Water is Too Cold," *CDT*, Apr. 7, 1893; "She is Insane," *CDT*, Apr. 8, 1893.

228 "Adjudged Insane," *CDT*, Apr. 9, 1893.

229 "Locked in the Vault," *CDT*, July 10, 1893.

230 "One More Unfortunate," *CDT*, July 19, 1895.

231 Elliott was a general ne'er-do-well who, among other things, ran a dancehall in Chattanooga that was an ill-concealed front for prostitution. At his death in 1906, he was described as an "ex-lawyer, ex-preacher, ex-gambler, ex-saloon keeper and a reformed man of the world." "'Fraid to Risk It," *CDT*, Nov. 5, 1906.

232 "The Green-Eyed Demon," *CDT*, Sep. 19, 1894.

233 "Not Dead, But Living," *CDT*, Sep. 23, 1894; "She Still Lives," *Knoxville Sentinel*, Sep. 24, 1894.

234 "Murder! Run!" *CP*, Sep. 1894; "Is She Dead?" *CP*, Sep. 22, 1894.

235 "She Writes a Letter," *Knoxville Sentinel*, Sep. 29, 1894; "Bill and Callie Ferguson," *Knoxville Sentinel*, Jan. 15, 1895; "She Rolled Him," *Knoxville Morning Tribune*, Mar. 13, 1897; "The First Case on Record," *Knoxville Morning Tribune*, June 5, 1897; "One Among Many," *Knoxville Sentinel*, Mar. 17, 1898. Susie kept up with some of these characters. When Cap Elliott died in 1906, she clipped an account of his final days from the paper and pasted it in her scrapbook. "Cap Elliott Near Death," clipping, unidentified Chattanooga newspaper, 1906, Jack-Tillett Scrapbook.

236 "In the Slums," *CP*, May 8, 1894.

237 "Dead Slow," *CN*, May 11, 1895; "Local Snap Shots," *CDT*, June 9, 1894; "Not Dead, But Living," *CDT*, Sep. 23, 1894.

238 "Dead Slow," *CN*, May 11, 1895.

239 Irish Moll was one of the Third Ward's longest-running madams. When she died in 1910, her obituary stated that she had been in the business for nearly thirty-five years, that her name "had become a synonym for the debauchery in Chattanooga," and that she was still "queening it" as the head of a disorderly house at the time of her death. "'Irish Moll' Ends Career," *CDT*, Jan. 29, 1910.

240 "Dead Slow," *CN*, May 11, 1895.

241 Arthur Jack's reasons for moving to Chattanooga were probably like Susie's. Both were fleeing a combination of social and familial disapproval in hopes of professional success—while having a good time. Whatever they were, though, Arthur's reasons were sufficient for him to abandon his family, friends, and hometown, permanently, as it turned out. Years later, he told his grandchildren that he was "the black sheep" of his family and that his father had disowned him. This may have been overstating the case: there is evidence that Arthur remained in touch with his father until the latter's death in 1901 and, to varying degrees, with his siblings. And it is unclear as to whether that "disowning," if it ever did occur, was the cause or the effect of Arthur's having left Atlanta. In any event, he inherited, or otherwise acquired, the Jack family bible, a material outcome that does not fit the "black sheep" model.

242 "One Saloon Less," *CDT*, Mar. 28, 1894.

243 *Sanborn Fire Insurance Map for Chattanooga* (1889), sheet 9; Ibid. (1901), sheets 7, 8, and 10. It is probably safe to assume that, like the many other saloons along this stretch of Ninth Street, the Two Jacks was "patronized liberally by the habitués of the five houses of ill-fame located within a block operated by whites and ten or twelve within two blocks operated by colored women." "The Other Side of Life," *CDT*, Dec. 9, 1894.

244 *City Directory of Chattanooga* (1894), 30, 716, Arthur Jack, James R. Jack. Despite its name, the bar was known around town as "Sue Tillett's bar" and she was commonly thought to own the building that housed it, which she did not. It was owned by J. W. Clift, a lawyer who had lived in Chattanooga before moving to Chicago. After he left town, he was swindled out of his real-estate income, including the rent for the Two Jacks, by his business partner, Thomas Batchelor. Clift and Batchelor also happened to be the lawyers who represented Arthur Jack in the Spencer affair, described below. "For Larceny," *CN*, Feb. 13, 1895.

245 "With A Gun," *CP*, Nov. 7, 1893; "Criminal News," *CP*, Nov. 6, 1893. The "lady of the town" in this case could have been Sue Tillett, using her first name and an alias here. I have found only one other reference to an Emma Olden in Chattanooga during this period: an arraignment in Hamilton County Recorder's Court in November 1893 in which she and a man named Tom Williams were charged with disorderly conduct. "Lengthy, But Uninteresting," *CDT*, Nov. 7, 1893.

246 "An Enraged Husband," *Daily American*, Mar. 1, 1894; "Ran for His Life," *Knoxville Journal*, Mar. 1, 1894; "Pretty Arthur," *Cincinnati Enquirer*, Mar. 1, 1894.

247 "Shot Three Times. Arthur Jack Figures in an Annie Skelton Sensation," *CDT*, Mar. 1, 1894.

248 Hamilton County, Tennessee, Circuit Court File 7077, *Edward G. Spencer vs. Nellie Spencer*, 1894, p. 1 [hereafter *Spencer vs. Spencer*]. Also see "An Application for Divorce," *CDT*, Mar. 4, 1894.

249 "Ran for His Life," *Knoxville Journal*, Mar. 1, 1894.

250 "Shot Three Times," *CDT*, Mar. 1, 1894; *Spencer vs. Spencer*, p. 2.

251 "Ran for Life! Ed and Si Spencer Waylay Arthur Jack," *CDT*, Mar. 1, 1894. This article, which covers most of the second page of this issue of the *Times*, is the most complete published account of the incident. It closely follows the official court records of the case. My account of the affair as given here relies on both the court case and contemporary newspapers as cited. I am particularly grateful to Mary Lee Rice of Chattanooga, a certified genealogist who tracked down these court documents with diligence, efficiency, and professionalism.

252 "Answer of Nellie E. Spencer," in *Spencer vs. Spencer*, 1–2.

253 Quoted in "Ran for Life!" *CDT*, Mar. 1, 1894.

254 "Ran for Life!" *CDT*, Mar. 1, 1894.

255 Ibid.

256 Ibid.

257 Ibid. John Emory Conner (1854–1916), who may be credited with saving Arthur Jack's life, was a farmer and, later, postmaster of Chattanooga. 1900 U.S. census, Hamilton County, Tennessee, 15th Civil District, ED 17, sheet 7B, dwell. 133, fam. 177, John E. Conner; Zella Armstrong, *The History of Hamilton County and Chattanooga, Tennessee* (2 vols.; Chattanooga, TN: Lookout Publishing Company, 1931), 2: 180.

258 "Shot Three Times," *CDT*, Mar. 1, 1894. Coincidentally, Arthur shared a cell with Henry MacDonald, another "gay society man and abductor" from Atlanta. "An Enraged Husband," *Daily American*, Chattanooga, Mar. 1, 1894.

259 "Ran for Life!" *CDT*, Mar. 1, 1894.

260 Ibid. According to the *Oxford English Dictionary*, the word "bagnio" comes from the Italian word for bathhouse. By the eighteenth century, it was being used to refer to slave prisons; from there it quickly evolved into a synonym for "brothel."

261 "Ran for Life!" *CDT*, Mar. 1, 1894.

262 "Waived Examination," *CP*, Mar. 2, 1894.

263 "Jack is Doing Well," *AC*, Mar. 3, 1894; "The Spencers Arrested," *CDT*, Mar. 2, 1894.

264 "The Spencers Arrested," *CDT*, Mar. 2, 1894.

265 *Spencer vs. Spencer*, 1–2; "An Application for Divorce," *CDT*, Mar. 4, 1894.

266 "Adultery and Indecency," *CDT*, Mar. 9, 1894.

267 "Were After Jack Again," *Knoxville Journal*, Mar. 9, 1894; "Jack Has to Run Again," *AC*, Mar. 1, 1894.

268 "Jack in Trouble Again," *Daily American*, Mar. 28, 1894; "Jacks in Hard Luck," *AC*, Mar. 39, 1894. The pistol is extant and in the possession of one of Arthur Jack's great-grandsons.

269 Final Decree, in *Spencer vs. Spencer*; "Spencer Gets a Separation," *AC*, Apr. 13, 1894.

270 "Ran for Life!" *CDT*, Mar. 1, 1894.

271 1910 U.S. census, Hamilton County, Tennessee, Chattanooga, ED 46, p. 1A, dwell. 3, fam. 3, Edward G. Spencer; City of Chattanooga, Tennessee, death certificate (1918), Edward G. Spencer, Tennessee State Library and Archives, Nashville, in "Tennessee, City Death Records, 1872–1923," *Ancestry.com*. Silas Spencer, Edward's brother and fellow vigilante, died that same year.

272 See *FindAGrave.com*, meml. no. 198638275, Nettie Elizabeth Robertson Spencer (1862–1907).

273 "New Schubert Arrivals," *Knoxville Tribune*, Aug. 11, 1894; "Left on Base," *CN*, July 8, 1895. The members of the ball club were "Arthur Jack, J. Jack, A. Litz, J. Litz, Nicklin, Dobbs, McDonald, Ford, Seitert, Haskins, Stoney, [and] Dillard."

274 "Jack in Trouble Again," *Daily American*, Mar. 28, 1894; "Jacks in Hard Luck," *AC*, Mar. 29, 1894. As the major—perhaps only—investor in the Two Jacks Saloon, Susie Tillett later sued several of the saloon's creditors, accusing them of taking furniture and fixtures from the bar that belonged to her. "The Wert-Henson Case," *CDT*, Oct. 18, 1894.

275 "Let 'Er Go!" *CP*, Nov. 7, 1894.

276 "A Skin Game," *CN*, Apr. 13, 1895. A skin game is a swindle involving gambling. A pair of Arthur Jack's loaded dice have survived and are in the author's possession.

277 "Will Buy A Farm," *CN*, July 6, 1895.

278 Ibid.

279 *Tillett vs. Richardson*.

280 "To Shoot Live Pigeons," *CN*, July 13, 1895.

281 Deposition, M. H. Doughty, in *Tillett vs. Richardson*.

282 Bill of sale, Arthur Jack to Lou [*sic*] Tillett, Jan. 2, 1896, Walker County, Georgia, Deed Book 11: 25–26, *FamilySearch.com*, film 393239, image group 8192793.

283 Depositions, T. A. Richardson, Sue Tillett, and M. H. Doughty, in *Tillett vs. Richardson*. Richardson's stable was on Carter Street, directly behind Susie's house.

See *City Directory of Chattanooga, Tennessee* (1895), 515, 723, 739.

284 Depositions T. A. Richardson, Sue Tillett, and M. H. Doughty, in *Tillett vs. Richardson*. The lawyer for the prosecution attempted to introduce evidence that Susie ran a lewd house, but the judge overruled him.

285 Deposition, Lucy Jewell, in *Tillett vs. Richardson*. Jewell made it clear that she was Susie's housekeeper, *not* an inmate of her house.

286 Charles Reif was on the board and eventually became the president of the Chattanooga Brewing Company. "Chattanooga Beer," *CDT,* Sep. 18, 1895.

287 These letters are now in the Dearinger Family Papers, Department of Special Collections, Margaret I. King Library, University of Kentucky, Lexington. In quoting from them here, I have retained Susie's original spelling and punctuation.

288 By August of that year, the saloon was under the management of J. J. Sullivan and George Conway who allegedly ran it "as a disorderly house," presumably meaning that they suffered gambling, prostitution, etc. Evidence suggests that this was no different from the way the place had been run by the Jacks. "In Recorder's Court," *CDT,* Aug. 5, 1896.

289 "In a Personal Way," *CDT,* July 6, 1897.

290 "Isadore Brickman Dies Friday After a Short Illness," *Montgomery Advertiser,* Montgomery, Alabama, May 15, 1920.

291 "In a New Dress," *Montgomery Advertiser,* Aug. 29, 1897.

292 Ibid.; "Made Good Time Over the L. & N.," *Montgomery Advertiser,* July 31, 1897; "Our Well Known Brands," *Montgomery Advertiser,* Nov. 14, 1897.

293 *Sanborn Fire Insurance Map for Montgomery, Alabama* (New York: Sanborn Map Company, 1894), sheet 3.

294 *City Directory of Montgomery, Alabama, 1897* (Montgomery: Maloney Directory Co., 1897), 328, Arthur Jack, 499, Madam Susie Tillett; *City Directory of Montgomery, Alabama, 1898* (Montgomery: Maloney Directory Co., 1898), 414, Madam Susie Tillett.

295 "Change at the Race Track," *CDT,* July 12, 1898. Bred by M. W. Boyd of Cynthiana, Kentucky, Dick Ferguson was sired by Kenova out of Ella Arnold and foaled in 1892. The horse "passed to J. W. Ferguson" and, in 1898, "to F. M. Jack, Atlanta, Ga." *Wallace's American Trotting Register* (Chicago: American Trotting Register Association, 1898), 14: 153, no. 29460. Francis Jack seems to have been a silent partner in the marketing of Dick Ferguson as the horse ran under his son's name during the short time that the Jacks owned it. This would seem to refute the family legend that Francis Jack did not approve of his son's dabbling in the horse trade.

296 "Change at the Race Track," *CDT,* July 12, 1898; "Rockwood Fair," *CDT,* Sep. 21, 1898. The Chattanooga Driving Club had been refurbished in 1895 under the new leadership of the trainer and handler Joseph W. Farley of Danville, Kentucky. The stalls, grounds, and track had been improved and plans were made to rent the newly attractive property out for "creditable entertainments" when it wasn't being used for horse racing. "The Driving Club," *CDT,* Sep. 3, 1895.

297 "Running and Trotting. Opening Day at Newburgh," clipping, unidentified newspaper, 1900, Jack Tillett Scrapbook.

298 "Second Day at Rockport, *Plain Dealer*, Cleveland, Ohio, June 14, 1900; "Running and Trotting," *Cleveland Leader*, June 21, 1900; "A Record Breaking Ride," *Plain Dealer*, July 8, 1900; "Races," *Repository*, Canton, Ohio, July 14, 1900; "Opening Day at Buffalo," *Plain Dealer*, Aug. 7, 1900; "A Good Day at the Valley," *Plain Dealer*, Aug. 16, 1900; "Easy Picking Continues," *Plain Dealer*, Aug. 21, 1900; "Salem (Ohio) Races," *Cincinnati Enquirer*, Sep. 22, 1900; "Full List of Entries in Harness Classes," *AC*, Oct. 15, 1900. Copies of some of these articles are in the Jack-Tillett Scrapbook.

299 "Harness Races at Lexington," *New York Times*, Oct. 3, 1900; "Last Week," clipping, unidentified newspaper, ca. 1900, Jack-Tillett Scrapbook; 1900 U.S. census, Fayette County, Kentucky, ED 30, p. 10A, dwell. 165, fam. 167, Fred McKee.

300 *Wallace's Year-Book of Trotting and Pacing in 1900* (Chicago: American Trotting Register Assoc., 1901), passim.

301 "Lilly Fulk Has Left Home," *Stark County Democrat*, Canton, Ohio, July 31, 1900; "Races," *Repository*, Canton, Ohio, July 14, 1900.

302 "The Courts," *Stark County Democrat*, Feb. 4, 1897.

303 In 1901, J.R.J. ran only once, in August at Youngstown, Ohio, and Susie T. ran twice, once in August at Sandy Creek, New York, and once in September at Boonville, New York. *Wallace's Year-Book of Trotting and Pacing in 1901* (1901), 129, 295. These latter venues were not Arthur Jack's usual stomping grounds, nor does his name appear in the racing press that year, suggesting that he had sold both horses by that time.

304 "Two Well Known Horsemen Arrive," [1900], an otherwise unidentified newspaper clipping in the Jack-Tillett Scrapbook, reported that "Mr. Maw. [*sic*] Beardsley arrived home from Wooster last night accompanied here by Mr. Arthur Jack of Chattanooga, who has his pacing horse, J.R.J., with a record of 2:17¼, entered for the Elks' races here next week. Mr. Beardsley also has Florida Monarch entered. Both horses arrived today." Not long after this, in November 1900, Beardsley (1850–1900) was killed in a train wreck in Jackson, Mississippi. "Dies in Railroad Wreck," *Rock Island Argus*, Rock Island, Illinois, Nov. 27, 1900.

305 Horse Sales," *LL*, Nov. 5, 1902; "Fifty-Four Horses Sold," *LH*, Nov. 6, 1902. George Lewis, a Lexington horseman, bought Ferana N. for $150.

306 1910 U.S. census, Fayette County, Kentucky, Lexington, ward 4, ED 24, 647 Chestnut Street, p. 14B (penned), dwell. 246, fam. 257, Thomas McElhinney, a native of Ireland who had immigrated to the US in 1902.

307 Gracie grew up understanding that she had been born in Chattanooga and, as far as is known, was never told otherwise by her parents. But in 1920, when she and her soon-to-be husband, June Dearinger, were courting, he asked her about her birthplace in one of the many letters that they exchanged during those years as discussed in Chapter 6.

308 Early twentieth-century school census records for Fayette County, Kentucky, are inconsistent about Gracie's date of birth. The census of 1907–1908 gives it as March

10, 1900; that of 1908–1909 as March 29, 1900; and that of 1909–1910 as April 1, 1900. Fayette County, Kentucky, Census Report of School Children, vols. 7 (1907–1909): 38–39, 360–361; 8 (1909–1910): 232–233, *Familysearch.org.*

309 "In Bad Company," *CN*, Mar. 26, 1902. Perhaps the anonymous author of this letter had, among other things, seen recent notices in the Chattanooga papers about Susie's indictment for lewdness or the attempted suicide, in Susie's house, of one of her employees. "Heavy Docket for Two Weeks," *CN*, Aug. 27, 1901; "Criminal Docket Assigned for Jan. Term," *CN*, Dec. 12, 1901; "One More Unfortunate," *CDT*, Nov. 26, 1901.

310 "Will Rescue the Child," *CN*, Mar. 26, 1902.

311 "Home is Wanted," *CN*, Mar. 28, 1902.

312 Quoted in Ibid. This article misidentifies the "humane" policeman as J. W. Rowden. It was actually Thomas M. Rowden, a former city officer and general do-gooder. Less than two months after he ratted on Susie Tillett, Karma came for Rowden in the form of death. Given his history of de facto kidnapping, we might read the inscription on his tombstone in Chattanooga's Forest Hills Cemetery with some irony: "Precious ones from us have gone. / Voices we loved are stilled. / Places are vacant in our home. / Which can never be filled." "Esquire Thomas M. Rowden," *CDT*, May 16, 1902; *FindAGrave.com*, meml. 186637596, Thomas McKiedy Rowden.

313 "Caring for Unfortunates," *CDT*, Aug. 29, 1883.

314 "Unnatural Mother," *CDT*," Feb. 2, 1885; "Poor Unfortunates," *CDT*, Aug. 30, 1885.

315 "Poor Unfortunates," *CDT*, Aug. 30, 1885.

316 "At the Station House," *CDT*, Aug. 26, 1895.

317 "To the Orphan's Home," *CDT*, June 26, 1895.

318 "Judge Hope's Budget," *CDT*, Nov. 15, 1898.

319 "Placed in Orphan's Home," *CDT*, Aug. 31, 1893. This was hardly the last of such incidents in the decidedly Christian city of Chattanooga. In 1908, for example, one Grace Smith, along with the other residents of the "resort" in which she lived, were accused of abusing and maltreating Smith's little boy. When he was snatched away from her by the Sisters of Charity, he was found to be blind in one eye and to be suffering from leg injuries. The good Sisters, the press predicted, would offer him "a better fate." "Waif Taken From Resort to Good Home," *Chattanooga Star*, Feb. 11, 1908. A decade later, authorities were still on the hunt for babies in the care of women of ill repute, some of whom were accused of keeping them simply to get a government allotment. The authorities also professed their outrage at finding white babies in the homes of "negroes." "Babyhood Up to Standard," *CDT*, July 30, 1918.

Chapter 4

320 Deed, Arthur Jack, Chattanooga, Tennessee, from Ellen McCormick, Lexington, Kentucky, Apr. 29, 1902, Fayette County, Kentucky, Deed Book 126: 367.

McCormick had bought the property from William Adams Gunn, a real-estate investor and civil engineer who, by 1900, had assembled a large tract of land on Lexington's north end and begun to develop it into new neighborhoods. "Mr. W. A. Gunn Passes Away," *LL*, Feb. 9, 1915.

321 See James Duane Bolin, "Mules to Motors: The Street Railway System in Lexington, Kentucky, 1882–1938," *Register of the Kentucky Historical Society* 87 (Spring 1989): 118–143.

322 Several large cabinet photographs of the house as it was in the first decades of the twentieth century are extant. Many years later, on the verso of one of them, Gracie (Jack) Dearinger recorded her memories of how the house and property looked during her childhood and my description of the place is partially based on that source.

323 "Auction Sale," *LH*, Apr. 18, 1920.

324 "Administrator's Sale of Desirable Residence and Investment Property," *LH*, Sep. 18, 1922.

325 Susie would have traveled on the Queen & Crescent route of the Southern Railroad, which offered direct, daily service between Lexington and Chattanooga. Excursion fares were relatively inexpensive—in 1911, for example, round-trip between the two cities could be had for as little as six dollars and fifty-five cents—and the central depots in Lexington and Chattanooga were only a short carriage ride from Susie's houses in those cities. See *Southern Railway and Connections* (Buffalo, NY, 1897) at *https://www.loc.gov*; "Excursion Fares," *Lexington Leader*, 13 Oct. 1911; Edward A. Johnson, "Railroads," in *Tennessee Encyclopedia* (Knoxville: University of Tennessee Press, 2002–2001), *tennesseeencyclopedia.net/entries/railroads/*.

326 Deed, Emma S. Jack, wife of Arthur Jack, to Dr. James T. Shannon, Dec. 27, 1904, Fayette County, Kentucky, Deed Book 137: 103; "Deeds," *LH*, Jan. 4, 1905. According to the Fayette County Tax Books (KDLA), 54 Megowan Street was assessed at two-thousand dollars in 1890, 1891, and 1892. The press continued to identify it as "belonging to Susan Tillett" as late September 1903. See for example, "City and Vicinity," *LL*, Sep. 14, 1903.

327 "The Criterion in Saloons," *LH*, Mar. 4, 1902; "The Criterion," *LL*, Mar. 9, 1902.

328 "Handsome New Bar Will Be Opened Today," *LH*, May 16, 1902; "The Criterion Opened," *LH*, May 18, 1902; *Lexington City Directory 1904–1905* (Lexington: R. L. Polk & Co., 1904), 182, 386.

329 "Goes to Germany," *LL*, Feb. 3, 1903; "Bankrupt's Petition for Discharge," *CDT*, Jan. 12, 1903.

330 "A Prince with Pilsener, or What Made the 90's Gay?" *LL*, June 1, 1930. A city ordinance prevented saloons from being located directly on Main Street in Lexington. Some managers got around that by operating a restaurant in the front while keeping a bar in the back. A good example was the Navarre, one of the city's best-known and swankiest establishments, which opened on Main Street in 1895. The arrangement allowed the owner to cater to Lexington's elite, male and female, up front while entertaining an all-male clientele in the back. Another solution for

saloonists, especially those who ran bars inside Main-Street hotels, was to have a separate entrance to the saloon on a side street. That was the case at the popular Phoenix Hotel: the hotel fronted on Main Street but the entrance to its saloon was around the corner on Limestone.

331 "Saloons," *Lexington City Directory* (1904), 699–702.

332 "A Prince with Pilsener," *LL*, June 1, 1930.

333 "Indictments," *LL*, Jan. 3, 1904; "Horse Gossip," *LL*, Feb. 19, 1904.

334 Fayette County, Kentucky, County Court Order Book 33: 82, 169, KDLA; *L. H. Ramsey vs. Arthur Jack, et al.*, Fayette County, Kentucky, Circuit Court Records (Civil), 1903, box 312, no. 3256, KDLA. Meiler, who advertised the place as the "finest and largest resort … and fastest bowling alley in the south," ran the Manhattan from 1898 until early 1901 when illness forced him to sell it. "Opening of the Manhattan," *LL*, Mar. 19, 1898; "Tony's Manhattan Café and Bowling Alley," *LH*, Oct. 15, 1900; "A. J. Meiler Dead," *LH*, July 3, 1901; "Assignee Will Run Alleys," *LH*, Jan. 11, 1901; "Manhattan Alleys Sold," *LH*, Feb. 15, 1901.

335 It was not uncommon for a turn-of-the-century saloon owner to upgrade an establishment simply by changing or amending its name. As historian Mara Keire has pointed out, a saloon might become a cafe or restaurant while a dance hall could be rebranded as a club or a cabaret. "The more a venue differed from a conventional saloon," she concludes, "the wider a demographic it attracted." Kiere, *For Business & Pleasure*, 35.

336 "Saloons Open Today but Not For Business," *LH*, Mar. 10, 1907. Several Lexington saloon owners, including Arthur Jack at the Majestic, were accused of installing cut-glass instead of clear-glass windows to prevent the police from seeing if anything illicit, such as the off-hour serving of alcohol, was going on inside.

337 "Manhattan Saloon. Sold to Arthur Jack," *LL*, June 29, 1903; "Trade Talk," *LL*, July 19, 1903; "Majestic Bar and Café," *LL*, Aug. 2, 1903.

338 "'Majestic.' Handsome New Saloon and Café Will Have Opening Monday Night," *LL*, Oct. 4, 1903.

339 "Read This," *LH*, Nov 26, 1906.

340 "City Briefs," *LH*, Oct. 6, 1903.

341 "Manhattan Saloon. Sold to Arthur Jack," *LL*, June 29, 1903; "Majestic Bar and Café," *LL*, Aug. 2, 1903.

342 "Boiling Soup Spluttered in Eyes," *LH*, Jan. 1, 1903, which reported that Marion Jack, a waiter at the Criterion, had received a painful but minor injury from hot soup.

343 Marriage, F. Marion Jack Jr and Hazel Crutcher, Fulton County, Georgia, Marriage Book L (1901): 51 (license and certificate); "Young Bridal Couple Wants to Be Forgiven," *Atlanta Journal*, July 15, 1901.

344 "F. M. Jack is Sued for Divorce," clipping, unidentified Atlanta newspaper, Feb. 28, 1902, Jack-Tillett Scrapbook; "Young Bride Asks Divorce," *AC*, Mar. 1, 1902.

345 While in Lexington, Marion lived with the Jacks on Chestnut Street. Family

tradition has that he and Susie did not get along (he supposedly owed her money), and he soon returned to Atlanta. Grace (Jack) Dearinger, Lexington, in conversations with the author, 1970s.

346 "Public Sale. Three Two-Story Brick Business Houses," *LL*, Dec. 8, 1908; "Majestic Building Sells for $28,000," *LH*, Dec. 16, 1908.

347 *Sanborn Fire Insurance Map for Lexington, Fayette County, Kentucky* (New York: Sanborn Map Company, 1896), sheet 11.

348 "Bowling Alley," *LL*, Mar. 10, 1898; "Bowling," *LH*, Apr. 8, 1898.

349 "Lexington Bowlers Win," *LL*, Mar. 15, 1907. The team consisted of Arthur Jack, manager, Matt Kerr, Robert P. Kennedy, James Scott, James Seibold, and William Sternberg.

350 "Match Game," *LL*, Nov. 28, 1906; "Lexington Bowlers Win a Victory," clipping, unidentified newspaper, Lexington, Kentucky, Jack-Tillett Scrapbook; "Bowling," *LL*, Mar. 31, 1907.

351 See, for example, "Scott's Bowling Club Defeats Combs," *LH*, Jan. 6, 1906; "Bowling Game Tonight," *LH*, Nov. 10, 1906; "Bowls 278 and Wins Gold Watch," *LH*, Nov. 17, 1906; "Bowling," *LL*, Mar. 31, 1907; "Majestics Second," *LL*, May 17, 1907.

352 "Lexington Bowlers Win a Victory," Jack-Tillett Scrapbook.

353 "Majestic Building Sells for $28,000," *LH*, Dec. 16, 1908. The property included a saloon, a bowling alley, a restaurant, and a shooting gallery.

354 "Big Fight. Will Be Called Off at the Majestic Café Tonight," *LH*, Aug. 26, 1904. Sensibly, Jack hired Linza C. Howard, a local telephone operator, to do the "calling."

355 "Suits Filed," *LL*, Aug. 31, 1903; "Stairless. In a Second Story Room," *Morning Herald*, Sep. 1, 1903; "Injunction," *LL*, Sep. 8, 1903; 1900 U.S. census, Fayette County, Kentucky, Lexington, ward 4, precinct 17, ED 21, sheet 13-B, Louis H. Ramsey.

356 "Criminal Trials Begin Today," *LH*, Sep. 10, 1903.

357 *Lexington City Directory 1906–1907* (Lexington: R. L. Polk & Co., 1906), 425, L H Ramsey & Co.

358 "'Tight Town' Takes on Another Phase and Five Saloonists Arrested," *LL*, Oct. 6, 1904; "Saloon Men Dismissed," *LH*, Oct. 7, 1904. The other saloonists caught up in the raid were Albert M. Heinl, who had a saloon at 132 North Limestone; Andrew F. Hickey, a bartender; James Kearns of the Criterion; and George B. Strader of the Café Royal, 326 East Main.

359 "Criminal Docket," *LL*, Sep. 3, 1905; "Circuit Court," *LL*, Dec. 12, 1905.

360 "Saloon Keepers Furnish Bond," *LH*, Dec. 27, 1905; "Eighty-Five Saloon Keepers Fined," *LL*, Jan. 11, 1906; "Criminal Court," *LL*, Jan. 23, 1906.

361 "Jas. Scott is Fined for Sunday Selling," *LH*, May 8, 1906.

362 Quoted in Ibid.

363 "Saloons Held to be Nuisances," *LH*, Mar. 31, 1906; "Criminal Term," *LL*, Apr. 3,

1906. One of Arthur's co-defendants in this case was Frank Brandt, with whom he had worked at the Criterion and who would soon marry Susie's sister Nettie. Marriage, Frank Brandt and Nettie Tillett, Apr. 3, 1907, Jefferson County, Kentucky, Marriage Book (1906–1910): 104, in "Kentucky, U.S., County Marriage Records, 1783–1865," *Ancestry.com*.

364 Business was such that, in 1906, Arthur was compelled to advertise for extra help in running the lunch counter and the bowling alley divisions of the establishment. "Wanted," *LL*, Nov. 9, 1906; "Read This," *LH*, Nov. 21, 1906.

365 "Burglar gets $250 at Arthur Jack's," *LH*, Oct. 3, 1907. Arthur offered "a handsome reward for apprehension of the marauders," but nothing came of it.

366 Fayette County, Kentucky, County Court Order Book 36: 383, Oct. 25, 1907, KDLA film 389000; "County Court Orders," *LH*, Oct. 26, 1907. By the end of 1907, Jack's former landlord, Claude S. Brownell, had sold the building to Charles H. Berryman, manager of Elmendorf, a major Bluegrass horse farm. "Majestic Building Sells for $28,000," *LH*, Dec. 16, 1908.

367 "A Prince with Pilsner," *LL*, June 1, 1930.

368 "New Vaudeville Theatre to be Opened Here," *LH*, Nov. 1, 1907.

369 "Twenty Years Old," *LL*, May 1, 1908. This brief history of the *Lexington Leader* states that the building was part of what was "known in earlier days as 'Jordan's Row' [and] is now the site of the Majestic Theater."

370 See Gregory A. Waller, *Main Street Amusements: Movies and Commercial Entertainment in a Southern City, 1896–1930* (Washington, DC: Smithsonian Institution Press, 1995).

371 "Local Stage. Majestic Theatre Opening," *LH*, Nov. 19, 1907; "Majestic Theatre Opens Tomorrow," *LH*, Dec. 15, 1907.

372 "Majestic Theater," *LL*, Nov. 23, 1907.

373 "Majestic Opens to Good Houses," *LH*, Dec. 3, 1907.

374 "Majestic Theater," *LL*, Dec. 3, 1907.

375 "Majestic Opens to Good Houses," *LH*, Dec. 3, 1907; "Munnell Heard From," *Watertown Weekly Leader*, Watertown, WI, Nov. 29, 1907.

376 "Local Stage. The Majestic," *LH*, Dec. 7, 1907; "A Big City Show at the Majestic Theatre Next Week," *LH*, Dec. 8, 1907.

377 See "Majestic," *LL*, Dec. 8, 1907, "Majestic Theater," *LH*, Dec. 10, 1907, and "Theatre Party," *LH*, Dec. 12, 1907, among others.

378 "Majestic Theater Closes Its Doors," *LH*, Dec. 13, 1907.

379 "Local Stage. At the Majestic," *LH*, Dec. 25, 1907.

380 "Majestic Theater Opens Tomorrow," *LH*, Dec. 15, 1907; "Majestic Reopens," *LL*, Dec. 17, 1907.

381 "The Stage" *LH*, Dec. 22, 1907; "Good Show on at Majestic Theater," *LH*, Dec. 27, 1908.

382 "Big Bill at the Majestic Theater," *LH*, Dec. 19, 1907.

383 By changing costumes in as little as three seconds, Beaugere was able to impersonate numerous characters during his fifteen-minute act, including Svengali, Cleopatra, Lady Macbeth, David Garrick, Shylock, Hamlet, and both Dr. Jekyll and Mr. Hyde. See "Jean Beaugere Big Hit at Lyric," *Daily Sentinel*, Junction City, Kansas, Nov. 27, 1908.

384 "Local Stage. At the Majestic," *LH*, Dec. 25, 1907; "Big Bill at the Majestic," *LH*, Dec. 29, 1907.

385 "Arthur Jack Buys Majestic Theater," *LH*, Jan. 30, 1908.

386 "Local Stage. At the Majestic," *LH*, Jan. 16, 1908. The fire that worried Arthur had occurred on January 12, 1908, at the Rhodes Opera House in Boyertown, Pennsylvania. It killed over 100 people, including a group of children on an outing with their Sunday school. The fire made the front pages of papers across the country, including "One Hundred People Are Burned to Death in Theatre Fire," *LH*, Jan. 14, 1908. I thank Kevin Lane Dearinger for making this connection for me.

387 "Scott Electric County," *LH*, May 29, 1908. Scott provided similar services for Lexington's other major Main Street theaters including the Hippodrome and Dreamland.

388 "The Stage," *LH*, Apr. 19, 1908; "Good Majestic Show," *LL*, Apr. 26, 1908.

389 "At the Majestic," *LL*, May 3, 1908.

390 "Amusements," *LL*, May 6, 1908.

391 These acts were documented by the *Lexington Herald* and the *Lexington Leader* between January and June 1908.

392 "Majestic Theater," *LH*, Feb. 23, 1908; "At the Majestic," *LL*, Mar. 2, 1908. A publicity photograph of the Great Lester holding his dummy is the only vaudeville-related document among the few surviving possessions of Arthur Jack that are in the collection of the author.

393 "At the Majestic," *LL*, Feb. 26, 1908. The Great Lester (1878–1956) had a long, successful career during which he not only performed but taught ventriloquism. Among his students was Edgar Bergen, perhaps the best-known of American ventriloquists. See the website of the Vent Haven Museum of Ventriloquism, Fort Mitchell, Kentucky, at *www.venthaven.org*; Joe Laurie Jr, *Vaudeville: From the Honky-tonks to the Palace* (New York: Henry Holt, 1953), 114.

394 "Local Stage. Returns to Lexington," *LH*, Apr. 18, 1908.

395 Ibid.

396 "Blindfolded. Magician Finds a Watch," *LL*, Mar. 30, 1908.

397 Ibid.

398 "New Manager," *LL*, Apr. 20, 1908.

399 Whether they made it to Pittsburgh or not, the Zartoons did put their act back on the road, first in Kentucky and then elsewhere. See 1910 U.S. census, Fulton County,

Kentucky, Fulton Town, ED 57, supplement sheet 27A, Harry S. and Alice Zartoon, which shows him as manager of a company of about seven actors; and the *Union City Commercial,* Union City, TN, which advertised the Zartoons' appearance at that city's Reynolds Opera House. The couple continued to tour the United States and Canada until at least 1918.

400 "Deeds and Transfers," *LL,* Mar. 10, 1908.

401 "Actresses Sue," *LL,* May 27, 1908; "Hung Jury," *LL,* Sep. 4, 1908; "Quarterly Court," *LL,* Apr. 26, 1911.

402 "The Majestic Opera Company Incorporates," *LH,* July 12, 1908; "Majestic Theater Under New Control," *LH,* July 26, 1908. For Linnig and McRohan, see *Lexington City Directory* (1909).

403 "Mr. J. D. McRohan Sells Interest in the Majestic," *LH,* Aug. 15, 1908; "Majestic Theater," *LL,* Sep. 1, 1908; "Close Majestic Theater," *LH,* Sep. 2, 1908.

404 "Will Reopen," *LL,* Sep. 6, 1908.

405 "Attachment. Mr. Linning's [*sic*] Statement," *LL,* Sep. 2, 1908.

406 "Will Reopen," *LL,* Sep. 6, 1908.

407 "Attachment," *LL,* Sep. 2, 1908; "Files an Attachment," *LH,* Sep. 3, 1908. The actors were joined in their suit by Otis E. Arbuckle, an otherwise unidentified employee of the theater.

408 "Hung Jury," *LL,* Sep. 4, 1908; "Quarterly Court," *LL,* Apr. 26, 1911; "Receiver Asked for Majestic Company," *LH,* Sep. 10, 1908. The Marys were still pursuing their case as late as 1911. Although in the end they did not prevail, their perseverance must have been an irritant for Jack.

409 "Combs Lumber Company Sues," *LH,* Dec. 15, 1908; "Want $2,062.65," *LL,* Mar. 3, 1909.

410 *Lexington City Directory* (1909), 438, Majestic Theater, John B. Elliott Mngr; "John B. Elliott, Operator of Theaters, Dies," *LL,* Mar. 15, 1945; Waller, *Main Street Amusements,* 89–92, 112–13, 138–40. The building had ceased being a theater by the early 1920s when it housed the offices of the Board of Commerce, a real-estate dealership, and, on the third floor, several apartments. In the spring of 1926, the Transylvania Printing Company began a long tenancy by completely remodeling the building, eventually replacing its Queen-Anne façade with a "20th-century modern" one, and erasing all vestiges of its days as a theater. "Printing Company to Move Quarters," *LL,* Apr. 11, 1926.

Chapter 5

411 Rosen, 76. Madams typically kept half of whatever their employees earned. In exchange, they provided room and board, maid service, regular medical care, and plenty of time off, at least during the day. Women in parlor houses did not have to work as hard to attract clients as did street or saloon prostitutes, since the madam generally took care of the front end of the business. See Rosen, *The Lost Sisterhood,*

157; Keire, *For Business & Pleasure*, 45–46.

412　Marcus Schmedling advertised as an "artistic photographer" and ran a studio at 828 Market Street in Chattanooga from about 1888 to 1897 when he returned to his native Norway. He sold cabinet photographs at four dollars a dozen and was Susie Tillett's preferred photographer until his retirement. After that, she patronized Louis Granert who had recently opened a studio on Market Street. He was born in Germany in 1862, came to the United States in 1881, and worked for a time in St. Louis, Missouri, before moving to Chattanooga in about 1896. He was in business there until at least 1910. *Chattanooga Daily Commercial*, Dec. 22, 1888; 1900 U.S. census, Hamilton County, Tennessee, Chattanooga, Ward 1, 109 Lindsay St., ED 54, dwell. 99, fam. 107, Louis Granert, NARL micro. publ. T623, roll 1574. Also see Chattanooga's city directories, 1897–1910.

413　Marriage, G. B. Goggan and Miss Lillie M. Tillett, DeKalb County, Georgia, marriage certificate, Sep. 15, 1898; photocopy in author's files, courtesy of Lillian Goggan Keller, San Antonio, Texas.

414　"Cost them $3," *Chattanooga Sunday Times*, Apr. 22, 1900.

415　1900 U.S. census, Hamilton County, Tennessee, Chattanooga, ward 3, E.D. 58, sheet 8B, dwell. 131, fam. 163, Nettie Peyser. The "inmates" were Mattie Holtz, age 21, Emma Fisher, 21, and Emma Maxwell, 22.

416　"Burglar Caught," *CDT*, Oct. 5, 1900; "Street Identified," *CDT*, Oct. 13, 1900.

417　Nettie and Frank Brandt lived in Lexington for the rest of their lives. Besides being a saloonist, Frank ran several entertainment venues, including Joyland Park, one of the city's best-known and most popular amusement parks. He died in 1933 and Nettie in 1952. Kentucky Department of Health, death certificate 116-52-408 (1952) Nettie Tillette [*sic*] Brandt, Bureau of Vital Statistics, Frankfort; Kentucky Department of Health, death certificate 15970 (1933), Frank Brandt, Bureau of Vital Statistics.

418　1900 U.S. census, Hamilton County, Tennessee, Chattanooga, Ward 3, 11 Helen St., ED 58, p. 33A, dwell. 77, fam. 88, Sue Tillett, NARA micro. publ. T623; 1910 U.S. census, Hamilton County, Tennessee, Chattanooga, 1020 Douglass St., 1st civil district, ED 64, sheet 15-A, dwell. 11, fam. 14, Sue Tillet [*sic*].

419　"O. E. 'Dick' Pooler Dies at Hospital," *CDT*, May 27, 1922; "Stories About Otis E. Pooler," *CN*, Sep. 8, 1922; entries for Pooler in General Index to Conveyances, P-Q, Hamilton County, Tennessee, Grantees, to July 25, 1928, p. 427, *FamilySearch. com*, film 008264860; General Index to Conveyances, N-Q, Hamilton County, Tennessee, Grantors, to July 25, 1928, p. 455, *FamilySearch.com*, film 00826.

420　"Affidavit of Mrs. Ed Whittenberg," in *Weidner vs. Friedman*, 68–71. The average monthly rent for a moderate sized house in the Third Ward was between thirty-five and fifty dollars a month. Small houses (shacks or cribs) could go for as low as one dollar a week.

421　"Council Has Much Work," *CDT*, Aug. 1, 1904; "City to Have Red-Light," *CDT*, Oct. 20, 1904.

422　"Two Deputies Get Busy!" *CDT*, Sep. 4, 1906; "The Cases Dismissed," *CDT*, Sep. 5,

1906.

423 "Wholesale Indictments," *CDT,* July 13, 1907.

424 "It's Up to the Officials," *CN,* Sep. 11, 1908.

425 "Deposition of James J. McMahon," in *Weidner vs. Friedman,* 87–90.

426 "Third Ward Folk Volunteer to Go Before Grand Jury," *Chattanooga Star,* Aug. 12, 1908.

427 J. L. Whiteside, letter to the Board of Public Safely, City of Chattanooga, quoted in "'Jim' Whiteside in Protest," *CDT,* June 11, 1908. In stating that the houses had been "built for prostitution," Whiteside presumably meant that their interiors had been divided up into as many workspaces—i.e., tiny bedrooms—as possible.

428 "Third Warders Hold Meeting," *CN,* Aug. 12, 1908; "Warrants for All Interested in Red Light Houses," *Chattanooga Star,* Sep. 11, 1908.

429 "Tenderloin Must Move," *CDT,* July 16, 1908.

430 "Third Ward Folk Volunteer to Go Before Grand Jury," *Chattanooga Star,* Aug. 12, 1908.

431 "Unpleasant Notoriety," *CDT,* Sep. 11, 1908. Susie Tillett's name appeared in this article on both the list of madams and, inaccurately, the list of property owners, possibly because she occasionally left her house in charge of another madam while she was out of town, thereby giving a public impression that she owned it.

432 "It's Up to the Officials," *CN,* Sep. 11, 1908; "Grand Jury Ignores Red Light Cases," *Chattanooga Star,* Oct. 6, 1908.

433 "Now Up to Grand Jury," *CDT,* Sep. 15, 1908; "Grand Jury Ignores Red Light Cases," *Chattanooga Star,* Oct. 6, 1908.

434 "Georgia Miller Case Dropped for Lack of Prosecutor," *Chattanooga Star,* Sep. 19, 1908.

435 *Weidner vs. Friedman.* The madams named in the suit were Ruth Anderson, 17 Florence Street; Willie Blythe, 20 Penelope; Anne Bouley, 17 Florence; Kate Cowan, 12 ½ Penelope; Mamie Crow (alias Mrs. Ed Whittenberg), 11 Florence; Ada Culver, 19 Florence; Irene Friedman, 19 Helen; Sadie Fuel, 21 Helen; Marion Fulgham, 15 Helen; Susie Green, 16 Helen; Blanche Harris, 17 Helen; Laura Hines, 8 Florence; Ollie Henderlight (no address given); Mollie "Irish Moll" Hicks, 11 Florence; Hallie Hood, 15 Florence; Alice Lee, 17 Helen; Lillian Sterling, 21 Helen; and Susie Tillett, 11 Helen. When the suit was renewed in 1911 (see below), the following "inmates of said houses of ill repute" were added to the list of defendants: Clare Arnold, Ruth Biddins, May Bishop, May Brock, Annie Burton, Liza Chambers, Viola Cross, May Dewey, Eveline English, Ruby Finn, Mattie Ford, Grace Foster, Nellie Gray, Lucy Ingram, Marie Johnson, Pearl Love, Ethel Lowe, Lucille Martin, Florence Mays, Bessie McBee, May McDermott, Pauline Miller, Viola Rice, Sallie Smith, Viola Stockwell, Jessie Ward, Hazel West, Madeline Woods, and May Woods.

436 *Weidner vs. Friedman,* 5, 8. Also see "They Seek Injunction," *CDT,* Nov. 11, 1908 and "Third Ward Folk After Women in Chancery Court," *Daily Chattanoogan,* Nov. 11, 1908.

437 *Weidner vs. Friedman*, 13–14. Witnesses stated that the area had no adequate sewer system, that it often flooded, and that it sometimes took days for standing water to percolate or evaporate from the unpaved streets.

438 *Weidner vs. Friedman*, 23–25.

439 "Red Light Wiped Out," *CDT*, Nov. 16, 1908.

440 "Disorderly Houses Closed by the Police," *CDT*, May 17, 1910.

441 1910 U.S. census, Hamilton County, Tennessee, Chattanooga, ward 7, ED 64, passim.

442 *City Directory of Chattanooga and Suburbs, 1908* (Chattanooga: G. M. Connelly, 1908), 173, 873, Mad Eva Clark; "Serious Affray Between Women," *CN*, Aug. 14, 1913.

443 *Chattanooga City Directory* (1909), 666, Mad Susie Tillett. Douglas Street was about five blocks east of Helen, on the other side of the city's train depot.

444 1910 U.S. census, Hamilton County, Tennessee, Chattanooga, Ward 7, ED 64, sheets 15-A, 15-B, dwells. 9-14, fams. 12-17. Susie's boarders were Fanny Anderson, age 21, Pearl Bishop, 20, Clara Fitzgerald, 29, Lucy Ryne, 29, and May Wooten, 17. Her servant, Annie Powell, was identified in the census as a sixty-year-old "mulatto." Of her neighbors, Annie Boully employed four women while Ruby Bernard, Laura Hines, Madge Moore, and Sallie Smith each employed three.

445 "Ed Boydston Busy Again," *CDT*, May 30, 1909.

446 Ibid.

447 "Want Evil Houses Moved," *CDT*, Mar. 7, 1910.

448 "Women in Reform Work," *CDT*, May 22, 1910.

449 "Disorderly Houses Closed by the Police," *CDT*, May 17, 1910.

450 "West Siders Indignant," *CDT*, July 15, 1910.

451 "Back to the Old Quarters," *CDT*, July 24, 1910.

452 "Cited to Appear Before Chancellor; Contempt Charged," *CN*, Oct. 17, 1910.

453 One of the original defendants, the infamous Mary Hicks, had died in January 1910. In announcing her death, the *Chattanooga Times* stated that her sobriquet, Irish Moll, had "become a synonym for debauchery in Chattanooga." " 'Irish Moll' Ends Career," *CDT*, Jan. 29, 1910.

454 "Answer of Susie Tillett," *Weidner vs. Friedman*, 44–46.

455 "Contempt Charges Before Chancellor," *CN*, Apr. 11, 1911.

456 "They Deny Contempt of Chancery Order," *CN*, Mar. 27, 1911.

457 *Weidner vs. Friedman*, passim. There was an attempt to get witnesses to speak ill of a nearby community of Russian Jews by implying that that group was also to blame for problems in the old red-light district. The ploy backfired when the witnesses spoke of the Russians only in positive terms.

458 See, for example, the affidavits of Albert J. Geismar, A. Moss, Horace R. Parsons,

and Samuel W. Ohls in *Weidner vs. Friedman*. Each of these men ran a business that abutted the red-light district.

459 "Guilty of Contempt," *CDT*, Apr. 13, 1911.

460 Ibid.

461 "Red Light District Once More in Court," *CDT*, Sep. 30, 1911.

462 "Final Decree, enrolled 22nd December 1911," *Weidner vs. Friedman*, 305–310. The defendants took this decision to the Court of Civil Appeals in Knoxville, but in August 1912, McConnell's ruling was upheld, finally ending the lawsuit. "Injunction Against Immoral Houses," *CN*, Aug. 29, 1912.

463 *City Directory of Chattanooga and Suburbs* (Chattanooga: G. M. Connelly, 1912), 747, Mad Susie Tillett; Ibid. (1913), 792, Mad Susie Tillett; "Demimonde in Court," *CN*, Dec. 30, 1912.

464 *Sanborn Fire Insurance Map of Chattanooga, Hamilton County, Tennessee* (New York: Sanborn Map Company, 1917), sheet 45.

465 "Annie Harper is Held to Court," *CN*, Apr. 19, 1913; "Night Time Sales Taboo," *CDT*, Oct. 2, 1913.

466 "For Violation of Quarantine Law," *CN*, Feb. 10, 1914; "Gross Violation of the Quarantine Ordinance," *CDT*, Feb. 10, 1914.

467 *City Directory of Chattanooga and Suburbs* (Chattanooga: G. M. Connelly, 1914), 753, Mad Susan Tillett; Ibid. (1915), 749, Mad Susan Tillett; Ibid. (1916), 1093, Mad Susie Tillet [*sic*].

468 "Ouster Bill's Blow Heavy," *CDT*, Feb. 6, 1915.

469 Ibid.

470 Quoted in Ibid.

471 Keire, *For Business & Pleasure*, 3, 90–91. Public opinion changed following the publication of *The Social Evil in Chicago,* that city's vice-commission report, in 1910.

472 See, for example, Rosen, *The Lost Sisterhood*, and Keire, *For Business & Pleasure,* passim.

473 Between 1910 and 1917, twenty-eight cities (including Lexington, Kentucky) and four states conducted vice investigations. Keire, *For Business & Pleasure*, 179, n27, citing Joseph Mayer, *The Regulation of Commercialized Vice* (New York, 1922).

474 "Police Have Their Orders," *CDT*, May 26, 1917.

475 Newton D. Baker, quoted in "Police Have Their Orders," *CDT*, May 26, 1917.

476 "Another Training Camp in August," *CN*, May 26, 1917.

477 Jones, "Municipal Vice," *Tennessee Historical Quarterly,* 114.

478 "Women Begin Exodus Today," *CN*, May 26, 1917; *1917 City Directory of Chattanooga and Suburbs* (Chattanooga: G. M. Connelly, 1917), 876, Susie Tillett.

479 Keire, *For Business & Pleasure*, 98, 103.

480 *1917 City Directory of Chattanooga and* Suburbs (Chattanooga: G. M. Connelly,

1917), 876, Susie Tillett.

481 "Start Drive Against Vice," *CDT*, Dec. 29, 1916; "War on Suspected Hotels," *CDT*, Jan. 13, 1917.

482 "Sunday Free From Drunks," *CDT*, Jan. 9, 1917.

Chapter 6

483 One of the ways her parents promoted Gracie's well-being was to keep the details of their pasts from her, including the facts of their own marriage, which was probably of the common-law variety, and of her parentage.

484 Census Report of School Children, Fayette County, Kentucky, 7 (1907–1908): 38–39; 8 (1908–1909): 360–61; 9 (1909–1910): 232–233; *Familysearch.com*, film 175011/8684635. Also, "Commencement of Miss Williams' School," *LH*, June 4, 1907. One of Gracie's classmates at Miss Williams' was J. Winston Coleman, future Kentucky historian and, with his pamphlet *The Private School of Ella M. Williams* (Lexington: Winburn Press, 1980), historian of the school itself.

485 "Social and Personal," *LL*, May 22, 1909; *LL*, Dec. 20, 1909; "Campbell-Hagerman Entertains Tonight," *LH*, Dec. 19, 1910.

486 "Social and Personal," *LL*, Dec. 19, 1916.

487 "Social and Personal," *LL*, June 19, 1906; "Charming Program," *LL*, June 8, 1906.

488 "Social and Personal," *LL*, Mar. 29, 1908.

489 "Mrs. Ford Closed Her Music Class Term With Recital," *LL*, June 19, 1910.

490 "Mrs. Ford's Pupils Give Recital," *LH*, June 18, 1913.

491 "Music Class Recital," *LH*, June 21, 1914. Gracie's piano medals survive and are in the possession of one of her granddaughters.

492 Deed, A. M. Spotswood to Emma S. Jack, July 27, 1903, Fayette County, Kentucky, Deed Bk. 131: 473; Mortgage, Emma S. and Arthur Jack to Security T. & S. V. Co., Oct. 21, 1905, Fayette County, Kentucky, Mortgage Bk. 67: 550; Deed, Emma S. Jack to E. L. Hutchinson, June 26, 1915, Fayette County, Kentucky, Deed Bk. 178: 451. Also see *Sanborn Fire Insurance Map for Lexington, Fayette County, Kentucky* (New York: Sanborn Map Company, 1907), sheet 73; "Oldham Lake's All Day 52nd Combination Auction Sale," *LL*, Apr. 20, 1915.

493 "Oklahoma's Five Growing Cities," *LL*, June 6, 1912; "Oklahoma Capital," *LL*, Sep. 22, 1912.

494 "For Sale," *LH*, July 12, 1913.

495 "For Sale," *LH*, Sep. 17, 1911.

496 "Wanted—Miscellaneous," *LH*, Mar. 26, 1911.

497 "Poultry Exhibit One of Best on Record," *LH*, Aug. 10, 1910, clipping in Jack-Tillett Scrapbook.

498 Jackson Hall fronted on South Limestone and ran along the south side of Water

Street. At street level, it functioned as a large marketplace, while its second floor held the offices of the city government. Its first-floor public space was large enough to accommodate a comprehensive display of prize poultry. See Ranck, *Guide to Lexington, Kentucky* (1883), 37.

499 "Kentucky Poultry Show to Open in Lexington Today," *LH*, Jan. 16, 1911; "Fayette People Win at Scott County Fair," *LH*, July 29, 1911.

500 Edward H. Borchers, "Feathered Kings and Queens Hold Court," *Louisville Evening Post*, 1912, clipping in Jack-Tillett Scrapbook; "Two Hundred Events for Chicken Raisers," *Louisville Courier-Journal*, Sep. 13, 1912.

501 "Poultry and Pigeon Awards Are Made," *LH*, Aug. 15, 1912; "Second Day a Hummer," *Bourbon News Fair Daily*, Paris, Kentucky, Aug. 21, 1913; "The Fair a Big Success," *Bourbon News*, Paris, Kentucky, Aug. 22, 1913.

502 "Free! Free!! Free!!! Automobile," *LL*, Feb. 24, 1914; "Total Vote Cast 8555," *LL*, Mar. 1, 1914; "Popularity Contest," *LL*, Apr. 10, 1914; "Arthur Jack First in Voting Context," *LH*, Apr. 10, 1914.

503 "Theater Auto Contest in Court," *LH*, Apr. 17, 1914.

504 "Five Off on Fishing Trip," *LL*, July 12, 1914.

505 Since 1912, the Kentucky Traction and Terminal Company had been the major tenant of the Maguire Building and it may have been from that company that Jack leased the space for his restaurant. The building is extant and retains some of its original architectural details, inside and out. See "Traction Company Negotiating for Site for a Terminal Station?" *LL*, Oct. 6, 1912.

506 "Two New Restaurants to Open in Lexington," *LH*, Apr. 11, 1915; "La Fayette Café is Open to Public," *LH*, Apr. 21, 1915.

507 "Jack's La Fayette Is First Class Café," *LH*, Apr. 27, 1915. The restaurant also offered catering services in the form of box lunches. "Oldham Lake's All Day 52nd Combination Auction Sale," *LL*, Apr. 20, 1915. Family tradition has that Susie herself contributed to the business by making sandwiches for the lunches.

508 "Maguire Building at Auction Today," *LH*, Sep. 18, 1915. The article noted that the building occupied a historic site. It was here that the *Kentucky Gazette*, the second newspaper west of the mountains, published its first issue in 1787.

509 *Emma S. Jack vs. E. L. March* and *Arthur Jack vs. E. L. March*, Feb. 1917, Fayette County, Kentucky, Circuit Court records (civil suits), box 11, bundles 120–121, KDLA; "County Court Orders," *LH*, Feb. 17, 1917. The disputed items were "82 3/4 yards linoleum, 8 1/6 yards of rubber, table, gas toaster & griddle, 6 ft. steel canopy; 2 six-gal coffee urns, 30 G. O. chairs, 6 G. O. tables, 6 fumed costumers, 6 table mats, 13 yards curtain goods, 31 ft. brass rods, 12 pair brackets, making and hanging, 2 tables, 4 chairs" and "a bar, mirror, counters, cigar case, table, ice-box, and signs."

510 "Common Law. Cases Assigned in Circuit Court for Trial," *LL*, Nov. 18, 1917.

511 *Emma Jack vs. March*, and *Arthur Jack vs. March*, Feb. 1917.

512 Nick Nickoson (1896–1997) married Gracie Jack's friend and sister-in-law Rosalie Dearinger (1902–1976) in 1924.

513 "These Grocers Will Feature the Cooker Offer Next Week," *LL*, Apr. 25, 1918.

514 *Lexington City Directory 1919* (Columbus, Ohio.: R. L. Polk & Co., 1919), 318; *Lexington City Directory 1921* (Columbus, Ohio.: R. L. Polk & Co., 1921), 391; "Auction Sale" *LH*, Apr. 16, 1920; "Business Opportunities," *LH*, Mar. 24, 1922.

515 "For Sale," *LH*, Aug. 29 and Sep. 24, 1919.

516 "Auction Sale," *LH*, Apr. 20, 1920.

517 "Ott & Smiley's Combination Sale" *LH*, June 5, 1921.

518 Waller, *Main Street Amusements*, 85–86.

519 Letter, June Dearinger to Gracie Jack, Dec. 7, 1918, Dearinger Family Papers.

520 Letter, same to same, Nov. 21, 1918, Dearinger Family Papers.

521 Letter, same to same, Jan. 3, 1919, Dearinger Family Papers.

522 Letter, same to same, Jan. 4, 1919, Dearinger Family Papers.

523 Letter, same to same, Jan. 23, 1919, Dearinger Family Papers.

524 Letter, same to same, Mar. 2, 1920, Dearinger Family Papers. Susie's mention of East Main, which was probably an unwitting reference to her own past, raised a red flag for June and the question of Gracie's place of birth stayed on his mind. "I'm going to ask your Mother one of these days why she told me that you were born here in Lexington Ky on East Main St.," he wrote a week later, "just to see what she will say." I have not been able to identity June's Chattanooga friend and cousin.

525 Letter, same to same, Jan. 23, 1919, Dearinger Family Papers.

526 Letter, same to same, Apr. 6, 1919, Dearinger Family Papers.

527 Letter, same to same, July 1, 1919, Dearinger Family Papers.

528 "Engagement Announced," *LH*, Apr. 24, 1921; "Jack-Derringer [*sic*]" *LL*, June 26, 1921.

529 Kentucky Department of Health, death certificate 6046 (1922), Emma S. Jack.

Epilogue

530 In his definitive study of the subject, historian David T. Courtwright writes, "During the nineteenth-century the dominant addict type was a middle-aged, middle-class or upper-class female; the drugs most commonly used by addicts were morphine and opium; and the majority of cases were medical in origin." Courtwright, *Dark Paradise: A History of Opiate Addiction in America* (Cambridge, MA: Harvard University Press, 2001): 110).

531 "For Sale," *LH*, June 23, 1922.

532 "Administrator's Sale of Desirable Residence and Investment Property Tuesday, Sep. 19th at 10 A.M.," *LH*, Sep. 16, 1922. In fact, not all of the furniture was sold at this time. Its later sale, piece by piece, was a painful sacrifice that helped get Arthur, Gracie, June, and their children through the Depression.

533 "Property Transfers," *LH*, Sep. 26, 1922; "Property Transfers," *LH*, Oct. 18, 1922. Julia Gormley and her brother Charles bought the house, store, and all the lots but one, which went to Sig Bing and Joseph Marks. These parties made their purchases for investment purposes and quickly resold the property. In the late 1930s, the main house became the parsonage for the Gunn Methodist Episcopal Church and remained so until it was razed in the 1960s. The building that had been Jack's store, was converted to a house in the 1940s, and still stands, veiled behind a century of domesticity, the only remaining onsite evidence of the Jacks having occupied the land.

534 "Property Transfers," *LH*, Nov. 28, 1922. They paid Joseph W. and Sarah Wright four-thousand dollars for the lot.

535 June and Gracie had two more children, Eugene Lewis, born in 1927, and Ruth Ann, born in 1933.

536 "Five Arrested," *LL*, Feb. 19, 1922.

537 "Collis Brothers Now in Charge of Leonard," *LH*, Aug. 6, 1922; "Collis Brothers Buy Hotel Lease," *LL*, Aug. 6, 1922.

538 *Lexington City Directory 1923* (Maryville, TN: Baldwin-Franklin Directory Co., 1923), 484, Arthur Jack.

539 *R. L. Polk & Co. Lexington City Directory 1925* (Columbus, OH: R. L. Polk & Co., 1925), 465; Arthur Jack to Reed Elliott, Receipt for payment of chattel mortgage, secured by "merchandise and fixtures located at 191 Jefferson Street, Lexington, Ky," June 30, 1925, Jack-Tillett Scrapbook.

540 Marriage, Frank Brandt and Nettie America Tillett, Apr. 3, 1907, Jefferson County, Kentucky.

541 *R. L. Polk & County's Lexington City Directory* (1925), 221, 687; *Polk's Lexington City Directory 1927* (Columbus, OH: R. L. Polk & Co., 1927), 323; *Polk's Lexington City Directory 1928* (Columbus, OH: R. L. Polk & Co., 1928), 299; *Polk's Lexington City Directory 1930* (Columbus, OH: R. L. Polk & Co., 1930), 322; *Polk's Lexington City Directory 1931–32* (Columbus, OH: R. L. Polk & Co., 1931), 294.

542 In 1917, a group of local property owners, fed up with the fact that "Megowan Street" was synonymous with "red-light district," petitioned the city to change its name. So Megowan again became Grant Street, its original name. At about the same time, the street was finally paved with "a smooth road bed instead of the former rocky and dusty condition existing for years when the street was the center of the segregated district." By 1940, the street had become Northeastern Avenue, which was eventually shortened to Eastern Avenue, its current name. In the 1970s, as part of the civic abomination known as "Urban Renewal," whatever nineteenth-century and early twentieth-century structures remained on the street were razed and the street's grade reduced to the level of Main Street. Although the ground was not actually sown with salt, its spicy history was nonetheless erased. "Name Change of Thoroughfare is Asked of City," *LH*, July 12, 1917; "Megowan is Now 'Grant Street'," *LL*, July 20, 1917; "Progress in Street Work is Reported," *LH*, Aug. 19, 1917.

543 See, for example, "Entries for Saturday," *LL*, Apr. 29, 1921, and "Two Features for

Tuesday Racing," *LL*, May 5, 1924.

544 Letter, John A. Dearinger to his son, David B. Dearinger, Oct. 13, 1991. Author's collection.

Addendum

545 1870 US census, Mobile County, Alabama, Mobile, ward 6, p 82, dwell. 594, fam. 710, George Bishoff household, NARA micro. publ. M563, roll 31; Death of Annie Bishop [*sic*] Gilardoni (1928), Alabama, U.S., Deaths and Burials, 1881-1974, *Ancestry.com*; Death of Julia Farley (1939), ibid.

546 1880 U.S. census, Mobile County, Alabama, Port of Mobile, ED 137, Julia and Annie Bishop [*sic*] in household of Silvester Festorazzi, NARA micro. publ. T9, roll 25.

547 Ibid., Paul Gilardoni.

548 "Paul Gilardoni, the Prominent Caterer Dies at Residence," *The Age-Herald*, Birmingham, Alabama, Aug. 31, 1905.

549 Marriage of Arthur Jack to Julia Bishoff, Nov. 26, 1891, Mobile County, Alabama, Marriage Book 32 (1889–1892): 690, *Familysearch.com*, microfilm no. 1550486. Also see "Married in Alabama," *Weekly Advertiser*, Montgomery, Alabama, Dec. 2, 1891.

550 The origin of "Archie," whether with Arthur or with Julia, possibly as an endearing nickname, is not known. Since he is clearly identified as "Arthur Jack" in the documents of their marriage, there can be little doubt that Julia was aware of his real name. I have found no other records in which he is called Archie.

551 For example, "Arthur Jack Shot," *Montgomery Advertiser*, Mar. 1, 1894; "Spencer Gets a Divorce," *Selma Times*, Apr. 15, 1894.

552 *Julia A. Jack vs. Archie W. Jack* [*sic*], Mobile County, Alabama, Chancery Court, divorce no. 5800 (1896), *FamilySearch.com*, microfilm no. 19544206.

553 Deposition of Julia A. Jack, in *Jack vs. Jack.*

554 "Notice to Non-Resident," *Mobile Daily Herald*, Mobile, Alabama, clipping in *Jack vs. Jack.* Per court order, the notice was published once a week for four weeks.

555 Marriage of J. J. Farley to Julia Bishoff, Dec. 30, 1897, Montgomery County, Alabama, "Alabama, U.S., County Marriage Records, 1895-1967," *Ancestry.com.*

556 1900 U.S. census, Orleans County, Louisiana, New Orleans, ED 5, sheet 2, Julian J. Farley., NARA micro. publ. T623, roll 570; 1910 U.S. census, Mobile County, Alabama, Mobile, ED 82, sheet 1A, Julian J. and Julia Farley in household of Julia Boyles, NARA micro. publ. T624, roll 27; 1930 U.S. census, Mobile County, Alabama, Mobile City, ED 49-77, Julia Farley, Family History Library, Salt Lake City, Utah, micro. 2339777; Death of Joseph J. Farley (1922) Alabama, U.S., Deaths and Burials, 1881–1974; Death of Julia Farley (1939), ibid.

Photographs and Documents

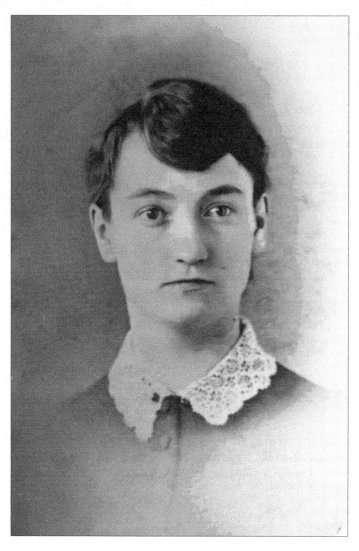

Susie Tillett, age sixteen, 1875. Photographer unknown.
Courtesy of a descendant

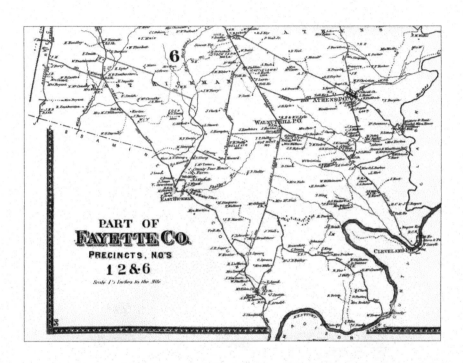

East Hickman Precinct, Fayette County, Kentucky, where the Samuel
and America Tillett family lived as of the mid-1850s. From D. G.
Beers, *Atlas of Bourbon, Clark, Fayette, Jessamine, and Woodford Counties, Ky*
(Philadelphia, 1877)

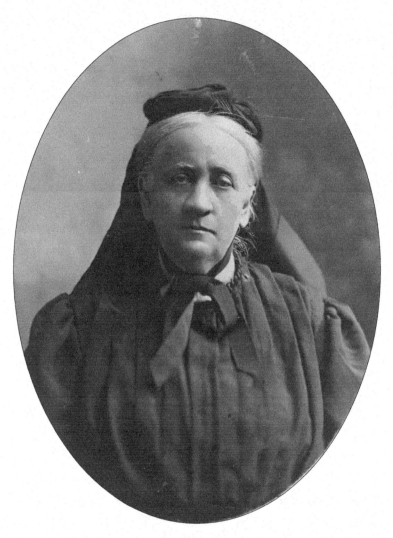

America Susan Lanham, wife of Samuel W. Tillett and mother of fourteen children, including Susie Tillett, not long before her death in 1883. Photographer unknown. Courtesy of a descendant

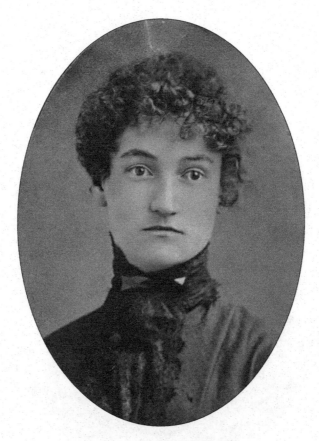

Susie Tillett, age eighteen, 1877. Photograph by Louis Granert, Chattanooga, Tennessee, copy of an earlier, now lost image made probably in Lexington, Kentucky

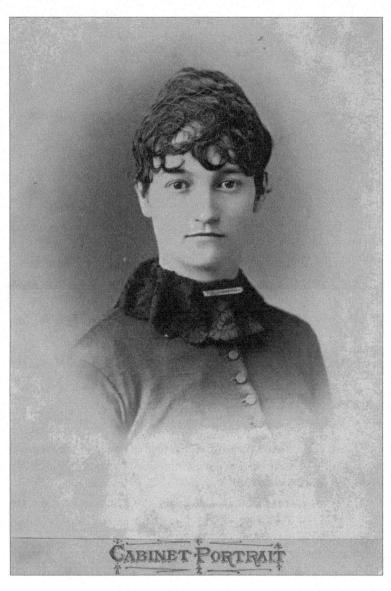

Susie Tillett, age nineteen, 1878. Photograph by W. E. Johns, Lexington, Kentucky

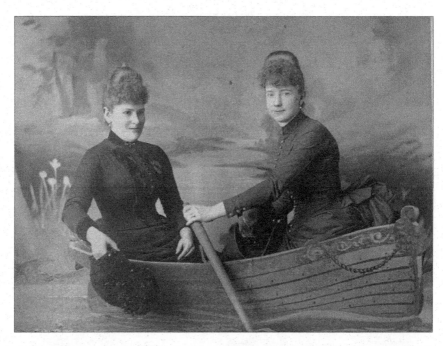

Lillie Tillett, at right, afloat with an unidentified friend in the studio of photographer Louis Schlegel, Richmond, Kentucky, probably mid-1880s. Courtesy of a descendant

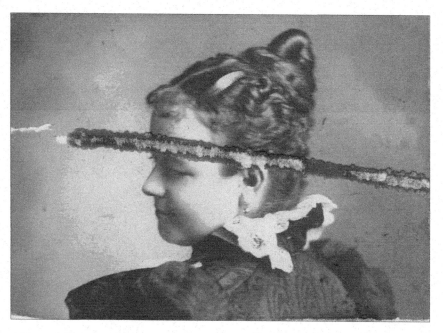

Nettie Tillett, age seventeen, about the time of her marriage to Daniel Reed in 1888. The slash, intentional or not, suggests the unpleasant events that immediately followed the marriage ceremony. Courtesy of a descendant

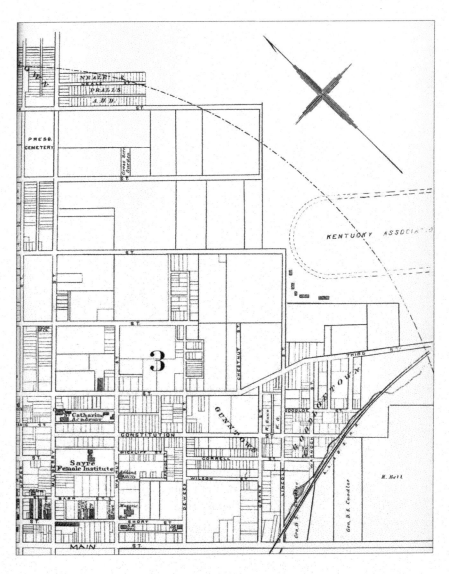

The Third Ward, Lexington, Kentucky, 1877. Grant Street, seen running north from Main Street at the bottom of this map, was renamed Megowan Street in the 1880s. From then until the late 1910s, the street was at the heart of the city's red-light district. From D. G. Beers, *Atlas of Bourbon, Clark, Fayette, Jessamine, and Woodford Counties, Ky* (Philadelphia, 1877)

372 LEXINGTON DIRECTORY.

Tilford Charles, c, whitewasher, res 57 Kenton.
Tilford James, c, farm hand, res 57 Kenton.
Tilford Lewis, c, with racers. res 178 Patterson.
Tillett Charles S., carpenter, res 79 Winnie.
Tillett Susie Mad., res 54 Megowan.
Tillett Wm. M., carpenter 32 E. Water, res 117 Constitution.
Tillow Wm. H., cashier Turf Exchange. res 178 S. Mill.
Tilman Tobias, c, wks W. S. Bell, res Henry.
Timberlake Francis M., "Tuck," bk-kpr Bush & Curran, res 40
 Barr.
Timberlake Frank R., clk C S frt depot, res 40 Barr.
Timberlake Geo. C., carriage painter, res 40 Barr.
Timmins Joseph, general machinist and res 14 W. Vine.
Timoney Tacy, wid James, res 297 E. Main.
Tindall John W., motorman Street Ry, res 21 Messick.
Tingle Eliza, clk 12 E. Main, res 214 N. Limestone.
Tingle Emma. res 214 N. Limestone.
Tingle Ernest B., clk and res 68 Race.
Tingle Leonard, clk 12 E. Main. res 214 N. Limestone.
Tingle Lulie, res 214 N. Limestone.
Tingle M. Ann, res 214 N. Limestone.
Tingle Mary E., res 214 N. Limestone.
Tingle Wm., carpenter, res 214 N. Limestone.
Tingle Wm., Jr., grocery and saloon 68 Race, res 269 E. Third.
Tinsley Adeline, c, wid Simon, res 22 Montmollin.
Tinsley Dafney, c, wid Wm., servt and res 134 Race.
Tinsley Saml., c, wks C. S. Ry. res 22 Montmollin.
Tipton Chas. E. (The Ky Steam Laundry), also member City
 Council, res 29 Lexington Ave.
Tipton Ed A., sec Ky Trotting Horse Breeders' Association,
 Northern Bank building, res 56 N. Upper.
Tisdale Annie G., res 290 N. Broadway.
Tisdale Aria C., res 290 N. Broadway.
Tisdale James F., fence builder, res 22 E. Maxwell.
Tishaus Henry, bar clk and res 87 E. Main.
Tobin Patrick J., wks Ky Union Ry, bds 394 E. Third.

Madam Susie Tillett and kin as they appeared in the 1890
City Directory of Lexington, Ky. (Lexington, 1890). Digital
image: *ancestry.com*

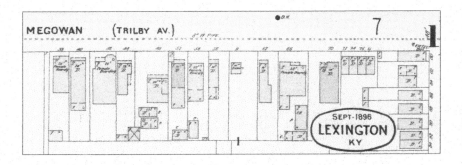

The house at 54 Megowan Street, Lexington, which Susie Tillett owned from 1889 to 1904. This and other nearby house are clearly identified as "female boarding houses," a recognized cartographic euphemism for a house of ill repute. Detail, *Sanborn Fire Insurance Map from Lexington, Fayette County, Kentucky* (New York, 1896), sheet 7. Library of Congress, Washington, D.C.

The block of Megowan Street (later Eastern Avenue), Lexington, where Susie Tillett owned a house from 1889 to 1904, as it looked in the 1970s just before the neighborhood was razed in the interest of "urban renewal." Buddy Thompson Papers, University of Kentucky Special Collections Research Center, Margaret I. King Library, Lexington, acc. 2009ms043

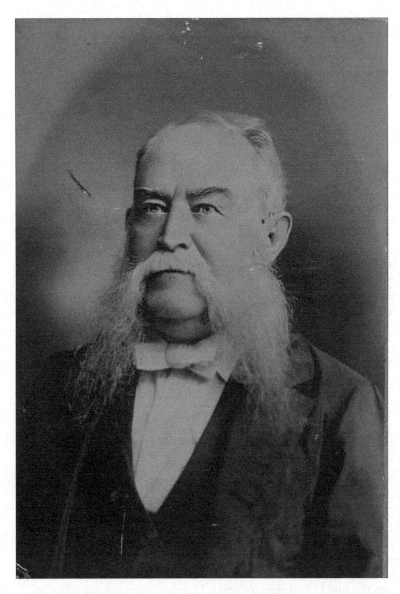

Francis Marion Jack, Atlanta businessman, official baker to the Confederacy, and father of William Arthur Jack, about 1880. Photographer unknown

CONFECTIONARIES.

F. M. JACK, Agent,

NEXT DOOR TO W. F. HERRING & CO.,

Whitehall St., Atlanta, Georgia.

KEEPS constantly on hand an excellent stock of CONFECTIONARIES,
• FRUITS,
CAKES,
NUTS,
CANDIES,
PRESERVES,
JELLIES,
PICKELS,
&c., &c.

Also, Fine Imported WINES, BRANDIES, TOBACCO, CIGARS, &c., &c.

Also, a great variety of Fancy Articles—Baskets, Toys, &c.

The Ladies and the Public generally are respectfully invited to call. mar8.

Advertisement for Francis M. Jack's bakery and confectionary on Whitehall Street, Atlanta, published in *Southern Confederacy*, Atlanta, April 12, 1861, the day rebel forces fired on Fort Sumter. Digital image: *gahistoricalnewspapers.galileo.usg.edu*

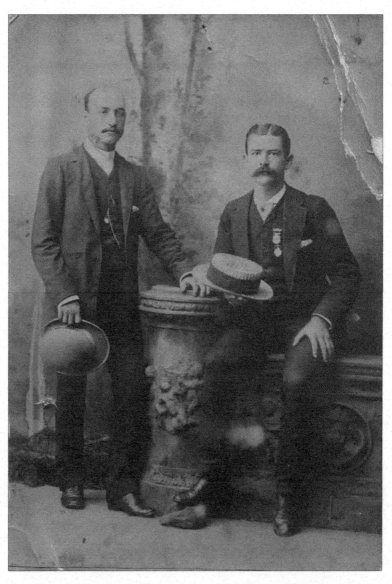

William Arthur Jack, known in his youth as "Will," age 20, seated, wearing his skating medals and holding a stylish boater, about 1881. The other man may be his friend and fellow skater George P. Lawshe. Photograph by Theophilus H. Ivie, High Art Production Co., Atlanta

Announcement of W. A. Jack's retirement from the
management of his skating rink in Milledgeville,
Georgia. *Milledgeville Union & Recorder,* April 19, 1881.
Digital image: *gahistoricalnewspapers.galileo.usg.edu*

J. J. FABER, Atlanta, Ga.

Francis Marion Jack II, son of William Arthur Jack and Belle
Harvill, 1889. Photograph by J. J. Faber, Atlanta

> ## Will Jack does the shaking at 43 Peachtree.

Advertisement for the Empire Baking Company, Atlanta, where Will Jack apparently showed off his talents as a mixologist. This is one of the last times that his name appeared in print as "Will." As of about 1890, he was more commonly known by his middle name, Arthur. *Atlanta Constitution,* May 6, 1888. Digital image: *newspapers.com*

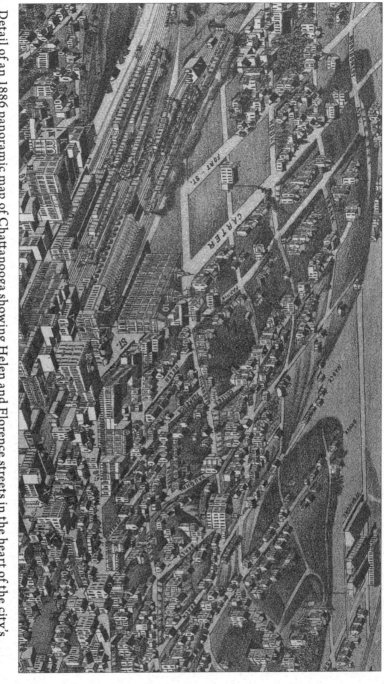

Detail of an 1886 panoramic map of Chattanooga showing Helen and Florence streets in the heart of the city's red-light district. From *Chattanooga, County Seat of Hamilton County, Tennessee 1886* (Milwaukee, 1886). Library of Congress, Geography and Map Division, Washington, D.C.

178

Thurman James, *c*, lab, r Orchard Knob
" Martha Miss, r Mtn Junc
" Shep, *c*, lab, bds 130 Harrison ave
" William, bds 5 E 4th
" William, *c*, r Ridgedale
" W, wks Sou Iron Co
Thurston Charles H, carp, r St Elmo
" G D G (Thurston & Pratt), sec and treas The Jet Marble Co, rooms 35 Keystone blk
THURSTON & PRATT (G D G Thurston, F B Pratt), timber, marble and mineral lands, room 18 Keystone blk (See opposite)
Thweatt Howard B, motorman Chatta Electric Ry, bds 622 Cherry
Tibbs A Jacob, bkkpr R Whigham Plumbing Co, r 302 Gillespie
" John L, agt, r Ridgedale
" L W, salesman T D Charlton, r Ridgedale
" Rousseau, *c*, driver J C Henderson & Bro
Tice Benjamin K, steward Hotel Stanton
Tidwell Walter L, painter C S Ry, r Alton Park

Tidyman Enoch, brick contractor, r 112 East Terrace
Tiffany Joseph M, millwright, r St Elmo
Tige G W, fireman, bds Citico Hotel
Tilford Albert, *c*, lab Howard & Parks, r 506 E Henry
" Lulah Miss clk Ladies' Bazaar, r Sherman Heights
" William E, clk E T V & G Ry, r St Elmo
Tiller Charles, confectioner 405 Market, r 413 Pine
" V A, wid Mason, bds 307 High
Tillett Susie Mad, r 113 10th
Tillman Dowell, *c*, lab Chatta Electric Ry, bds 407 W 9th
" Emmett, *c*, lab, bds 108 Union al
" James, *c*, lab, r 908 E 5th
" John, *c*, lab, r 536 W Montgomery ave
" Josephine Miss, r Vine St Orphan Home
" Robert, *c*, lab H A McQuade
" William, *c*, lab Snodgrass & Field
Tilman David, *c*, lab, bds 102 Forest ave
" James, *c*, lab, r 102 Forest ave
" William, *c*, lab, bds 102 Forest ave

Madam Susie Tillett as she appeared in the 1891 *Directory of Chattanooga Tennessee* (Chattanooga, 1891). Digital image: *ancestry.com*

179

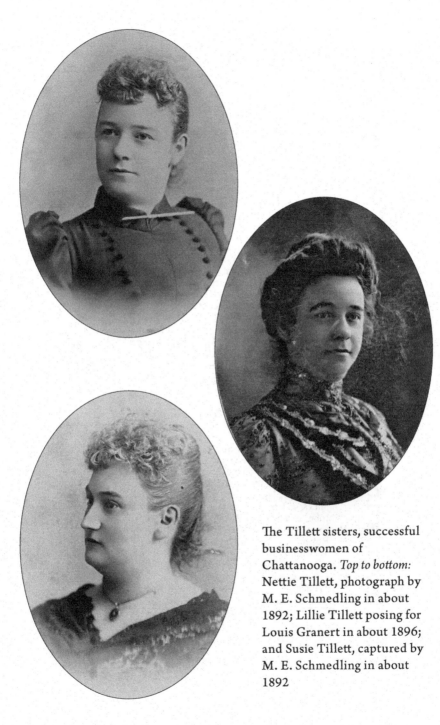

The Tillett sisters, successful businesswomen of Chattanooga. *Top to bottom:* Nettie Tillett, photograph by M. E. Schmedling in about 1892; Lillie Tillett posing for Louis Granert in about 1896; and Susie Tillett, captured by M. E. Schmedling in about 1892

Lillie, Susie, and Nettie Tillett, dressed for success, in
a tintype taken by an unknown photographer probably
in the early 1890s in Chattanooga. Courtesy of a
descendant

Right to left: Susie Tillett, Nettie Tillett, and unknown child, swathed and on the hoof, climbing Lookout Mountain, Chattanooga, probably mid-1890s. Photographer unknown

Lillie Tillett, at left, with an unidentified friend, Lookout Mountain, probably mid-1890s. Photographer unknown. Courtesy of a descendant

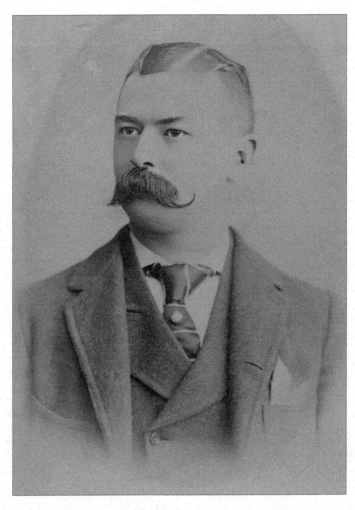

William Arthur Jack, henceforth known as "Arthur," as
he looked at the time he met Susie Tillett, about 1892.
Photograph by M. E. Schmedling, Chattanooga

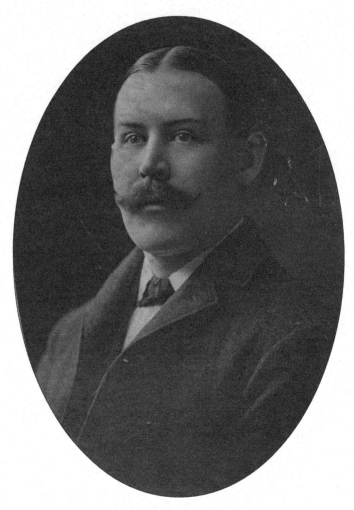

James Russell Jack, famed mixologist, taken by an unknown photographer, probably in Atlanta in the early 1890s

Arthur Jack (seated at left) and Susie Tillett (standing at right) with two
unidentified friends, Umbrella Rock, Lookout Mountain, Tennessee,
probably mid-1890s. Photograph by Rollins & Linn, Lookout Mountain

PLUGGED BY HUBBY'S BULLETS.
ARTHUR JACK GETS THREE BULLETS IN HIM FOR MONKEYING WITH MRS. SPENCER, CHATTANOOGA, TENN.

The shooting of Arthur Jack, Missionary Ridge, Tennessee. *Left to right*: Nellie Spencer, Arthur Jack, Ed Spencer, unnamed horse, and Si Spencer; as imagined by an unknown illustrator for the *National Police Gazette*, March 24, 1894

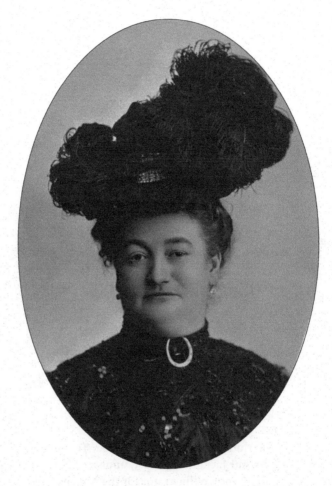

Madam Susie Tillett, formidable in feathered hat and horseshoe-shaped diamond brooch, probably late 1890s. Photograph by Louis Granert, Chattanooga

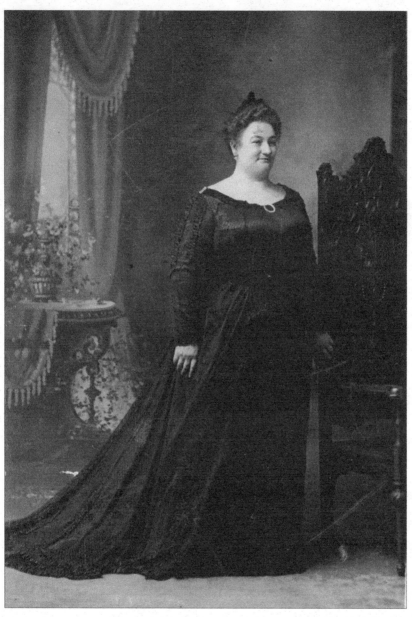

Susie Tillett at the height of her Rubenesque beauty, wearing her favorite diamond brooch, probably late 1890s. Photograph by Louis Granert, Chattanooga

Arthur Jack, at right in bartender's apron, in front of Isadore Brickman's
Saloon, Commerce Street, Montgomery, Alabama, 1897. The door at far
right, next to the vaudeville poster, leads to an undertaker's parlor.

Two of Arthur Jack's trotting horses, 1899 or 1900. *Above:* J.R.J., his
most successful horse. Photographer unknown. *Below:* Susie T., from
unidentified newspaper clipping in the Jack-Tillett Scrapbook

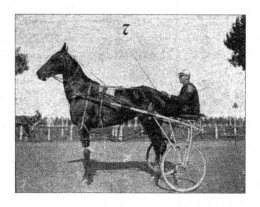

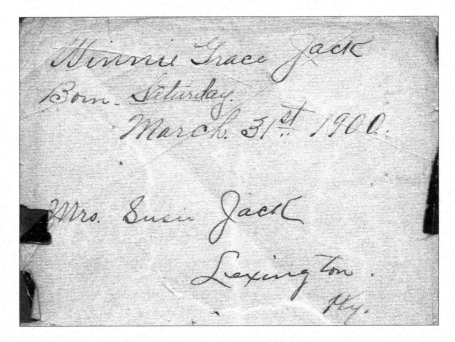

Detail of the only surviving page of Susie Tillett Jack's bible with the only surviving contemporaneous record of the birth of her daughter. (Transcription below). Collection of the author

Winnie Grace Jack
Born Saturday.
 March 31st 1900
Mrs. Susie Jack
 Lexington,
 Ky.

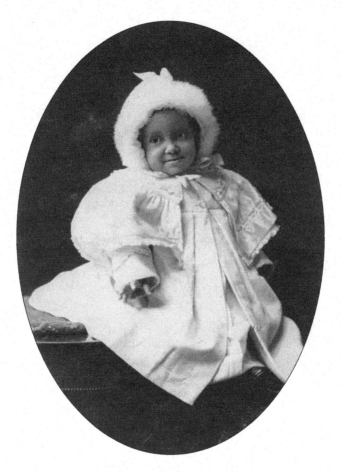

Gracie Jack, age six months, 1900. Photograph by
Louis Granert, Chattanooga

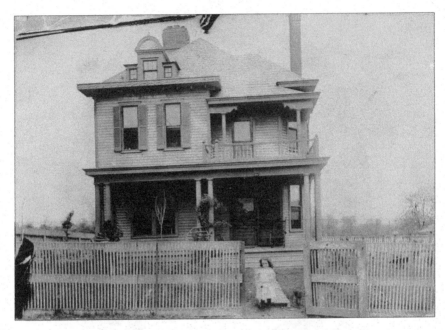

Gracie Jack at home, 647 Chestnut Street, Lexington, Kentucky, about 1903. Photographer unknown

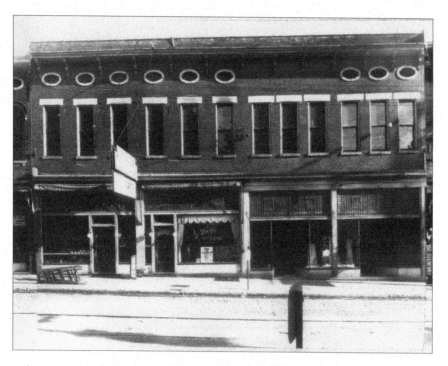

The east side of the block of North Limestone between Main and Short streets, Lexington, as it appeared around 1920. The double-entranced storefront on the right was the site of Jack's Majestic Saloon from 1903 to 1907. The Asa Coleman Chinn Downtown Lexington, Kentucky, Photographic Collection, 1920-1921. University of Kentucky Special Collections Research Center, Margaret I. King Library, Lexington

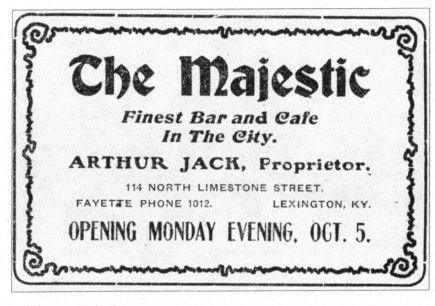

Advertisement for Arthur Jack's popular Majestic Saloon & Café, Lexington. *Lexington Leader,* October 5, 1903. Digital image: *newspapers. com*

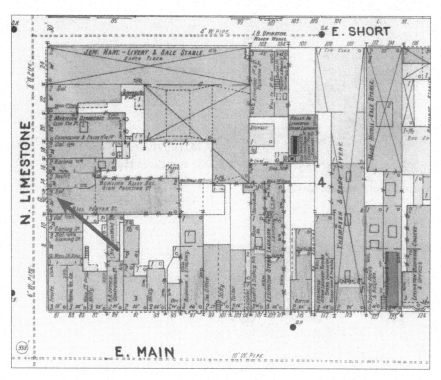

Arthur Jack's Majestic Saloon & Café, 12-14 North Limestone,
Lexington. Thanks to the depth of the lot that it occupied, the Majestic
was substantially larger than other saloons in the area. Detail, *Sanborn
Fire Insurance Map for Lexington, Fayette County, Kentucky* (New York, 1901),
sheet 17. Library of Congress, Washington, D.C.

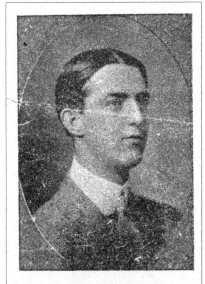

F. MARION JACK.

F. Marion Jack, son of Arthur Jack and Belle Harvill, Atlanta, age eighteen, 1900. From an unidentified clipping in the Jack-Tillett Scrapbook

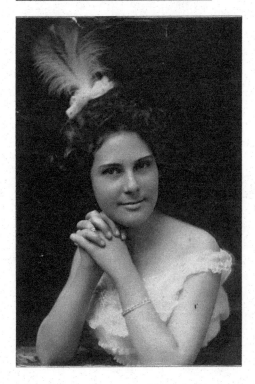

Hazel Madeline Crutcher (1885-1986), long-lived veteran of a short-lived marriage to Marion Jack, shown here at the time of that marriage in 1901. Photographer unknown

The Majestic Theater, North Upper Street, Lexington, Kentucky, as it looked in 1908. Reconstruction drawing by Darrell S. Ung, 2019. Collection of the author

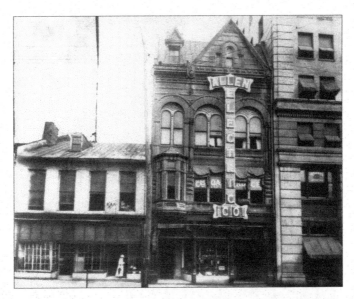

10-14 North Upper Street, Lexington, formerly Arthur Jack's Majestic Theater, as it looked in 1920. The Asa Coleman Chinn Downtown Lexington, Kentucky, Photographic Collection, 1920-1921. University of Kentucky Special Collections Research Center, Margaret I. King Library, Lexington

Arthur Jack in front of his Majestic Theater, North Upper Street, Lexington, 1908. Photographer unknown

MAJESTIC THEATER

THE HOME OF PROGRESSIVE

VAUDEVILLE

ALL THIS WEEK

THE CARPENTERS,
Comedy Sketch Artists.
NEMO,
Equilbrist and Barrel Jumper.
THE MARTINES,
Singing, Talking, Dancing Sketch Artists.
HALL BARTON,
Comedian.
THE MAJESTIC ORCHESTRA,
Best in the City.
MAJESTISCOPE
Latest Motion Pictures.
3—SHOWS DAILY—3
Matinees 3 P. M. .Evenings, 7:30 and 9.
TWO MATINEES

Saturday 2:30 and 4.

Prices reduced to

10c

NIGHT SHOWS 7:30 AND 9:00.

A typical bill for Jack's Majestic Theater, Lexington.
Lexington Herald, January 27, 1908. Digital image:
newspapers.com

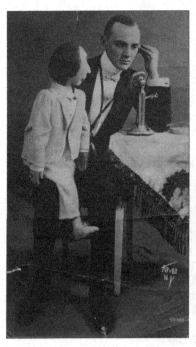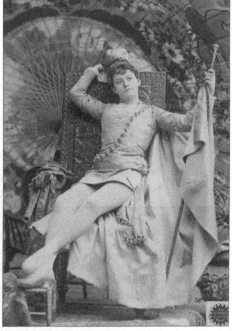

Here, and on the following page, vaudeville stars who performed at
Arthur Jack's Majestic Theater, Lexington, Kentucky in 1908.
Left: The Great Lester, ventriloquist, and his side-kick Frank Byron Jr,
photograph by Apollo, New York
Right: Marie Jansen, singer and actress. Photograph by Falk, New York

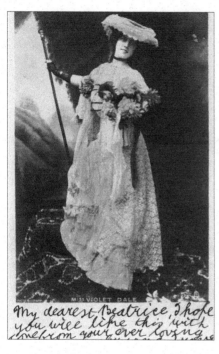
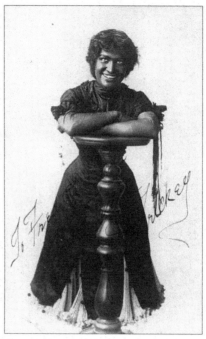

Left: the actress Violet Dale, in one of her coquettish roles. Photograph by Biograph, New York
Right: Coy de Trickey in one of her unfortunate blackface ones. Photograph by Striffler Studio, Marinette, Wisconsin

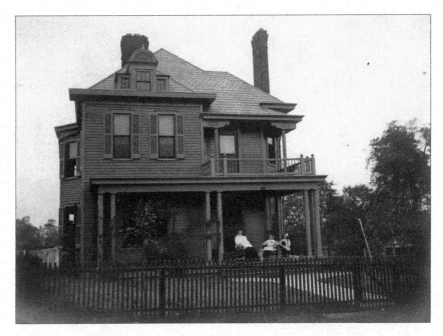

Mrs. Susie Jack, her niece, Nettie O'Hare, and her daughter, Gracie Jack, on the porch of 647 Chestnut Street, Lexington, about 1907. Photograph by Butler Brothers, Lexington

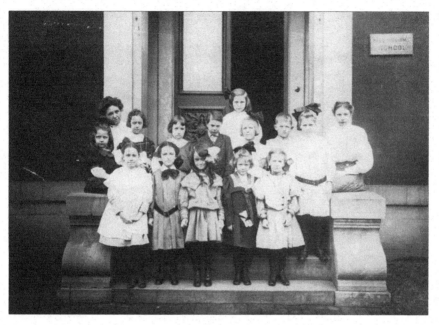

Miss Ella Williams' School, North Broadway, Lexington, 1907. Gracie Jack, age seven, is front and center. Photographer unknown

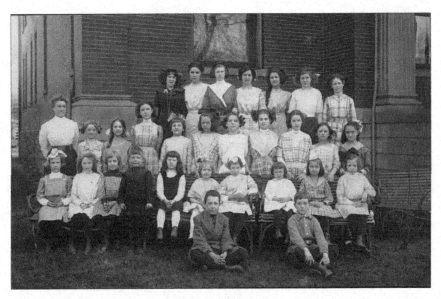

The Preparatory Department of Campbell-Hagerman College, Lexington, 1910. Gracie Jack, age ten, is in the second full row, far right. Photographer unknown

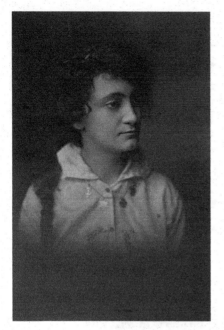
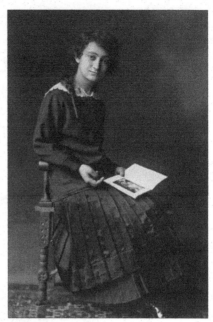

Gracie Jack, growing up: in 1914, wearing her piano medals; in 1915; and in 1916. Photographers unknown

La Fayette Cafe

ARTHUR JACK, MGR.

MAIN AND BROADWAY.

JUST OPEN

ONLY THE BEST THINGS TO EAT

MENU

BOUILLON SOUP BRANCHES OF CELERY
 SUPREME BREAST OF CHICKEN
 BRAISED HAM, CHAMPAGNE SAUCE
SNOWFLAKE POTATOES CANDIED YAMS
EGG PLANT JUNE PEAS
 CALIFORNIA A LA PERRIE SARATOGA FLAKES
 ICE CREAM
ROQUEFORT CHEESE BENT CRACKERS
 COFFEE, TEA, ICED TEA, MILK

SPECIAL DINNER, 5:30 TO 7:30, 50 CENTS

SUNDAY, MAY 9, FROM 5:30 TO 7:30

La Fayette Café

CORNER MAIN AND BROADWAY

Arthur Jack's short-lived La Fayette Café, as advertised in *Lexington Leader*, April 22 and *Lexington Herald*, May 9, 1915. Digital images: *newspapers.com*

I Discovered That Chickens Must Eat

"I Discovered That Chickens Must Eat," clipping from an unidentified magazine, about 1910, Jack-Tillett Scrapbook. Family tradition says that the woman in this photograph is Susie Jack, breeder of prize-winning poultry.

Jack's Staple & Fancy Grocery, 651 Chestnut
Street, Lexington, 1916. Arthur Jack and Nick
Nickoson during construction of the store

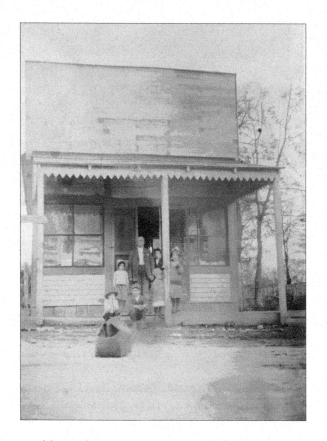

Jack's Staple & Fancy Grocery, 651 Chestnut
Street, Lexington, 1916. Arthur Jack and
neighborhood children on the store's porch

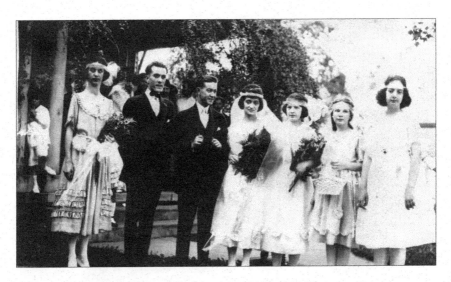

Dearinger–Jack wedding party, June 21, 1921, 647 Chestnut Street, Lexington.
Left to right: Rosalie Dearinger, maid of honor; Paul Dearinger, best man; the newlyweds, June Dearinger and Gracie Jack; Gracie's best friend, Nellie Griffing, bridesmaid; and Gracie's cousins Frances Brandt, flower girl, and Almeda Warnock, bridesmaid

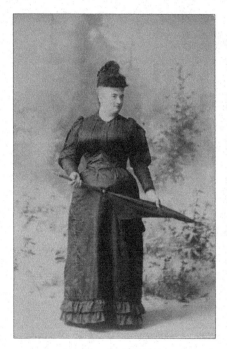 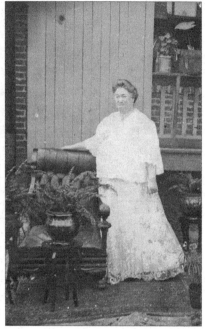

Left: Susie Tillett in her prime, early 1890s. Photograph by M. E. Schmedling, Chattanooga
Right: Susie as one of what the press called the "last roses" of Chattanooga's red light district, mid to late 1910s. Photographer unknown

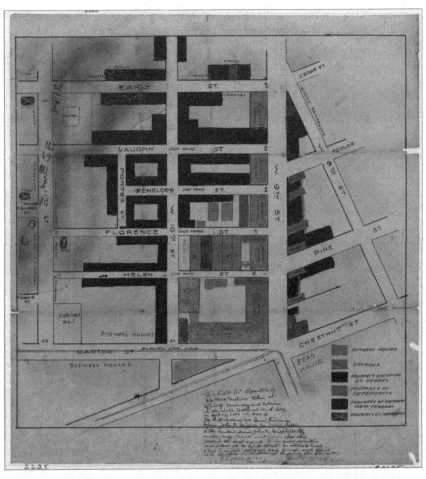

Color-coded map of Chattanooga's red light district, made for and presented into evidence in the case of *Weidner vs. Friedman,* Hamilton County Circuit Court, 1908-1912. Digital image: *digital.mtsu.edu/digital/collection/p15838coll7/id/119/*

Helen Street as recorded in the 1917 Chattanooga city directory, following the final purge of the city's red light district. *City Directory of Chattanooga and Suburbs* (Chattanooga, 1917). Digital image: *ancestry.com*

Arthur and Susie Jack on the porch at home,
647 Chestnut Street, Lexington, about 1921.
Photographer unknown

Arthur Jack reading at "his window" at home, Lexington, 1935.
Photograph by his thirteen-year-old grandson, Jack Dearinger

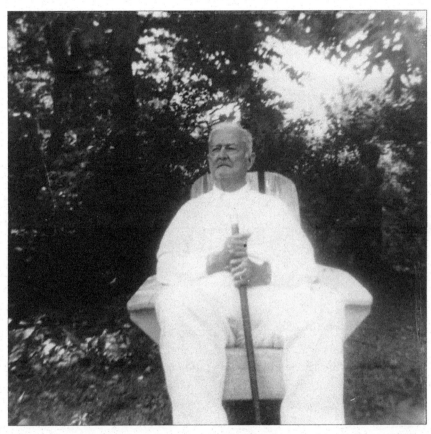

Arthur Jack, Lexington, Kentucky, May 29, 1944, the day before he died

Genealogy Charts

1a. Descendants of Samuel W. and America Susan (Lanham) Tillett

(Continued on facing page)

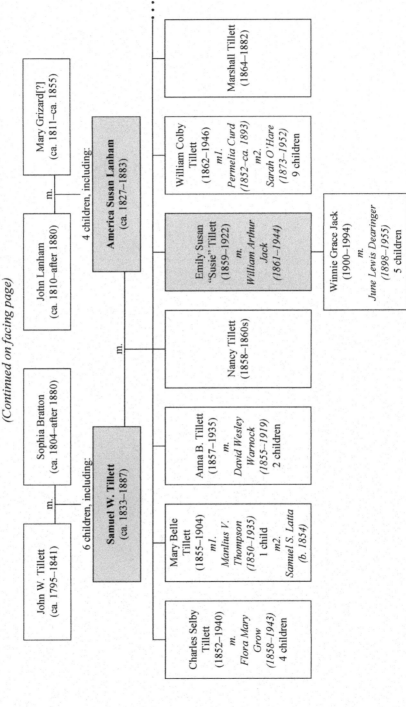

John W. Tillett
(ca. 1795–1841)

m.

Sophia Bratton
(ca. 1804–after 1880)

John Lanham
(ca. 1810–after 1880)

m.

Mary Grizard[?]
(ca. 1811–ca. 1855)

6 children, including:

Samuel W. Tillett
(ca. 1833–1887)

m.

4 children, including:

America Susan Lanham
(ca. 1827–1883)

Charles Selby Tillett
(1852–1940)
m.
*Flora Mary Grow
(1858–1943)*
4 children

Mary Belle Tillett
(1855–1904)
m1.
*Manlius V. Thompson
(1850–1935)*
1 child
m2.
*Samuel S. Latta
(b. 1854)*

Anna B. Tillett
(1857–1935)
m.
*David Wesley Warnock
(1855–1919)*
2 children

Nancy Tillett
(1858–1860s)

Emily Susan "Susie" Tillett
(1859–1922)
m.
*William Arthur Jack
(1861–1944)*

William Colby Tillett
(1862–1946)
m1.
*Permelia Curd
(1852–ca. 1893)*
m2.
*Sarah O'Hare
(1873–1952)*
9 children

Marshall Tillett
(1864–1882)

Winnie Grace Jack
(1900–1994)
m.
*June Lewis Dearinger
(1898–1955)*
5 children

220

1b. Descendants of Samuel W. and America Susan (Lanham) Tillett

(Continued from facing page)

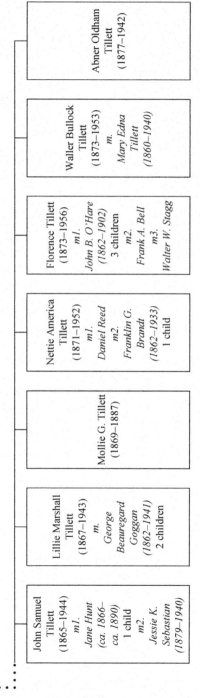

John Samuel
Tillett
(1865–1944)
m1.
Jane Hunt
(ca. 1866–
ca. 1890)
1 child
m2.
Jessie K.
Sebastian
(1879–1940)

Lillie Marshall
Tillett
(1867–1943)
m.
George
Beauregard
Goggan
(1862–1941)
2 children

Mollie G. Tillett
(1869–1887)

Nettie America
Tillett
(1871–1952)
m1.
Daniel Reed
m2.
Franklin G.
Brandt
(1862–1933)
1 child

Florence Tillett
(1873–1956)
m1.
John B. O'Hare
(1862–1902)
3 children
m2.
Frank A. Bell
m3.
Walter W. Stagg

Waller Bullock
Tillett
(1873–1953)
m.
Mary Edna
Tillett
(1860–1940)

Abner Oldham
Tillett
(1877–1942)

221

2. Descendants of Francis Marion and Sophia W. (Rucker) Jack

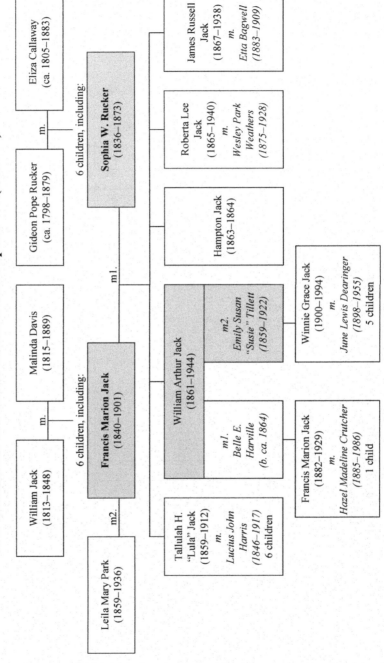

APPENDIXES

These lists include the names of women who were identified in contemporary sources as having been owners or operators (madams) of houses of prostitution in the cities of Lexington, Kentucky, and Chattanooga, Tennessee, in the years between the Civil War and World War I. The following abbreviations are used here:

BGB	*Blue-Grass Blade*
CC	*Chattanooga Commercial*
CDC	*Chattanooga Daily Commercial*
CDT	*Chattanooga Daily Times*
CN	*Chattanooga News*
CStar	*Chattanooga Star*
CSun	*Chattanooga Sun*
DC	*Daily Chattanoogan*
LH	*Lexington Herald*
LL	*Lexington Leader*

Weidner & Friedman *M. G. Weidner, et al., vs. Irene Friedman, et al.,* Hamilton County, Tennessee, Chancery Court, suit no. 11444, 1908-1912. Tennessee State Library and Archives, Nashville

Census records cited here are federal population schedules.

Sources: *ancestry.com*; *newspapers.com*; and *genealogybank.com*, all accessed in 2022 or 2023.

In the interest of space, the titles of most articles have been abbreviated.

A. The Madams of Lexington, Kentucky

Abrams, Nellie
 Lexington city directory 1887 — madam 52 Megowan St
 Lexington city directory 1888 — madam 59 Dewees St
 "Anyone Get Away," *LL*, 18 Feb 1889 — charged as nuisance
Adams, Birdie
 "Criminal Court Begins," *LL*, 8 Jun 1918 — disorderly house
Albright Isabelle
 Census 1910 Fayette Co KY Lexington — in house of ill fame
 "Shoots Woman," *LH*, 14 Apr 1911 — in resort Megowan St
 "57 Cases," *LL*, 1 Oct 1914 — disorderly house
 "Misdemeanor Docket," *LL*, 12 Oct 1914 — disorderly house
Allen, Minnie
 Lexington city directory 1906-07 — 139 Megowan St
 "3 Wounded," *LL*, 31 May 1908 — resort 139 Megowan St
 "Two Women and Man," *LH*, 31 May 1908 — disorderly house
 "Coroner's Inquest," *LL*, 1 Jun 1908 — resort Megowan St
 "Classified Ads: Lost," *LL*, 7 Dec 1908 — 139 Megowan St
 Lexington city directory 1909 — 139 Megowan St
 Census 1910 Fayette Co KY Lexington — of ill fame
 "Woman Shot Dead," *LH*, 4 Sep 1910 — 139 Megowan St
 "Killing in a Resort," *LL*, 4 Sep 1910 — resort 139 Megowan St
 Lexington city directory 1911 — 139 Megowan St
 "Vaughn Found Guilty," *LL*, 14 Jan 1911 — resort Megowan St
 Lexington city directory 1912 — 139 Megowan St
 "John Bishop," *LL*, 20 Apr 1912 — resort 139 Megowan St
 "John Bishop Ends Life," *LH*, 21 Apr 1912 — resort 139 Megowan St
 "Elimination of Red Light," *LL*, 8 Nov 1913 — rents bawdy house
 "Grand Jury Advises," *LH*, 8 Nov 1913 — rents bawdy house
 Lexington city directory 1914-15 — 139 Megowan St
 "City Indicted," *LL*, 9 Nov 1915 — disorderly house
 "Those Charged," *LL*, 16 Mar 1916 — disorderly house
Ambrose, Sarah
 Lexington city directory 1888 — madam 103 West High St
Anderson, Belle
 "Shot Woman," *LL*, 18 Sep 1915 — resort 165 Megowan St
 "Grand Jury," *LH*, 12 Nov 1915 — disorderly house
 "Those Charged," *LL*, 16 Mar 1916 — disorderly house
Armstrong, Jennie
 "The Legal Record," *LL*, 19 Aug 1889 — disorderly house
Arnold, Fannie
 Lexington city directory 1881-82 — 157 North Upper
 Lexington city directory 1883-84 — 148 North Upper
 Lexington city directory 1888 — 54 Megowan St

"Megowan Muddle," *LL*, 20 Jun 1888 — "lady of Megowan St"
Lexington city directory 1895 — madam 52 Megowan St
"Serious Charges," *LH*, 12 Jan 1896 — in disreputable house
"Locked Up," *LL*, 12 Jan 1896 — arrested on Megowan St
"In the Police Court," *LL*, 30 Jun 1896 — ill-governed house
"Young Boys Are Fined," *LL*, 13 Sep 1899 — lives on Megowan St
"Police Court," *LL*, 14 Sep 1899 — house on Megowan St
Census 1900 Fayette Co KY Lexington — boards 52 Megowan St
"Two Fires," *LL*, 4 Apr 1900 — 52 Megowan St
Lexington city directory 1902-03 — 142 (52) Megowan St
"Police Court," *LL*, 8 Feb 1902 — house on Megowan St
"Fannie Arnold Dies," *LL*, 22 Jun 1904 — died 48 Megowan St

Atchison, Sue/Susie
Lexington city directory 1888 — madam 61 W Water St

Bailey, Margaret
"Disorderly Houses," *LH*, 24 Jan 1912 — disorderly house

Baker, Jessie
"Police Court," *LL*, 5 Jun 1903 — disorderly house Dewees St

Baker, Josephine
"Three Women," *LH*, 17 Apr 1918 — disorderly house
"14 Arrested," *LL*, 21 Aug 1918 — disorderly house
"Vice Hearing," *LH*, 29 Aug 1918 — disorderly house

Banks, Clara
"Disorderly House," *LL*, 14 Dec 1911 — disorderly house 219 Constitution
"Disorderly Houses," *LH*, 24 Jan 1912 — disorderly house 219 Dewees

Barbee, Bertha
"June Criminal Court," *LL*, 14 Jun 1914 — disorderly house
"Lee Anderson Case," *LL*, 22 Jun 1914 — disorderly house
"57 Cases," *LL*, 1 Oct 1914 — disorderly house
"Misdemeanor Docket," *LL*, 12 Oct 1914 — disorderly house

Barkley, Maggie (Mrs. West P.)
"Civil Term," *LH*, 6 Oct 1903 — disorderly house
"Shooting Affray," *LL*, 28 Nov 1903 — denizen of Megowan St
"Nine Murder," *LH*, 5 Apr 1914 — disorderly house

Barnes, Bettie
Lexington city directory 1888 — madam 5 Spruce St
"Good Long List," *LL*, 9 Nov 1892 — bawdy house
"101," *LL*, 16 Nov 1892 — bawdy house

Barnett, Mrs. Belle (a.k.a. Belle Campbell)
Lexington city directory 1902-03 — 129 (35) Megowan St
Lexington city directory 1904-05 — 129 Megowan St
Lexington city directory 1906 — 129 Megowan St
Lexington city directory 1909 — 129 Megowan St
Census 1910 Fayette Co KY Lexington — house of ill fame
Lexington city directory 1911 — 129 (35) Megowan St
Lexington city directory 1912 — 131 (35) Megowan St
"Grand Jury Advises," *LH*, 8 Nov 1913 — rents bawdy house

Lexington city directory 1914-15	131 Megowan St
"Attempted Robbery," *LH*, 8 Jan 1915	resides 35 Megowan St
"City Indicted," *LL*, 9 Nov 1915	disorderly house
Lexington city directory 1916-17	148 Megowan St
"Those Charged," *LL*, 16 Mar 1916	disorderly house
Bennett, Leona/Lena	
"Good Long List," *LL*, 9 Nov 1892	bawdy house
"One Hundred " *LL*, 16 Nov 1892	bawdy house
Berry, Amelia	
"Fifty-Three Cases," *LL*, 15 Jul 1895	disorderly house
Black, Lula	
"Will He Hang," *LL*, 20 Jun 1889	house 22 Wickliffe St
"Good Long List," *LL*, 9 Nov 1892	bawdy house
"101," *LL*, 16 Nov 1892	bawdy house
Blackburn, Fannie	
Lexington city directory 1895	madam 44 Megowan St
Board, Lucille/Lucy (a.k.a. Mother Board)	
Lexington city directory 1911	146 Megowan St
"Men Indicted," *LL*, 20 Feb 1914	disorderly house
"Nine Murder," *LH*, 5 Apr 1914	disorderly house
"Bradley Gets $25," *LL*, 15 Apr 1914	disorderly house
"June Criminal Court," *LL*, 14 Jun 1914	disorderly house
"Lee Anderson Case," *LL*, 22 Jun 1914	disorderly house
"Cases Disposed," *LL* 15 Jun 1915	disorderly house
"Those Charged," *LL*, 16 Mar 1916	disorderly house
"Misdemeanor," *LL*, 27 Mar 1918	disorderly house
"Vice Cases," *LH*, 23 Jun 1918	disorderly house
"14 Arrested in Raid," *LL*, 21 Aug 1918	577 E Third
"Vice Hearing," *LH*, 29 Aug 1918	disorderly house
"Cases," *LH*, 25 Sep 1918	disorderly house
Bohannon, Mrs. J. T.	
"Bench Warrants," *LH*, 23 Sep 1917	disorderly house
"Held to Grand Jury," *LL*, 3 Dec 1918	disorderly house
Bonnell, Mamie	
"Police Court," *LL*, 1 Aug 1908	disorderly house
Boone, Lucy	
Lexington city directory 1888	madam 30 Wickliffe St
"Recorder's Court," *LL*, 22 May 1888	of demi monde North Upper
Bowers, Lillian	
Census 1910 Fayette Co KY Lexington	140 Megowan St
Lexington city directory 1911	133 Megowan St
"Woman Injured," *LL*, 12 Mar 1911	resort 137 Megowan St
Lexington city directory 1912	133 Megowan
"Grand Jury Advises," *LH*, 8 Nov 1913	rents bawdy house
Lexington city directory 1914-15	house 133 Megowan St
Bowman, Pauline	
"Circuit Court," *LL*, 23 Jul 1908	disorderly house

"Sig H. Speyer Indicted," *LL*, 15 Apr 1912 — disorderly house
"Grand Jury," *LH*, 16 Apr 1912 — disorderly house
"Thirteen Murder Cases," *LL*, 30 Jun 1912 — disorderly house
"Minimum Sentence," *LH*, 16 Jul 1912 — disorderly house
Bowman, Pet M.
"Ten Persons Indicted," *LH*, 27 Jun 1900 — disorderly house Patterson St
"232 Cases," *LL*, 1 Oct 1911 — disorderly house
"Criminal Term," *LL*, 1 Oct 1911 — disorderly house
Bradley, Mollie
"Good Long List," *LL*, 9 Nov 1892 — bawdy house
"101," *LL*, 16 Nov 1892 — bawdy house
Brassart, Catherine
Census 1860 Fayette Co KY Lexington — house of ill fame
Brezing/Breezing, Belle
Census 1880 Fayette Co KY Lexington — boards Jennie Hill's house
Lexington city directory 1881-82 — boards Jennie Hill's house
Lexington city directory 1885-86 — 194 North Upper St
Lexington city directory 1887 — madam 194 North Upper
Lexington city directory 1888 — madam 194 North Upper
"Set 'Em Up," *LL*, 23 May 1888 — madam
"Thurman Talks," *LL*, 22 Jun 1888 — madam
"Complaints Made," *LL*, 24 Sep 1888 — madam 5th and Chestnut
"A Correction," *LL*, 28 Sep 1888 — madam 5th and Chestnut
"The Thurman Trial," *LL*, 7 Dec 1888 — deposed in theft trial
"That Box Case," *LL*, 9 Dec 1888 — deposed in theft trial
"Anyone Get Away?" *LL*, 18 Feb 1889 — charged with nuisance
"For Sale," *LL*, 12 Mar 1889 — 194 North Upper for sale
"Take Notice," *LL*, 6 Jun 1889 — moving from present residence
Lexington city directory 1890 — Megowan and Wilson Sts
"National Committee," *BGB*, 19 Dec 1891 — madam
"M'Garvey's Sermon," *BGB*, 19 Dec 1891 — madam
"Jailed," *LL*, 29 Mar 1892 — madam on Megowan St
"On Trial," *LL*, 30 Mar 1892 — immoral madam
"Good Long List," *LL*, 9 Nov 1892 — bawdy house
"101," *LL*, 16 Nov 1892 — bawdy house
Lexington city directory 1893 — madam 59 Megowan St
"After Saloons," *LL*, 5 Oct 1893 — unlawful sale of liquor
Lexington city directory 1895 — madam 59 Megowan St
"Madam Breezing's Loss," *LL*, 23 Mar 1895 — madam
"Trial Docket," *LL*, 9 Feb 1896 — Breezing vs. Brown
Lexington city directory 1898 — house 59 Megowan St
"A Marked Bill," *LL*, 12 Sep 1898 — madam
"Captures," *LH*, 13 Sep 1898 — madam
"Losing No Time," *LL*, 13 Dec 1898 — madam
"Given One Year," *LH*, 14 Dec 1898 — madam
Census 1900 Fayette Co KY Lexington — house with 4 female boarders
Lexington city directory 1902-03 — 149 (59) Megowan St

"Fires of a Day," *LL*, 14 Jan 1902	madam on Megowan St
"Seven," *LL*, 30 May 1902	immoral house
"Criminal Docket," *LH*, 31 Aug 1902	immoral house
"Grand Jury," *LL*, 6 Dec 1903	immoral house
Lexington city directory 1904-05	153 Megowan St
Lexington city directory 1906-07	153 Megowan St
Lexington city directory 1909	153 Megowan St
Census 1910 Fayette Co KY Lexington	house of ill fame
"Grand Jury," *LL*, 5 Feb 1910	immoral house
"Grand Jury," *LH*, 6 Feb 1910	immoral house
"458 Cases Docketed" *LH*, 3 Apr 1910	immoral house
Lexington city directory 1911	153 Megowan St
"Pledge Offered," *LL*, 15 Jan 1911	madam
"Broaddus Gives Up," *LL*, 11 Jul 1911	resort Megowan St
"Insanity," *LL*, 5 Oct 1911	resort Megowan St
"Oliver Broaddus," *LL*, 6 Oct 1911	resort Megowan St
Lexington city directory 1912	153 Megowan St
"Grand Jury Advises," *LH*, 8 Nov 1913	bawdy house
"Elimination Red Light," *LL*, 8 Nov 1913	bawdy house
Lexington city directory 1914-15	153 Megowan St
Lexington city directory 1916-17	153 Megowan St
"Those Charged," *LL*, 16 Mar 1916	disorderly house
"Report," *LL*, 23 Oct 1917	house of prostitution
Britton, Jane	
"Police Court," *LL*, 1 Sep 1900	disorderly house
Brown, Mollie	
"Police Court," *LH*, 9 Jul 1915	disorderly house
Brown, Sophie	
"Those Charged," *LL*, 16 Mar 1916	disorderly house
Bruin, Sue	
"Good Long List," *LL*, 9 Nov 1892	bawdy house
"101," *LL*, 16 Nov 1892	bawdy house
Bryant, Maud	
"Those Charged," *LL*, 16 Mar 1916	disorderly house
Bryant, Sarah	
Census 1860 Fayette Co KY Lexington	house of ill fame
Buckner, Kate	
"In Police Court," *LL*, 18 Nov 1895	disorderly house
Bullock, Carrie K.	
"Circuit Court," *LH*, 27 Jun 1917	disorderly house
Caldwell, Ada	
Lexington city directory 1895	madam 89 Dewees St
Campbell, Belle (a.k.a. Belle Barnett)	
"Suicide," *LL*, 1 Sep 1894	resort 31 Megowan St
Lexington city directory 1890	madam 31 Megowan St
Lexington city directory 1895	madam 31 Megowan St
"On the Doorstep," *LL*, 31 May 1895	house on Megowan St

"Shot Twice," *LL*, 25 May 1896 — house on Megowan St
Lexington city directory 1895 — madam 31 Megowan St
Lexington city directory 1898 — 31 Megowan St
Census 1900 Fayette Co KY Lexington — 54 Megowan St
"Robbery," *LL*, 9 Feb 1903 — resident 35 Megowan St
"Forgery," *LL*, 13 Feb 1903 — resident Megowan St
"Another Warrant," *LL*, 23 Feb 1903 — resident Megowan St
"J. R. Lucas," *LL*, 14 Jul 1905 — resort on Megowan St
Campbell, Katie
Census 1900 Fayette Co KY Lexington — 52 Megowan St
Carlisle, Mattie
"Two Indictments," *LL*, 17 Oct 1916 — disorderly house
"Criminal Docket," *LL*, 23 Mar 1917 — disorderly house
Carroll, Eliza
"Most All Continued," *LL*, 30 Jul 1894 — disorderly house
Case, Sophie
"Three Cases," *LL*, 4 Oct 1917 — disorderly house
Cassidy, May
Lexington city directory 1893 — madam 52 Megowan St
Childers, Ella (Mrs. Boston "Bull" Durham)
Lexington city directory 1890 — madam 52 Megowan St
"Recorder's Court," *LL*, 17 May 1891 — member of the demi-monde
"Megowan Fight," *LL*, 18 Aug 1892 — madam 52 Megowan St
"She Wanted to Die," *LL*, 15 Sep 1892 — "toughest resort in the city"
"Recorder's Court," *LL*, 27 Sep 1892 — disorderly house Megowan St
"Good Long List," *LL*, 9 Nov 1892 — bawdy house
"101," *LL*, 16 Nov 1892 — bawdy house
Lexington city directory 1893 — madam 33 Megowan St
Lexington city directory 1895 — madam 34 Megowan St
"Fire This Morning," *LH*, 22 Oct 1896 — 34 Megowan St
Lexington city directory 1898 — 34 Megowan St
"Two Hours' Session," *LL*, 20 Jun 1899 — house on Megowan St
"Another Small Blaze," *LL*, 22 Feb 1901 — madam 34 Megowan St
"Real Estate," *LH*, 20 Nov 1901 — buys house on Megowan St
Lexington city directory 1902-03 — 128 (34) Megowan St
"Big Deal," *LL*, 7 May 1902 — property on Megowan St
Lexington city directory 1904-05 — 148 Megowan St
"Purging the List," *LL*, 10 Oct 1904 — 146 Megowan St
"Boston Durham," *LL*, 11 Oct 1904 — 146 Megowan St
Lexington city directory 1906-07 — 148 Megowan St
"Real Estate," *LL*, 23 Jan 1907 — buys lot on Megowan St
"Ella Childers," *LL*, 10 Jun 1907 — died at home on Megowan St
"Auction!" *LH*, 23 Jun 1907 — sale of residence on Megowan St
"Wants Real Estate," *LL*, 4 Apr 1908 — estate of Ella Childers Durham
Church, Lizzie
Lexington city directory 1895 — madam 74 Dewees St
"In Police Court," *LL*, 10 Sep 1898 — questionable resort

Clark, Alice
 Lexington city directory 1881-82 boards Mollie Irvin's
 Lexington city directory 1885-86 madam 65 Dewees St
 Lexington city directory 1885-86 boards madam Susie Green's
 "Police Arrests," *LL*, 22 Aug 1890 house on Short St
 "Good Long List," *LL*, 9 Nov 1892 bawdy house
 "101," *LL*, 16 Nov 1892 bawdy house
Clark, Cora
 "Minimum Sentence," *LH*, 16 Jul 1912 disorderly house
 "171 Cases," *LH*, 6 Oct 1912 disorderly house
 "Misdemeanor," *LH*, 29 Dec 1912 disorderly house
 "Big Docket," *LL*, 5 Jan 1913 disorderly house
 "260 On Circuit Court," *LL*, 11 Jan 1914 disorderly house
 "Criminal Docket," *LH*, 6 Apr 1913 disorderly house
 "Nine Murder Cases," *LH*, 5 Apr 1914 disorderly house
 "June Criminal Court," *LL*, 14 Jun 1914 disorderly house
Clark, Ida (a.k.a. Ida Riddle)
 "Used Hatchet," *LL*, 14 Mar 1907 disorderly house
 "Woman Accused," *LH*, 14 Mar 1907 disorderly house
Clark, Maggie
 "Police Court," *LH*, 8 Oct 1896 disorderly house
Cleveland, Maggie
 Census 1900 Fayette Co KY Lexington with 2 female boarders 42
 Megowan
Cole, Babe
 "Recorder's Court," *LL*, 16 May 1892 disorderly house Spring St
Coleman, Lizzie
 "Disorderly House," *LH*, 18 Jul 1912 resort 434 Morton Alley
Collins, Bertie
 "Police Court," *LH*, 13 Sep 1911 disorderly house
Collins, Molly
 Census 1900 Fayette Co KY Lexington with 5 female boarders 31
 Megowan
Combs, Lillie
 "Cases," *LH*, 25 Sep 1918 disorderly house
Combs, Margaret
 Census 1910 Fayette Co KY Lexington house of ill fame
 Lexington city directory 1911 165 Megowan St
Cooper, Ellen
 "260 On Circuit Court," *LL*, 11 Jan 1914 disorderly house
 "Not a Conviction," *LL*, 21 Jan 1914 disorderly house 121 Water
Corbin, Mamie
 "Names of Indicted," *LL*, 31 Oct 1910 disorderly house
Courtney, Sis
 "Recorder's Court," *LL*, 16 May 1892 disorderly house Spring St
Cox, Jane
 "Good Long List," *LL*, 9 Nov 1892 bawdy house

"101," *LL*, 16 Nov 1892 — bawdy house
Cox, Jennie
 Lexington city directory 1885-86 — madam 26 W Bolivar
Craig, Lizzie
 "Good Morning," *LL*, 14 Aug 1918 — disorderly house
Craig, Sadie
 "Disorderly Houses," *LL*, 28 Jan 1918 — disorderly house
 "Two Women Jailed," *LH*, 29 Jan 1918 — disorderly house
 "Misdemeanor," *LL*, 27 Mar 1918 — disorderly house
 "Cases," *LH*, 25 Sep 1918 — disorderly house
Crawford, Joanna
 "House Raided," *LH*, 23 Mar 1918 — in Lizzie Nelson's disorderly house
 "Vice Violation," *LH*, 27 Sep 1918 — disorderly house
Crawford, Maggie
 Census 1900 Fayette Co KY Lexington — with 2 female boarders 42
 Megowan
Crawford, Pearl
 Lexington city directory 1890 — boards madam Sue Tillett's
 "Recorder's Court," *LL*, 28 May 1890 — used insulting language
 "Jones-Neal Feud," *LL*, 29 Jul 1890 — injured property of Kate O'Brien
 "Considerably Worsted," *LL*, 28 Sep 1890 — in Fanny Jackson's house of ill
 fame
 "Recorder's Court," *LL*, 15 Mar 1891 — obscene letter to Ella Childers
 "Recorder's Court," *LL*, 17 Mar 1891 — "soiled dove"
 "Recorder's Court," *LL*, 8 May 1893 — assault on Cora Davis
 "Recorder's Court," *LL*, 4 Apr 1894 — assault and battery
 Lexington city directory 1895 — madam 63 Dewees St
 Lexington city directory 1898 — 66 Megowan St
 "Pearl Crawford," *LL*, 13 Jan 1902 — house of ill fame 66 Megowan
 "Woman Killed Herself," *LH*, 14 Jan 1902 — "an unfortunate"
 "Crawford Jewels," *LL*, 17 Jan 1902 — suicide
 "Pearl Crawford Estate," *LH*, 27 Feb 1902 — suicide
 "Attached," *LL*, 2 Mar 1902 — former member demi monde
Crews, Mamie/Minnie
 "Minimum Sentence," *LH*, 16 Jul 1912 — disorderly house 374 Constitution
 "171 Cases," *LH*, 6 Oct 1912 — disorderly house
 "Misdemeanor," *LH*, 29 Dec 1912 — disorderly house
 "Big Docket," *LL*, 5 Jan 1913 — disorderly house
Cunningham, Effie
 "Police Court," *LL*, 7 Jun 1897 — disorderly house
Dague, Orlanda
 "General Row," *LL*, 20 Oct 1898 — landlady 54 Megowan St
 "Lively Fight," *LL*, 20 Oct 1898 — arrested for shooting
Davenport, Dora
 Census 1900 Fayette Co KY Lexington — with 2 female boarders 47
 Megowan
Davidson, Lillie/"Big Tit" Lil

"3 People Wounded," *LL*, 31 May 1908	in Minnie Allen's resort
"Coroner's Inquest," *LL*, 1 Jun 1908	resort on Megowan St
Lexington city directory 1911	140 Megowan St
Lexington city directory 1912	140 Megowan St
"Grand Jury," *LH*, 8 Nov 1913	rents bawdy house
"Elimination of Red Light," *LL*, 8 Nov 1913	rents house
"City Indicted," *LL*, 9 Nov 1915	disorderly house
"Grand Jury," *LH*, 12 Nov 1915	disorderly house
"Man & Woman," *LH*, 14 Dec 1915	140 Megowan St
"Those Charged," *LL*, 16 Mar 1916	disorderly house

Davidson, Lizzie

Lexington city directory 1909	boards Minnie Allen's house
Census 1910 Fayette Co KY Lexington	150 Megowan St
Lexington city directory 1911	150 Megowan St
Lexington city directory 1912	143 Megowan St
"Disorderly Houses," *LH*, 24 Jan 1912	disorderly house
"Nine Judgments," *LH*, 6 Aug 1912	house on Megowan St
"Grand Jury Advises," *LH*, 8 Nov 1913	rents bawdy house
"Girl of Underworld," *LL*, 8 Jul 1914	148 Megowan St
"Kills Self," *LL*, 8 Nov 1914	148 Megowan St
"Those Charged," *LL*, 16 Mar 1916	disorderly house

Davis, Belle

"Grand Jury Returns," *LH*, 16 Apr 1912	disorderly house
"Murder Cases," *LL*, 30 Jun 1912	disorderly house
"Minimum Sentence," *LH*, 16 Jul 1912	disorderly house
"171 Cases," *LH*, 6 Oct 1912	disorderly house
"Misdemeanor Cases," *LH*, 29 Dec 1912	disorderly house
"Big Docket," *LL*, 5 Jan 1913	disorderly house
"260 On Circuit Court," *LL*, 11 Jan 1914	disorderly house
"Criminal Docket," *LH*, 6 Apr 1913	disorderly house

Davis, Mary

"In Police Court," *LL*, 2 Sep 1895	assignation house
"In Police Court," *LL*, 3 Sep 1895	house of ill repute

Dawson, Lillian

"Woman Injured," *LL*, 12 Mar 1911	resort 137 Megowan St

Denver, Willie

"Attempted Suicide," *LL*, 29 Jul 1894	landlady 42 Megowan

Dillon, Rose

"Grand Jury," *LL*, 24 Jul 1911	disorderly house
"232 Cases," *LL*, 1 Oct 1911	disorderly house
"Criminal Term," *LL*, 1 Oct 1911	disorderly house

Dobbs, Maggie (a.k.a. Mag Oliver)

"Fatally Shot," *LL*, 7 Aug 1888	woman of loose habits
"Branch Alley," *LL*, 14 Aug 1888	bagnio in Branch Alley
Lexington city directory 1890	madam 31 Megowan
"Beating A Board Bill, *LL*, 26 Jan 1890	house in Branch Alley
"Recorder's Court," *LL*, 30 Nov 1890	mansion in Branch Alley

"Branch Alley," *LL*, 12 Jan 1891 — mansion in Branch Alley
"City's Business," *LL*, 6 Feb 1891 — notorious house Branch Alley
"Megowan St Fire," *LL*, 23 Feb 1892 — house Megowan St
"Clubbed With Pistol," *LL*, 6 Jun 1892 — bagnio Megowan St
"Sunday Robbery," *LL*, 27 Jun 1892 — formerly of Branch Alley
"Recorder's Court," *LL*, 29 Jun 1892 — madam house Megowan St
"Was Not Successful," *LL*, 9 Aug 1892 — maison de joi Megowan St
"101," *LL*, 16 Nov 1892 — bawdy house
Lexington city directory 1893 — madam 31 Megowan
"Fitch Dismissed," *LL*, 24 Nov 1893 — bagnio
"The Morphine Route," *LL*, 20 Aug 1894 — bagnio in Branch Alley
"John Jenkins," *LH*, 17 Sep 1896 — ill repute on Branch Alley
Dobbs, Phoebe
"Good Long List," *LL*, 9 Nov 1892 — bawdy house
"Phoebe Dobbs," *LL*, 4 Nov 1898 — resident Chicago Bottoms
"Recorder's Court," *LL*, 30 Nov 1890 — in Maggie Dobbs' mansion
Dodson/Dotson, Dolly
"Aged, But Gay," *LL*, 3 Jan 1894 — house of ill repute 48 Megowan
Lexington city directory 1895 — madam 33 Megowan St
Dodson, Mattie
"Those Charged," *LL*, 16 Mar 1916 — disorderly house
Downing, Ann
Lexington city directory 1885-86 — madam 70 Spruce St
Downing, Birdie
"Police Court," *LL*, 8 Jul 1901 — disorderly house
Census 1910 Fayette Co KY Lexington — house of ill fame 345 Wilson St
Downing, Ella
"Stafford Arrested," *LH*, 17 Jun 1910 — disorderly house
Dudley, Hazel
"Police Court," *LL*, 27 Sep 1901 — disorderly house Vertner Avenue
Dudley, Mary
"Trial," *LH*, 24 Apr 1898 — disorderly house
Duncan, May
"Those Charged," *LL*, 16 Mar 1916 — disorderly house
"Misdemeanor," *LL*, 27 Mar 1918 — disorderly house
Duncan, Emma
"Police Court News," *LH*, 27 Jul 1911 — disorderly house
Duncan, Lena
Census 1900 Fayette Co KY Lexington — with 4 female boarders 34
Megowan
Duncan, Mae/May/Mary
"Grand Jury," *LL*, 21 Jun 1904 — disorderly house
"Trial Docket," *LL*, 22 Jan 1918 — disorderly house
"Man Claims," *LH*, 15 May 1918 — disorderly house E Short St
"Throws Out Vice," *LH*, 18 May 1918 — disorderly house 132 E Short St
"Vice Cases," *LH*, 23 Jun 1918 — disorderly house
"Cases," *LH*, 25 Sep 1918 — disorderly house

Duncanson, Emma
 "The Legal Record," *LL*, 19 Aug 1889 disorderly house
Dunleavy, M.
 "Seven," *LL*, 30 May 1902 leasing house for immoral
purposes
Edwards, Belle
 Lexington city directory 1895 madam 42 Megowan St
 "The Dual Role," *LL*, 10 Sep 1895 owner resort 42 Megowan St
 "Police Court," *LL*, 17 Sep 1895 disorderly house
English, Lou
 Lexington city directory 1890 madam 48 Megowan St
Finley, Alice
 Lexington city directory 1895 boards madam Belle Edwards'
house
 "Police Court," *LH*, 1 Sep 1896 disorderly house
 "Police Court," *LH*, 3 Sep 1896 disorderly house
Fleece, Anna
 "Arrested," *LL*, 28 May 1904 resort 66 Megowan St
 "Held Over," *LL*, 1 Jun 1904 house on Megowan St
 Lexington city directory 1904-05 156 Megowan St
Ford, Mrs. B. A.
 "License Revoked," *LL*, 16 Apr 1905 disorderly house
Ford, Bettie
 "Minimum Sentence," *LH*, 16 Jul 1912 disorderly house 355 Constitution
 "171 Cases," *LH*, 6 Oct 1912 disorderly house
 "Disorderly House," *LL*, 4 Nov 1912 disorderly house 355 Constitution
Forman, Mrs. Dora
 "57 Cases," *LL*, 1 Oct 1914 disorderly house
 "Misdemeanor," *LL*, 12 Oct 1914 disorderly house
 "Circuit Court," *LL*, 4 Nov 1914 disorderly house
Frazier, Laura
 "Recorder's Court," *LL*, 11 Jun 1888 disorderly house
 "Slashed with a Knife," *LL*, 18 Sep 1898 resident Chicago Bottoms
Frazier, Rose
 "Good Long List," *LL*, 9 Nov 1892 bawdy house
 "101," *LL*, 16 Nov 1892 bawdy house
Freeman, Mrs. Jennie (a.k.a. Mrs. H. J. Menzies)
 "232 Cases," *LL*, 1 Oct 1911 disorderly house
 "Criminal Term," *LL*, 1 Oct 1911 disorderly house
 "Found Not Guilty," *LH*, 29 Apr 1916 disorderly house 244 E Second
Freeman, Lee
 "Bench Warrants Served," *LH*, 23 Sep 1917 disorderly house
Gabbard, Laura
 "3 People Wounded," *LL*, 31 May 1908 in Minnie Allen's resort
 Lexington city directory 1912 house 144 Megowan St
 "Those Charged," *LL*, 16 Mar 1916 disorderly house
Gans, Mrs. Mollie

"Police Court," *LL*, 22 May 1909	disorderly house
Gentry, Jeane	
"Woman Held," *LH*, 27 Mar 1915	house of prostitution 161
Megowan St	
"Charged," *LL*, 17 Mar 1915	house of prostitution 161
Megowan St	
"Gentry and Her Maid," *LH*, 6 Apr 1915	resident 161 Megowan St
"White Slave Case," *LL*, 9 Apr 1915	resort 161 Megowan St
"Women Accused," *LH*, 10 Apr 1915	resort 161 Megowan St
"Resort Keeper," *LH*, 10 Nov 1915	resort 161 Megowan St
"Grand Jury," *LH*, 12 Nov 1915	disorderly house
Gentry, Lillian	
"57 Cases," *LL*, 1 Oct 1914	disorderly house
"Misdemeanor," *LL*, 12 Oct 1914	disorderly house
"Those Charged," *LL*, 16 Mar 1916	disorderly house
Gibson, Mrs.	
"Police Court," *LH*, 6 Jul 1907	disorderly house
"Police Court," *LL*, 9 Jul 1907	disorderly house South Mill
Gill, Malicia/Malvissa	
Lexington city directory 1893	madam 34 Megowan St
"Good Long List," *LL*, 9 Nov 1892	bawdy house
"101," *LL*, 16 Nov 1892	bawdy house
Gill, Mary	
"Criminal Court," *LL*, 8 Jun 1918	disorderly house
"Murder Case," *LH*, 8 Jun 1918	murdered in disorderly house
"Vice Cases," *LH*, 23 Jun 1918	disorderly house
"Cases," *LH*, 25 Sep 1918	disorderly house
Ginger, Lou	
"Recorder's Court," *LL*, 29 Oct 1889	house of ill repute 44 Megowan St
Glover, Bertha	
"Those Charged," *LL*, 16 Mar 1916	disorderly house
Gooch, Mrs. L. C.	
"Seven," *LL*, 30 May 1902	leasing bawdy house
"Term Ends," *LL*, 28 Jun 1902	disorderly house
Gordon, Katie/Kittie	
"June Court," *LL*, 14 Jun 1914	disorderly house
"Anderson Case," *LL*, 22 Jun 1914	disorderly house
"57 Cases," *LL*, 1 Oct 1914	disorderly house
"Misdemeanor," *LL*, 12 Oct 1914	disorderly house
"Those Charged," *LL*, 16 Mar 1916	disorderly house
Gould, Alice	
Census 1910 Fayette Co KY Lexington	house of ill fame 156 Short St
Graves, Cora	
"Criminal Court," *LL*, 8 Jun 1918	disorderly house
"Disorderly Houses," *LL*, 24 Jun 1918	disorderly house
Graves, Elvira	
"Circuit Court," *LH*, 27 Jun 1917	disorderly house

Graves, Gertie
 "Good Long List," *LL*, 9 Nov 1892 bawdy house
 "101," *LL*, 16 Nov 1892 bawdy house
 "Chief Lusby," *LL*, 29 Jan 1894 house on Megowan St
 Lexington city directory 1895 boards madam Edna Verner's
 "Frank Perkins Shot," *LH*, 7 Oct 1900 on Megowan St
Graves, Julia
 "Judge Riley," *LL*, 26 Jan 1903 disorderly house
Graves, Leta
 "Investigation," *LL*, 23 Oct 1917 house of prostitution 356 Wilson
Green, Bettie (a.k.a. Bettie James)
 "Fight Causes Fire," *LL*, 19 Mar 1905 disorderly house 416-18 Campbell
Green, Cynthia
 Census 1910 Fayette Co KY Lexington house of ill fame 316 Wilson St
 "Minimum Sentence," *LH*, 16 Jul 1912 disorderly house 258 Constitution
 "171 Cases," *LH*, 6 Oct 1912 disorderly house
 "Misdemeanor," *LH*, 29 Dec 1912 disorderly house
 "Big Docket," *LL*, 5 Jan 1913 disorderly house
Green, Elizabeth
 "Bench Warrants," *LH*, 23 Sep 1917 disorderly house
Green, Jennie
 "Disorderly Houses," *LH*, 24 Jan 1912 disorderly house
Green, Lou
 "Nabbed a Burglar," *LL*, 11 Jun 1888 house of ill repute in Pralltown
Green, Rosie (a.k.a. Rose Turner)
 Census 1910 Fayette Co KY Lexington house of ill fame 347 Wilson St
 "Grand Jury Advises," *LH*, 8 Nov 1913 bawdy house 351 Wilson St
 "Elimination of Red Light," *LL*, 8 Nov 1913 bawdy house 351 Wilson St
 "57 Cases," *LL*, 1 Oct 1914 disorderly house
 "Misdemeanor," *LL*, 12 Oct 1914 disorderly house
 "More Give Bond," *LL*, 10 Nov 1914 disorderly house 351 Wilson St
 "Investigation," *LL*, 23 Oct 1917 house of prostitution 347 Wilson St
 "Good Morning, Judge," *LL*, 26 Aug 1918 disorderly house
Green, Sue/Susie (see Appendix B)
 Lexington city directory 1881-82 boards 7 W Water St
 Lexington city directory 1885-86 madam 35 Megowan St
 Lexington city directory 1887 madam 35 Megowan St
 Lexington city directory 1888 madam 35 Megowan St
 "Megowan Muddle," *LL*, 28 May 1888 35 Megowan St
 Lexington city directory 1889 35 Megowan St
 "Anyone Get Away?" *LL*, 18 Feb 1889 charged with nuisance
 "Will He Hang," *LL*, 20 Jun 1889 sporting house Megowan St
 Lexington city directory 1890 madam 35 Megowan St
 "Recorder's Court," *LL*, 22 Apr 1890 on Megowan St
 "Good Long List," *LL*, 9 Nov 1892 bawdy house
 "101," *LL*, 16 Nov 1892 bawdy house
 Lexington city directory 1893 madam 34 Megowan St

Lexington city directory 1895	madam 35 Megowan St
"At Auction," *LL*, 16 Jul 1899	35 Megowan
Green, Rosa	
"More Indictments," *LH*, 22 Jun 1915	disorderly house
Grinstead, Julia	
"Indictments," *LL*, 14 Jul 1912	disorderly house 118 Mechanic
"171 Cases," *LH*, 6 Oct 1912	disorderly house
"Misdemeanor Cases," *LH*, 29 Dec 1912	disorderly house
"Big Docket," *LL*, 5 Jan 1913	disorderly house
Hadden, Annie	
"White Persons" *LH*, 18 Apr 1916	disorderly house
Haggard, Nancy	
"Police Court," *LL*, 1 Sep 1900	disorderly house
Hall, Effie	
"Cutting Scrape," *LL*, 3 Aug 1888	bagnio Water St
Hall, Lizzie	
"171 Cases," *LH*, 6 Oct 1912	disorderly house
"Not Guilty Plea," *LL*, 22 Jun 1915	disorderly house
Hall, Mary	
"War of Words," *LL*, 1 Oct 1898	resident Megowan St
"Police Court," *LL*, 18 Jul 1910	disorderly house
"Disorderly House," *LH*, 31 Jan 1915	disorderly house 437 Kenton St
"$10 And Costs," *LL*, 1 Feb 1915	disorderly house
"Police Court News," *LH*, 6 Feb 1915	disorderly house on Kenton St
Hambrick, Bessie	
"Those Charged," *LL*, 16 Mar 1916	disorderly house
Hamilton, Fay	
Census 1910 Fayette Co KY Lexington ED 27	in Schuler's house of ill fame
"Minimum Sentence," *LH*, 16 Jul 1912	disorderly house 363 Constitution
"Disorderly," *LL*, 4 Nov 1912	disorderly house 363 Constitution
"Misdemeanor," *LH*, 29 Dec 1912	disorderly house
"Big Docket," *LL*, 5 Jan 1913	disorderly house
"Disorderly House," *LL*, 23 Jan 1913	disorderly house 363 Constitution
"Criminal Docket," *LH*, 6 Apr 1913	disorderly house
"260 On Circuit Court," *LL*, 11 Jan 1914	disorderly house
Hamilton, Lulie	
"Today's Police Court," *LL*, 15 May 1914	disorderly house
Hampton, Lillian	
"Good Long List," *LL*, 9 Nov 1892	bawdy house
"101," *LL*, 16 Nov 1892	bawdy house
Hampton, Leah/Lear	
"In the court," *LL*, 15 Sep 1903	in fight on 150 Megowan
"Mysterious Shooting," *LL*, 23 Mar 1907	iniquitous house 138 Megowan
"Bill Britton," *LL*, 30 Apr 1907	in 150 Megowan St
Lexington city directory 1909	150 Megowan St
Census 1910 Fayette Co KY Lexington	resides 138 Megowan St
City directory 1911	138 Megowan St

Hardesty, Mrs. Alice
 "Vice Warrant Idle," *LH*, 17 Oct 1916 disorderly house 340 Nelson Avenue
 "Sheriff's Office," *LL*, 17 Oct 1916 disorderly house
 "Criminal Docket," *LL*, 23 Mar 1917 disorderly house
Hargiss, Mary
 "Thomas Found Guilty," *LL*, 24 Jan 1912 disorderly house
Harris, Hattie
 "Those Charged," *LL*, 16 Mar 1916 disorderly house
Harris, Mary
 "Police Court," *LH*, 2 Feb 1904 disorderly house
Harris, Sue
 "Police Court," *LL*, 25 May 1910 disorderly house
Hart, Nannie
 "Arrested," *LL*, 9 Nov 1911 disorderly house North Upper St
 "Nannie Hart Arrested," *LH*, 9 Nov 1911 disorderly house North Upper St
 "Sig H. Speyer Indicted," *LL*, 15 Apr 1912 disorderly house
 "Grand Jury," *LH*, 16 Apr 1912 disorderly house
 "Thirteen Murder Cases," *LL*, 30 Jun 1912 disorderly house
Harvey, Debbie (a.k.a. Alice Allen, Alice Ely, Alice Roach)
 "Broaddus Gives Up," *LL*, 11 Jul 1911 resort on Megowan St
 "Victim Buried," *LL*, 12 Jul 1911 stabbed in resort 153 Megowan St
 "Grand Jury," *LL*, 16 Jul 1911 Megowan St
 "Insanity Defense," *LL*, 5 Oct 1911 resort on Megowan St
 "Broaddus to Asylum," *LL*, 6 Oct 1911 stabbed at Breezing resort Megowan
 "Broaddus Captured," *LL*, 30 Oct 1912 in Breezing's house Megowan St
Hayes, Libbie
 Lexington city directory 1893 madam 53 Megowan St
 "Good Long List," *LL*, 9 Nov 1892 bawdy house
 "101," *LL*, 16 Nov 1892 bawdy house
 Lexington city directory 1895 madam 47 Megowan St
 Lexington city directory 1898 47 Megowan St
Helm, Mary
 "Recorder's Court," *LL*, 7 May 1891 disorderly house
 "Recorder's Court," *LL*, 8 May 1891 disorderly house
 "Series of Charges," *LL*, 27 Jan 1899 house on Megowan St
Hensley, Anna
 "Aged, But Gay," *LL*, 3 Jan 1894 house of ill repute 48 Megowan St
 Lexington city directory 1895 madam 294 Foushee St
 "Davy's 'Roll,'" *LH*, 21 Aug 1899 robbery in Chicago Bottoms
Hensley, Fannie
 Lexington city directory 1895 madam 48 Megowan St
 "Davy's 'Roll,'" *LH*, 21 Aug 1899 robbery in Chicago Bottoms
Herndon, Florence
 Lexington city directory 1885-86 madam 21 Ayres Alley
Higginbotham, Lena

"Played Censor," *LL*, 12 Apr 1901 — disorderly house

Hill, Jennie
 Census 1880 Fayette Co. Ky. Lexington — house with 7 female boarders 137
 W Main
 Lexington city directory 1883-84 — 128 W Main St
 "Burglar Johnson," *LL*, 17 Jul 1890 — charged with assault

Hill, Lizzie
 "Indictments," *LL*, 14 Jul 1912 — disorderly house 120 Mechanic St
 "Lizzie Hill Released," *LL*, 16 Jul 1912 — disorderly house 120 Mechanic St
 "Was Not in Jail," *LL*, 21 Jul 1912 — disorderly house 120 Mechanic St
 "Misdemeanor Cases," *LH*, 29 Dec 1912 — disorderly house
 "Big Docket," *LL*, 5 Jan 1913 — disorderly house
 "Cases," *LH*, 25 Sep 1918 — disorderly house

Hill, Mamie
 "Police Court," *LL*, 11 Jul 1905 — Fun and Frolic Club on Megowan St
 "Police Court," *LL*, 15 Aug 1905 — in resort Megowan St
 Census 1910 Fayette Co KY Lexington — in Smith's house of ill fame 349
 Wilson
 "Stafford Arrested," *LH*, 17 Jun 1910 — disorderly house

Hinkle, Kate (a.k.a. Kate Wood)
 "Good Long List," *LL*, 9 Nov 1892 — bawdy house
 "101," *LL*, 16 Nov 1892 — bawdy house

Holland, M. A.
 "Seven," *LL*, 30 May 1902 — leasing bawdy house

Holman, Jennie
 "Misguided Girl," *LH*, 9 Feb 1898 — in house of ill repute
 "Jennie Holman," *LL*, 11 Feb 1898 — in house of ill repute
 "Abduction," *LH*, 11 Feb 1898 — in house of ill repute
 "Those Charged," *LL*, 16 Mar 1916 — disorderly house

Holmes, Lou
 "Civil Term," *LH*, 6 Oct 1903 — disorderly house

Houston, Beatrice
 Lexington city directory 1912 — 167 Megowan St
 Lexington city directory 1914-15 — 167 Megowan St
 "Those Charged," *LL*, 16 Mar 1916 — disorderly house

Howard, Fannie
 "Held to Grand Jury," *LL*, 28 Dec 1909 — disorderly house

Howard, Kitty
 Lexington city directory 1888 — madam 52 Megowan St
 "Attempted Suicide," *LL*, 17 May 1888 — bagnio on Megowan St
 "Megowan Muddle," *LL*, 28 May 1888 — madam of bagnio 44 Megowan St
 "Arrested in Cincinnati," *LL*, 17 Sep 1888 — "a Lexington character"
 "The Thurman Trial," *LL*, 7 Dec 1888 — house on Megowan St

Hughes, Mable
 "Grand Jury," *LH*, 8 Nov 1913 — rents bawdy house
 "Takes Bichloride," *LL*, 6 Jan 1916 — immoral house 143 Megowan
 "Unfortunate Woman," *LH*, 6 Jan 1916 — immoral house 143 Megowan

"Upheld by Kerr," *LL*, 8 Jan 1916 proprietor house of ill fame on
Megowan
"Vice Ordinance," *LH*, 9 Jan 1916 immoral house 143 Megowan St
"Those Charged," *LL*, 16 Mar 1916 disorderly house
"14 Arrested," *LL*, 21 Aug 1918 in Patterson's disorderly house 70
Megowan
Hughes, Margaret
"Grand Jury," *LH*, 8 Nov 1913 rents bawdy house
Huguely, Minnie
"Busy Time," *LL*, 16 Jul 1900 disorderly house in Branch Alley
Husley, Fannie
Lexington city directory 1893 madam 44 Megowan St
Huston, Beatrice
"Report of Investigation," *LL*, 23 Oct 1917 house of prostitution 4 inmates
519 W Fifth
Innis, May
Census 1910 Fayette Co KY Lexington house of ill fame 132 E Short
Insco, Mamie/Nannie
"Suspicious Case," *LH*, 17 Jul 1896 disorderly house
"The Police Court," *LL*, 22 Jul 1896 disorderly house
Insco, Sallie (a.k.a. Mrs. Ewalt, Mrs. Debalt)
"Held to Circuit Court," *LL*, 21 Jan 1889 disorderly house
"Insco-Ewalt House," *LL*, 24 Jan 1889 disorderly house
"More of Them," *LL*, 27 Jan 1889 disorderly house
Irvin, Mollie
Lexington city directory 1881-82 west side Dewees St
Lexington city directory 1887 66 Megowan St
Lexington city directory 1888 66 Megowan St
Lexington city directory 1890 madam 66 Megowan St
"In Bad Company," *LL*, 29 Apr 1892 house of ill fame on Megowan St
"Good Long List," *LL*, 9 Nov 1892 bawdy house
"101," *LL*, 16 Nov 1892 bawdy house
Lexington city directory 1893 madam 66 Megowan St
"Officers in Court," *LL*, 29 Jan 1893 house of ill repute
"After Saloons," *LL*, 5 Oct 1893 unlawful sale of liquor
Lexington city directory 1904-05 house 136 Dewees St
Lexington city directory 1909 house 136 Dewees St
"Police Court," *LL*, 1 Nov 1909 leasing house for immoral
purposes
Census 1910 Fayette Co KY Lexington 136 Dewees St
"Grand Jury," *LL*, 5 Feb 1910 leasing house for improper
purposes
"Grand Jury," *LH*, 6 Feb 1910 leasing house for improper
purposes
"458 Cases Docketed" *LH*, 3 Apr 1910 leasing house for improper
purposes
Lexington city directory 1912 156 Megowan St

"Ugly Charge," *LL*, 11 Jan 1912 — house on Megowan St
"$75 and Costs," *LL*, 19 Feb 1912 — proprietor house of ill repute
"Witnesses Fined," *LH*, 18 Jul 1912 — resident Megowan St
"Grand Jury," *LH*, 8 Nov 1913 — bawdy house 156 Megowan St
Lexington city directory 1914-15 — 156 Megowan St
"Mollie Irvin Dead," *LL*, 8 Dec 1915 — proprietor East End resort 66
Megowan

Jackson, Fanny
Lexington city directory 1885-86 — madam 30 Wickliffe St
"Worsted," *LL*, 28 Sep 1890 — house of ill fame on Dewees St
"Good Long List," *LL*, 9 Nov 1892 — bawdy house
"101," *LL*, 16 Nov 1892 — bawdy house
"Her Hated Rival," *LL*, 11 Jun 1895 — chased with knife by Sallie
Gilmore

Jackson, Isabelle
"Women Are Fined," *LH*, 4 Feb 1910 — disorderly house

Jackson, Janie
"Police Court," *LL*, 30 Jun 1903 — disorderly house

Jackson, Malinda
"Twice Arrested," *LH*, 19 Dec 1900 — disorderly house on Branch Alley

Jackson, Nancy
"Twenty-Six Cases," *LL*, 23 Dec 1890 — disorderly house

Jackson, Nora
"Good Long List," *LL*, 9 Nov 1892 — bawdy house
"101," *LL*, 16 Nov 1892 — bawdy house

Jackson, Willie
"Police Court," *LL*, 20 Aug 1917 — disorderly house

Johnson, Fannie
"101," *LL*, 16 Nov 1892 — bawdy house

Jones, Anna Bell
"Those Charged," *LL*, 16 Mar 1916 — disorderly house

Jones, Elizabeth (a.k.a. Lizzie Jonesy)
Census 1910 Fayette Co KY Lexington — house of ill fame 355 Wilson St
"Woman Cut," *LL*, 16 Feb 1914 — resident of Megowan St
"Garrison," *LH*, 28 Feb 1914 — housekeeper resort on Megowan

Jones, Lillian
"Minimum Sentence," *LH*, 16 Jul 1912 — disorderly house 359 Constitution
"171 Cases," *LH*, 6 Oct 1912 — disorderly house
"Misdemeanor Cases," *LH*, 29 Dec 1912 — disorderly house
"Big Docket," *LL*, 5 Jan 1913 — disorderly house

Jones, Mary East
"Police Arrests," *LL*, 13 Nov 1907 — disorderly house

Jones, Maude
Census 1880 Fayette Co KY Lexington — boards Jennie Hill's house 137 W
Main

Jones, Nannie
"Good Long List," *LL*, 9 Nov 1892 — bawdy house

"101," *LL*, 16 Nov 1892 — bawdy house
"Police Court," *LL*, 12 Apr 1916 — in disorderly house 35 Megowan St

Jones, Phoebe
 Lexington city directory 1893 — madam 41 Megowan St

Kane, Lena
 "Caught in Store," *LH*, 28 Jun 1900 — disorderly house
 "Played Censor," *LL*, 12 Apr 1901 — disorderly house

Kennedy, Bertha
 "Minimum Sentence," *LH*, 16 Jul 1912 — disorderly house 357 Constitution
 "171 Cases," *LH*, 6 Oct 1912 — disorderly house
 "Misdemeanor," *LH*, 29 Dec 1912 — disorderly house
 "Big Docket," *LL*, 5 Jan 1913 — disorderly house
 "Tompkins," *LL*, 14 Jan 1913 — disorderly house Constitution St

Kennedy, Molly
 Lexington city directory 1887 — madam 38 Megowan St
 Lexington city directory 1888 — madam 38 Megowan St
 "Attempted Suicide," *LL*, 25 Jun 1888 — bagnio on Megowan St
 "For Sale," *LL*, 11 Mar 1889 — selling 38 Megowan St
 "No Solution," *LL*, 11 Apr 1889 — house on Megowan St
 "In Jail," *LL*, 27 May 1889 — house on Megowan St
 "Will He Hang," *LL*, 20 Jun 1889 — sporting house on Megowan St
 Lexington city directory 1890 — madam 38 Megowan St
 "Good Long List," *LL*, 9 Nov 1892 — bawdy house
 "101," *LL*, 16 Nov 1892 — bawdy house
 Lexington city directory 1893 — madam 38 Megowan St

Kensler, Mamie
 "Fight," *LL*, 19 Oct 1905 — 140 Megowan St

Keys, Mattie
 "Police Court," *LL*, 21 Aug 1900 — disorderly house

Kidd, Bell
 "Good Long List," *LL*, 9 Nov 1892 — bawdy house
 "101," *LL*, 16 Nov 1892 — bawdy house

King, Ada
 "101," *LL*, 16 Nov 1892 — bawdy house

King, Alberta
 "Stiff Vice Penalty," *LH*, 14 Jul 1918 — disorderly house Bradley Ave

King, May
 Census 1910 Fayette Co KY Lexington — house of ill fame 258 Constitution
 "Two Fines," *LL*, 17 Jul 1910 — disorderly house
 "Police Court," *LH*, 23 Nov 1910 — disorderly house

Lack/Lark, Kate
 "Disorderly House" *LL*, 9 Apr 1916 — disorderly house 231 Wickliffe St
 "Circuit Court," *LL*, 10 Apr 1916 — disorderly house

Lambert, Mable
 "Varied Excuses," *LL*, 16 Apr 1915 — disorderly house
 "Excuses Are Varied," *LH*, 17 Apr 1915 — disorderly house

"Grand Jury," *LH*, 12 Nov 1915	disorderly house
"Those Charged," *LL*, 16 Mar 1916	disorderly house
Lawrence, Grace	
Census 1910 Fayette Co KY Lexington	house of ill fame 157 E Short
Lawrence, Lillian	
"Police Court," *LL*, 27 Sep 1901	disorderly house on Vertner Ave
Lexington city directory 1902-03	160 (70) Megowan St
Lawson, Rebecca	
"Disorderly Houses," *LH*, 24 Jan 1912	disorderly house 521 W Main St
"Misdemeanor," *LL*, 27 Mar 1918	disorderly house
"Cases," *LH*, 25 Sep 1918	disorderly house
Leon, Ethel	
"Talk About Town," *LL*, 16 Mar 1892	spoiled dove on Megowan St
"Took Morphine," *LL*, 21 Jan 1894	house of questionable repute
Wilson	
Lewis, Lou	
"Police Court," *LL*, 8 Oct 1895	disorderly house
Linney, Maggie	
"Bench Warrants," *LL*, 16 Jan 1917	disorderly house
"Criminal Docket," *LL*, 23 Mar 1917	disorderly house
Locks, Altha	
"Circuit Court," *LH*, 8 Jun 1904	disorderly house
"The Police Court," *LL*, 1 Nov 1909	disorderly house 317 W Fourth
Long, Annie	
Census 1910 Fayette Co KY Lexington	house of ill fame 312 Wilson St
Long, Grace	
Census 1910 Fayette Co KY Lexington	in Allen's house of ill fame 139
Megowan	
Lexington city directory 1912	148 Megowan St
"Fiscal Court," *LH*, 24 Mar 1912	house on Megowan St
"Grand Jury," *LH*, 8 Nov 1913	rents bawdy house
Lexington city directory 1914-15	house 148 Megowan St
Long, Mollie	
"Claude Harvey," *LL*, 25 Jan 1891	house of ill repute on Water St
Lexington city directory 1890	madam 53 Water St
"Good Long List," *LL*, 9 Nov 1892	bawdy house
"101," *LL*, 16 Nov 1892	bawdy house
Lexington city directory 1895	madam 85 Dewees St
Lyle/Lisle, Gertrude/Gertie	
Census 1900 Fayette Co KY Lexington	house 5 female boarders 41
Megowan	
Lexington city directory 1902-03	137 (41) Megowan St
Lexington city directory 1904-05	137 Megowan St
Lexington city directory 1909	137 Megowan St
Census 1910 Fayette Co KY Lexington	house of ill fame 137 Megowan St
Lexington city directory 1911	137 Megowan St
Lexington city directory 1912	137 Megowan St

Lexington city directory 1914-15	137 Megowan St
"Grand Jury," *LH*, 12 Nov 1915	disorderly house
"Woman Despondent," *LH*, 20 Dec 1915	proprietress 137 Megowan St
"Those Charged," *LL*, 16 Mar 1916	disorderly house

Mack, Bettie

"Got Them All," *LL*, 26 Oct 1894	disorderly house in Chicago
district	

Malone, Annie

Lexington city directory 1888	madam 13 Spruce St

Marshall, Fannie/Frances

Lexington city directory 1881-82	house Grant north of Main
Lexington city directory 1883-84	48 Megowan St
Lexington city directory 1887	48 Megowan St
Lexington city directory 1888	48 Megowan St
Lexington city directory 1890	48 Megowan St
"Notice," *LL*, 3 Apr 1890	estate Alice Tryman 48 Megowan St
"Good Long List," *LL*, 9 Nov 1892	bawdy house
"101," *LL*, 16 Nov 1892	bawdy house
Lexington city directory 1893	madam 48 Megowan St
"Notice," *LL*, 26 Mar 1899	owes taxes 44-48 Megowan St
"Wanted," *LL*, 15 Aug 1903	resides Reed Hotel
Lexington city directory 1904-05	house 140 Megowan St

Martin, Katie

Census 1910 Fayette Co KY Lexington	house of ill fame 318 Corral

Martin, Lizzie

"Police Court," *LL*, 7 Jul 1896	disorderly house
"In Police Court," *LH*, 8 Jul 1896	disorderly house

Mary, Jessie

"Police Court," *LL*, 21 Nov 1917	disorderly house

Mason, Mrs.

"Good Long List," *LL*, 9 Nov 1892	bawdy house
"101," *LL*, 16 Nov 1892	bawdy house

Mayfield, Mary M.

Census 1910 Fayette Co KY Lexington	house of ill fame 146 Dewees

Mayfield, Marjorie

"Slashed His Own Throat," *LL*, 28 Oct 1899	madam resort on Megowan

McAfee, Hannah

"Good Long List," *LL*, 9 Nov 1892	bawdy house
"101," *LL*, 16 Nov 1892	bawdy house
Census 1910 Fayette Co KY Lexington	house of ill fame 147 Dewees
"Hearing," *LH*, 21 Oct 1910	disorderly house
"154 Criminal Cases," *LH*, 8 Jan 1911	disorderly house
"Criminal Term Begins," *LL*, 2 Apr 1911	disorderly house
"232 Cases on Docket," *LL*, 1 Oct 1911	disorderly house
"Criminal Term," *LL*, 1 Oct 1911	disorderly house
"Grand Jury," *LH*, 16 Apr 1912	disorderly house

"Those Charged," *LL*, 16 Mar 1916	disorderly house
"Report of Investigation," *LL*, 23 Oct 1917	house of prostitution 3 inmates
317 Wilson	
"Police Notes," *LH*, 1 May 1918	disorderly house 317 Wilson
McAnn, Ellen	
"Man Who Cut Wife," *LH*, 12 Apr 1910	disorderly house
McCowan, Maggie	
"City is Indicted," *LH*, 23 Jul 1911	disorderly house
"232 Cases," *LL*, 1 Oct 1911	disorderly house
"Criminal Term," *LL*, 1 Oct 1911	disorderly house
"Disorderly Houses," *LH*, 24 Jan 1912	disorderly house
McDaniel, Annie	
"Recorder's Court," *LL*, 11 Jun 1888	disorderly house
"Recorder's Court," *LL*, 16 Jun 1888	disorderly house
McIntosh, Alice	
"Grand Jury," *LH*, 8 Nov 1913	rents 150 Megowan for bawdy
house	
McKnight, Eliza	
"In Police Court," *LL*, 28 Sep 1916	disorderly house 154 E Vine St
"Police Court News," *LH*, 29 Sep 1916	disorderly house on Vine St
McGlothen, Kate	
Lexington city directory 1885-86	madam 224 S. Broadway
McWain, Nancy	
Census 1860 Fayette Co KY Lexington	house of ill fame
Melone, Annie	
Lexington city directory 1885-86	madam 11 Spruce St
Merritt, Josie	
"Police Court," *LL*, 22 Nov 1917	disorderly house
Metcalf, Sadie	
Lexington city directory 1898	house 44 Megowan St
"Police Court," *LL*, 7 Mar 1898	grand larceny
Meyers, Inez	
"$75 and Costs," *LL*, 19 Feb 1912	proprietor house of ill-repute
"Grand Jury," *LH*, 12 Nov 1915	disorderly house
Miller, Cora	
"Police Court," *LL*, 27 Apr 1904	keeps maison de joie Megowan St
Census 1910 Fayette Co KY Lexington	in Grace Lawrence's house 157 E
Short	
"Two Fines Assessed," *LL*, 17 Jul 1910	disorderly house
Miller, Mattie	
"Attempted Suicide," *LL*, 25 Jun 1888	in Kennedy's bagnio on Megowan
Lexington city directory 1911	142 Megowan
Census 1910 Fayette Co KY Lexington	house of ill fame 311 Corral
"Six Are Arrested," *LH*, 28 Sep 1914	resort on Spruce St
"Police Court," *LL*, 28 Sep 1914	disorderly house
"Big Fines," *LH*, 29 Sep 1914	disorderly house
Miller, Pearl	

"Those Charged," *LL*, 16 Mar 1916 — disorderly house

Miller, Sarah
"Man Who Cut Wife," *LH*, 12 Apr 1910 — disorderly house

Minor/Miner, Ida
"Negress Charged," *LL*, 25 Dec 1915 — disorderly house on Branch Alley
"Vice Hearings," *LH*, 26 Dec 1915 — disorderly house on Branch Alley
"Those Charged," *LL*, 16 Mar 1916 — disorderly house

Mitchell, Annie
"Police Court," *LL*, 20 Aug 1917 — disorderly house

Mitchell, Lucy
"Police Court," *LL*, 20 Aug 1917 — disorderly house

Moberly, Lillie
"Will He Hang," *LL*, 20 Jun 1889 — 101 Dewees St
"Coroner's Inquest," *LL*, 27 Feb 1890 — house of ill fame on Megowan

Mockabee, Mollie
"Returned to Parents," *LL*, 7 Nov 1890 — disorderly house on Dewees

Morgan, Hattie
"Good Long List," *LL*, 9 Nov 1892 — bawdy house

Moore, Mrs. G. A.
"Grand Jury," *LH*, 8 Nov 1913 — rents 151 E Short St for bawdy house
"Elimination of Red Light," *LL*, 8 Nov 1913 — rents 151 E Short St for bawdy house

Moore, Mrs. Minnie
"The Police Court," *LL*, 29 May 1895 — disorderly house

Moore, Sarah/Sallie
Lexington city directory 1909 — 148 Megowan St
Census 1910 Fayette Co KY Lexington — 148 Megowan St
Lexington city directory 1911 — 148 Megowan St
"Free-For-All," *LH*, 13 Dec 1911 — in resort on Megowan St
Lexington city directory 1912 — 146 Megowan St
Lexington city directory 1914-15 — 141 Megowan St
"Those Charged," *LL*, 16 Mar 1916 — disorderly house

Morgan, Hattie
"Anyone Get Away," *LL*, 18 Feb 1889 — nuisance
"Recorder's Court," *LL*, 4 Aug 1894 — disorderly house
"Judge Jewell," *LL*, 7 Aug 1894 — disorderly house in Chicago district

Morgan, Mattie
Lexington city directory 1885-86 — madam 62 Dewees St
"101," *LL*, 16 Nov 1892 — bawdy house

Morris, Lou
"Robbery Charged," *LH*, 21 Dec 1896 — house in Chicago Bottoms
"Riley's Tribunal," *LH*, 17 Apr 1899 — used insulting language
"Did Not Kill Herself," *LH*, 7 Sep 1899 — madam on Wickliffe St
"Police Court," *LL*, 6 Jul 1901 — resides Chicago Bottoms
"Circuit Court," *LL*, 6 Dec 1901 — disorderly house

"Term Ends," *LL*, 28 Jun 1902 — disorderly house
"Civil Term," *LH*, 6 Oct 1903 — disorderly house
"Police Court," *LL*, 8 Jun 1905 — nymph from Chicago Bottoms
"Police Court," *LL*, 13 Jun 1905 — soubrette of Chicago Bottoms
"Stancill Acquitted," *LH*, 8 Aug 1908 — disorderly house
Morton, Ellen
"Late Police News," *LH*, 25 Apr 1897 — disorderly house on Dewees St
Mountjoy, Mary Jane
"101," *LL*, 16 Nov 1892 — bawdy house
Moxie, Mary
"Four Fines Aggregate," *LH*, 18 Apr 1912 — disorderly house
Mukes, Agnes
"Anyone Get Away?" *LL*, 18 Feb 1889 — charged with nuisance
"Good Long List," *LL*, 9 Nov 1892 — bawdy house
"101," *LL*, 16 Nov 1892 — bawdy house
Lexington city directory 1895 — madam 72 Dewees St
Murphy, Mamie (a.k.a. Mrs. Mack Trisler)
"Thomas Guilty," *LL*, 24 Jan 1912 — disorderly house
"Jury for Dolan Case," *LH*, 17 Apr 1912 — disorderly house
"13 Murder Cases," *LL*, 30 Jun 1912 — disorderly house
"Minimum Sentence," *LH*, 16 Jul 1912 — disorderly house
"171 Cases," *LH*, 6 Oct 1912 — disorderly house
"Misdemeanor Cases," *LH*, 29 Dec 1912 — disorderly house
"Big Docket," *LL*, 5 Jan 1913 — disorderly house
"260 On Circuit," *LL*, 11 Jan 1914 — disorderly house
"Nine Murder Cases," *LH*, 5 Apr 1914 — disorderly house
"June Criminal Court," *LL*, 14 Jun 1914 — disorderly house
"Lee Anderson Case," *LL*, 22 Jun 1914 — disorderly house
"Woman Arrested," *LL*, 10 Apr 1917 — disorderly house
"Police Court News," *LH*, 12 Apr 1917 — disorderly house
"No Decision Reached," *LL*, 24 May 1917 — disorderly house
"Bench Warrants," *LH*, 23 Sep 1917 — disorderly house
"Police Handicap," *LL*, 27 Oct 1917 — disorderly house at 181 Colfax
"Report," *LL*, 23 Oct 1917 — house of prostitution 2 inmates
181 Colfax
Myers, Inez
Lexington city directory 1912 — 138 Megowan St
"Myers Not Guilty," *LL*, 1 Mar 1912 — 138 Megowan St
"Myers Acquitted," *LH*, 1 Mar 1912 — 138 Megowan St
"Girl Taken," *LH*, 15 Dec 1912 — disorderly house on Megowan St
"Girl to School," *LH*, 17 Dec 1912 — house on Megowan St
"Court News," *LH*, 22 Jun 1913 — house on Megowan St
"Grand Jury," *LH*, 8 Nov 1913 — rents 138 Megowan St for bawdy
house
Lexington city directory 1914-15 — house 138 Megowan St
"Those Charged," *LL*, 16 Mar 1916 — disorderly house
Myers, Sadie

Census 1910 Fayette Co KY Lexington

Nelson, Lizzie

"House Raided," *LH*, 23 Mar 1918 — house of ill fame 160 E Short St

Spruce

"Vice Violation," *LH*, 27 Sep 1918 — proprietress disorderly house 208

Norman, Sue

"In Police Court," *LL*, 23 Jul 1895 — disorderly house 213 Clark St

Nunnelly, Lilly

Lexington city directory 1895 — disorderly house

"The Death Roll," *LL*, 1 Mar 1897 — madam 58 Dewees St

Oliver, Mag (see Dobbs, Mag) — died at 42 Megowan St

Lexington city directory 1890

Overton, Minnie — madam 31 Megowan St

"More Give Bond," *LL*, 10 Nov 1914

Parker, Anna — disorderly house 163 Sycamore St

"Fatally Injured," *LL*, 12 Mar 1911

Megowan St — resident Bowers' resort 137

"John Morgan," *LL*, 29 Dec 1916

Race — disorderly house Goodloe and

"Police Court," *LH*, 18 Jan 1917 — disorderly house

Parker, Florence

"John Morgan Shot," *LL*, 29 Dec 1916 — disorderly house Goodloe and

Race

Parker/Parks, Irene

"Circuit Court," *LL*, 26 Jan 1916 — disorderly house

"Police Court," *LH*, 27 Jan 1915 — disorderly house 343 Mack's Alley

Parker, Mollie (a.k.a. "Mosley")

Lexington city directory 1888 — madam 150 N Upper St

"Recorder's Court," *LL*, 17 Sep 1890 — house on Dewees St

"Three Offenders," *LL*, 22 Feb 1891 — bad behavior

"Continued," *LL*, 10 Apr 1891 — assault and battery

"Good Long List," *LL*, 9 Nov 1892 — bawdy house

"101," *LL*, 16 Nov 1892 — bawdy house

"Recorder's Court," *LL*, 19 Dec 1893 — vagrancy

Parrish, Jennie

"260 On Circuit Court," *LL*, 11 Jan 1914 — disorderly house

Patterson, Blanche (see Jackson, Mary)

Lexington city directory 1912 — 160 Megowan St

Lexington city directory 1914-15 — 160 Megowan St

"Concealed Weapon," *LH*, 18 Jan 1914 — 70 Megowan St

"City Indicted," *LL*, 9 Nov 1915 — disorderly house

Lexington city directory 1916-17 — 160 Megowan St

"Those Charged," *LL*, 16 Mar 1916 — disorderly house

"Report," *LL*, 23 Oct 1917 — house of prostitution 5 inmates 70

Megowan

"14 Arrested," *LL*, 21 Aug 1918 — matron disorderly house 70

Megowan

"Vice Hearing," *LH*, 29 Aug 1918 disorderly house
Patterson, Lizzie
 Lexington city directory 1909 160 Megowan St
 Census 1910 Fayette Co KY Lexington 160 Megowan St
 Lexington city directory 1911 160 Megowan St
Patterson, Matilda
 "Large Police Court," *LH*, 17 May 1910 disorderly house
Penny, Eliza
 "Police Court," *LH*, 6 Nov 1896 disorderly house
Perry, Hattie
 "Not Guilty Plea," *LL*, 22 Jun 1915 disorderly house
Phillips, Mary
 "Young Girls Found," *LH*, 22 Aug 1915 disorderly house 578 Vine St
Phillips, Lizzie
 Lexington city directory 1885-86 madam 40 Todd St
Pierce, Lottie S.
 "Police Court," *LH*, 27 Jul 1911 disorderly house
 "232 Cases," *LL*, 1 Oct 1911 disorderly house
 "Criminal Term," *LL*, 1 Oct 1911 disorderly house
 "Men Are Indicted," *LL*, 20 Feb 1914 disorderly house
 "Nine Murder Cases," *LH*, 5 Apr 1914 disorderly house
 "Good Morning," *LL*, 13 Jul 1918 disorderly house
 "Vice Case," *LH*, 14 Jul 1918 disorderly house on Colfax
 "Riley Stabs," *LH*, 19 Jul 1918 disorderly house on Colfax
 "14 Arrested," *LL*, 21 Aug 1918 matron disorderly house 185
 Colfax
 "Vice Hearing," *LH*, 29 Aug 1918 disorderly house
Poindexter, Mrs. Hattie
 "Arrested," *LL*, 23 Apr 1914 disorderly house on S Broadway
 "Criminal Court," *LL*, 14 Jun 1914 disorderly house
 "Anderson Case," *LL*, 22 Jun 1914 disorderly house
Points, Mamie
 "Today's Police Court," *LL*, 15 May 1914 disorderly house
Powell, Margaret
 "Disorderly Houses," *LH*, 24 Jan 1912 disorderly house
Powell, Mary
 "Murder Case," *LH*, 17 Jun 1918 disorderly house 181 Prall St
Powell, May
 Census 1900 Fayette Co KY Lexington house 35 Megowan St
Prather, Millie
 "Police Court," *LL*, 21 Aug 1905 resort 144 Megowan St
Preston, Effie
 "Police Court," *LH*, 29 Apr 1897 disorderly house
Price, Emma
 "Grand Jury Work," *LL*, 5 Feb 1910 leases house for improper
 purposes
 "458 Cases," *LH*, 3 Apr 1910 leases house for improper

purposes

Quisenberry, Ella
 "Ella Quisenberry," *LH,* 20 Jan 1916 disorderly house

Ratcliffe, Ida
 "Recorder's Court," *LL,* 26 Jan 1891 disorderly house on Dewees St

Reed, Ettie
 "Recorder's Court," *LL,* 12 Feb 1894 disorderly house

Reed, Millie
 "White Persons Arrested," *LH,* 18 Apr 1916 disorderly house 532 Bright
Avenue

Reed, Pearl (a.k.a. Pearl Bess)
 "Police Court," *LL,* 24 Jul 1901 Megowan St
 "Scene in Court," *LL,* 29 Jul 1901 Megowan St
 "Police Court," *LL,* 17 May 1902 denizen of Megowan St
 "Police Court," *LL,* 13 Jun 1905 "nymph of the red light district"
 "Be Properly Dressed," *LH,* 14 Jun 1905 "of questionable character"
 "In Clad Raiment," *LL,* 11 Aug 1905 "Pearl of Precious Price"
 Census 1910 Fayette Co KY Lexington house of ill fame 153 E Short St

Renick, Stella
 "Arrested," *LL,* 23 Apr 1914 disorderly house North Upper St
 "Criminal Court," *LL,* 14 Jun 1914 disorderly house
 "Anderson Case," *LL,* 22 Jun 1914 disorderly house
 "Circuit Court," *LL,* 29 Jun 1914 disorderly house

Richardson, Mary
 "Circuit Court," *LL,* 28 Jan 1916 disorderly house Fourth St
 "Acting Judge," *LH,* 28 Jan 1916 disorderly house 221 Fourth St
 "Circuit Court," *LL,* 3 Feb 1916 disorderly house Fourth St
 "Negress Fined," *LH,* 4 Feb 1916 disorderly house 221 Fourth St

Riley, Sis
 "Good Long List," *LL,* 9 Nov 1892 bawdy house
 "101," *LL,* 16 Nov 1892 bawdy house

Robinson, Carrie
 "Recorder's Court," *LL,* 7 Sep 1890 disorderly house

Robinson, Patsy
 "The Legal Record," *LL,* 19 Aug 1889 disorderly house

Roman, Mrs. Jane
 "Most All Continued," *LL,* 30 Jul 1894 disorderly house

Ross, Annie
 Lexington city directory 1895 madam 54 Megowan St

Ross, Georgia May
 "Vice Ordinance," *LH,* 9 Jan 1916 operates house for immoral
purposes

Rule, Fannie
 "Good Long List," *LL,* 9 Nov 1892 bawdy house
 Lexington city directory 1895 madam 298 Foushee St

Sawyer, Florence (Mrs. Charles Sawyer)
 "Disorderly House," *LH,* 8 Mar 1912 disorderly house 143 Megowan St

"Resort Closed," *LL*, 9 Mar 1912 proprietress resort 142 Megowan St
"Disorderly House," *LH*, 9 Mar 1912 disorderly house 143 Megowan St
"Russell Held," *LH*, 10 Jul 1912 now on Montmullin St
"Police Court," *LL*, 6 Feb 1915 disorderly house
"Police Court," *LL*, 7 Feb 1915 disorderly house on William St
"Police Court," *LH*, 10 Feb 1915 disorderly house 157 E High St

Sayre, Clara/Claire (a.k.a. Clara Kessler)
 Lexington city directory 1904-05 boards Brezing's house 153
 Megowan St
 Census 1910 Fayette Co KY Lexington house of ill fame 142 E Short St
 "Those Charged," *LL*, 16 Mar 1916 disorderly house
 "Report," *LL*, 23 Oct 1917 house of prostitution 3 inmates
 142 Short

Scruggs, Lillie
 "Disorderly House," *LH*, 18 Jul 1912 Morton Alley

Schaeffer, Fannie (a.k.a. Dutch, Duck Sullivan)
 "Minimum Sentence," *LH*, 16 Jul 1912 disorderly house 357 Constitution St
 "Light Prison Term," *LL*, 16 Jul 1912 disorderly house 357 Constitution St
 "171 Cases," *LH*, 6 Oct 1912 disorderly house
 "Misdemeanor Cases," *LH*, 29 Dec 1912 disorderly house
 "Big Docket," *LL*, 5 Jan 1913 disorderly house

Schuler, Bertha
 Census 1910 Fayette Co KY Lexington house of ill fame 329 Constitution St

Shanklin, Mrs. Frank
 "Police Court," *LL*, 22 May 1909 disorderly house

Shaw, Mrs. Julia
 "Police Court," *LL*, 3 May 1907 disorderly house on Shreve Ave
 "Police Court Session," *LL*, 8 May 1907 kept disorderly house on Shreve Ave

Shea, Grace (a.k.a. Mrs. Perkins)
 Census 1910 Fayette Co KY Lexington house of ill fame 256 Constitution St
 "Woman Wounded," *LH*, 9 Jun 1911 in resort at 153 Megowan St
 "Perkins Shoots," *LL*, 9 Jun 1911 landlady resort at 153 Megowan St
 "Will Perkins," *LH*, 10 Jun 1911 in resort on Megowan St
 "Perkins and Shea," *LH*, 29 Dec 1911 resort 150 Megowan St
 Lexington city directory 1912 150 Megowan St
 "Serious Charge," *LL*, 5 Apr 1912 resides resort at 150 Megowan St
 "Caught Bringing Girls," *LL*, 6 Apr 1912 proprietress resort 150 Megowan St
 "Witnesses Fined," *LH*, 18 Jul 1912 Megowan St
 "Emma Strange," *LH*, 31 Jan 1913 house on Megowan St
 "Shea's House," *LL*, 13 Oct 1913 disorderly house on Megowan St
 "Disorderly Resort," *LH*, 14 Oct 1913 disorderly house on Megowan St
 Lexington city directory 1914-15 150 Megowan St
 "Court Declines," *LH*, 18 Jun 1914 now of Pemberton St
 "Grace Shea's House," *LH*, 9 Feb 1915 disorderly house 150 Megowan St
 "Jones Shooting," *LL*, 9 Feb 1915 disorderly house 150 Megowan St
 "Police Court," *LH*, 10 Feb 1915 disorderly house 150 Megowan St
 "Those Charged," *LL*, 16 Mar 1916 disorderly house

Simms, Maria
 "Police Court," *LL*, 13 Sep 1912 disorderly house
Single, Mrs.
 "Good Long List," *LL*, 9 Nov 1892 bawdy house
Slater, Annie
 "Good Long List," *LL*, 9 Nov 1892 bawdy house
Sloan, Effie
 "Arrested for Stealing," *LL*, 7 May 1888 woman of bad repute
Small, Mollie
 "Recorder's Court," *LL*, 16 May 1892 disorderly house on Spring St
Smedley, Florence
 "Police Court," *LH*, 8 Oct 1896 disorderly house
Smith, Ann
 "Recorder's Court," *LL*, 16 Jul 1894 a disorderly house
Smith, Annie
 "June Criminal Court," *LL*, 14 Jun 1914 disorderly house
Smith, Esther Smith
 "Jury," *LH*, 17 Apr 1912 disorderly house
 "Murder Cases," *LL*, 30 Jun 1912 disorderly house
 "Minimum Sentence," *LH*, 16 Jul 1912 disorderly house
 "171 Cases," *LH*, 6 Oct 1912 disorderly house
 "Misdemeanor," *LH*, 29 Dec 1912 disorderly house
 "Big Docket," *LL*, 5 Jan 1913 disorderly house
 "Circuit Court," *LL*, 11 Jan 1914 disorderly house
Smith, Gertie
 "Disorderly Houses," *LH*, 24 Jan 1912 disorderly house Smith and Fifth
Smith, Hallie/Harriet
 "Police Court," *LL*, 20 Sep 1914 disorderly house
 "Those Charged," *LL*, 16 Mar 1916 disorderly house
 "Bench Warrants," *LL*, 18 Nov 1917 disorderly house
 "Disorderly Houses," *LL*, 28 Jan 1918 disorderly house
 "Two Women Jailed," *LH*, 29 Jan 1918 disorderly house
 "Cases," *LH*, 25 Sep 1918 disorderly house
Smith, Lizzie
 Lexington city directory 1904-05 boards 146 Megowan St
 "Labor Problem," *LL*, 6 Jul 1905 house on Megowan St
 Lexington city directory 1906-07 house 143 Megowan St
Smith, Mamie
 Lexington city directory 1895 madam 66 Megowan St
Smith, Margaret
 "M'Cord Gets Year," *LH*, 23 Jun 1915 disorderly house
 "Granted Stay," *LL*, 25 Jun 1915 disorderly house
Smith, Nora
 "Haul in Pralltown," *LH*, 27 Nov 1910 disorderly house
Smith, Pearl
 "Police Court," *LL*, 8 Jun 1905 nymph from Chicago Bottoms
 "Woman Charged," *LH*, 6 May 1909 resort on Megowan St

"Police Court," *LL*, 6 May 1909 charged with grand larceny
Census 1910 Fayette Co KY Lexington house of ill fame 349 Wilson St
"Those Charged," *LL*, 16 Mar 1916 disorderly house
Smith, Polly
 "Grand Jury," *LH*, 23 Jan 1916 disorderly house
 "Those Charged," *LL*, 16 Mar 1916 disorderly house
Smith, Vivian
 "Police Court," *LL*, 15 Nov 1917 disorderly house
Snowden, Emeline
 Census 1910 Fayette Co KY Lexington house of ill fame 136 Dewees St
Sparks, Maude
 Lexington city directory 1895 in madam Dodson's house 33
 Megowan
 "Serious Charges," *LH*, 12 Jan 1896 in disreputable house Megowan St
 "Locked Up," *LL*, 12 Jan 1896 arrested on Megowan St
 "Police Court," *LL*, 6 Jul 1901 resident of Chicago Bottoms
 "Red Hot Fight," *LL*, 28 Jul 1901 house on Spruce St in Chicago
 Bottoms
 "Goes to Relief," *LH*, 19 Jan 1905 disorderly house
 "Police Court," *LL*, 8 Jun 1905 nymph from Chicago Bottoms
Spears, America
 "Megowan Muddle," *LL*, 20 Jun 1888 in Arnold's house Megowan St
 "Criminal Court," *LL*, 14 Jun 1914 disorderly house
 "Anderson Case," *LL*, 22 Jun 1914 disorderly house
 "57 Cases," *LL*, 1 Oct 1914 disorderly house
 "Misdemeanor," *LL*, 12 Oct 1914 disorderly house
 "Those Charged," *LL*, 16 Mar 1916 disorderly house
Spears, Margaret
 "Report," *LL*, 23 Oct 1917 house of prostitution 4 inmates
 322 Wilson
Spencer, Jessie
 "Misdemeanor," *LL*, 27 Mar 1918 disorderly house
Steele, Elizabeth (Mrs. Bert Steele)
 "Special Term," *LL*, 31 May 1914 disorderly house
 "Special Court," *LL*, 7 Jun 1914 disorderly house
 "Mrs. Bert Steele," *LL*, 15 Jun 1914 disorderly house 537 Pemberton
 Avenue
 "57 Cases," *LL*, 1 Oct 1914 disorderly house
 "Misdemeanor," *LL*, 12 Oct 1914 disorderly house
 "Vigorous Charge," *LH*, 12 Jan 1915 disorderly house
Stern, Sue
 "Grand Jury," *LH*, 8 Nov 1913 rents 165 Megowan for bawdy
 house
Stevenson, Lou
 "Disorderly House," *LH*, 13 Aug 1915 disorderly house on W Second St
Stewart, Florence
 "Girl Taken Out," *LH*, 30 Oct 1915 proprietor disorderly house 204

Patterson
"Those Charged," *LL*, 16 Mar 1916 disorderly house

Stokes, Maryland
"Those Charged," *LL*, 16 Mar 1916 disorderly house

Story, Emma
Census 1900 Fayette Co KY Lexington boards Lyle's house 41 Megowan St
"Judge Riley's Matinee," *LL*, 1 Aug 1904 Mother Hubbard Club of
Megowan St
"Stafford Arrested," *LH*, 17 Jun 1910 disorderly house

Strange, Emma
"Disorderly Houses," *LH*, 24 Jan 1912 disorderly house 182 Colfax St
"Jury for Dolan Case," *LH*, 17 Apr 1912 disorderly house
"Murder Cases," *LL*, 30 Jun 1912 disorderly house
"Minimum Sentence," *LH*, 16 Jul 1912 a disorderly house
"Many Cases Up," *LL*, 17 Jul 1912 Colfax St
"Witnesses Fined," *LH*, 18 Jul 1912 Megowan St
"171 Cases," *LH*, 6 Oct 1912 disorderly house
"Disorderly House," *LL*, 23 Jan 1913 disorderly house 182 Colfax St
"Strange Fined," *LH*, 31 Jan 1913 disorderly house 188 Colfax St
"Ask New Trials," *LL*, 7 Feb 1913 disorderly house
"Those Charged," *LL*, 16 Mar 1916 disorderly house
"Bench Warrants," *LH*, 23 Sep 1917 disorderly house
"Investigation," *LL*, 23 Oct 1917 house of prostitution 2 inmates
182 Colfax

Strange, Margaret
"Circuit Court," *LL*, 15 Sep 1905 disorderly house
"Jury for Dolan Case," *LH*, 17 Apr 1912 disorderly house
"Thirteen Murder Cases," *LL*, 30 Jun 1912 disorderly house
"171 Cases," *LH*, 6 Oct 1912 disorderly house
"Misdemeanor," *LH*, 29 Dec 1912 disorderly house
"Big Docket," *LL*, 5 Jan 1913 disorderly house
"Circuit Court," *LL*, 11 Jan 1914 disorderly house
"Criminal Court," *LL*, 14 Jun 1914 disorderly house
"Lee Anderson Case," *LL*, 22 Jun 1914 disorderly house

Sullivan, Margaret
"Heavy Fines," *LH*, 27 Jan 1912 disorderly house 158 Montmullin
"Dinelli Loses," *LH*, 6 Feb 1912 disorderly house

Sumers, Florence
"Six Arrested," *LH*, 28 Sep 1914 disorderly house Spruce St

Taylor, Carrie
Lexington city directory 1898 53 Megowan St
Census 1900 Fayette Co KY Lexington 53 Megowan St with 4 female
boarders
"Failed," *LL*, 4 Jul 1900 resort 53 Megowan St
"Police Court," *LL*, 24 Jul 1901 Megowan St
"Police Court," *LL*, 9 Aug 1901 denizen of Megowan St
Lexington city directory 1902-03 153 (53) Megowan St

"Shooting Affray," *LL*, 28 Nov 1903	denizen of Megowan St
"Civil Term," *LH*, 6 Oct 1903	disorderly house
"Libel Suit," *LL*, 16 Dec 1903	Megowan St
Lexington city directory 1904-05	150 Megowan St
"Dismissed," *LL*, 25 Sept 1904	denizen of Megowan St
"Police Court," *LL*, 14 Feb 1905	resort on Megowan St
"Probably Fatally Shot," *LH*, 25 Nov 1905	house on Megowan St
"Carrie Taylor," *LL*, 25 Nov 1905	keeper resort 150 Megowan St
"Carrie Taylor Dead," *LL*, 26 Nov 1905	shot at home on Megowan St
"Mysterious Shooting," *LL*, 23 Mar 1907	former proprietress 138 Megowan St
"Refused a Pardon," *LL*, 15 May 1910	proprietress resort Megowan St

Taylor, Cornelia

Census 1870 Fayette Co KY Lexington	prostitute
"Grand Jury," *LL*, 24 Jul 1911	disorderly house
"232 Cases," *LL*, 1 Oct 1911	disorderly house
"Criminal Term," *LL*, 1 Oct 1911	disorderly house
"Bench Warrant," *LL*, 24 May 1914	disorderly house on Henry St
"June Criminal Court," *LL*, 14 Jun 1914	disorderly house

Taylor, Julia

"Lexington Man Victim," *LH*, 11 Feb 1918	disorderly house 610 Sellers St
"Persons Arrested," *LL*, 21 Feb 1918	disorderly house 610 Sellers St
"Rogers Defends Woman," *LL*, 27 Feb 1918	disorderly house 610 Sellers St
"Misdemeanor," *LL*, 27 Mar 1918	disorderly house
"Vice Cases," *LH*, 23 Jun 1918	disorderly house
"Criminal Court," *LH*, 25 Sep 1918	disorderly house

Thomas, Lizzie

"Friday's Police Court," *LL*, 15 Jul 1911	disorderly house

Thomas, Mamie (a.k.a. Pinkie Thomas)

"Grand Jury Advises," *LH*, 8 Nov 1913	rents 144 E Short St as bawdy house
"Elimination of Red Light," *LL*, 8 Nov 1913	rents 144 E Short St as bawdy house
"Goes to Pen," *LL*, 14 Apr 1914	disorderly house
"Criminal Court," *LL*, 14 Jun 1914	disorderly house
"Anderson Case," *LL*, 22 Jun 1914	disorderly house

Thompson, Margaret

"Grand Jury," *LL*, 5 Feb 1910	leasing house for improper purposes
"458 Cases" *LH*, 3 Apr 1910	leasing house for improper purposes

Thompson, Mary B.

Census 1910 Fayette Co KY Lexington	house of ill fame 146 E Short St
"Court News," *LH*, 22 Jun 1913	in Myers's house on Megowan St
"Woman Shoots Herself," *LL*, 17 Oct 1913	resort 144 Megowan St
"Grand Jury," *LH*, 8 Nov 1913	rents 144 Megowan as bawdy house
Lexington city directory 1914-15	144 Megowan St

"Pat O'Hara," *LH*, 16 Jan 1915	144 Megowan St
"Grand Jury," *LH*, 12 Nov 1915	disorderly house
"Those Charged," *LL*, 16 Mar 1916	disorderly house
Thompson, Nellie	
"Grand Jury," *LL*, 21 Jun 1904	disorderly house
Thompson, Pink	
"Those Charged," *LL*, 16 Mar 1916	disorderly house
Thompson, Sarah	
"Those Charged," *LL*, 16 Mar 1916	disorderly house
Tibbs, Annie	
"Grand Jury," *LL*, 21 Jun 1904	disorderly house
Tillett, Susie (Mrs. Emma S. Jack) (see Appendix B)	
Lexington city directory 1885-86	41 Megowan St
Lexington city directory 1887	madam 41 Megowan St
Lexington city directory 1888	41 Megowan St
"Chief Lusby's Haul," *LL*, 19 Jul 1888	bagnio Megowan St
"Anyone Get Away?" *LL*, 18 Feb 1889	charged with nuisance
Lexington city directory 1890	madam 54 Megowan St
"Mysterious Affair," *LL*, 23 Feb 1891	house on Megowan St
"City and Vicinity," *LL*, 14 Sep 1903	owns house on Megowan St
"Deeds," *LH*, 4 Jan 1905	sells lot on Megowan St
Tingle, Mrs.	
"101," *LL*, 16 Nov 1892	bawdy house
Todd, Susie	
Lexington city directory 1895	boards madam Blackburn's 44
Megowan	
"In Police Court," *LL*, 30 Jul 1895	arrested for drunkenness
"Serious Charges," *LH*, 12 Jan 1896	in disreputable house Megowan St
"Locked Up," *LL*, 12 Jan 1896	arrested on Megowan St
"In Police Court," *LL*, 14 May 1896	three months in the workhouse
Lexington city directory 1898	house 44 Megowan St
"Joint," *LL*, 3 Feb 1905	"of the low neck and short
sleeves set"	
Toles/Tolls, Georgia	
"Good Long List," *LL*, 9 Nov 1892	bawdy house
"101," *LL*, 16 Nov 1892	bawdy house
"Cops Came," *LL*, 23 Jul 1894	disorderly house
Trimble, Ida	
"Those Charged," *LL*, 16 Mar 1916	disorderly house
Trimble, Mag	
"Recorder's Court," *LL*, 16 May 1892	disorderly house Spring St
Tyree, Mary	
"Good Long List," *LL*, 9 Nov 1892	bawdy house
"Talk About Town," *LL*, 10 Nov 1892	resort 44 Megowan St
Lexington city directory 1893	resides 42 Megowan St
"Lost His Cash," *LL*, 29 Oct 1894	house Megowan St
"Police Court," *LL*, 15 Apr 1899	frequenter of courts

"Police Court," *LL*, 16 Sep 1901 — disorderly house Robinson's Row

Tyrell, Mary
 "101," *LL*, 16 Nov 1892 — bawdy house

Van Gordon, J. Ollie
 Lexington city directory 1895 — madam 59 Dewees St

Vanmeter, Susetta
 "Police Court," *LL*, 12 Mar 1895 — disorderly house

Vaughn, Eliza
 "Those Charged," *LL*, 16 Mar 1916 — disorderly house

Verner, Edna
 Lexington city directory 1895 — madam 53 Megowan St
 Lexington city directory 1898 — residence 293 E Short St

Vogt, Lillian
 "Grand Jury," *LH*, 8 Nov 1913 — rents 167 Megowan St as bawdy house
 Lexington city directory 1914-15 — 146 Megowan St
 "Grand Jury," *LH*, 12 Nov 1915 — disorderly house
 "Those Charged," *LL*, 16 Mar 1916 — disorderly house

Walker, Mary
 Lexington city directory 1895 — madam 92 Dewees St

Walker, Mayme/Mamie
 "Dismissals," *LL*, 22 Feb 1916 — disorderly house
 "Disorderly Houses," *LH*, 22 Feb 1916 — disorderly house on Coleman St

Walker, Nellie
 "House-Breaking," *LH*, 23 Aug 1898 — house on Wilson St
 Lexington city directory 1895 Megowan — boards madam Smith's house 66
 Census 1910 Fayette Co KY Lexington Megowan — in Wilson's house of ill fame 143
 "Dismissals," *LL*, 22 Feb 1916 — disorderly house
 "Disorderly Houses," *LH*, 22 Feb 1916 — disorderly house 204 Coleman St
 "Violators of Vice," *LH*, 23 Feb 1916 — disorderly house Coleman St

Walters, Emma
 "Recorder's Court," *LL*, 16 May 1894 — using insulting language
 Lexington city directory 1895 — madam 296 Foushee St

Ward, Edna
 Lexington city directory 1895 — resides Megowan St
 "Attempts Suicide," *LH*, 29 Nov 1910 — disorderly house 190 Dewees St

Ward, Lillian
 "Police Court," *LL*, 28 Oct 1907 — proprietress 66 Megowan St
 Lexington city directory 1909 — boards 156 Megowan St
 "Women Arrested," *LL*, 22 Dec 1910 — contributing to delinquency
 Lexington city directory 1912 — house 145 Megowan St
 "$75 and Costs," *LL*, 19 Feb 1912 — proprietor house of ill-repute
 "Webb Trial Begins," *LL*, 3 Jan 1913 — resides 154 Megowan St
 "Grand Jury Advises," *LH*, 8 Nov 1913 — rents 145 Megowan as bawdy house

Lexington city directory 1914-15 — house 145 Megowan St
"City Indicted," *LL*, 9 Nov 1915 — disorderly house
"Those Charged," *LL*, 16 Mar 1916 — disorderly house
"Former Resort," *LH*, 30 Jul 1916 — former madam 145 Megowan St

Watson, Mrs. Elizabeth
"Two Indictments," *LL*, 17 Oct 1916 — disorderly house 609 South Broadway

Watts, Bettie
"Police Court," *LL*, 31 May 1916 — disorderly house Pleasant Stone St

Weathers, Mary
"Police Court," *LL*, 14 Sep 1914 — disorderly house
"Police Court News," *LH*, 28 Mar 1916 — disorderly house
"Good Morning," *LL*, 1 Jun 1918 — disorderly house

Wells, Mary
"Recorder's Court," *LL*, 20 Jun 1888 — disorderly house

West, Nina
"Grand Jury," *LH*, 12 Nov 1915 — disorderly house
"Those Charged," *LL*, 16 Mar 1916 — disorderly house
"Criminal Court," *LL*, 8 Jun 1918 — disorderly house
"Cases," *LH*, 25 Sep 1918 — disorderly house

White, Alice
"Circuit Court," *LL*, 28 Oct 1910 — disorderly house Limestone
"154 Criminal Cases," *LH*, 8 Jan 1911 — disorderly house
"No More Gambling," *LH*, 21 Jan 1911 — disorderly house
"Ulmot Fain," *LL*, 26 Jan 1911 — disorderly house High St

White, Bessie
"Nuisance," *LL*, 21 Nov 1906 — disorderly house Grinstead St

White, Florida
"Police Court," *LL*, 18 Nov 1895 — disorderly house

White, Julia
"Barlow Knife," *LL*, 21 Sep 1893 — mansion in Branch Alley
"Will Brinegar," *LL*, 13 Dec 1893 — house of ill repute in Branch Alley

White, Lucie
"Those Charged," *LL*, 16 Mar 1916 — disorderly house

White, Mary
"Nuisance," *LL*, 21 Nov 1906 — disorderly house on Grinstead St
"Caught in Raid," *LH*, 26 Mar 1912 — resort 312 W Water St

Wilkson, Emma
"Held," *LH*, 29 Mar 1915 — disorderly house 227 Clark St

Williams, Annie/Anna
Census 1910, Fayette Co KY Lexington — in Brezing's house of ill fame
"Report," *LL*, 23 Oct 1917 — madam

Williams, Tessie
"Report," *LL*, 23 Oct 1917 — madam

Wilson, Ella
Census 1910 Fayette Co KY Lexington — house of ill fame 143 Megowan St
Lexington city directory 1911 — 143 (53) Megowan

"Suicide Pact," *LL*, 9 Jan 1911 143 Megowan St

Wilson, Emma
 "Lizzie Hill," *LH*, 30 Mar 1915 disorderly house
 "Police Court," *LL*, 31 Mar 1915 disorderly house

Wilson, Ida (a.k.a. Lil Johnson, Stella Lambert)
 "Recorder's Court," *LL*, 30 Nov 1890 in Dobbs' mansion in Branch
 Alley
 "'On the Wabash'," *LH*, 5 Sep 1899 disorderly house Wickliffe St
 "Slugged a Woman," *LL*, 10 Dec 1899 well known character of Chicago
 Bottoms
 "Police Court," *LL*, 15 Jul 1902 disorderly house in Chicago
 Bottoms
 Lexington city directory 1902-03 127 (33) Megowan St
 Census 1910 Fayette Co KY Lexington house of ill fame 351 Wilson St
 "Woman Held," *LH*, 27 Mar 1915 in Gentry's house of prostitution
 161 Megowan
 "Charged," *LL*, 27 Mar 1915 Gentry's house 161 Megowan St
 "Gentry and Maid," *LH*, 6 Apr 1915 Gentry's house 161 Megowan St
 "White Slave Case," *LL*, 9 Apr 1915 Gentry's resort 161 Megowan St
 "Women Accused," *LH*, 10 Apr 1915 Gentry's resort 161 Megowan St
 "Resort Keeper," *LH*, 10 Nov 1915 Gentry's resort 161 Megowan St

Wilson, Mrs. T. A.
 "Criminal Term," *LL*, 2 Feb 1917 disorderly house

Winn, Emma
 "Recorder's Court," *LL*, 26 Mar 1891 disorderly house Fifth and Hanson

Witt, Margaret
 "Police Court," *LL*, 26 Dec 1912 disorderly house

Wright, Fanny
 "Good Long List," *LL*, 9 Nov 1892 bawdy house

Yates, Pearl
 "Police Court," *LL*, 13 Jun 1905 "nymph of the red-light district"
 "Properly Dressed," *LH*, 14 Jun 1905 "person of questionable character"
 "Bottle of Blackberry," *LL*, 11 Jun 1906 villa in the East End
 "Went Out," *LL*, 30 Sep 1906 place on Megowan St
 "14 Year Old Girl," *LL*, 9 Jan 1907 resort Megowan St
 Lexington city directory 1906-07 150 Megowan St
 "Pearl Yates," *LL*, 11 Jan 1907 resort Megowan St
 Census 1910 Fayette Co KY Lexington house of ill fame 356 Wilson St
 "Four Women," *LL*, 22 Dec 1910 contributing to delinquency 348
 Wilson St
 "Says She's Over 18," *LL*, 23 Dec 1910 contributing to delinquency
 "Case Against Yates," *LH*, 24 Dec 1910 contributing to delinquency
 "Police Court," *LL*, 1 Jan 1911 disorderly house
 "Trial of Webb," *LL*, 3 Jan 1913 corner of Short and Wilson
 "Grand Jury," *LH*, 8 Nov 1913 rents 348 Wilson for bawdy house

Young, Hattie
 Census 1910 Fayette Co KY Lexington in Shea's house of ill fame 256

Constitution
"More Give Bond," *LL*, 10 Nov 1914 disorderly house at 355 Wilson St
Young, Ray
Lexington city directory 1895 madam 70 Dewees St

B. The Madams of Chattanooga, Tennessee

Adams, Ruby
 "Squire Hogan," *CStar*, 17 Apr 1908 — in Hallie Hood's house
 "Mad Ride," *CDT*, 6 Jun 1909 — in Hallie Hood's house
 "Charles Dietz," *CDT*, 3 Oct 1911 — woman of underworld
 "Downfall ," *CN*, 3 Oct 1911 — woman of underworld
 "Dietz Bound," *CDT*, 15 Oct 1911 — woman of underworld
 Chattanooga city directory 1914 — madam 11 Helen St
Alfonz, Amelia
 Chattanooga city directory 1910 — madam
Allen, Mrs.
 "Woman Arrested," *CN*, 10 Aug 1908 — disorderly house in Avondale
Allen, Emma
 "Fisticuff," *CDC*, 14 Jul 1885
 "Police Points," *CDT*, 23 Oct 1885 — bagnio W 7th St
 Chattanooga city directory 1887 — madam 109 W 7th St
 Chattanooga city directory 1888 — madam 109 W 7th St
 Chattanooga city directory 1889 — madam 109 W 7th St
 Chattanooga city directory 1890 — madam 109 W 7th St
 Chattanooga city directory 1891 — madam 109 W 7th St
 Chattanooga city directory 1892 — madam 109 W 7th St
 Chattanooga city directory 1894 — madam 109 W 7th St
Allen, Mary
 "Special Term," *CN*, 16 Jun 1909 — bawdy house
 "Judge Tilts," *CDT*, 20 Jul 1909 — from red-light district
Allen, Tennie
 "Aiding in Escape," *CDT*, 28 May 1905 — disorderly house
 "Ricketts Case," *CDT*, 29 May 1905 — disorderly house
Alexander, Carrie
 "Negro," *CDT*, 27 Sep 1907 — disorderly conduct
 "Fight in Courtroom," *CDT*, 7 Mar 1910 — fight on Florence St
 "Some Received Limit," *CN*, 10 Sep 1910 — disorderly house
Alexander, Maud
 "City Court," *CDT*, 4 Apr 1882 — house of ill fame
 "Raiding Maisons," *CDT*, 26 Jun 1885 — in house of ill fame
 "Mayor's Court," *CDT*, 11 Dec 1885 — in house of ill fame
 "Mayor's Court," *CDM*, 16 Aug 1886 — soiled dove
Alfonz, Amelia
 Chattanooga city directory 1910 — madam 332 E Tenth St
Alliger, Mrs. Free
 "Before Recorder," *CDT*, 25 Jul 1891 — house of ill fame
Anderson, Ellen
 "Circuit Court," *CDT*, 19 Jul 1882 — disorderly house
Anderson, Harriet/Hattie R.
 Chattanooga city directory 1880 — east side of Florence St

"Circuit Court," *CDT*, 25 Mar 1880	disorderly house
"Circuit Court," *CDT*, 22 Jul 1880	disorderly house
Chattanooga city directory 1881	madam east side Florence St
Chattanooga city directory 1882	madam east side Florence St
"Local Brevities," *CDT*, 26 Mar 1882	disorderly house
"City Court," *CDT*, 4 Apr 1882	house of ill fame
"Circuit Court," *CDT*, 19 Jul 1882	disorderly house
"Recorder's Court," *CDT*, 1 Jul 1882	house of ill fame
Chattanooga city directory 1883	madam 6 Florence St
"An Overdose," *CDT*, 5 Feb 1883	bagnio
"Circuit Court," *CDT*, 8 Apr 1883	disorderly house
"Brevities," *CDT*, 12 Aug 1883	raided
Chattanooga city directory 1884-85	madam 6 Florence St
"Magistrates Court," *CDT*, 20 Feb 1884	bagnio
"Circuit Court," *CDT*, 8 Feb 1885	disorderly house
"Fickle Floyd," *CDC*, 16 Mar 1885	bagnio
"Raiding Maisons," *CDT*, 26 Jun 1885	keeper house of ill fame
"The Order Given," *CDT*, 19 Jul 1885	lewd house
"Circuit Court," *CDT*, 18 May 1886	disorderly house

Anderson, Katie

"Local Brevities," *CDT*, 26 Mar 1882	disorderly house
"Circuit Court," *CDT*, 8 Apr 1883	disorderly house
"Recorder's Court," *CDT*, 1 Jul 1882	in house of ill fame
Chattanooga city directory 1884	6 Florence St
"Raiding Maisons," *CDT*, 26 Jun 1885	keeper house of ill fame

Anderson, Lillie

"Heavy Docket," *CN*, 28 Jul 1913	disorderly house

Anderson, Ruth

Weidner & Friedman 1908-1912	bawdy house 17 Florence St
"Girls Got Noisy," *CDT*, 10 Apr 1908	in Georgia Miller's 16 Helen St
"Same Kelly," *CDT*, 11 Apr 1908	arrested on Helen St
"House of Negress," *CDT*, 14 Sep 1908	in immoral house W Ninth St
"Seek Injunction," *CDT*, 11 Nov 1908	immoral place
"Third Ward Folk," *DC*, 11 Nov 1908	operating immoral place
1910 Hamilton Co TN Chattanooga Foster	house with 1 female boarder 9
"For Violation," *CN*, 10 Feb 1914	in resort 11 Helen St
"Gross Violation," *CDT*, 10 Feb 1914	in 11 Helen St
"Breaking Quarantine," *CDT*, 11 Feb 1914	11 Helen St

Andrews, Fannie (a.k.a. Mrs. James Andrews)

"Man and Wife," *CN*, 13 Apr 1911	disorderly house

Andrews, Mrs. G. W.

"Cherry St House," *CDT*, 20 Nov 1917	house of ill fame

Armstrong, Stella

"Unpleasant," *CDT*, 11 Sep 1908	operates immoral resort
"Up to Officials," *CN*, 11 Sep 1908	operates resort

Arnold, Mary

"Mayor's Court," *CC*, 15 May 1886	disorderly house
Arnold, May	
Chattanooga city directory 1909	madam 17 Florence St
Asbury, Lucy	
"Indictments," *CN*, 7 Apr 1916	disorderly house
Ashmore, Mary	
"In the Courts," *CDT*, 27 Sep 1900	disorderly house
Austin, Jane	
"Justices' Costs," *CDT*, 19 Feb 1889	house of ill fame
"Recorder's Court," *CDT*, 4 Jun 1891	house of ill fame
Avery, Holly	
"Disorderly Houses," *CDT*, 17 Nov 1914	disorderly house
Bailey, Georgia	
"Raiding Maisons," *CDT*, 26 Jun 1885	in house of ill fame
"Rough House," *CN*, 27 Dec 1910	disorderly house
Bailey, Lottie	
"Circuit Court," *CN*, 10 Jan 1902	disorderly house
Baird, Anna	
"Rampage," *CN*, 16 Jan 1907	disorderly house
Baker, Annie	
"Disorderly House," *CN*, 26 May 1914	resort
"Negro 'Stole'," *CDT*, 11 Dec 1915	disorderly house
Bailey, Loraine	
"Hulbert and Cain," *CN*, 15 Jan 1917	disorderly house
Ball, Maggie	
"Indictments," *CDT*, 13 Jul 1907	woman of underworld
"Vindication," *CN*, 17 Apr 1908	woman of underworld
"Ouster Bill's," *CDT*, 6 Feb 1915	madam with house of 5 women
Banard, Blanche	
"Boozers," *CN*, 3 Jul 1911	house 11 Helen St
Barger, Cynthia	
"Recorder's Court," *CDT*, 22 Sep 1891	in house of ill fame
"Their Fun," *CDT*, 26 Nov 1891	bagnio
Barnes, Laura	
Chattanooga city directory 1883	madam 300 Chestnut St
"Mayor's Court," *CDC*, 9 Oct 1886	disorderly house
"Mayor's Court," *CDC*, 12 Jul 1887	house of ill fame
"Mayor's Court," *CDT*, 19 Jul 1887	house of ill fame
"Mayor's Court," *CDT*, 26 Oct 1887	house of ill fame
"Mayor's Court," *CDT*, 1 Nov 1887	house of ill fame
"Mayor's Court," *CDT*, 8 Nov 1887	house of ill fame
"Mayor's Court," *CDT*, 27 Jan 1888	in house of ill fame
"Mayor's Court," *CDT*, 27 Jun 1888	in house of ill fame
"Before Recorder," *CDT*, 25 Jul 1891	house of ill fame
"Recorder's Court," *CDT*, 24 Sep 1891	house of ill fame
"Recorder's Court," *CDT*, 13 Oct 1891	house of ill fame
Barnes, Laura	

Chattanooga city directory 1883	madam 300 Chestnut St
"Mayor's Court," *CC,* 9 Oct 1886	disorderly house
Baugh, Maggie	
Chattanooga city directory 1915	madam 11 Florence St
Bayless, Cleo	
Chattanooga city directory 1915	madam 8 Penelope St
Baynes, Annie	
"Fleming Urges," *CDT,* 5 Apr 1916	disorderly house
Baxter, Kate/Caty	
"Wanted," *CDC,* 18 Sep 1884	house of ill fame
"Mayor's Court," *CDT,* 8 Dec 1885	in house of ill fame
"Mayor's Court," *CDT,* 2 Aug 1889	in house of ill fame
"Police Pickups," *CDT,* 23 Aug 1889	woman of the town
Chattanooga city directory 1891	madam 225 Chestnut St
"Life in City," *CDT,* 4 Dec 1891	den on Pine St
"Judgement," *CDT,* 8 Sep 1892	disorderly house
"Wicked Women," *CDT,* 9 Aug 1893	wicked woman
"Circuit Court," *CDT,* 21 Sep 1893	disorderly house
"Leaves," *CDT,* 29 Dec 1893	most notorious negress in city
"Recorder's Court," *CDT,* 23 Feb 1894	courtesan
"Snap Shots," *CDT,* 16 Apr 1894	proprietress house of ill fame
"Police Circles," *CDT,* 17 Nov 1894	courtesan Chestnut St
Chattanooga city directory 1896	madam 225 Chestnut St
"Shot," *CDT,* 17 Aug 1896	madam resort Chestnut St
Chattanooga city directory 1897	madam 809 Pine St
Beeson, Mollie/Mary (a.k.a. Mollie Bird)	
"Circuit Court," *CDT,* 27 Mar 1881	disorderly house
"Circuit Court," *CDT,* 6 Apr 1881	disorderly house
"Circuit Court," *CDT,* 7 Apr 1882	disorderly house
"Mayor's Court," *CDT,* 18 Sep 1888	house of ill repute
"Mayor's Court," *CDT,* 17 Oct 1888	lewdness
"Mayor's Court," *CDT,* 28 Sep 1889	street walker
"You'll Find It," *CDT,* 30 Dec 1894	"colored prostitute"
Bell, Annie	
"Hole in Floor," *CN,* 21 Oct 1915	disorderly house
Bell, Maud (a.k.a. Maud Baird)	
"Recorder's Court," *CDT,* 1 Jul 1882	house of ill fame
"Recorder's Court," *CDT,* 26 Oct 1882	house of ill fame
"Maud Bell," *CDT,* 9 Jan 1883	madam
"Tired of Life," *CDT,* 20 May 1884	madam
"Stolen," *CDT,* 11 Jan 1885	madam Georgia Ave
"Unnatural Mother," *CDT,* 2 Feb 1885	madam
"Eloped," *CDT,* 8 Feb 1885	maison
"Confidence," *CDT,* 26 Feb 1885	madam
"Four Crooks," *CDT,* 27 Feb 1885	madam
"Breaking up Bagnio," *CDT,* 17 Mar 1885	bagnio on Georgia Ave
"Justice Jottings," *CDT,* 18 Mar 1885	bagnio on Georgia Ave

"Through the Neck," *CDC*, 29 Mar 1885	courtesan
"Through His Neck," *CDT*, 29 Mar 1885	courtesan
"Brevities," *CDT*, 19 Apr 1885	madam
"Robbed," *CDT*, 28 Apr 1885	madam
"Cox Robberies," *CDT*, 19 Apr 1885	bagnio
"Raiding Maisons," *CDT*, 26 Jun 1885	house of ill fame
"Order Given," *CDT*, 19 Jul 1885	lewd house
"Maud Bell Sells," *CDT*, 21 Aug 1885	madam on Georgia Ave
"Enticing Girl," *CDT*, 25 Oct 1885	courtesan
"The Charge," *CDT*, 28 Oct 1885	notorious woman
"Procuress," *CDC*, 28 Oct 1885	madam
"Mayor's Court," *CDT*, 11 Dec 1885	house of ill fame
"Brevities," *CDT*, 11 Dec 1885	madam
Chattanooga city directory 1886	madam 6 Florence St
"In Court Circles," *CDT*, 27 Jan 1886	disorderly house
"Dual Deaths," *CDC*, 18 Mar 1886	bagnio Georgia Ave
"A Minister's Son," *CDT*, 24 Apr 1886	bagnio
"Police Points," *CDT*, 30 Aug 1886	madam
"Circuit Court," *CDT*, 21 Sep 1886	bawdy house
"The Courts," *CDT*, 12 Oct 1886	house of ill fame
"Mayor's Court," *CDC*, 11 Dec 1886	bawdy house
"Mayor's Court," *CDT*, 25 Jan 1887	house of ill fame
"Mayor's Court," *CDC*, 30 Mar 1887	house of ill fame
"Saturday Night," *CDT*, 24 Oct 1887	disorderly house
"Echoes Judicial," *CDT*, 25 Oct 1887	bagnio
"Mayor's Court," *CDC*, 26 Oct 1887	bagnio Chestnut St
"Mayor's Court," *CDT*, 26 Oct 1887	house of ill fame
"Police Points," *CDT*, 31 Oct 1887	disorderly house Chestnut St
"Mayor's Court," *CDT*, 1 Nov 1887	house of ill fame
"Cathcart Mystery," *CDT*, 13 Nov 1887	madam
"In a Brothel," *CDT*, 11 Dec 1887	brothel
Chattanooga city directory 1888	madam 217 Tenth St
"The Courts," *CDT*, 14 Feb 1888	disorderly house
"The Courts," *CDT*, 24 May 1888	disorderly house
"City Court," *CSun*, 28 Jun 1888	prostitute
"Saloonists," *CDT*, 15 Feb 1888	disorderly house
"Arm Broken," *CDT*, 20 Jun 1888	madam
"Calendar," *CDT*, 7 May 1889	bagnio
Bennett, Minnie Lee	
"Local News," *CDT*, 2 Sep 1917	disorderly house E Ninth St
Bentley, Anna Bell	
"Inner Tire Thief," *CN*, 17 Dec 1915	disorderly house
Bernard, Rudy	
Census 1910 Hamilton Co TN Chattanooga Douglas St	with 3 female boarders 1008
Berry, Martha	
"Court Items," *CDT*, 28 Mar 1879	disorderly house

"Justices' Costs," *CDT*, 19 Feb 1889 — lewdness

Berry, Nan
"Odds and Ends," *CDT*, 12 May 1881 — assault and battery
"Mayor's Court," *CDT*, 4 Dec 1885 — lewd house
"Mayor's Court," *CC*, 5 Dec 1885 — lewd house
"Mayor's Court," *CDT*, 24 Mar 1886 — in house of ill fame
"A Vain Bluff," *CDT*, 23 Feb 1887 — lewdness
"Mayor's Court," *CDT*, 12 Mar 1887 — house of ill fame
"A Row," *CDT*, 18 Feb 1890 — notorious house East End Ave
"Shooting Affair," *CDT*, 19 Feb 1890 — place near Montgomery Ave
"Justice's Court," *CDT*, 23 Feb 1890 — bawdy house
"Justice Courts," *CDT*, 17 Jan 1891 — notorious
"He Broke Record," *CDT*, 25 Oct 1891 — notorious prostitute
"Recorder," *CDT*, 21 Jan 1892 — notorious prostitute
"At It Again," *CDT*, 2 Jun 1893 — house in "Red Row"
"The Good Result," *CDT*, 3 Jun 1893 — house raided
"Horrible Example," *CDT*, 17 Jul 1901 — disorderly house West Side

Bird, Maggie (Mrs. Prince Bird)
"Pulled," *CDT*, 28 Sep 1880 — lewd house

Bird, Mary (see Beeson, Mary)

Black, Nell/Nellie
"Indictments," *CDT*, 13 Jul 1907 — woman of underworld
Chattanooga city directory 1912 — madam 9 Florence St
"Demimonde," *CN*, 30 Dec 1912 — woman of the demimonde
Chattanooga city directory 1913 — madam 9 Florence St
"Ames Under Bond," *CN*, 18 Apr 1913 — house of ill repute
"Sales," *CDT*, 22 Oct 1913 — "lady of the night"
Chattanooga city directory 1914 — madam 9 Florence St
Chattanooga city directory 1915 — madam 17 Helen St
"Ouster Bill's Blow," *CDT*, 6 Feb 1915 — madam with 6 women
"Sunday Free," *CDT*, 9 Jan 1917 — madam

Blake, Effie
Chattanooga city directory 1902 — madam 12 1/2 Penelope St

Blake, Ethel
"Recorder's Court," *CDT*, 3 Aug 1895 — disorderly conduct
Chattanooga city directory 1896 — madam 323 W Ninth St
Chattanooga city directory 1897 — madam 329 W Ninth St
Census 1900 Hamilton Co TN Chattanooga — in Sue Tillett's house 11 Helen St
"Butt Brains Out," *CDT*, 31 Jul 1901 — madam
Chattanooga city directory 1903 — madam 12 1/2 Penelope St
"Day with the Police," *CN*, 15 Sep 1903 — disorderly house
"Police Notes," *CN*, 18 Sep 1903 — disorderly house Penelope St
"Delinquent," *CDT*, 13 Feb 1904 — resides Penelope St
"Locals," *CDT*, 7 Mar 1905 — house of ill fame Penelope St
"Docket," *CDT*, 19 May 1905 — disorderly house
Chattanooga city directory 1906 — madam 12 1/2 Penelope St
"Tenderloin," *CN*, 27 Jun 1906 — madam

"Banished," *CDT,* 28 Jun 1906 — madam 15 Penelope St
"Deputies Get Busy," *CDT,* 4 Sep 1906 — house of ill fame
"Robert Drake," *CDT,* 11 Sep 1907 — lewdness

Blevins, Willie
 Chattanooga city directory 1898 — madam 305 Pine St

Block, Carrie
 "Recorder's Court," *CDT,* 26 Oct 1882 — house of ill fame

Blythe, Willie
 Chattanooga city directory 1905 — 20 Penelope St
 "Docket," *CDT,* 19 May 1905 — disorderly house
 Chattanooga city directory 1906 — 20 Penelope St
 "Banished," *CDT,* 28 Jun 1906 — "negress" madam 20 Penelope St
 "Indictments," *CDT,* 13 Jul 1907 — woman of underworld
 "Back to Penelope," *CDT,* 14 Jul 1907 — resort Penelope St
 "Close Up," *CN,* 15 Jul 1907 — Penelope St
 "Where Will She Go," *CDT,* 16 Jul 1907 — "unsavory character" of Penelope St
 "Nobody Will Rent," *CDT,* 22 Jul 1907 — "dive-keeper"
 "Some Released," *CDT,* 24 Dec 1907 — disorderly house Penelope St
 Weidner & Friedman 1908-1912 — bawdy house 20 Penelope St
 Chattanooga city directory 1909 — 20 Penelope
 "Ed Boydston," *CDT,* 30 May 1909 — proprietress disorderly house
 Chattanooga city directory 1910 — 10 Foster St
 Chattanooga city directory 1911 — 101 W Tenth

Boggs, Ida
 Chattanooga city directory 1892 — madam

Bonner, Tennie
 "Police Raid," *CN,* 21 Dec 1912 — resort W Tenth St

Booker, Minnie
 "Circuit Court," *CDT,* 25 Jul 1875 — disorderly house

Bouley/Boulie, Annie
 Census 1910 Hamilton Co TN Chattanooga — with 4 female boarders 1004
 Douglas
 Chattanooga city directory 1911 — madam 15 Florence St
 "Additional Bonds," *CN,* 29 Sep 1911 — resort in red-light district
 "Found Guilty," *CDT,* 11 Nov 1911 — house in red-light district
 Weidner & Friedman 1908-1912 — bawdy house
 Chattanooga city directory 1912 — madam 15 Florence St
 "Demimonde," *CN,* 30 Dec 1912 — woman of the demimonde
 Chattanooga city directory 1913 — madam 15 Florence St
 "Possessors," *CDT,* 7 Apr 1914 — disorderly house
 Chattanooga city directory 1915 — madam 19 Penelope St
 "Ouster Bill's Blow," *CDT,* 6 Feb 1915 — madam with 3 women

Boyd, Flora
 "Tired of Life," *CDT,* 22 Apr 1879 — bagnio
 "Murdered," *CDT,* 29 Apr 1879 — madam
 "Another Arrest," *CDT,* 30 Apr 1879 — bagnio
 "One Chapter," *CDT,* 12 Oct 1885 — in bawdy house 24 Chestnut St in

1875
Brady, Bridget
 "Police Points," *CDT,* 14 Apr 1885 disorderly house
 "Freeman's Court," *CDC,* 17 Apr 1885 house of ill fame
 "Justice Jottings," *CDT,* 18 Apr 1885 house of ill fame
 "Circuit Court," *CDT,* 28 May 1885 disorderly house
 "Circuit Court," *CDT,* 26 Jan 1886 disorderly house
Brady, Kate/Kittie
 "Circuit Court," *CDT,* 28 May 1885 disorderly house
 "Circuit Court," *CDC,* 28 May 1885 disorderly house
 "Circuit Court," *CDT,* 26 Jan 1886 disorderly house
 "Mayor's Court," *CDC,* 7 Apr 1887 open house
 "Mayor's Court," *CDC,* 22 Nov 1887 house of ill fame
 "A Free Fight," *CDT,* 18 Dec 1887 notorious
 "Mayor's Court," *CDT,* 21 Feb 1888 street walking
 "Mayor's Court," *CDT,* 22 May 1888 street walking
Brakeman, Kindness
 "His Slash," *CDT,* 27 Mar 1893 bagnio Water St
Branch, Addie
 "Negress Held," *CDT,* 15 Aug 1917 disorderly house
Brantley, Jessie
 Chattanooga city directory 1897 madam 25 Chestnut St
 Chattanooga city directory 1899 madam 225 E St
Breeden, Nancy
 "Circuit Court," *CDT,* 20 Dec 1881 disorderly house
Breeden, Nellie
 "Circuit Court," *CDT,* 21 Mar 1882 disorderly house
Breeden, Sallie
 "Circuit Court," *CDT,* 26 Nov 1881 disorderly house
 "Circuit Court," *CDT,* 21 Mar 1882 disorderly house
Brooks, Annie
 "Made Fur Fly," *CDT,* 17 Mar 1886 house Chestnut St
Brown, Addie
 "Brief Mention," *CDT,* 14 Aug 1917 disorderly house Grove St
Brown, Annie
 "Recorder's Court," *CDT,* 21 Mar 1882 house of ill fame
Brown, Carrie
 "Vindication," *CN,* 17 Apr 1908 woman of underworld
 Census 1910 Hamilton Co TN Chattanooga in Hallie Hood's house 31 Clift
 "Born Medium," *CN,* 31 Aug 1910 disorderly house 833 E Eighth
 "Neighbors," *CDT,* 1 Sep 1910 disorderly house 833 E Eighth
Brown, Lena
 "Men Left Woman," *CN,* 24 Aug 1917 disorderly house
Buchanan, Mary
 "Monday's City Court," *CN,* 22 Jul 1912 disorderly house
Burnette, Lucile
 "Harness," *CN,* 4 Jan 1912 disorderly house

Burns, Catherine
 "First Victory," *CN*, 9 Mar 1909 in Kate Cowan's bawdy house
 "Ed Boydston," *CDT*, 30 May 1909 proprietress disorderly house
Burton, Nan
 "Mayor's Court," *CDC*, 5 Jul 1886 lewd house
Butler, Millie
 "Circuit Court," *CDT*, 16 Mar 1880 disorderly house
Butlery, Sarah
 "Circuit Court," *CDT*, 16 Mar 1880 disorderly house
Butters, Allie
 Chattanooga city directory 1895 madam 3 Porter St
 Chattanooga city directory 1896 madam 2 Porter St
 Chattanooga city directory 1897 madam 2 Porter St
Byas, Cora
 "Docket," *CDT*, 19 May 1905 disorderly house
Byrd, Sarah Lee
 "Cold Morning," *CDT*, 6 Feb 1917 disorderly house
 "John Barleycorn's," *CN*, 4 Apr 1917 disorderly house
 "Sarah Lee Byrd," *CDT*, 18 Dec 1917 disorderly house
Byrne, Catherine/Kate
 Chattanooga city directory 1910 madam 320 E Tenth St
 "Police Raid," *CN*, 21 Dec 1912 resort W Tenth St
Calhoun, Mabel
 "City Police Court," *CN*, 22 Jan 1913 disorderly house
Cannon, Maggie (a.k.a. Marguerite Fried)
 "Indictments," *CDT*, 13 Jul 1907 woman of the underworld
 "'Squire Hogan," *CStar*, 17 Apr 1908 in Georgia Miller's resort
 "Vindication," *CN*, 17 Apr 1908 woman of the underworld
 "Ed Boydston," *CDT*, 30 May 1909 proprietress disorderly house
 Census 1910 Hamilton Co TN Chattanooga boards Ada Culver's house 8
 Foster St
 "Will Gallahire," *CDT*, 14 May 1910 house of ill fame
Carmichael, Julia
 "Wrongdoers," *CDT*, 20 Nov 1907 disorderly house Penelope St
Carmichael, Lena
 "Justices Courts," *CDT*, 23 Nov 1888 in house of ill repute
 "Justice Courts," *CDC*, 23 Nov 1888 in Mattie Shults' house of ill fame
 "Justice Courts," *CDC*, 23 Nov 1888 house of ill fame
 "Squire Adams," *CDT*, 2 Dec 1889 bad reputation in house on High
 St
 "Before Recorder," *CDT*, 25 Jul 1891 in house of ill fame
 "Monday Meanness," *CDT*, 30 May 1893 maison de joie
 "Before Recorder," *CDT*, 1 Jun 1893 house of ill fame
 "A Tariff on Beer," *CDT*, 16 Jun 1893 house of ill fame on E St
 "Morphine Route," *CDT*, 11 Dec 1893 operates bagnio
 "Tired of Life," *CDT*, 24 Jul 1894 house of prostitution
 "Bagnio Raided," *CDT*, 30 Jul 1894 landlady of bagnio

"Jury Cases," *CDT,* 23 Sep 1894	house of ill fame
Chattanooga city directory 1895	madam 10 Porter St
Chattanooga city directory 1896	madam 13 Penelope St
"Tired of Life," *CDT,* 26 Jun 1896	resort
Chattanooga city directory 1897	madam 12-16 Helen St
Carson, Ann	
"Whisky Bottle," *CN,* 26 Jan 1917	madam
"Bone-Dry Scene," *CDT,* 27 Jan 1917	disorderly house
Carter, Annie	
"City Court Verdicts," *CN,* 15 Aug 1912	assignation house
Chapman, Minnie	
"Loan Shark," *CDT,* 2 Oct 1911	disorderly house
Charles, Sadie	
"Tom Chapman," *CDT,* 25 Aug 1892	bagnio Chestnut St
"Hazing," *CDT,* 15 Sep 1893	disorderly house
"Ways of Wicked," *CDT,* 18 Nov 1893	house of ill repute
Chatman, Lula	
"Declares Intention," *CN,* 14 Jul 1914	disorderly house Market St
Clark, Eva	
"Women of Town," *CN,* 14 Sep 1907	house of ill repute
"Unlawful Selling," *CDT,* 16 Sep 1907	house of ill repute
Chattanooga city directory 1908	madam 11 Helen St
Clark, Kate	
Chattanooga city directory 1904	madam 4 Clift St
Clark, Maggie	
"Pulled," *CDT,* 28 Sep 1880	lewd house
"Police Notes," *CN,* 18 Sep 1903	in disorderly house
Clayton, Margaret	
"Recorder's Court," *CDT,* 16 Jan 1882	disorderly house
Cline, Delia	
"Recorder's Court," *CDT,* 20 Jun 1890	disorderly house
Cobb, Helen	
"Several Bound Over," *CN,* 24 Sep 1913	disorderly house
Cochran, Hattie	
Chattanooga city directory 1899	madam 324 Tenth St
Cole, Beulah	
"Four Young Men," *CN,* 16 May 1914	house in restricted district
"Ouster Bill's Blow," *CDT,* 6 Feb 1915	madam house of 7 women
Coleman, Lillie	
Census 1900 Hamilton Co TN Chattanooga	128 Foundry Alley
"Justice is Sought," *CN,* 10 Sep 1901	bawdy house
Conley, Sarintha	
"Libel Suit," *CDT,* 28 Oct 1882	prostitute Ninth St
"Circuit Court," *CDT,* 5 Jun 1883	disorderly house
Connelly, Cynthia	
"Criminal Record," *CDT,* 12 Jan 1888	disorderly house
Cook, May	

"Mayor's Court," *CDC*, 9 Aug 1887 — assignation house

Cook/Cooke, Roxie
Chattanooga city directory 1915 — madam 11 Helen St
"Ouster Bill's Blow," *CDT*, 6 Feb 1915 — madam house of 7 women

Cooper, Alice (née Allie Zan Chambers)
Chattanooga city directory 1878 — corner Fourth and Railroad
"Accused," *CDT*, 23 May 1879 — madam
Chattanooga city directory 1880 — west side Railroad Ave
Census 1880 Hamilton Co TN Chattanooga — prostitute
Chattanooga city directory 1881 — madam west side Broad St
"Circuit Court," *CDT*, 5 Apr 1881 — disorderly house
"In Bagnio," *CDT*, 20 Apr 1881 — house Fourth and Broad
"At the Threshold," *CDT*, 8 Sep 1881 — bagnio
Chattanooga city directory 1882 — madam west side on Broad St
"Madame Cooper," *CDT*, 4 Mar 1882 — madam
"City Court," *CDT*, 4 Apr 1882 — house of ill fame
"Recorder's Court," *CDT*, 1 Jul 1882 — house of ill fame
"Robberies," *CDT*, 21 Sep 1882 — madam
"Recorder's Court," *CDT*, 27 Oct 1882 — house of ill fame
"Banging Up Bagnio," *CDT*, 14 Dec 1882 — a bagnio
"Exhuming a Body," *CDT*, 11 Nov 1882 — madam
Chattanooga city directory 1883 — madam house west side Broad
Chattanooga city directory 1884-85 — madam 409 Broad St
"Circuit Court," *CDT*, 11 Jun 1884 — disorderly house
"Committed," *CDT*, 7 Sep 1884 — bagnio
"Robbed," *CDT*, 6 Sep 1884 — madam
"Fire," *CDT*, 11 Nov 1884 — madam corner Broad and Fourth
"Fine Apartments," *CDT*, 4 Jan 1885 — madam Broad near Fourth St
"Frail Fugitives," *CDC*, 6 Jun 1885 — madam
"Order Given," *CDT*, 19 Jul 1885 — keeper lewd house
"Gave Bond," *CDT*, 26 Oct 1885 — house of ill fame in Dayton
"Arson," *CDT*, 5 Dec 1885 — madam
"Tit for Tat," *CDC*, 8 Dec 1885 — madam house on Broad St
"Bagnio Burning," *CDC*, 18 Dec 1885 — madam house Broad St
Chattanooga city directory 1886 — madam 403 Broad St
"State Cases," *CDC*, 17 Apr 1886 — house of ill fame
"Mayor's Court, *CDT*, 18 Apr 1886 — house of ill fame
"Bad House," *CDT*, 18 Apr 1886 — madam
"Irate Madame," *CDT*, 21 Apr 1886 — madam
"Reformed Woman," *CDT*, 22 Apr 1886 — madam
"Girl Discharged," *CDT*, 23 Apr 1886 — madam
"Building Permits," *CDT*, 2 Jun 1886 — house Broad and Fourth
"Mayor of Dayton," *CDC*, 1 Nov 1886 — lewd house
"Dayton," *CDT*, 27 Apr 1887 — bawdy house
"The Courts," *CDC*, 10 Nov 1887 — madam
"Mayor's Court," *CDT*, 15 Nov 1887 — house of ill fame
"Brevities," *CDT*, 20 Nov 1887 — madam new house Florence St

'Soiled Doves," *CDT*, 2 Dec 1887	"soiled dove"
"A Big Fine," *CDT*, 27 Dec 1887	house of ill fame
"Mayor's Court," *CC*, 27 Dec 1887	house of ill fame
Chattanooga city directory 1888	madam 10 Florence St
"Saloonists," *CDT*, 15 Feb 1888	disorderly house
"Circuit Court," *CDT*, 22 May 1888	disorderly house
"Circuit Court," *CDT*, 8 Oct 1888	house of ill repute
"Justices' Courts," *CDT*, 17 Oct 1888	house of ill repute
"Justices' Courts," *CDT*, 22 Nov 1888	house of ill repute
Chattanooga city directory 1889	madam 8 Florence St
"Rasor Talks," *CDT*, 21 Jan 1889	bagnio
"Saved from Sin," *CDT*, 16 Feb 1889	house of ill fame
"Bill's Ignored," *CDT*, 19 Feb 1889	house of ill fame
"His Honor's Court," *CDT*, 5 Mar 1889	house of ill repute
"Threatened to Shoot," *CDT*, 9 Mar 1889	madam
"Killed Herself," *CDT*, 9 Apr 1889	bagnio
"Brevities," *CDT*, 17 May 1889	bagnio
"Not in Harmony," *CDT*, 12 Dec 1889	house of ill fame with 10 girls
Chattanooga city directory 1890	madam 8 Florence St
"Woman's Warning," *CDT*, 30 Jan 1890	madam
Chattanooga city directory 1891	madam 13 Helen St
"Sold Her Child," *CDT*, 29 Jul 1891	bagnio Helen St
"Where Sin Stalks," *CDT*, 30 Jul 1891	"should be driven out of town"
"In a Decent House," *CDT*, 11 Aug 1891	notorious
"A Busy Day," *CDT*, 14 Aug 1891	house of ill fame
"At It Again," *CDT*, 16 Aug 1891	nefarious business
"Blind Justice," *CDT*, 18 Aug 1891	bagnio
"Said She Was Dying," *CDT*, 30 Oct 1891	landlady Helen St
"Local Snap Shots," *CDT*, 3 Nov 1891	resides Helen St
"Sensational Suit," *CDT*, 2 Dec 1891	character of Helen St
"Alice Cooper," *CDT*, 12 Dec 1891	faked own death
"She Must Vacate," *CDT*, 18 Dec 1891	madam Helen St
Chattanooga city directory 1892	madam 13 Helen St
"Allen vs. Times," *CDT*, 3 Mar 1892	leader of demi monde
"A Parrot in Court," *CDT*, 26 Oct 1892	madam
"Gentlemen Angels," *CDT*, 5 Jan 1893	madam
"The Grand Jury," *CDT*, 14 Jan 1893	madam
"Mother Hubbards," *CDT*, 24 Feb 1893	joint of soiled birds Helen St
"The Bad Ones," *CDT*, 23 May 1893	madam dive Helen St
"Police Points," *CDT*, 13 Jun 1893	dive
"Talked At the Station," *CDT*, 29 Jul 1893	house of ill fame
"She Cut Her Throat," *CDT*, 29 Nov 1893	infamous procuress 11 Helen St
"No Kindly Words," *CDT*, 30 Nov 1893	notorious courtesan
"Alice Cooper," *CDT*, 2 Dec 1893	Elliott administers estate
"Alice Cooper," *CDT*, 10 Dec 1893	madam's goods sold at auction
"Unfortunate Girls," *CDT*, 18 Nov 1894	notorious procuress
Cooper, Kittie	

"A Parrot in Court," *CDT*, 26 Oct 1892	daughter-in-law madam Alice
Cooper	
"Gentlemen Angels," *CDT*, 5 Jan 1893	deserted wife of John Cooper
"The Grand Jury," *CDT*, 14 Jan 1893	madam
Cooper, Mary A.	
"Mayor's Court," *CDT*, 16 May 1888	disorderly house
"Justice's Court," *CDT*, 13 Jul 1888	lewd house
Copeland, Mandy	
"Circuit Court," *CDT*, 20 Mar 1880	disorderly house
Cosby, Rosa	
"Six Negro Women," *CN*, 5 May 1914	disorderly house
Coviet, Helen	
"Police Raid," *CN*, 21 Dec 1912	resort W Tenth St
Cowan, Kate	
"Justice Jottings," *CDT*, 28 Jan 1885	house of ill fame
"Circuit Court," *CDT*, 26 May 1885	disorderly house
"Circuit Court," *CDC*, 27 May 1885	disorderly house
"Smoking Grate," *CDT*, 19 Mar 1893	dive corner Leonard and Penelope
"'Mahogany Hall' Raided," *CDT*, 24 Jul 1893	house of ill repute
"Circuit Court," *CDT*, 6 Sep 1893	disorderly house
"Mahogany Hall," *CDT*, 14 Nov 1893	corner Leonard and Penelope
"Wanted Divorce," *CDT*, 25 Mar 1896	maison de joie
Chattanooga city directory 1898	madam 313 Leonard St
Census 1900 Hamilton Co TN Chattanooga	madam 313 Leonard St
Chattanooga city directory 1904	madam 313 Leonard St
Chattanooga city directory 1905	madam 313 Leonard St
"Docket," *CDT*, 19 May 1905	disorderly house
"Wild Shooting," *CN*, 30 Dec 1905	Mahogany Hall on Penelope
"Banished," *CDT*, 28 Jun 1906	"negress" madam 12 1/2 Penelope
"Two Deputies," *CDT*, 4 Sep 1906	house of ill fame
"Shot Negro," *CDT*, 6 May 1907	disorderly house corner
"Sunday Murder," *CN*, 6 May 1907	disorderly house corner
"Gave Himself Up," *CDT*, 7 May 1907	disorderly house corner
"Leaving the City," *CDT*, 8 May 1907	resort
"Grand Jury in Action," *CDT*, 13 May 1907	brothel
"Wholesale Indictments," *CDT*, 13 Jul 1907	woman of the underworld
"Close Up," *CN*, 15 Jun 1907	resort
"Back to Penelope," *CDT*, 14 Jul 1907	resorts
"Close Up," *CN*, 15 Jul 1907	resort Penelope St
"Where Will She Go," *CDT*, 16 Jul 1907	resort Penelope St
"Nobody Will Rent," *CDT*, 22 Jul 1907	"notorious dive-keeper"
"Rev. S. L. Crouch," *CStar*, 30 May 1907	resort near river
Weidner & Friedman 1908-1912	bawdy house 12 1/2 Penelope
Chattanooga city directory 1909	madam 12 1/2 Penelope St
"Justices," *DC*, 4 Feb 1909	house of ill fame
"Officers Charged," *CN*, 4 Feb 1909	house red-light district
"Argument," *CDT*, 5 Feb 1909	house red-light district

"Verdict Guilty," *CN*, 5 Feb 1909	madam
"Guilty," *CDT*, 6 Feb 1909	house in red-light district
"First Victory," *CN*, 9 Mar 1909	bawdy house
"Crox Indignant," *CDT*, 10 Mar 1909	madam
"Ed Boydston," *CDT*, 30 May 1909	proprietress disorderly house
"Incendiary," *CDT*, 22 Jun 1909	resort
Chattanooga city directory 1911	madam 12 1/2 Penelope St
Chattanooga city directory 1912	madam 12 1/2 Penelope St
"Police Raid," *CN*, 21 Dec 1912	resort W Tenth St
Chattanooga city directory 1913	madam 12 1/2 Penelope St
"Monday's Meeting," *CN*, 14 Jan 1913	resort
"No True Bills," *CDT*, 12 Jun 1915	bawdy house
Chattanooga city directory 1916	house 128 Foundry St
"True Bills," *CDT*, 5 May 1916	bawdy house
Chattanooga city directory 1918	house 20 Penelope St
"Brief Mention," *CDT*, 12 Feb 1918	disorderly house 20 Penelope St
"Brief Mention," *CDT*, 17 Dec 1918	notorious "negress" house of ill
fame	
"Bootleggers and Such," *CDT*, 7 May 1919	"78-year-old negress" on trial
"Names Get Mixed," *CN*, 7 May 1919	disorderly house
"Yellow Fever," *CDT*, 21 Nov 1929	"Queen of Mahogany Hall"
Cowan, Lucille	
"Brief Mention," *CDT*, 11 Dec 1917	disorderly house
Craighead, Hattie/Hallie	
"Circuit Court," *CDT*, 19 Jul 1882	disorderly house
"Circuit Court," *CDT*, 26 Jul 1882	disorderly house
Cross, Gussie	
"Cherry St House," *CDT*, 20 Nov 1917	disorderly house
"16 Merchants," *CDT*, 19 Dec 1917	disorderly house
Crow, Josie	
Chattanooga city directory 1880	madam south side Water St
Crow, Mamie (a.k.a. Mrs. Ed Whittenburg)	
Weidner & Friedman 1908-1912	in bawdy house
"34 Drunks," *CN*, 27 Dec 1909	in Culver's "gilded den of vice"
Chattanooga city directory 1911	madam 11 Florence St
"Grand Jury," *CN*, 13 Apr 1921	bawdy house
"Wrongdoers," *CDT*, 23 Apr 1921	bawdy house E Ninth St
Crow, Maggie/Mattie	
"Circuit Court," *CDT*, 26 May 1885	disorderly house
"In the Courts," *CDT*, 27 Sep 1900	disorderly house
Chattanooga city directory 1903	madam 15 Helen St
Chattanooga city directory 1904	madam 15 Helen St
Chattanooga city directory 1905	madam 15 Helen St
Chattanooga city directory 1906	madam 15 Helen St
"Caught the Girls," *CN*, 7 Jun 1906	"leading light of Red-light district"
"Two Deputies," *CDT*, 4 Sep 1906	house of ill fame
"Cases Dismissed," *CDT*, 5 Sep 1906	proprietor house of disrepute

Chattanooga city directory 1907 — madam 11 Helen St
"Closing Law," *CStar*, 2 Mar 1907 — in red-light district 15 Helen St
"Restaurant Man," *CDT*, 7 Mar 1907 — resort
"Agree to Fines," *CStar*, 26 Jun 1907 — house of ill fame
Census 1910 Hamilton Co TN Chattanooga — boards Ida Miller's house 135 Pine
"West Siders," *CDT*, 15 Jul 1910 — owns place of prostitution
Chattanooga city directory 1911 — madam 19 Helen St
"Additional Bonds," *CN*, 29 Sep 1911 — resort in red-light district
Chattanooga city directory 1912 — madam 17 Helen St
Chattanooga city directory 1918 — 15 Florence St

Crutchfield, Cornelia
"Justices' Court," *CDT*, 4 Nov 1888 — house of ill repute

Culver, Ada
Chattanooga city directory 1904 — madam 19 Florence St
Weidner & Friedman 1908-1912 — bawdy house 19 Florence St
"Seek Injunction," *CDT*, 11 Nov 1908 — immoral place
"Third Ward Folk," *DC*, 11 Nov 1908 — immoral place
Chattanooga city directory 1909 — madam 23 Florence St
"Ed Boydston," *CDT*, 30 May 1909 — disorderly resort
"34 Drunks," *CN*, 27 Dec 1909 — "gilded den of vice"
Chattanooga city directory 1910 — madam 8 Foster
1910 Hamilton Co. TN Chattanooga — house with 7 female boarders 8
Foster

Chattanooga city directory 1910 — madam 132 Foundry Alley
"West Siders," *CDT*, 15 Jul 1910 — owns place of prostitution
Chattanooga city directory 1911 — madam 132 Foundry Alley
"Additional Bonds," *CN*, 29 Sep 1911 — owns resort in red-light district
"Found Guilty," *CDT*, 11 Nov 1911 — house in red-light district
Chattanooga city directory 1912 — madam 16 Helen St
"Sales," *CDT*, 22 Oct 1913 — "lady of the night"
Chattanooga city directory 1914 — madam 12 1/2 Penelope St
Chattanooga city directory 1915 — madam 12 Penelope St
"Ouster Bill's Blow," *CDT*, 6 Feb 1915 — madam house with 6 women

Curtis, Mollie
"Raiding Maisons," *CDT*, 26 Jun 1885 — in house of ill fame
"Raiding Bagnios," *CDT*, 22 Oct 1885 — noted bagnio E Tenth St
"Policeman Bell," *CDT*, 4 Nov 1885 — lewd house
"Justices' Courts," *CDT*, 23 Nov 1888 — in house of ill repute
"Justice Courts," *CDC*, 23 Nov 1888 — in Mattie Shults' house of ill fame

Daffey, Mary
Chattanooga city directory 1905 — madam 414 Tenth St

Daniels, Ada
"Justice Jottings," *CDT*, 11 May 1886 — disorderly house

Darnell, Edna
"Women Submit," *CStar*, 18 Jul 1907 — west side resort
"Drunkenness," *CStar*, 19 May 1908 — resort
"Once More Lid," *CDT*, 19 May 1908 — house 11 Helen St

"Beer Sales," *CDT,* 20 May 1908 — resort 11 Helen St
"Beer Case," *CDT,* 11 Jun 1908 — house of underworld
"Man Charged," *CStar,* 29 Aug 1908 — woman of underworld 21 Helen St
"Notoriety," *CDT,* 11 Sep 1908 — operates immoral resort
"Up to Officials," *CN,* 11 Sep 1908 — operates resort
"Up to Grand Jury," *CDT,* 15 Sep 1908 — proprietress house in tenderloin
"Grand Jury," *CStar,* 6 Oct 1908 — bawdy house
"Houses Raided," *CN,* 11 Dec 1908 — former resort Helen St
Chattanooga city directory 1909 — madam 21 Helen St

Davis, Anna
"Special Term," *CN,* 16 Jun 1909 — bawdy house
Census 1900 Hamilton Co TN Chattanooga — in Sue Green's house 15 Helen

Davis, Grace
"Special Term," *CN,* 16 Jun 1909 — bawdy house

Davis, Lizzie
"Police Items," *CDT,* 11 Sep 1878 — house of ill fame
"Mother and Daughters," *CDT,* 17 May 1881 — disorderly house
"Bonds Reduced," *CDT,* 19 May 1881 — disorderly house
"Odd and Ends," *CDT,* 24 May 1881 — house of ill fame
"Recorder's Court," *CDT,* 6 Nov 1881 — house of ill fame
"Circuit Court," *CDT,* 26 Nov 1881 — bawdy house
"Circuit Court," *CDT,* 21 Mar 1882 — bawdy house
"Circuit Court," *CDT,* 22 Mar 1882 — disorderly house
Chattanooga city directory 1886 — house 303 E Second St
"Three Sisters Arrested," *CDT,* 23 Jan 1886 — corner Walnut and Second
"Justice Doings," *CDC,* 23 Mar 1886 — house of ill fame
Chattanooga city directory 1887 — madam 308 Chestnut St
Census 1910 Hamilton Co TN Chattanooga — 207 Chestnut St

Davis, Mattie/Martha
Census 1880 Hamilton Co TN Chattanooga — bawdy house Helen St
"Mother and Daughters," *CDT,* 17 May 1881 — disorderly house
"Bonds Reduced," *CDT,* 19 May 1881 — disorderly house
"Circuit Court," *CDT,* 20 Jul 1881 — in disorderly house
"Recorder's Court," *CDT,* 7 Mar 1882 — house of ill fame
"Recorder's Court," *CDT,* 27 Oct 1882 — in house of ill fame
Chattanooga city directory 1884-85 — boards madam Cooper's 409
Broad
"Mayor's Court," *CDT,* 8 Dec 1885 — in house of ill fame
Chattanooga city directory 1886 — 303 E Second St
"Three Sisters," *CDT,* 23 Jan 1886 — corner of Walnut and Second
"Mayor's Court," *CDT,* 9 Mar 1886 — in house of ill repute
"Justice Doings," *CDC,* 23 Mar 1886 — in Lizzie Davis's house of ill fame
"Mayor's Matinee," *CC,* 30 Apr 1887 — street walking
"Mayor's Court," *CDT,* 28 May 1886 — street walking
"Mayor's Court," *CDC,* 12 Jul 1887 — in house of ill fame
"Mayor's Court," *CDT,* 19 Jul 1887 — street walking
"Echoes Judicial," *CDC,* 25 Oct 1887 — in house of ill fame

"Mayor's Court," *CDT*, 24 Nov 1887	street walking
"Mayors Court," *CDT*, 2 Mar 1888	in house of ill fame
"Mayor's Court," *CDT*, 19 Mar 1888	in house of ill repute
"Police Court," *CSun*, 7 Jul 1888	house of ill fame
"The Mayor's Court," *CDT*, 7 Aug 1888	in house of ill repute
"Justices' Court," *CDT*, 7 Oct 1888	house of ill repute
"Mayor's Court, *CDC*, 6 Nov 1888	prostitution
"Justices' Court," *CDT*, 21 Nov 1888	house of ill repute
Chattanooga city directory 1889	madam 306 Chestnut St
"Justices' Costs," *CDT*, 19 Feb 1889	lewdness
"His Honor's Court," *CDT*, 5 Mar 1889	in house of ill fame
"Mayor's Court," *CDT*, 7 Mar 1889	in house of ill fame
"Mayor's Court," *CDT*, 6 Apr 1889	in house of ill fame
"Police Pickups," *CDT*, 23 Aug 1889	woman of the town
Chattanooga city directory 1890	madam 306 Chestnut
"Matters Personal," *CDT*, 31 Mar 1891	died

Davis, Sallie (a.k.a. Sallie Dunn)

"The Recorder's," *CDT*, 30 Mar 1875	bagnio
"Mother and Daughters," *CDT*, 17 May 1881	disorderly house
"Bonds Reduced," *CDT*, 19 May 1881	disorderly house
"Recorder's Court," *CDT*, 7 Mar 1882	house of ill fame
Chattanooga city directory 1886	303 E Second St
"Three Sisters," *CDT*, 23 Jan 1886	corner of Walnut and Second
"Mayor's Court," *CDT*, 9 Mar 1886	in house of ill repute
"Justice Doings," *CDC*, 23 Mar 1886	in Lizzie Davis's house of ill fame
"Mayor's Court," *CDT*, 20 Jun 1886	street walking
"Mayor's Court," *CDT*, 6 Jan 1887	in house of ill fame
"Mayor's Court," *CDC*, 12 Jul 1887	in house of ill fame
"Mayor's Court," *CDC*, 19 Jul 1887	in house of ill fame
"Mayor's Court," *CDT*, 19 Jul 1887	street walking
"Mayors Court," *CDT*, 2 Mar 1888	in house of ill fame
"Mayor's Court," *CDT*, 19 Mar 1888	in house of ill repute
"Police Court," *CSun*, 7 Jul 1888	house of ill fame
"The Mayor's Court," *CDT*, 7 Aug 1888	in house of ill repute
"Justices' Court," *CDT*, 7 Oct 1888	house of ill repute
"Mayor's Court, *CDC*, 6 Nov 1888	prostitution
"Justices' Court," *CDT*, 21 Nov 1888	house of ill repute
Chattanooga city directory 1889	madam 306 Chestnut St
"Justices' Costs," *CDT*, 19 Feb 1889	a bawdy house
"Police Pickups," *CDT*, 23 Aug 1889	woman of the town
Chattanooga city directory 1891	madam 306 Chestnut St
"Recorder's Court, *CDT*, 1 Sep 1891	in house of ill fame
Chattanooga city directory 1892	madam 306 Chestnut
"Few Lines," *CDT*, 12 Mar 1893	prostitute
"Circuit Court," *CDT*, 21 Sep 1893	disorderly house
"Minor Points," *CDT*, 14 Jan 1894	demimonde of North Chestnut St
Chattanooga city directory 1894	house 206 Chestnut St

Chattanooga city directory 1895	madam 207 Chestnut St
Chattanooga city directory 1896	madam 207 Chestnut St
Chattanooga city directory 1897	madam 207 Chestnut St
Chattanooga city directory 1899	madam 207 Chestnut St
Census 1900 Hamilton Co TN Chattanooga Chestnut	house with 2 female boarders 207
"Proceedings," *CDT*, 26 Sep 1900	disorderly house
Chattanooga city directory 1902	madam 207 Chestnut St
Chattanooga city directory 1903	madam 207 Chestnut St
Chattanooga city directory 1904	madam 207 Chestnut St
Chattanooga city directory 1905	madam 214 Chestnut St
Chattanooga city directory 1906	madam 207 Chestnut St
Chattanooga city directory 1907	madam 207 Chestnut St
Chattanooga city directory 1908	madam 207 Chestnut St
Chattanooga city directory 1909	madam, 207 Chestnut St
Census 1910 Hamilton Co TN Chattanooga	207 Chestnut St
Chattanooga city directory 1910	madam 207 Chestnut St
Chattanooga city directory 1911	madam 207 Chestnut St
"Mat Taylor," *CDT*, 22 Oct 1911	"largest & best appointed house"

Davis, Scylla
"Disorderly House," *CDT*, 17 May 1897	W Eighth St

Deckerd/Dechard/Decker, Annie
"Recorder's Court," *Dispatch*, 4 Aug 1877	improper house
Chattanooga city directory 1880	madam Cedar St
"Recorder's Court," *CDT*, 1 Jul 1882	in house of ill fame
Chattanooga city directory 1883	madam 113 E Tenth St
"Deluded Girl," *CDT*, 24 Jun 1883	bagnio
Chattanooga city directory 1884-85	madam 113 E Tenth St
"Circuit Court," *CDT*, 5 Feb 1884	disorderly house
"Circuit Court," *CDT*, 8 Feb 1885	disorderly house
"Raiding Maisons," *CDT*, 26 Jun 1885	house of ill fame
"Order Given," *CDT*, 19 Jul 1885	lewd house
Chattanooga city directory 1886	madam 113 E Tenth St

Deckerd/Dechard/Decker, Fannie
Chattanooga city directory 1881	madam east side Georgia Ave
Chattanooga city directory 1882	madam house Georgia Ave
"City Court," *CDT*, 4 Apr 1882	house of ill fame
"Recorder's Court," *CDT*, 1 Jul 1882	house of ill fame
"Recorder's Court," *CDT*, 26 Oct 1882	in house of ill fame
Chattanooga city directory 1883	madam 920 Georgia Ave
"Brevities," *CDT*, 2 Jun 1883	bagnio
"Brevities," *CDT*, 8 Jul 1883	bagnio raided
"Robbed," *CDT*, 10 Jul 1883	well-known sporting woman
Chattanooga city directory 1884-85	madam 920 Georgia Ave
"Circuit Court," *CDT*, 23 Jan 1884	lewd house
"Close Call," *CDT*, 13 Jun 1884	bagnio
"Raiding Maisons," *CDT*, 26 Jun 1885	house of ill fame

"Order Given," *CDT,* 19 Jul 1885 lewd house
 Chattanooga city directory 1886 madam 920 Georgia Ave
Degg, Youlander (see Appendix A)
 "Saloon," *Press,* 6 Jan 1905 disorderly house in Gadsden
DeMoss, Ida
 Chattanooga city directory 1896 madam 823 Chestnut St
 Chattanooga city directory 1897 madam 823 Chestnut St
 Chattanooga city directory 1898 madam 823 Chestnut St
DeMoss, Louise
 Chattanooga city directory 1899 madam 4 Clift St
Dickey, Jennie
 "Mayor's Court," *CC,* 15 May 1886 disorderly house
Dobbs, Alma
 "Police Raid," *CN,* 21 Dec 1912 resort W Tenth St
Dobbs, Helen
 "Police Raid," *CN,* 21 Dec 1912 resort W Tenth St
Dobbs, Willie
 Chattanooga city directory 1911 314 E Tenth St
 "Police Raid," *CN,* 21 Dec 1912 resort W Tenth St
 "Negro Women," *CDT,* 7 Mar 1916 in disreputable house
 "Long Report," *CDT,* 13 Mar 1915 in bawdy house
 "Docket," *CN,* 9 Apr 1915 in bawdy house
 Chattanooga city directory 1916 rooms 129 Foundry Alley
 "Myers Case," *CDT,* 8 Mar 1916 free-for-all fight Florence St
Donaldson, Mrs. East
 "Fines," *CN,* 13 Aug 1913 disorderly house 417 Pleasant St
Dorsey, Lessie
 "Judge the Man," *CN,* 8 Sep 1910 disorderly house
Dotson, Mattie
 "Negro Man," *CN,* 2 Apr 1914 disorderly house
Dougherty, Mary
 "House of Negress," *CDT,* 14 Sep 1908 immoral house W Ninth St
Dunlap, Celia
 "Mayor's Court," *CDT,* 23 Mar 1886 house of ill fame
Dyer, Mrs. Rat
 "Routing Mrs. Rat," *CC,* 28 Jul 1887 disorderly house
Dyson, Vivien (a.k.a. Mrs. George Dyson)
 "Rounding Up," *CDT,* 22 May 1916 disorderly house
Eakin, Bettie
 "Court Circles," *CDT,* 27 Jan 1886 disorderly house
Edmundson, Mrs.
 "Mayor's Court," *CDT,* 15 Nov 1887 house of ill fame
Elliot, Fannie
 "Mayor's Court," *CDT,* 17 Apr 1888 disorderly house
Ellis, Mrs.
 "Unfortunates," *CDT,* 29 Aug 1883 bawdy house
 "Unfortunates," *CDT,* 30 Aug 1883 prostitute with 3 children

English, Elizabeth

Census 1910 Hamilton Co TN Chattanooga	in Hallie Hood's house 31 Clift St
"Took Own Life," *CDT*, 5 Apr 1912	in "valley of shadows" 11 Helen St
"Reported Suicide," *CDT*, 6 Apr 1912	in local resort
"Demimonde," *CN*, 30 Dec 1912	woman of demimonde
Chattanooga city directory 1913	madam 17 Helen St
"Sales," *CDT*, 22 Oct 1913	"lady of the night"
Chattanooga city directory 1914	madam 17 Helen St
Chattanooga city directory 1915	madam 19 Helen St
"Ouster Bill's Blow," *CDT*, 6 Feb 1915	madam of house with 10 women
"Blackmail," *CDT*, 23 Sep 1915	notorious woman
"Woman Held," *CDT*, 17 Oct 1915	19 Helen St
Chattanooga city directory 1916	madam 19 Helen St
"English Dies," *CN*, 12 Sep 1916	"the English woman"

Falls, Annie

"In the Courts," *CDT*, 27 Sep 1900	disorderly house

Farmer, Rosa

Chattanooga city directory 1903	madam 212 B St

Fenton, Rosa

"Demimonde," *CN*, 30 Dec 1912	woman of the demimonde

Fenton, Ruby

Chattanooga city directory 1913	madam 11 Helen St
"Sales," *CDT*, 22 Oct 1913	"lady of the night"

Ferguson, Jane/Jennie

"Mayor's Court," *CDT*, 4 Apr 1884	disorderly house
"'Squire Freeman," *CDC*, 13 Sep 1884	well-known character
"Circuit Court," *CDT*, 30 Sep 1885	disorderly house
"Brevities," *CDT*, 1 Jul 1886	disorderly house
"Police Points," *CDT*, 30 Aug 1886	in Maud Bell's house
"Circuit Court," *CDT*, 21 Sep 1886	disorderly house
"Justices' Court," *CDT*, 20 Sep 1888	house of ill repute
"Mayor's Court," *CDT*, 8 Oct 1889	in house of ill fame
"Police Pointers," *CDT*, 10 Jan 1887	den Scruggstown
"Circuit Court," *CDT*, 22 Jan 1887	disorderly house
"Mayor's Court," *CDT*, 8 Oct 1889	in house of ill fame
"Recorder's Court," *CDT*, 29 Dec 1889	bawdy house Scruggstown

Field, Annie

"Mayor's Court," *CDC*, 18 Oct 1888	disorderly house

Fisk, Flora

"Notorious Dive," *CDT*, 6 Feb 1896	in Mary West's on Florence St
"Recorder's Court," *CDT*, 31 Jul 1896	disorderly house
"Grew Tired of Life," *CDT*, 4 May 1907	house 8 Florence St
"Women Submt," *CStar*, 18 Jul 1907	west side resort
Chattanooga city directory 1908	madam 8 Florence St
"Tragedy," *CDT*, 5 Mar 1908	house of ill fame 8 Florence St

Ford, Fannie

Chattanooga city directory 1891	madam 12 and 16 Helen St

"Fair But Frail," *CDT*, 18 Jan 1891 — house of ill repute 11 Helen St
Chattanooga city directory 1892 — madam 12 Helen St
"Four Fellows Full," *CDT*, 13 Apr 1892 — dive
"Heart and Harness," *CDT*, 4 Aug 1892 — bagnio
"Miss Roberts," *CDT*, 22 Dec 1892 — bagnio
"Grand Jury," *CDT*, 14 Jan 1893 — madam
Chattanooga city directory 1894 — madam 12 Helen St
"Caught on Fly," *Press*, 22 May 1894 — madam of bagnio
Chattanooga city directory 1895 — madam 12-16 Helen St
"Case of Depravity," *CDT*, 28 Feb 1896 — house on Helen St
"Assignment," *CDT*, 19 Apr 1896 — immoral house
"Circuit Court," *CDT*, 18 May 1897 — house of ill fame

Fortner, Clara/Clarissa
"Jail Jots," *CDC*, 24 Feb 1885 — disorderly house
"Dynamite," *CDC*, 25 May 1885 — house of ill fame
"Circuit Court," *CDT*, 28 May 1885 — disorderly house
"Tired of Life," *CDT*, 19 Jan 1886 — sister of Maria Fortner prostitute
"Mayor's Court," *CC*, 4 Nov 1886 — in house of ill fame

Foster, Jennie
"Circuit Court," *CDT*, 28 May 1885 — in disorderly house
"Made Fur Fly," *CDT*, 17 Mar 1886 — Chestnut St
"Jim Dowling," *CDC*, 19 May 1886 — in disorderly house
"Mayor's Court," *CDC*, 12 Jul 1887 — house of ill fame
"Mayor's Court," *CDC*, 12 Jul 1887 — house of ill fame

Foster, Tennie
"Recorder's Court," *CDT*, 2 Apr 1882 — in house of ill fame
"City Court," *CDT*, 4 Apr 1882 — in house of ill fame
"Shooting," *CDC*, 27 Dec 1884 — woman of easy habits
"Mayor's Court," *CDC*, 8 Jan 1886 — in house of ill fame
"Mayor's Court," *CDC*, 1 Apr 1887 — inmate
"Mayor's Court," *CDC*, 22 Apr 1887 — street walking
"Charged," *CDT*, 18 Jun 1887 — house of unsavory repute
"Mayor's Court," *CDC*, 26 Jun 1887 — in house of ill fame
"The Courts," *CDT*, 21 Sep 1887 — house of ill fame
"Mayor's Court," *CDT*, 21 Mar 1888 — house of ill repute
"Mayor's Court," *CDT*, 3 Mar 1888 — in house of ill fame
"Mayor's Court," *CDT*, 3 Apr 1888 — in house of ill fame

Fowler, Hattie
"Budget," *CDT*, 15 Nov 1898 — disorderly house

Francis, Harriet
"Circuit Court," *CDT*, 20 Mar 1880 — disorderly house

Francis, Mollie
"Arrests Yesterday," *CDT*, 2 Jul 1888 — street walking
"Arrests Yesterday," *CDT*, 6 Aug 1888 — house of ill repute
"The Mayor's Court," *CDT*, 7 Aug 1888 — house of ill repute

Franklin, Ella
"True Bills," *CDT*, 12 Jan 1917 — disorderly house

Fried, Marguerite (a.k.a. Maggie Cannon)
 "Criminal Court," *CDT*, 2 May 1910 — assignation house
 "Will Gallahire," *CDT*, 14 May 1910 — operates house of ill fame
Friedman, Irene

Census 1900 Hamilton Co TN Chattanooga	resides 114 Helen St
Chattanooga city directory 1904	madam 7 Grove Street
"Grand Jury," *CN*, 12 May 1904	house of ill fame
"Grand Jury," *CDT*, 13 May 1904	house of ill fame
"Today's Docket," *CDT*, 19 Jan 1905	house of ill fame
"Docket," *CDT*, 19 May 1905	bawdy house
Chattanooga city directory 1905	madam 628 Leonard St
Chattanooga city directory 1906	madam 628 Leonard St
"Caught the Girls," *CN*, 7 Jun 1906	"leading light of Red-light district"
"Another Moves," *CN*, 20 Jun 1906	house in tenderloin Leonard St
"Irene's Place," *CDT*, 30 Jun 1906	resort 628 Leonard St
"Saloon Licenses," *CN*, 3 Jul 1906	house of bad reputation
"Houses of Ill Fame," *CDT*, 17 Jul 1906	disorderly house
Chattanooga city directory 1907	madam 628 W Tenth St
"Closing Law," *CStar*, 2 Mar 1907	house in red-light district Helen St
"Women of Town," *CN*, 14 Sep 1907	house of ill repute
"Unlawful Selling," *CDT*, 16 Sep 1907	house of ill repute
"Busy Day," *CN*, 24 Sep 1907	woman of the world
Weidner & Friedman 1908-1912	bawdy house 19 Helen St
Chattanooga city directory 1908	madam 19 Helen St
"Women Charge," *CDT*, 31 Jan 1908	proprietress Helen St resort
"Praying on Bridge," *CDT*, 30 May 1908	house 19 Helen St
"Notoriety," *CDT*, 11 Sep 1908	operates immoral resort
"Up to Officials," *CN*, 11 Sep 1908	operates resort
"Up to Grand Jury," *CDT*, 15 Sep 1908	proprietress house in tenderloin
"Grand Jury," *CStar*, 6 Oct 1908	bawdy house
"Policemen Raid," *CN*, 28 Oct 1908	resort on Helen St
"Seek Injunction," *CDT*, 11 Nov 1908	immoral place
"Third Ward Folk," *DC*, 11 Nov 1908	operates immoral place
"Red-light Wiped Out," *CDT*, 16 Nov 1908	red-light district Helen and Florence
Chattanooga city directory 1909	madam 19 Helen St
"Ed Boydston," *CDT*, 30 May 1909	proprietress disorderly house
"Fee-Grabbing," *CDT*, 18 Jun 1909	house of ill fame
"Ed Boydston," *CDT*, 19 Jun 1909	ill-famed house
Chattanooga city directory 1910	madam 19 Helen St
"West Siders," *CDT*, 15 Jul 1910	owns place of prostitution
"Judge M'Connell," *CN*, 30 Jul 1910	madam
"Cited to Appear," *CN*, 17 Oct 1910	disorderly house
Chattanooga city directory 1911	house 7 Custom House St
"Deny Contempt," *CN*, 27 Mar 1911	house of ill fame Helen St
"Answering Contempt," *CDT*, 12 Apr 1911	house in red-light district
"Guilty," *CDT*, 13 Apr 1911	house in red-light district

"Red-light District," *CDT*, 30 Sep 1911	denizen of red-light district
"Red-light Injunction," *CN*, 10 Oct 1911	in red-light district
"Decree," *CDT*, 11 Dec 1911	house of ill fame
"Injunction," *CN*, 29 Aug 1912	bawdy house
"Injunction," *CN*, 9 Sep 1912	bawdy house
"Blue Goose Hollow," *CDT*, 8 Apr 1916	house on Helen St

Fryar, Morgan

"Circuit Court," *CDT*, 20 Mar 1880	disorderly house

Fuell, Saide

Weidner & Friedman 1908-1912	bawdy house 21 Helen St
"Seek Injunction," *CDT*, 11 Nov 1908	immoral place
"Third Ward Folk," *DC*, 11 Nov 1908	operates immoral place

Fulgham/Fulghum, Marion

Weidner & Friedman 1908-1912	bawdy house 17 Helen St
"Seek Injunction," *CDT*, 11 Nov 1908	immoral place
"Third Ward Folk," *DC*, 11 Nov 1908	operates immoral place
"Special Term," *CN*, 16 Jun 1909	bawdy house
Chattanooga city directory 1910	madam 108 Pine St
Census 1910 Hamilton Co TN Chattanooga St	with 6 female boarders 108 Pine
"They Deny Contempt," *CN*, 27 Mar 1911	house of ill fame Helen St
"Answering Contempt," *CDT*, 12 Apr 1911	house in red-light district
"Guilty of Contempt," *CDT*, 13 Apr 1911	house in red-light district
"Red-light District," *CDT*, 30 Sep 1911	denizen of red-light district
"Sales Taboo," *CDT*, 22 Oct 1913	"lady of the night"
Chattanooga city directory 1914	madam 18 Helen St
Chattanooga city directory 1915	madam 16 Helen St
"Ouster Bill's Blow Heavy," *CDT*, 6 Feb 1915	madam of house with 4 women

Fuller, Marion

Chattanooga city directory 1909	madam 15 Helen St

Fulton, Mary

Chattanooga city directory 1911	madam 15 Helen St

Garretty, Carrie

Chattanooga city directory 1883	madam 550 Sidney St

Garnel, Gerta

"Recorder's Court," *CDT*, 21 Mar 1882	house of ill fame

Gentry, Lena

"Disorderlies," *CDT*, 22 May 1916	bawdy house

Gibbs, Ada/Addie

Census 1880 Hamilton Co TN Chattanooga	prostitute
"Recorder's Court," *CDT*, 2 Apr 1882	in house of ill fame
"City Court," *CDT*, 4 Apr 1882	in house of ill fame
"Recorder's Court," *CDT*, 26 Oct 1882	house of ill fame
"Recorder's Court," *CDT*, 18 Feb 1883	in house of ill fame
Chattanooga city directory 1884-85 Broad St	in madam Morris's house 403
"Mayor's Court," *CDM*, 16 Aug 1886	soiled dove

"Mayor's Court," *CDT*, 25 Jan 1887 — in house of ill fame
"His Honor's Court," *CDT*, 5 Mar 1889 — in house of ill fame
"Recorder's Court," *CDT*, 29 Jan 1890 — soliciting company on street

Gibson, Eva
"Police Raid," *CN*, 21 Dec 1912 — resort on W Tenth St
Chattanooga city directory 1915 — 127 Foundry Alley
"Negro Women," *CDT*, 7 Mar 1916 — in disreputable house
"Myers Case," *CDT*, 8 Mar 1916 — free-for-all fight
"Man Held," *CDT*, 31 Mar 1916 — disorderly house
"Hear Lectures," *CDT*, 20 May 1916 — disorderly house
Chattanooga city directory 1916 — house 127 Foundry Alley
Chattanooga city directory 1917 — house 23 Florence St

Gillum/Gillom, Mrs. Maggie
"Hotel Owners," *CN*, 7 Sep 1917 — disorderly house
"Set Docket," *CN*, 22 Sep 1917 — disorderly house

Gilmore, Willie
"Hulbert and Cain," *CN*, 15 Jan 1917 — disorderly house

Girley, Florence
"Justice Doings," *CDC*, 24 Dec 1885 — disorderly house

Glover, Selma
"Clerk Assigns," *CN*, 27 Jan 1914 — disorderly house

Godsey, Sarah
Chattanooga city directory 1880 — madam

Goings, Mary
"Recorder's Court," *CDT*, 30 Jun 1891 — disorderly house

Gossett, Oma
"Highway Robbery," *CN*, 3 Apr 1916 — disorderly house

Granberry, Jessie
Chattanooga city directory 1897 — madam 301 W Ninth St

Gray, Annie
Chattanooga city directory 1903 — madam 208 E St

Gray, Nannie
"Justices' Courts," *CDT*, 11 Apr 1890 — a bawdy house

Gray, Nellie
"Miniature Distillery," *CDT*, 17 Jan 1911 — in Hines' resort 8 Florence St
"Heavy Fines," *CN*, 1 Aug 1911 — in white slave case
"Additional Bonds," *CN*, 29 Sep 1911 — owns resort in red-light district
Weidner & Friedman 1908-1912 — in bawdy house
"Usual Woman," *CDT*, 22 Aug 1916 — in Hines' disorderly house
Census 1920 Hamilton Co TN Chattanooga — in Hines' rooming house 11
Florence

Green, Ella
"Came as Witnesses," *CN*, 27 Sep 1910 — disorderly house

Green, Mary (a.k.a. Ledford)
"Rounding Up," *CDT*, 22 May 1916 — disorderly house

Green, Sue/Susie (see Appendix A)
Chattanooga city directory 1898 — madam 12-16 Helen St

"Yesterday's Fire," *CDT*, 5 Feb 1898	18 Helen St
Chattanooga city directory 1899	madam 16 Helen St
"Recorder's Court," *CDT*, 6 Jan 1899	Helen St
Census 1900 Hamilton Co TN Chattanooga	house of prostitution 15 Helen St
Chattanooga city directory 1902	madam 16 Helen St
Chattanooga city directory 1903	madam 16 Helen St
Chattanooga city directory 1904	madam 16 Helen St
"Delinquent Licenses," *CDT*, 15 Feb 1904	Florence St
Chattanooga city directory 1905	madam 16 Helen St
"Tired of Life," *CN*, 6 Jul 1905	resort 16 Helen St
"At Forest Hills," *CN*, 7 Jul 1905	resort Helen St
Chattanooga city directory 1906	madam 16 Helen St
"Houses of Ill Fame," *CDT*, 17 Jul 1906	disorderly house
"'Weary of Breath," *CDT*, 10 Aug 1906	Helen St
"Two Deputies," *CDT*, 4 Sep 1906	house of ill fame
"Cases Dismissed," *CDT*, 5 Sep 1906	proprietor house of disrepute
Chattanooga city directory 1907	madam 16 Helen St
"Closing Law," *CStar*, 2 Mar 1907	house in red-light district 16
Helen	
"Peculiar Blaze," *CStar*, 3 Dec 1907	15 Helen St
Weidner & Friedman 1908-1912	bawdy house 16 Helen St
Chattanooga city directory 1908	madam 16 Helen St
"Seek Injunction," *CDT*, 11 Nov 1908	immoral place
"Third Ward Folks," *DC*, 11 Nov 1908	operates immoral place
Chattanooga city directory 1909	madam 16 Helen St
"Ed Boydston," *CDT*, 30 May 1909	proprietress disorderly house
Census 1910 Hamilton Co TN Chattanooga	house with 4 female boarders 118
Pine	
Chattanooga city directory 1910	madam 118 Pine St
"West Siders," *CDT*, 15 Jul 1910	owns place of prostitution
"Cited to Appear," *CN*, 17 Oct 1910	disorderly house
"Fined," *CN*, 12 Apr 1911	defendant in red-light case
"Guilty," *CDT*, 13 Apr 1911	house in red-light district
"Nuisance Bills," *CN*, 10 Sep 1914	house of ill fame 18 Florence St
"Ouster Bill's Blow," *CDT*, 6 Feb 1915	madam in house with 10 women
Chattanooga city directory 1916	madam 21 Helen St
Chattanooga city directory 1917	resides 617 E 5th St
Grigsby, Nina	
"Whipping Post," *CDT*, 5 Jun 1906	house on Douglas
"Grand Jury," *CN*, 12 Jul 1907	house of ill fame
"Indictments," *CDT*, 13 Jul 1907	woman of underworld
"John Taylor Case," *CN*, 28 May 1910	disorderly house
"Bad House," *CDT*, 27 Feb 1912	disorderly house E Ninth St
"Revelers," *CDT*, 28 Feb 1912	bad place
"Deadly Stab," *CDT*, 7 Aug 1913	place on E Ninth St
"Man Stabbed," *CN*, 7 Aug 1913	resort on Ninth St
"Night Time Taboo," *CDT*, 22 Oct 1913	"lady of the night"

"Colored Woman," *CN,* 16 Jun 1916 — place on Douglas St
"'No-Cutting Week,'" *CDT,* 14 Jan 1920 — 8 Florence St
Gross, Amanda
"Recorder's Court," *CDT,* 22 Sep 1891 — disorderly house
"Before Judge Moon," *CDT,* 6 Jan 1892 — prostitute W Ninth St
Gunsilas, Mary
"Circuit Court," *CDT,* 27 Mar 1881 — disorderly house
"Circuit Court," *CDT,* 19 Jul 1881 — disorderly house
"Circuit Court," *CDT,* 3 Aug 1881 — disorderly house
"Circuit Court," *CDT,* 22 Nov 1881 — disorderly house
"Circuit Court," *CDT,* 4 Dec 1881 — disorderly house
"Circuit Court," *CDT,* 20 Dec 1881 — disorderly house
Gye, Bessie
"Recorder's Court," *CDT,* 16 Jun 1895 — disorderly house
Haines, Lula
"House Broken Up," *CDT,* 8 Feb 1899 — disorderly house
Hall, Bertie/Bert
"Indictments," *CDT,* 13 Jul 1907 — woman of the underworld
"Women Submit," *CStar,* 18 Jul 1907 — west side resort
"Vindication," *CN,* 17 Apr 1908 — woman of the underworld
1910 Hamilton Co. TN Chattanooga — with 2 female boarders 15 Foster
"Called An Officer," *CN,* 4 Jun 1910 — disorderly house
"Soiled Doves," *CN,* 13 Jul 1911 — in "glimmering red light district"
"Physician is Held," *CN,* 4 Nov 1911 — resort on Florence St
"Demimonde," *CN,* 30 Dec 1912 — woman of the demimonde
Chattanooga city directory 1912 — madam 11 Florence St
Chattanooga city directory 1913 — madam 11 Florence St
"Ames Under Bond," *CN,* 18 Apr 1913 — house of ill repute
"Sales," *CDT,* 22 Oct 1913 — "lady of the night"
Hall, Ida
"Colored Gunman," *CN,* 16 Aug 1913 — disorderly house
"Thirty Cases," *CN,* 25 Sep 1914 — disorderly house
"Busy Session," *CN,* 20 Jan 1915 — disorderly house
Hall, Jo
Chattanooga city directory 1909 — madam 15 Florence St
Hall, Ruth
Chattanooga city directory 1914 — madam 11 Florence St
Hamilton, Lillian (née Morrison)
"Innocent Child," *CDT,* 9 Feb 1892 — house of ill fame
"In Sins Abode," *CDT,* 10 Feb 1892 — maison de joie Tenth St
Hampton, Pauline
"Special Term," *CN,* 16 Jun 1909 — bawdy house
Hancock, Hattie
"Indictments," *CDT,* 25 Sep 1915 — disorderly house
"Gossett Cursed," *CDT,* 22 Oct 1915 — disorderly house
Hanks/Hankins, Mary
"Arrests," *CDT,* 12 Mar 1888 — house of ill repute

"Mayor's Court," *CDT*, 13 Mar 1888 — house of ill repute
Hardin, Annie
 "Circuit Court," *CDT*, 7 Apr 1882 — disorderly house
Hardin, Marg
 "Mayor's Court," *CDT*, 9 Sep 1888 — house of ill fame
Hardy, Maude (a.k.a. Maude Perry)
 "Women Charged," *CN*, 15 Jun 1915 — disorderly house
 "Trickster is Held," *CDT*, 16 Jun 1915 — disorderly house
Hargrove, Alice
 "Mayor's Matinee," *CC*, 30 Apr 1887 — street walking
 "Courts," *CC*, 3 Nov 1887 — in house of ill fame
 "Mayor's Court," *CDT*, 22 May 1888 — street walking
 Chattanooga city directory 1898 — madam 8 State St
 Chattanooga city directory 1899 — madam 8 State St
Hargrove/Hargraves, Zola
 "Mayor's Court," *CDT*, 4 Mar 1888 — in house of ill repute
 "Recorder's Court, *CDT*, 1 Sep 1891 — in house of ill fame
 "Minor Points," *CDT*, 14 Jan 1894 — demimonde of Chestnut St
 "Two Deputies," *CDT*, 4 Sep 1906 — house of ill fame
 "Cases Dismissed," *CDT*, 5 Sep 1906 — proprietor house of disrepute
 "Disorderly House," *CDT*, 16 Jun 1914 — disorderly house 16th and Carr
Harper, Annie
 "Catches Robber," *CN*, 7 Jul 1913 — disorderly house
Harper, Gabe
 "Circuit Court," *CDT*, 25 Jul 1875 — disorderly house
Harper, Lena
 "East Ninth," *CN*, 16 Jan 1907 — disorderly house
Harrell, Ethel
 Chattanooga city directory 1910 — madam 1004 Douglas St
 Census 1910 Hamilton Co TN Chattanooga — in Boully's house 1004 Douglas St
Harris, Blanche
 "Transgressors," *CDT*, 19 Mar 1896 — prostitute
 Chattanooga city directory 1902 — madam 15 Florence St
 "Belle," *CN*, 15 Jan 1902 — sister Vivian Harris shoots self
 "Pathetic Scene," *CN*, 15 Jan 1902 — house of ill fame
 Chattanooga city directory 1903 — madam 15 Florence St
 "Real Estate," *CDT*, 3 Jun 1903 — lot on Helen St
 Chattanooga city directory 1904 — madam 15 Florence St
 "Delinquent," *CDT*, 13 Feb 1904 — resides Florence St
 Chattanooga city directory 1905 — madam 15 Florence St
 "Bullet Hits Girl," *CDT*, 16 Apr 1905 — resides 15 Florence St
 Chattanooga city directory 1906 — madam 15 Florence St
 "Houses Ill Fame," *CDT*, 17 Jul 1906 — disorderly house
 "Two Deputies," *CDT*, 4 Sep 1906 — house of ill fame
 "Cases Dismissed," *CDT*, 5 Sep 1906 — proprietor house of disrepute
 Chattanooga city directory 1907 — madam 15 Florence St
 Weidner & Friedman 1908-1912 — owns Lee's bawdy house 17 Helen

"Notoriety," *CDT*, 11 Sep 1908 — operates immoral resort
"Grand Jury," *CStar*, 6 Oct 1908 — rents property for bawdy house
"Seek Injunction," *CDT*, 11 Nov 1908 — immoral place
"Third Ward Folks," *DC*, 11 Nov 1908 — operates immoral place
Census 1910 Hamilton Co TN Chattanooga — house of ill fame 17 Helen St
Chattanooga city directory 1910 — madam 17 Helen St
"Cited to Appear," *CN*, 17 Oct 1910 — disorderly house
"Deny Contempt," *CN*, 27 Mar 1911 — house of ill fame Helen St
"Contempt," *CDT*, 12 Apr 1911 — in red-light district
"Red-light District," *CDT*, 30 Sep 1911 — denizen red-light district
"Fourteen More," *CN*, 10 Sep 1914 — house of ill fame 18 Florence St

Harris, Lizzie
"Circuit Court," *CDT*, 6 Oct 1886 — disorderly house
"The Courts," *CDT*, 20 Sep 1887 — disorderly house

Harris, Mary
"Jail Notes," *CDT*, 12 Jan 1887 — disorderly house

Harris, Millie/Willie
"Nine Arrests," *CN*, 20 Nov 1908 — bawdy house 16 Penelope St
"R. H. Crox," *CDT*, 10 Mar 1909 — madam
"Ed Boydston," *CDT*, 30 May 1909 — proprietress disorderly house
"City Judge," *CN*, 6 Jul 1910 — disorderly house with Daisy
Hunter
"Old Offender," *CN*, 11 Mar 1911 — worst house ever known by police
"Judge Fleming," *CDT*, 12 Mar 1911 — house of ill fame
"Police Raid," *CN*, 21 Dec 1912 — resort W Tenth St
"Police Court," *CDT*, 14 Nov 1914 — disorderly house Foundry Alley

Harris, Vina/Vinie
"Four Frail Ones," *CDT*, 25 Jun 1890 — disorderly house 210 Cowart St
"Recorder's Court," *CDT*, 9 Sep 1890 — has bagnio 210 Cowart St

Harris, Vivian
"Way of Transgressors," *CDT*, 19 Mar 1896 — prostitute
"Belle," *CN*, 15 Jan 1902 — sister of madam commits suicide
"Pathetic Scene," *CN*, 16 Jan 1902 — burial in Kentucky

Harrison, Maud
"Circuit Court," *CDT*, 20 Mar 1880 — disorderly house

Haskins, Mary
"Pickens Acquitted," *CDT*, 7 Feb 1888 — disorderly house

Harvey, Fannie (Mrs. Henry Nichol)
"Sanctum," *CDC*, 13 Apr 1886 — lewd house
"Nichol," *CDC*, 7 Jan 1887 — notorious prostitute

Hatcher, Beulah
"Murder Verdict," *CN*, 17 Aug 1914 — in Williams's house 309 E Tenth
"Tries to Lay Killing," *CN*, 29 Sep 1914 — house of bad repute
"M'Clusky," *CDT*, 30 Sep 1914 — house of ill repute
"M'Clusky Guilty," *CDT*, 6 Feb 1915 — house on E Tenth St

Hawk, Martha
"Difference in Morning," *CDT*, 30 Sep 1907 — house of ill fame

Hayden, Augusta
 "Charges Against Ames," *CN*, 21 Mar 1903 disorderly house
Hayes, Rosa
 "Girls Too Noisy," *CDT*, 10 Apr 1908 in Miller's house 16 Helen St
 "Kelly is Bound," *CDT*, 11 Apr 1908 arrested on Helen St
 "Demimonde," *CN*, 30 Dec 1912 woman of the demimonde
 Chattanooga city directory 1913 madam 21 Helen St
 "Sales," *CDT*, 22 Oct 1913 "lady of the night"
 Chattanooga city directory 1914 madam 15 Helen St
 Chattanooga city directory 1915 madam 21 Helen St
Henden, Clara
 "Circuit Court," *CDT*, 10 Feb 1885 disorderly house
Henderlight, Allie/Ollie
 Chattanooga city directory 1899 in Sanders' house 809 Pine St
 Census 1900 Hamilton Co TN Chattanooga in Sanders' house 809 Pine St
 "Three-Cornered Fight," *CN*, 9 Oct 1901 woman of the demimonde
 Weidner & Friedman 1908-1912 bawdy house
 "Seek Injunction," *CDT*, 11 Nov 1908 immoral place
 "Third Ward Folk," *DC*, 11 Nov 1908 immoral place
 Chattanooga city directory 1909 madam 8 Florence St
 Chattanooga city directory 1911 320 1/2 W Eighth St
 Chattanooga city directory 1912 320 1/2 W Eighth St
 Chattanooga city directory 1915 802 Poplar St
 Chattanooga city directory 1916 802 Poplar St
 Chattanooga city directory 1917 320 1/2 W Eighth St
Hendricks, Pearl
 Census 1900 Hamilton Co TN Chattanooga in Hicks' house of ill fame 11
 Florence
 Chattanooga city directory 1902 madam 208 E St
Henry, Dora
 Chattanooga city directory 1905 madam 633 E Ninth St
 "Case Against Women," *CDT*, 19 Jan 1906 house of ill fame
Henry, Fanny
 "Circuit Court," *CDT*, 25 Sep 1886 disorderly house
Heskew, Annie
 "Justices' Costs," *CDT*, 19 Feb 1889 house of ill fame
Hickman, Jennie
 "Two Women," *CDT*, 15 Apr 1910 disorderly house 511 W 7th St
Hicks, Dona
 "Supreme Court," *CN*, 13 Oct 1906 house of ill fame in Knox County
 "Prosecutor Swears," *CN*, 20 Jan 1909 bawdy house
Hicks, Mollie (a.k.a. "Irish Moll")
 "Circuit Court," *CDT*, 19 Jul 1882 disorderly house
 "Unnatural Mother," *CDT*, 26 Sep 1882 questionable character
 "Arrested ," *CDT*, 28 Feb 1885 depraved woman
 "Breaking Up," *CDT*, 18 Apr 1886 in madam Cooper's house
 "Justices' Courts," *CDT*, 22 Nov 1888 in house of ill repute

Chattanooga city directory 1890	madam 11 Florence St
"Recorder's Court," *CDT*, 14 Jan 1890	in madam Cooper's house
"Recorder's Court," *CDT*, 27 May 1890	temporary proprietress Red Ellen's
"Courts," *CDT*, 27 Jul 1890	in bad house
Chattanooga city directory 1891	madam 11 Florence St
"Recorder's Court," *CDT*, 9 Apr 1891	den
"Who Was Hackman?" *CDT*, 15 Nov 1891	notorious dive on Florence St
"Confederate Goods," *CDT*, 30 Jun 1892	bagnio
Chattanooga city directory 1892	madam 11 Florence St
"Sins and Sinners," *CDT*, 2 Nov 1892	house of ill fame
"Still Under Weather," *CDT*, 16 Sep 1893	madam
"A Brand," *CDT*, 28 Oct 1893	"aggregation of soiled doves"
"Cut Her Throat," *CDT*, 29 Nov 1893	madam
Chattanooga city directory 1894	madam 11 Florence St
"Warrants," *CDT*, 26 Jan 1894	mansion on Florence St
"Drunken Father," *CDT*, 22 Mar 1894	dive on Florence St
Chattanooga city directory 1895	madam 8 Florence St
"Depraved Mother," *CDT*, 10 Feb 1895	bagnio
"Rescued," *CDT*, 11 Feb 1895	bagnio
Pitiable Case," *CDT*, 28 Feb 1895	bagnio
Chattanooga city directory 1896	madam 8 Florence St
"More Fee Getting," *CDT*, 3 Oct 1896	madam
Chattanooga city directory 1897	madam 8 Florence St
Chattanooga city directory 1898	madam 11 Florence St
Chattanooga city directory 1899	madam 11 Florence St
Census 1900 Hamilton Co TN Chattanooga	madam 11 Florence St
Chattanooga city directory 1902	madam 11 Florence
"Bob Johnson," *CN*, 3 Dec 1902	notorious house 11 Florence St
Chattanooga city directory 1903	madam 11 Florence St
Chattanooga city directory 1904	madam 11 Florence St
"Pistol Ball," *CN*, 12 Jun 1904	resort on Florence St
Chattanooga city directory 1905	11 Florence St
Chattanooga city directory 1906	madam 15 Florence St
"Two Deputies," *CDT*, 4 Sep 1906	house of ill fame
Chattanooga city directory 1907	madam 11 Florence St
"Too Many Loves," *CStar*, 31 Jan 1907	mistress resort on Florence St
"Indictments," *CDT*, 13 Jul 1907	woman of underworld
"Women Submit," *CStar*, 18 Jul 1907	west side resort
"Mollie Hicks," *CStar*, 31 Aug 1907	house on Florence St
"'Irish Moll'," *CDT*, 31 Aug 1907	low dive on Florence St
Weidner & Friedman 1908-1912	bawdy house 11 Florence St
"Squire Hogan," *CStar*, 17 Apr 1908	woman of demimonde
Chattanooga city directory 1908	madam 11 Florence St
"Notoriety," *CDT*, 11 Sep 1908	operates immoral resort
"Its Up to Officials," *CN*, 11 Sep 1908	operates resort
"Up to Grand Jury," *CDT*, 15 Sep 1908	proprietress house in tenderloin
"Grand Jury," *CStar*, 6 Oct 1908	bawdy house

"Seek Injunction," *CDT*, 11 Nov 1908 — immoral place
"Third Ward Folk," *DC*, 11 Nov 1908 — operates immoral place
Chattanooga city directory 1909 — madam 11 Florence St
Chattanooga city directory 1910 — madam 11 Florence St
"'Irish Moll'," *CDT*, 29 Jan 1910 — queen of disorderly house
"Will of 'Irish Moll'," *CDT*, 17 Feb 1910 — years in the underworld

Hight, Rosa
"Heavy Docket," *CN*, 19 May 1913 — disorderly house

Hightower, Minnie
"Recorder's," *CDT*, 30 Mar 1875 — bagnio

Hill, Amanda
"Mayor's Court," *CC*, 11 Aug 1886 — disorderly house
"Mayor's Court," *CDC*, 12 Aug 1886 — disorderly house

Hill, Anna
"No Openers," *CDT*, 26 Feb 1912 — disorderly house 834 Fort

Hill, Frankie
Chattanooga city directory 1896 — madam 3 Porter St
Chattanooga city directory 1897 — madam 3 Porter St

Hill, Mary
" Witness," *CDT*, 12 Apr 1916 — disorderly house Penelope St

Hill, Mollie
"Ouster Bill's Blow," *CDT*, 6 Feb 1915 — madam of house with 2 women

Hill, Mrs. R. A.
"Mayor's Court," *CDT*, 3 Dec 1885 — lewd house

Hill, Willie
"Off on Honeymoon," 1 Mar 1908 — house of ill repute E Ninth St

Hines, Laura
Census 1910 Hamilton Co TN Chattanooga Douglas — house with 3 females 1024
Chattanooga city directory 1910 — madam 1024 Douglas St
Chattanooga city directory 1911 — madam 8 Florence St
"Miniature Distillery," *CDT*, 17 Jan 1911 — resort 8 Florence St
"Additional Bonds," *CN*, 29 Sep 1911 — owns resort ed-light district
"Found Guilty," *CDT*, 11 Nov 1911 — house in red-light district
Weidner & Friedman 1908-1912 — in bawdy house
Chattanooga city directory 1912 — madam 8 Florence St
"Demimonde," *CN*, 30 Dec 1912 — woman of the demimonde
Chattanooga city directory 1913 — madam 8 Florence St
"Emma Walker," *CN*, 22 Apr 1913 — disorderly house
"Sales," *CDT*, 22 Oct 1913 — "lady of the night"
Chattanooga city directory 1915 — madam 9 Florence St
"Ouster Bill's Blow," *CDT*, 6 Feb 1915 — madam with 9 women
Chattanooga city directory 1916 — madam 11 Florence St
"Few Drunks," *CDT*, 10 Jan 1916 — disorderly house
"Grand Jury," *CDT*, 12 Feb 1916 — house of ill fame
"Memory Lapsed," *CN*, 21 Aug 1916 — disorderly house 6 inmates
"Usual Woman," *CDT*, 22 Aug 1916 — disorderly house 4 inmates

Chattanooga city directory 1917	house 11 Florence St
Chattanooga city directory 1918	house 11 Florence St
Chattanooga city directory 1919	house 11 Florence St
Census 1920 Hamilton Co TN Chattanooga	rooming house 11 Florence St

Hobbs, Lou
"Justices' Costs," CDT, 19 Feb 1889	disorderly house

Hodge, Dora
"Negroes," CDT, 11 Nov 1912	sells whisky at E Ninth St home
"Police Court," CN, 12 Nov 1912	disorderly house
"Heavy Fines" CDT, 14 Nov 1912	disorderly house
"Tries to Lay," CN, 29 Sep 1914	in house of bad repute
"M'Clusky Says," CDT, 30 Sep 1914	in house of ill repute
"Disorderly Houses," CDT, 12 Jan 1917	"hotel" at Tenth and King Sts
"'Syndicate'," CDT, 18 Feb 1917	house E Tenth St

Hood, Hallie
"Women Submit," CStar, 18 Jul 1907	west side resort
"Women of Town," CN, 14 Sep 1907	house of ill repute
"Unlawful Selling," CDT, 16 Sep 1907	house of ill repute
"Busy Day," CN, 24 Sep 1907	woman of world
"Under-World," CDT, 20 Dec 1907	resort 15 Florence St
Weidner & Friedman 1908-1912	bawdy house 15 Helen St
Chattanooga city directory 1908	madam 15 Florence St
"Seek Injunction," CDT, 11 Nov 1908	immoral place
"Squire Hogan," CStar, 17 Apr 1908	woman of demimonde
"Notoriety," CDT, 11 Sep 1908	operates immoral resort
"Up to Officials," CN, 11 Sep 1908	operates resort
"Up to Grand Jury," CDT, 15 Sep 1908	proprietress house in tenderloin
"Grand Jury," CStar, 6 Oct 1908	bawdy house
"Third Ward Folk," DC, 11 Nov 1908	operates immoral place
Chattanooga city directory 1909	madam 15 Florence St
"Ed Boydston," CDT, 30 May 1909	proprietress of disorderly house
"Brains Dashed Out," CN, 5 Jun 1909	madam
"Mad Ride," CDT, 6 Jun 1909	woman of underworld
Census 1910 Hamilton Co TN Chattanooga Clift	house with 7 female boarders 31
Chattanooga city directory 1910	madam 129-31 Foundry Alley
Chattanooga city directory 1911	madam 31 Clift St
Chattanooga city directory 1912	madam 31 Clift St
Chattanooga city directory 1913	madam 31 Clift St
"Sales," CDT, 22 Oct 1913	lady of the night
Chattanooga city directory 1914	madam 21 Helen St

Hood, Mollie
Chattanooga city directory 1908	madam 15 Florence St

Hooper, Annie (a.k.a. Mrs. Austin Hooper)
"Local News," CDT, 13 Aug 1896	house of ill repute

Horden, Ann
"Circuit Court," CDT, 19 Jul 1882	disorderly house

Horn, Kate
 Chattanooga city directory 1913 madam 118 Florence St
Howard, Abbie
 "Woman with Knife," *CDT*, 6 Dec 1885 bagnio
Hunter, Daisy
 "Stole from Stranger," *CDT*, 29 Oct 1907 house of ill repute
 "Nine Arrests," *CN*, 20 Nov 1908 in Harris' bawdy house 16
 Penelope
 "R. H. Crox," *CDT*, 10 Mar 1909 in Harris' house
 "City Judge," *CN*, 6 Jul 1910 runs disorderly house
Husky, Maria
 "Mayor's Court," *CC*, 9 Jun 1887 disorderly house
Hussman, Julia
 Chattanooga city directory 1880 madam Railroad Ave
Irish Moll (see Hicks, Mollie)
Jackson, Belle
 "Escaped," *CDT*, 4 Jun 1881 disorderly house
Jackson, Jennie
 "Heaviest Docket," *CN*, 6 Jan 1913 disorderly house
 "Arson," *CDT*, 21 Mar 1916 disorderly house
Jackson, Minnie
 "Police Docket," *CN*, 9 Mar 1904 disorderly house
James, Fannie (a.k.a. Fannie Martin)
 "Disorderly," *CDT*, 22 Jan 1917 disorderly house
Jenkins, Alberta
 "Judge Fleming," *CN*, 5 Jul 1910 disorderly house 311 Vaughn St
Jennings, Ida
 "Heavy Docket," *CN*, 24 May 1910 disorderly house
Jennings, Ophelia
 "Heavy Docket," *CN*, 15 Jan 1912 disorderly house
Jewell, Lucy
 Chattanooga city directory 1898 madam 15 Helen St
 Chattanooga city directory 1899 madam 15 Helen St
 Census 1900 Hamilton Co TN Chattanooga madam house of ill fame 15 Helen
 "Heavy Docket," *CN*, 27 Aug 1901 lewdness
 Chattanooga city directory 1902 madam 15 Helen St
Johnson, Annie
 "Ignored Bills," *CDT*, 18 Feb 1888 lewd house
 "Soldier Held," *CDT*, 11 Jan 1916 in disorderly house
Johnson, Bessie
 "Four Frail Ones," *CDT*, 25 Jun 1890 disorderly house 210 Cowart St
 "She Cut to Kill," *CDT*, 26 Jun 1892 in Mollie Turner's bagnio
 "Local Points," *CDT*, 14 Jan 1894 demimonde of N Chestnut St
 Chattanooga city directory 1896 madam 1 Porter St
 "Terrible Tragedy," *CDT*, 27 Oct 1896 house 12 Helen St
 "Boger Tragedy," *CDT*, 28 Oct 1896 madam
 "Police," *CDT*, 4 Jan 1897 disorderly house Helen St

Johnson, Mrs. Henry
"Justices' Costs," *CDT,* 19 Feb 1889 — house of ill fame
Johnson, Louise
Chattanooga city directory 1905 — house 12 1/2 Penelope St
Chattanooga city directory 1905 — house 16 Penelope St
Johnson, Marie/Maria
"Vindication," *CN,* 17 Apr 1908 — woman of underworld
"Chrisman House," *CN,* 7 Sep 1908 — in house of ill fame
'Fee-Grabbing," *CDT,* 18 Jun 1909 — house of ill fame
"Ed Boydston," *CDT,* 19 Jun 1909 — house of ill fame
Weidner & Friedman 1908-1912 — in bawdy house
Johnson, Mary
"Mayor's Court," *CDT,* 18 Jun 1889 — disorderly house
"Indictments," *CDT,* 13 Jul 1907 — woman of underworld
"Two Were Company," *CN,* 18 Oct 1911 — disorderly house
Johnson, Paula
Chattanooga city directory 1904 — madam 807 Pine St
Johnson, Ruth
"Demimonde in Court," *CN,* 30 Dec 1912 — woman of the demimonde
Chattanooga city directory 1913 — madam 17 Helen St
Johnson, Sue
"Recorder's," *CDT,* 7 Mar 1882 — house of ill fame
Johnson, Viola
"Weaving Web," *CDT,* 17 Jun 1908 — engagements with men
"Called Officer," *CN,* 4 Jun 1910 — disorderly house
"Miniature Distillery," *CDT,* 17 Jan 1911 — in Hines' resort 8 Florence St
Johnson, Zola
"Two Deputies," *CDT,* 4 Sep 1906 — house of ill fame
Johnston, Marie
"Ed Boydston," *CDT,* 30 May 1909 — proprietress disorderly house
Jones, Annie
"Last Night's Fire," *CDT,* 11 Nov 1884 — in Alice Cooper's house
"State Cases," *CDC,* 17 Apr 1886 — in house of ill fame
Census 1900 Hamilton Co TN Chattanooga Florence — madam house of ill fame 8
Chattanooga city directory 1902 — madam 31 Clift St
"Not a Nuisance," *CN,* 6 Aug 1903 — house 8 Florence St
"Constable Trewhitt," *CN,* 9 Oct 1903 — house 8 Florence St
"Self Destruction," *CN,* 3 Nov 1903 — notorious house 8 Florence St
"Licenses," *CDT,* 13 Feb 1904 — resides Florence St
Jones, Georgia
Chattanooga city directory 1913 — madam 15 Helen St
Jones, Lizzie
"Mayor's Court," *CDC,* 25 Dec 1887 — in Susan Walker's house of ill fame
"Mayor's Court," *CDT,* 11 Mar 1888 — street walking
"Special Term," *CN,* 16 Jun 1909 — bawdy house
Jones, Maggie

"City Court," *CDT*, 4 Apr 1882 in house of ill fame
"Woman Killed," *CN*, 23 Jan 1915 disorderly house Tenth and King
Jones, Rena
 "Negro Doped," *CDT*, 4 May 1916 disorderly house
Jones, Sallie
 "Justices' Costs," *CDT*, 19 Feb 1889 assignation house
Jones, Willie May
 "Short Session," *CN*, 8 Jul 1909 house of ill repute
Kebler, Carrie
 "Carrie Drew," *CN*, 10 Jun 1910 disorderly house Market St
Keel, Georgia
 Chattanooga city directory 1912 madam 15 Helen St
Keith, Dinah
 "Recorder's Court," *CDT*, 7 Mar 1882 house of ill fame
Kellogg, Louise
 "Praying on Bridge," *CDT*, 30 May 1908 resort Water and Pine
 "Kellogg House," *CStar*, 25 Sep 1908 proprietress on Pine St
 Chattanooga city directory 1909 madam 108 Pine St
Kelly, Ellen (a.k.a. Red Ellen, née Walker)
 "Mayors Court," *CDT*, 2 Mar 1888 house of ill fame
 "Red Ellen's Dive," *CDT*, 28 Jul 1889 opens house for the depraved
 "Recorder's Court," *CDT*, 11 Dec 1889 house of ill fame
 "Not in Harmony," *CDT*, 12 Dec 1889 house of ill fame
 "Recorder's Court," *CDT*, 27 May 1890 proprietress of a place
 "Red Ellen Dead," *CDT*, 5 Jun 1890 death
 "'Red Ellen's' Death," *CDT*, 7 Jun 1890 overdose of morphine
Kennedy, Mollie
 "Crazy," *CDT*, 21 Apr 1892 bagnio
Kesterson, Maggie
 "Wages of Sin," *CDT*, 3 Dec 1891 bagnio
 "Life in City," *CDT*, 4 Dec 1891 den Pine St
 Chattanooga city directory 1892 madam 204 Pine St
 Chattanooga city directory 1897 madam 204 Pine St
 Chattanooga city directory 1898 madam 204 Pine St
 Chattanooga city directory 1899 madam 204 Pine St
 Chattanooga city directory 1904 madam 522 1/2 Market St
Lamb, Mary
 Chattanooga city directory 1899 madam 226 E St
Lambert, Lola
 "With Police," *CDT*, 18 Nov 1896 in Fannie Ford's place
 Chattanooga city directory 1897 madam 301 W Ninth St
Landrum, Mary
 "Demimonde," *CN*, 30 Dec 1912 woman of demimonde
 Chattanooga city directory 1913 madam 8 Penelope St
Lane, Mollie
 "The Courts," *CDT*, 1 Mar 1887 in house of ill fame
 "Mayor's Court," *CDT*, 8 Feb 1889 in house of ill fame

"Bill's Ignored," *CDT*, 19 Feb 1889 — house of ill fame

Lane, Ruth
"Grand Jury," *CN*, 13 Apr 1921 — bawdy house
"Wrongdoers," *CDT*, 23 Apr 1921 — in Whittenberg's bawdy house

LaRue, Ruth
"Painted Women," *CN*, 18 Aug 1917 — disorderly house

Laury, Lula
Chattanooga city directory 1883 — madam 923 Whiteside St

Ledford, Mary (see Green, Mary)

Lee, Alice
Chattanooga city directory 1899 — madam 31 Clift St
Census 1900 Hamilton Co TN Chattanooga — boarding house 31 Clift St
"Important Arrests," *CDT*, 24 Sep 1900 — madam
"Three Suspected," *CDT*, 25 Sep 1900 — resort
Chattanooga city directory 1902 — madam 31 Clift St
Chattanooga city directory 1903 — madam 31 Clift St
Chattanooga city directory 1904 — madam 31 Clift St
"Licenses," *CDT*, 13 Feb 1904 — resides Clift St
"Usual Scenes," *CN*, 4 May 1904 — a resort
Chattanooga city directory 1905 — madam 31 Clift St
"Docket," *CDT*, 19 May 1905 — disorderly house
"Dr. Taylor," *CN*, 20 Nov 1905 — resort
"Physician," *CDT*, 20 Nov 1905 — resort
Chattanooga city directory 1906 — madam 414 Tenth St
"Houses of Ill Fame," *CDT*, 17 Jul 1906 — disorderly house
"Two Deputies," *CDT*, 4 Sep 1906 — house of ill fame
"Cases Dismissed," *CDT*, 5 Sep 1906 — proprietor house of disrepute
Chattanooga city directory 1907 — madam 17 Helen St
"Whiskey," *CStar*, 1 Mar 1907 — place on Helen St red-light district
"Restaurant Man," *CDT*, 7 Mar 1907 — resort
"Indictments," *CDT*, 13 Jul 1907 — woman of the underworld
"Agree to Fines," *CStar*, 26 Jun 1907 — house of ill fame
"Women of Town," *CN*, 14 Sep 1907 — keeper house of ill repute
"Unlawful Selling," *CDT*, 16 Sep 1907 — keeper house of ill repute
"Busy Day," *CN*, 24 Sep 1907 — woman of the world
"Fire Helen St," *CStar*, 22 Oct 1907 — house 17 Helen St
"Looks Like Fire," *CDT*, 22 Oct 1907 — house of ill fame 17 Helen St
Weidner & Friedman 1908-1912 — bawdy house 17 Helen St
Chattanooga city directory 1908 — madam 17 Clift St
"Troubles," *CDT*, 26 Jan 1908 — proprietress resort on Helen St
"'Squire Hogan," *CStar*, 17 Apr 1908 — woman of the demimonde
"Notoriety," *CDT*, 11 Sep 1908 — operates immoral resort
"Its Up to Officials," *CN*, 11 Sep 1908 — operates resort
"Up to Grand Jury," *CDT*, 15 Sep 1908 — proprietress house in tenderloin
"Grand Jury," *CStar*, 6 Oct 1908 — bawdy house
"Persistence," *CDT*, 21 Oct 1908 — proprietor resort in red-light district

"Seek Injunction," *CDT,* 11 Nov 1908 — immoral place
"Third Ward Folk," *DC,* 11 Nov 1908 — operating immoral place
Chattanooga city directory 1909 — madam 17 Helen St
Chattanooga city directory 1910 — madam 135 Chestnut St
"Cited," *CN,* 17 Oct 1910 — disorderly house
"Contempt," *CDT,* 12 Apr 1911 — house in red-light district
"Guilty," *CDT,* 13 Apr 1911 — house in red-light district
"Red-light District," *CDT,* 30 Sep 1911 — denizen red-light district
"Criminal Court," *CN,* 14 Mar 1917 — disorderly house

Lee, Cora
"Murdered," *CDT,* 29 Apr 1879 — operates bagnio
"Circuit Court," *CDT,* 20 Mar 1879 — disorderly house

Lee, Mrs. Lucinda
"Lee and Ross," *CDT,* 16 Aug 1893 — disorderly house Cherry St

Lee, Ruby
"City Offenders," *CDT,* 25 Mar 1891 — in house of ill fame
"Before Recorder," *CDT,* 25 Jul 1891 — in house of ill fame
"Recorder's Court," *CDT,* 24 Sep 1891 — in house of ill fame
"Stump-Tailed Fice," *CDT,* 15 Feb 1893 — soiled dove of "Crow's nest"
"Houses," *CDT,* 6 Jul 1893 — "uncertain house"
Chattanooga city directory 1902 — madam 331 W Ninth St
Chattanooga city directory 1905 — madam 331 W Ninth St

Levan, Blanche
Chattanooga city directory 1914 — madam 19 Penelope St

Lewis, Jennie
"Mayor's Court," *CDT,* 15 Aug 1888 — disorderly house

Lewis, Mary
"Special Term," *CN,* 16 Jun 1909 — bawdy house

Lister, Mollie
Chattanooga city directory 1896 — madam 15 Helen St
Chattanooga city directory 1897 — madam 13 Helen St

Lloyd, Bertie
Chattanooga city directory 1914 — madam 17 Florence St

Lock(e,) Jennie
"Circuit Court," *CDT,* 28 May 1885 — disorderly house
"Circuit Court," *CDC,* 28 May 1885 — disorderly house
"Circuit Court," *CDT,* 30 Sep 1885 — disorderly house
"Brevities," *CDT,* 19 Nov 1885 — disorderly house in Fifth Ward
"Mayor's Court," *CDT,* 5 Jan 1887 — in house of ill fame

Long, Lizzie
"'Martin the Just,'" *CN,* 16 Aug 1911 — house 11 Helen St

Long, Mabel
"Buddie Bachman," *CN,* 2 Oct 1911 — resort on Florence St
Chattanooga city directory 1912 — madam 8 Penelope St

Lowe, Kate
"At It Again," *CDT,* 16 Aug 1891 — in Alice Cooper's house
"Small Offenders," *CDT,* 27 May 1893 — in Madam Mattie Shultz's place

Chattanooga city directory 1895	madam 34 Eleventh St
"Tragedy," *CDT*, 27 Oct 1896	in Bessie Johnson's house 12
Helen St	
"Police," *CDT*, 4 Jan 1897	in Bessie Johnson's house Helen St
Census 1900 Hamilton Co TN Chattanooga	in Hicks' house of ill fame 11
Florence	
"Kate Lowe," *CDT*, 7 Nov 1900	woman of the town Helen St
Lynn, Cecil	
"Ouster Bill," *CDT*, 6 Feb 1915	madam house with 3 other
women	
Maceo, Leona	
Chattanooga city directory 1903	madam 6 Clift St
Madel, Maggie	
"Four Frail Ones," *CDT*, 25 Jun 1890	disorderly house 210 Cowart St
Magby, Ann	
"Shot at Brothel, *CDT*, 16 Feb 1885	house of ill fame
Maney, Molly	
"Circuit Court," *CDT*, 18 Jul 1882	disorderly house
Mansfield, Ida	
"Brief Mention," *CDT*, 28 Oct 1914	disorderly house
Marion, Amanda	
"He Saw Town," *CDC*, 3 Jan 1885	madam bagnio George St
Martin, Fannie (see James, Fannie)	
Martin, Frances	
"Anticipating Drought," *CDT*, 22 Jan 1917	disorderly house
Martin, Lucille	
Census 1910 Hamilton Co TN Chattanooga	boards Fulgham's house 108 Pine
St	
"Additional Bonds," *CN*, 29 Sep 1911	owns resort red-light district
Weidner & Friedman 1908-1912	in bawdy house
"Sales," *CDT*, 22 Oct 1913	lady of the night
Chattanooga city directory 1914	madam 15 Florence St
Martin, Sue	
"Shooting," *CDT*, 30 Sep 1873	bagnio Chestnut St
Mathias, Georgia	
"His Honor's," *CDT*, 5 Mar 1889	house of ill fame
Matlock, Lula	
"Liquor Cases," *CN*, 13 Dec 1915	disorderly house
"On the Bench," *CDT*, 14 Dec 1915	disorderly house
Matson, Jennie	
"City Court," *CN*, 2 Apr 1913	in disorderly house
"Officers Raid," *CDT*, 17 May 1917	disorderly house
Matthews, Elnora/Elenor	
"Docket," *CDT*, 19 May 1905	disorderly house
"Banished," *CDT*, 28 Jun 1906	madam 27 Penelope St
Mayfield, Odell	
"Not Guilty," *CN*, 7 Oct 1915	disorderly house

Mays, Florence
 "Houses Raided," *CN,* 11 Dec 1908 — in house of Edna Darnell
 "Carrie Drew," *CN,* 10 Jun 1910 — in Carrie Kebler's disorderly house
 Chattanooga city directory 1911 — madam 16 Helen St
 Weidner & Friedman 1908-1912 — in bawdy house
McAnnally, Elizabeth
 "Raid," *CDT,* 19 Jul 1915 — proprietress disorderly house
 "Big List," *CDT,* 20 Jul 1915 — disorderly house
McBee, Bessie
 "Bonds," *CN,* 29 Sep 1911 — owns resort red-light district
 "Found Guilty," *CDT,* 11 Nov 1911 — house red-light district
 Weidner & Friedman 1908-1912 — in bawdy house
McCallie, Lottie
 "Some Old-Times," *CN,* 6 Oct 1911 — disorderly house
McCloud, Annie
 "Mayor's Court," *CC,* 10 May 1886 — street walking
 "Justice Doings," *CC,* 11 May 1886 — disorderly house
 "Mayor's Court," *CDT,* 22 Apr 1887 — street walking
McCoy, Dulcenia
 "Mayor's Court," *CDT,* 13 Mar 1886 — disorderly house
McCoy, Madame
 "Order Given," *CDT,* 19 Jul 1885 — lewd house
 "Justices' Courts," *CDT,* 21 Sep 1888 — lewd house
 "Justices' Costs," *CDT,* 19 Feb 1889 — house of ill fame
McCoy, Munsey/Minsey
 "Arrests," *CDT,* 1 Aug 1887 — disorderly house
 "Mayor's Court," *CDT,* 2 Aug 1887 — assignation house
McDonald, Alice
 Chattanooga city directory 1903 — madam 6 Clift St
 Chattanooga city directory 1904 — madam 6 Clift St
McDonald, Annie
 "Docket," *CDT,* 19 May 1905 — disorderly house
McDonald, Dollie
 "Justices," *CDT,* 19 Mar 1889 — disorderly house
McIntyre, Rosie
 "Colored Dance," *CN,* 19 Jun 1911 — disorderly house Fort St
McLemyer, Mrs.
 "Official Raid," *CDT,* 18 Jun 1889 — house
 "Wanted Laudanum," *CDT,* 20 Jun 1889 — famous house
 "Midnight Horror," *CDT,* 3 Apr 1890 — bagnio on East End Ave
McNamara, Sarah
 "Arrest of Constable," *CDT,* 5 May 1890 — house of ill repute
Means, Emma
 "Mayor's Court," *CDT,* 17 Aug 1886 — disorderly house
Medaris, Kate
 Chattanooga city directory 1889 — madam 225 Chestnut St
 Chattanooga city directory 1892 — madam 200 Pine St

Melvin, Kitty
 Chattanooga city directory 1903 madam 301 W Ninth St
Meredith, Lou/Lula
 "Brevities," *CDT*, 2 May 1887 prostitute
 "Jail Register," *CDC*, 10 May 1887 bigamy
 "Very Bad Ones," *CDC*, 11 Sep 1887 bagnio on Fourth St
 "Mayor's Court," *CDC*, 13 Sep 1887 house of ill fame
 "Mayor's Court," *CDT*, 16 May 1888 street walking
Meredith, Sarah/Sis (née Day)
 1880 Hamilton Co TN Chattanooga prostitute
 Chattanooga city directory 1880 madam east side of Georgia Ave
 "Stabbed by His Sister," *CDT*, 17 Jan 1880 very low character
 Chattanooga city directory 1881 madam Helen St
 "Recorder's Court," *CDT*, 7 Mar 1882 in house of ill fame
 "Brevities," *CDT*, 2 May 1887 prostitute
 "Very Bad Ones," *CDC*, 11 Sep 1887 in Meredith's bagnio Fourth St
 "Mayor's Court," *CDC*, 13 Sep 1887 in house of ill fame
 "His Honor's Court," *CDT*, 5 Mar 1889 in house of ill fame
Miller, Amanda
 "Arrested," *CDT*, 20 Dec 1882 bagnio near the river
 "Shot Down," *CDT*, 14 Jul 1886 notorious prostitute
Miller, Mrs. Edward
 "Two Women," *CDT*, 15 Apr 1910 disorderly house 511 W Seventh
Miller, Emma
 "Night-Hawk," *CDT*, 2 Dec 1898 disorderly house on Boyce St
Miller, Georgia (a.k.a. Mrs. Georgia Lester)
 "Indictments," *CDT*, 13 Jul 1907 woman of underworld
 "Women Submit," *CStar*, 18 Jul 1907 west side resort
 "Women of Town," *CN*, 14 Sep 1907 house of ill repute
 "Unlawful Selling," *CDT*, 16 Sep 1907 house of ill repute
 "Busy Day," *CN*, 24 Sep 1907 woman of the world
 "Frightened," *CDT*, 18 Dec 1907 kept resort
 Chattanooga city directory 1908 madam 17 Florence St
 "Girls Noisy," *CDT*, 10 Apr 1908 house 5 inmates 16 Helen St
 "Squire Hogan," *CS.ar*, 17 Apr 1908 woman of demimonde
 "Raised Bill," *CN*, 6 May 1908 resort 16 Helen St
 "Jury Fails," *CDT*, 7 May 1908 house 16 Helen St
 "Suicide," *CDT*, 20 May 1908 resort 16 Helen St
 "Did Woman Jump," *CN*, 20 May 1908 madam of resort 16 Helen St
 "Some Doubt," *CDT*, 22 May 1908 resort 16 Helen St
 "Undesirable Neighbors," *CDT*, 8 Sep 1908 former resident tenderloin
 "Miller Case," *CDT*, 9 Sep 1908 proprietress of house in tenderloin
 "Georgia Miller," *CStar*, 12 Sep 1908 former denizen of tenderloin
 "Could Find No Place," *CStar*, 15 Sep 1908 former place on Florence St
 "Miller Case," *CStar*, 19 Sep 1908 disorderly place
 "Ed Boydston," *CDT*, 30 May 1909 proprietress disorderly house
 "Miller Dead," *CDT*, 18 Feb 1910 death

Miller, Ida
 "Continuances," *CDT*, 01 Jan 1908 resort 21 Helen St
 "Woman's Aim," *CStar*, 17 Mar 1908 proprietress 23 Helen St
 "Shot a Burglar," *CDT*, 18 Mar 1908 house 21 Helen St
 "Atlanta Girl," *CDT*, 14 Jun 1908 resort 21 Helen St
 "Innocence Lured," *CDT*, 17 Jul 1908 resort on Helen St
 Census 1910 Hamilton Co TN Chattanooga house with 4 female boarders 135
 Pine
 Chattanooga city directory 1911 madam 133 Chestnut St
Miller, Mollie
 Chattanooga city directory 1905 madam 408 Tenth St
 Chattanooga city directory 1906 madam 406 Tenth St
Milligan Sallie
 Census 1900 Hamilton Co TN Chattanooga in Morris' house of ill fame 15
 Florence
 Chattanooga city directory 1904 madam 113 King St
 Chattanooga city directory 1905 madam 113 King St
 "Docket," *CDT*, 19 May 1905 disorderly house
Monroe, Lillian
 Chattanooga city directory 1912 madam 19 Helen St
 "Demimonde," *CN*, 30 Dec 1912 woman of demimonde
 Chattanooga city directory 1913 madam 19 Helen St
 "Annie Harper," *CN*, 19 Apr 1913 disorderly house
 "Sales," *CDT*, 22 Oct 1913 lady of the night
 Chattanooga city directory 1914 madam 19 Helen St
Montague, Lizzie
 "Local," *CDT*, 11 Mar 1882 disorderly house
Moon, Mrs.
 "Held to Grand Jury," *CDT*, 16 Feb 1917 disorderly "Kentucky House"
Mooney, Gertrude
 "Leonard's Record," *CN*, 9 Jan 1913 disorderly house
Moore, Julia
 Census 1880 Hamilton Co TN Chattanooga prostitute
 "Recorder's Court," *CDT*, 26 Oct 1882 house of ill fame
Moore, Madge
 Chattanooga city directory 1910 madam 1006 Douglas St
 Census 1910 Hamilton Co TN Chattanooga 1006 Douglas St with 3 female
 boarders
Moore, Mary
 "Charged with Theft," *CDT*, 12 Jan 1910 resort 1006 Douglas St
Morgan, Adeline
 "Justices," *CDT*, 11 Apr 1890 bawdy house
Morgan, Alice
 "Justices," *CDT*, 11 Apr 1890 bawdy house
 "Recorder's Court," *CDT*, 30 Dec 1891 street walking
 "Modern Instance," *CDT*, 12 Jul 1892 in madam Smith's house Cowart
 St

"Moonlight Stroll," *CDT*, 26 Aug 1892	street walking
"Half Hours," *CDT*, 27 Aug 1892	"street walking
"Grand Jury," *CDT*, 10 Jan 1893	house of ill fame
"Ladies' Day," *CDT*, 17 Oct 1893	soiled dove
"Pitiable Case," *CDT*, 28 Feb 1895	notorious
Morgan, Mollie	
"Fifth Ward," *CDT*, 21 Oct 1883	noted character
"Mayor's Court," *CC*, 9 Aug 1887	house of ill fame
"Murder Mystery," *CDT*, 19 Dec 1892	prostitute
Morris, Mary/May	
"Recorder's Court," *Dispatch*, 4 Aug 1877	in improper house
Census 1880 Hamilton Co TN Chattanooga	house with female boarders
Chattanooga city directory 1880	madam Railroad Ave
Chattanooga city directory 1881	madam Broad St
Chattanooga city directory 1882	madam Broad St
"Recorder's Court," *CDT*, 2 Apr 1882	house of ill fame
"City Court," *CDT*, 4 Apr 1882	house of ill fame
"Recorder's Court," *CDT*, 1 Jul 1882	house of ill fame
"Recorder's Court," *CDT*, 26 Oct 1882	house of ill fame
Chattanooga city directory 1883	madam 403 Broad St
"Recorder's Court," *CDT*, 18 Feb 1883	in house of ill fame
"Deluded Girl," *CDT*, 24 Jun 1883	has bagnio
Chattanooga city directory 1884-85	madam 403 Broad St
"Morning's Fire," *CDT*, 6 Oct 1884	has maison
"Fire," *CDT*, 11 Nov 1884	madam corner Broad and Fourth
"Circuit Court," *CDT*, 10 Feb 1885	disorderly house
"Order Given," *CDT*, 19 Jul 1885	lewd house
"One Chapter," *CDT*, 12 Oct 1885	bawdy house 24 Chestnut St
Chattanooga city directory 1886	madam 13 Florence St
"Mayor's Court," *CDM*, 16 Aug 1886	soiled dove
Chattanooga city directory 1887	madam 13 Florence St
"Mayor's Court," *CDT*, 25 Jan 1887	house of ill fame
"Mayor's Court," *CDC*, 13 Mar 1887	"gay, giddy girls gulling grangers"
"Mayor's Court," *CDT*, 15 Nov 1887	house of ill fame
"Mayor's Court," *CDC*, 25 Dec 1887	in Walker's house of ill fame
Chattanooga city directory 1888	madam 13 Florence St
"Court Cases," *CDT*, 10 Feb 1888	disorderly house
"Circuit Court," *CDT*, 9 Oct 1888	house of ill repute
Chattanooga city directory 1889	madam 13 Florence St
"His Honor," *CDT*, 5 Mar 1889	house of ill repute
"Was It Morphine," *CDT*, 5 May 1889	bagnio on Florence St
Chattanooga city directory 1890	madam 15 Florence St
"Queer Fish," *CDT*, 25 Jan 1890	bagnio
Chattanooga city directory 1891	madam 15 Florence St
"Not a Drunk," *CDT*, 16 Jun 1891	in house of ill fame
"Real Estate," *CDT*, 2 Sep 1891	buys lot on Florence St
Chattanooga city directory 1892	madam 15 Florence St

"The Grand Jury," *CDT*, 14 Jan 1893	madam
"Wicked Women," *CDT*, 9 Aug 1893	wicked woman
"Circuit Court," *CDT*, 6 Sep 1893	disorderly house
"Local Snap Shots," *CDT*, 21 Oct 1893	dissolute woman
Chattanooga city directory 1894	madam 15 Florence St
Chattanooga city directory 1895	madam 15 Florence St
"A Story," *CDT*, 5 Apr 1895	bagnio
Chattanooga city directory 1896	madam 15 Florence St
"Recorder's Séance," *CDT*, 7 Feb 1896	infests dives on Ninth St
Chattanooga city directory 1897	madam 15 Florence St
"At Court House," *CDT*, 8 Sep 1897	charged with murdering own
infant	
Chattanooga city directory 1898	madam 15 Florence St
Chattanooga city directory 1899	madam 15 Florence St
Census 1900 Hamilton Co TN Chattanooga	madam house of ill fame 15 Flor-
ence St	

Morris, Minnie

"Circuit Court," *CDT*, 3 Apr 1881	disorderly house
"Recorder's Court," *CDT*, 1 Jul 1882	in house of ill fame

Morrison, Sarah

"Sunday," *CDT*, 21 Aug 1905	"running the worst kind of dive"
"Chain of Arrests," *CN*, 3 May 1906	disorderly house corner Foundry
and Clift	
"Negro Doped," *CDT*, 4 May 1916	disorderly house
"True Bills," *CN*, 8 Jul 1916	house of ill fame

Nast, Georgiana

"Before the Recorder," *CDT*, 23 Sep 1893	disorderly house

Neal, Mary

"Syndicate," *CDT*, 18 Feb 1917	house of E Tenth St

Newsome, Lela

"Recorder's Docket," *CDT*, 2 Feb 1892	house of ill fame

Nolan, Kate

"J. B. Cummins," *CDT*, 17 Jan 1892	boards with Mollie Hicks
"Police Register," *CDT*, 20 Jan 1896	prostitute
"Recorder' Court," *CDT*, 8 Jul 1896	disorderly house
"Recorder's Court," *CDT*, 31 Jul 1896	disorderly house
"Bound Over," *CDT*, 11 Dec 1896	disorderly house
"Violating Law," *CDT*, 8 Nov 1897	proprietress disorderly house
Chattanooga city directory 1899	madam 220 E St

Nolan, Nade

"Mayor's Court," *CC*, 10 May 1886	house of ill fame

Norton, Annie

Chattanooga city directory 1896	madam 323 W Ninth St
"One More," *CDT*, 7 Nov 1900	woman of the town 144 Cowart St
"Still Alive," *CDT*, 8 Nov 1900	attempted suicide questioned
"Norton Case," *CDT*, 13 Nov 1900	prostitute
"Raid," *CDT*, 13 Mar 1908	in Ransom's disorderly house 17

Chattanooga city directory 1894	madam 2 Porter St
"Grand Jury," *CN*, 15 Nov 1911	murder
Posey, Sadie A.	
Chattanooga city directory 1888	madam 1224 William St
Powers, Sallie	
"One Out of Way," *CDT*, 7 Aug 1890	bagnio 839 Madison St
"Two For Murder," *CDT*, 10 Aug 1890	in bagnio Madison St
"Woman for Murder," *CDT*, 14 Aug 1890	testimony
"Acquitted," *CDT*, 15 Aug 1890	testimony
Prattes, Florence M.	
Census 1910 Hamilton Co TN Chattanooga	house with 2 female boarders 11
Foster	
Pregmare, Lucy	
"Recorder's Court," *CDT*, 11 Aug 1882	disorderly house
Price, Laura	
Chattanooga city directory 1883	madam 18 Florence St
Chattanooga city directory 1884-85	madam 18 Florence St
Primrose, Emma	
Chattanooga city directory 1903	madam 114 Leonard St
Ransom, Mary	
"Raid on Penelope," *CDT*, 13 Mar 1908	disorderly house 17 Penelope St
"Soldiers Pay," *CDT*, 14 Mar 1908	disorderly house 17 Penelope St
"Disorderly Houses," *CDT*, 22 Jan 1917	disorderly house
Raymond, Lillie/Lil/Lily (see Tillett, Lillie)	
"Justices Courts," *CDT*, 4 Oct 1888	in house of ill repute
"Justices Courts," *CDT*, 23 Nov 1888	in house of ill repute
"Justice Courts," *CDC*, 23 Nov 1888	in Shultz's house of ill fame
"Mayor's Court," *CDT*, 23 Dec 1888	disorderly conduct
"A Row," *CDT*, 18 Feb 1890	in Berry's house on East End Ave
"Shooting Affair," *CDT*, 19 Feb 1890	quarrel in Nan Berry's house
"Recorder's Court," *CDT*, 18 Jul 1890	disorderly house
"Lewd Women," *CDT*, 25 Jun 1891	house of ill repute with sister Sue
Tillett	
Chattanooga city directory 1892	madam 208 E St
"Social Session," *CDT*, 12 May 1892	house on E Ninth St back of
Crow's saloon	
"Cholly's Letter," *CDT*, 3 Jul 1892	an unfortunate in sin
Reese, Louise	
Chattanooga city directory 1915	madam 17 Florence St
Reno, Mollie	
"Only Four Drinks," *CDT*, 26 May 1891	disorderly conduct
"Recorder's Court, *CDT*, 1 Sep 1891	disorderly house
Reyes, Jennie	
"Cuban House," *CN*, 9 Aug 1904	disorderly house Penelope St
"Case," *CDT*, 19 Jan 1906	in Louise Reyes' house of ill fame
Reyes/Rayes, Louise (a.k.a. Johnson)	
"Encounter," *CN*, 7 Sep 1903	in disorderly house 17 Florence St

"Cuban House," *CN*, 9 Aug 1904	disorderly house Penelope St
Chattanooga city directory 1905	madam
Chattanooga city directory 1906	madam
"Case," *CDT*, 19 Jan 1906	house of ill fame
"Two Deputies" *CDT*, 4 Sep 1906	house of ill fame
Chattanooga city directory 1907	madam 12 Florence St
"Chief Moseley," *CN*, 28 Jan 1907	proprietress of "dump"
"Got Baggage," *CDT*, 28 Jan 1907 record"	"Cuban woman with a police
"Eighteen Tried," *CDT*, 3 Feb 1907	receiving stolen goods
"Alleged Bail," *CStar*, 28 Mar 1907	receiving stolen goods
"Robert Drake," *CDT*, 11 Sep 1907	lewdness
"Demimonde," *CN*, 30 Dec 1912	woman of demimonde
"Emma Walker," *CN*, 22 Apr 1913	disorderly house
"Sales," *CDT*, 22 Oct 1913	"lady of the night"
"Ouster Bill," *CDT*, 6 Feb 1915 women	madam of house with 5 other
"Women Fined," *CN*, 6 Apr 1915	soliciting
"Trickster Held," *CDT*, 16 Jun 1915	prostitute
Chattanooga city directory 1916	madam 15 Florence

Richards, Annie

Chattanooga city directory 1891	madam 8 Florence St
"Not a Drunk," *CDT*, 16 Jun 1891	house of ill fame
"She Cut Throat," *CDT*, 29 Nov 1893	in Alice Cooper's house
"Scarlet Women," *CDT*, 26 Oct 1895	in Smith's house of assignation

Richards, Lola

"Sues," *CDT*, 31 Oct 1896	disorderly house

Richardson, Alice

"Sales," *CDT*, 22 Oct 1913	lady of the night
Chattanooga city directory 1914	madam 23 Florence St
Chattanooga city directory 1915	madam 15 Florence St
"Ouster Bill," *CDT*, 6 Feb 1915	madam with 3 women
"Criminal Docket," *CN*, 9 Feb 1917	disorderly house

Rober, Amanda

"Jail Notes," *CC*, 14 Jul 1886	disorderly house

Rober, Deborah

"Jail Notes," *CC*, 14 Jul 1886	disorderly house

Roberts, Lena

"True Bills," *CN*, 8 May 1915	disorderly house

Roberts, Nina/Mina

"Disorderlies," *CDT*, 22 May 1916	disorderly house
"Alleged Arson," *CN*, 22 May 1916	disorderly house
"Heavy Fines," *CDT*, 23 May 1916	disorderly house

Robinson, Minnie

"Large Docket," *CN*, 24 May 1915	disorderly house

Rocks, Margaret

"Circuit Court," *CDT*, 26 May 1885	disorderly house

Rogers, Alice
 "Mayor's Court," *CDT*, 18 Jun 1889 disorderly house
Rogers, Jennie
 Chattanooga city directory 1912 madam 23 Florence St
 Chattanooga city directory 1913 madam 23 Florence St
Rogers, Mollie
 "Recorder' Court," *CDT*, 8 Jul 1896 in disorderly house
 "Bound Over," *CDT*, 11 Dec 1896 a disorderly house
Roland(s), Anna
 "Jail Jottings," *CDT*, 20 Feb 1885 disorderly house
 "Circuit Court," *CDT*, 28 May 1885 disorderly house
 "Circuit Court," *CDT*, 26 Jan 1886 disorderly house
Roland, Cut
 "Jail Register," *CDT*, 19 Nov 1888 house of ill repute
 "Mayor's Court," *CDT*, 4 Dec 1888 house of ill repute
Roper, Lillian
 Chattanooga city directory 1911 madam 21 Helen St
Rose, Maude
 "Sunday Offenders," *CDT*, 2 Jul 1906 disorderly house Florence St
Ross, Mrs. Sylvania
 "Lee and Ross," *CDT*, 16 Aug 1893 disorderly house on Cherry St
Rowe, Sue
 "Brevities," *CDT*, 19 Nov 1885 disorderly house in Fifth Ward
Rowel, Amanda
 "Mayor's Court," *CDT*, 21 Apr 1886 lewd house
Rowland/Roland, Cat/Kate
 "Mayor's Court," *CDT*, 25 Apr 1888 street walking
 "Jail Register," *CDT*, 19 Nov 1888 house of ill repute
 "Justices' Costs," *CDT*, 19 Feb 1889 house of ill fame
 "Mayor's Court," *CDT*, 8 Oct 1889 house of ill fame
 "Recorder's Court," *CDT*, 29 Dec 1889 bawdy house in Scruggstown
 "Recorder's Court," *CDT*, 26 Feb 1890 prostitute
 "Recorder's Court, *CDT*, 1 Sep 1891 house of ill fame
Rudd, Rhoda
 "Disorderly House," *CN*, 6 Oct 1914 disorderly house Whiteside St
Rushworth, Kate
 "Neighbors Object," *CN*, 20 Jun 1914 disorderly house 112 Vine St
 "Many Offenders," *CN*, 24 Aug 1914 disorderly house
Russell, Virgie
 Chattanooga city directory 1898 madam 10 Van Dyke St
Sanders/Saunders, Tennie S.
 Chattanooga city directory 1898 madam 809 Pine St
 Chattanooga city directory 1899 house 809 Pine St
 Census 1900 Hamilton C. TN Chattanooga house with 5 female boarders 809
 Pine
 "Dazzling," *CN*, 13 Jun 1901 raided in Dugger's Alley
 "Day's Doings," *CN*, 12 Sep 1901 joint on Pine St

"Negro Shot," *CDT*, 23 Mar 1902 — house on Pine St
Chattanooga city directory 1903 — madam 809 Pine St
Chattanooga city directory 1904 — madam 809 Pine St
"Women Arrested," *CN*, 28 Jul 1904 — mansion Cocaine Alley Pine St
"Chester Goss," *CN*, 10 Dec 1904 — establishment on Pine St
Chattanooga city directory 1906 — madam 809 Pine St
"Tennie Sanders," *CN*, 24 Apr 1906 — immoral house
"Tenderloin," *CN*, 27 Jun 1906 — madam 809 Pine St
"Banished," *CDT*, 28 Jun 1906 — madam 809 Pine St
"Two Deputies," *CDT*, 4 Sep 1906 — house of ill fame
Chattanooga city directory 1907 — madam 8 Florence St
"Tennie No More," *CStar*, 19 Apr 1907 — disreputable house in Cocaine
Alley
"Sanders Died," *CN*, 19 Apr 1907 — resort in Cocaine Alley
"Wages of Sin," *CDT*, 19 Apr 1907 — dive in Cocaine Alley
Scales, Clemmie
 "Recorder's Court," *CDT*, 16 Jun 1895 — disorderly house
Scarbrough, Louise
 Chattanooga city directory 1912 — madam 17 Florence St
 Chattanooga city directory 1913 — madam 17 Florence St
Scott, Fannie
 "Disorderlies," *CDT*, 29 May 1916 — disorderly house
Senters, Mag
 "In the Courts," *CDT*, 27 Sep 1900 — disorderly house
Sevier, Annie
 "Burge Gunning," *CDT*, 26 Jul 1892 — Charlie Bird's mistress
 "Half Hours," *CDT*, 2 Aug 1892 — "Walter Seaton's girl"
 "Recorder," *CDT*, 1 Jun 1893 — in house of ill fame
 "Bird's Woes," *CDT*, 13 Jul 1893 — notorious character
 "In Courts," *CDT*, 27 Sep 1900 — disorderly house
Shadrick, Nannie
 "Justice's Court," *CDT*, 13 Jul 1888 — lewdness
 Chattanooga city directory 1894 — madam 108 W 3rd St
Shelton, Emma
 "Mayor's Court," *CDC*, 14 April 1886 — house of ill fame
 "Mayor's Court," *CDC*, 13 May 1886 — house of ill fame
Shultz/Schultz, Mattie
 Chattanooga city directory 1888 — madam 31 Clift St
 "Brevities," *CDT*, 13 Oct 1888 — pulled in by police
 "Mayor's Court," *CSun*, 21 Feb 1888 — house of ill fame
 "Disgraceful Affair," *CDT*, 1 Oct 1888 — bagnio
 "Justices Courts," *CDT*, 4 Oct 1888 — madam
 "Sensational Case," *CDC*, 30 Oct 1888 — bagnio
 "Justice Courts," *CDC*, 23 Nov 1888 — madam
 Chattanooga city directory 1889 — madam 31 Clift St
 "His Honor," *CDT*, 5 Mar 1889 — house of ill repute
 "Localettes," *CDT*, 6 Apr 1889 — arrested with inmates

"Death," *CDT*, 25 Apr 1889 — bagnio
"Calendar," *CDT*, 7 May 1889 — bagnio
"Deputies," *CDT*, 22 Oct 1889 — bagnio
Chattanooga city directory 1890 — madam 31 Clift St
"Circuit Court," *CDT*, 22 May 1890 — in house of prostitution
"Brevities," *CDT*, 30 May 1890 — sporting house
"Recorder's Court," *CDT*, 13 Jul 1890 — house of soiled doves
"Adams' Raid," *CDT*, 26 Aug 1890 — maison de joie raided
Chattanooga city directory 1891 — madam 31 Clift St
"Fair But Frail," *CDT*, 18 Jan 1891 — house of prostitution
"Divorce Day," *CDT*, 31 Mar 1891 — bagnio
Chattanooga city directory 1892 — madam 31 Clift St
"Not One Cent," *CDT*, 29 Jan 1892 — bagnio
"Fool From Atlanta," *CDT*, 18 May 1892 — bagnio on Tenth St
"Candidate for Hell," *CDT*, 20 Jul 1892 — house of ill fame
"Chase After Girl," *CDT*, 27 Oct 1892 — bagnio
"The Grand Jury," *CDT*, 14 Jan 1893 — madam
"Small Offenders," *CDT*, 27 May 1893 — madam
"Circuit Court," *CDT*, 6 Sep 1893 — disorderly house
Chattanooga city directory 1894 — madam 31 Clift St
"A Queer Case," *CDT*, 22 Jan 1894 — house of ill fame Founders Alley
Chattanooga city directory 1896 — madam 31 Clift St
"An Early Fire," *CDT*, 26 Feb 1896 — house on Clift St
Chattanooga city directory 1897 — madam 31 Clift St
Chattanooga city directory 1898 — madam 31 Clift St

Sims, Georgia
"House Raided," *CN*, 30 Jul 1906 — disorderly house

Slaten, Rosa
"Mayor's Court," *CDT*, 24 Jun 1888 — house of ill repute

Slaughter, Annie
"Disgrace," *CDT*, 29 Jul 1885 — bagnio 105 Penelope St

Slayton, Jessie
"Sanctum," *CDC*, 13 Apr 1886 — street walking
"Mayor's Court," *CDT*, 8 Dec 1888 — house of ill repute
"Mayor's Matinee," *CDC*, 8 Dec 1888 — house of ill repute

Sledge, Lela
"Jobs Scarce," *CDT*, 2 Sep 1917 — disorderly house

Smith, Ada
"Mayor's Court," *CDT*, 17 Aug 1886 — disorderly house

Smith, Annie (Mrs. Jack Ryan)
1880 Hamilton Co TN Chattanooga — prostitute in Cooper's house
"Breaking Up," *CDT*, 8 May 1885 — in disgraceful dive
"Mayor's Court," *CC*, 16 Aug 1886 — house of cloudy reputation
"Mayor's Court," *CDT*, 17 Aug 1886 — house of ill fame
"Courts," *CDT*, 10 May 1887 — house of ill fame
"Mayor's Court," *CDC*, 25 Dec 1887 — in Walker's house of ill fame
"Mayor's Court," *CDT*, 13 Apr 1888 — house of ill repute

"Mayor's Court," *CDT*, 16 May 1888	in disorderly house
"Justices Courts," *CDT*, 23 Nov 1888	in house of ill repute
"Bad Ones," *CDT*, 23 May 1893	resident Madame Cooper's dive
Helen	
"Ways of Wicked," *CDT*, 18 Nov 1893	house of ill repute
"Police Points," *CDT*, 13 Jun 1893	in Alice Cooper's dive
"Broken Up," *CDT*, 11 Apr 1895	disorderly house Ninth and Pine
"With Coppers," *CDT*, 21 Apr 1895 and Pine	mistress disorderly house Ninth
"Scarlet Women," *CDT*, 26 Oct 1895	house of assignation Chestnut St
Chattanooga city directory 1896	madam 809 Pine St
Chattanooga city directory 1897	madam 111 Vaughn St
"Busy Day," *CN*, 15 Oct 1903	house of ill fame
Smith, Dixie	
"Mixed Meanness," *CDT*, 7 Jul 1893	in maison de joie
"On Trial," *CDT*, 12 Jan 1896	house of ill fame
Smith, Ida	
"Indictments," *CDT*, 16 May 1914	lewd house
"Criminal Docket," *CDT*, 22 May 1914	lewd house
Smith, Laura	
"Rumpus," *CN*, 19 May 1910	disorderly house
Smith, Lizzie	
"Judge the Man," *CN*, 8 Sep 1910	disorderly house
Smith, Sallie	
"Local Snap Shots," *CDT*, 16 Apr 1894	prostitute
"City News," *CDT*, 11 Aug 1895	well-known character
"Recorder' Court," *CDT*, 8 Jul 1896	disorderly house
Chattanooga city directory 1897	madam 301 W Ninth St
"Docket," *CDT*, 19 May 1905	disorderly house
Chattanooga city directory 1906	madam 807 Pine St
"Two Deputies," *CDT*, 4 Sep 1906	house of ill fame
Census 1910 Hamilton Co TN Chattanooga	1022 Douglas St
"Bonds," *CN*, 29 Sep 1911	owns resort in red-light district
Sniderman, Nan	
"Justice Jottings," *CDT*, 3 Nov 1885	disorderly house
"Circuit Court," *CC*, 22 Sep 1886	disorderly house
Snyder, Josie	
"Circuit Court," *CDT*, 25 Sep 1886	disorderly house
Sterling, Lillian	
"Indictments," *CDT*, 13 Jul 1907	woman of underworld
"Women Submit," *CStar*, 18 Jul 1907	west side resort
"Women of Town," *CN*, 14 Sep 1907	house of ill repute
"Unlawful Selling," *CDT*, 16 Sep 1907	house of ill repute
"Busy Day," *CN*, 24 Sep 1907	woman of the world
Chattanooga city directory 1908	madam 15 Helen St
"Notoriety," *CDT*, 11 Sep 1908	operates immoral resort
"Up to Officials," *CN*, 11 Sep 1908	operates resort

Census 1910 Hamilton Co TN Chattanooga	boards Hood's house 31 Clift St
"Additional Bonds," *CN*, 29 Sep 1911	owns resort in red-light district
"Found Guilty," *CDT*, 11 Nov 1911	house in red-light district
Weidner & Friedman 1908-1912	in bawdy house
Chattanooga city directory 1912	madam 21 Helen St
Steward, Rebecca	
"The Courts," *CDC*, 21 Sep 1887	house of ill fame
"The Courts," *CDT*, 21 Sep 1887	house of ill fame
Stewart, Mrs.	
"Grand Jury," *CN*, 13 Apr 1921	bawdy house
Strange, Ellen	
"Order Given," *CDT*, 19 Jul 1885	lewd house
Streeter, Mollie	
"St Patrick," *CDT*, 19 Mar 1909	resides 15 Florence St
"Police Raid," *CN*, 21 Dec 1912	resort W Tenth St
Swartz, Pauline	
"Circuit Court," *CDT*, 16 Mar 1880	disorderly house
Tanner, Sylvia	
"Miniature Distillery," *CDT*, 17 Jan 1911	in Hines' resort 8 Florence St
"Woman of Tenderloin," *CN*, 8 Dec 1911	proprietress 11 Helen St
"Depths of Vice," *CDT*, 9 Dec 1911	woman of underworld 11 Helen
Chattanooga city directory 1912	madam 11 Helen St
Teasley, Jennie	
"Circuit Court," *CDT*, 18 May 1887	disorderly house
Thatcher, Sarah	
"Recorder's Court," *CDT*, 16 Jun 1895	disorderly house
Thomas, Carrie	
Census 1880 Hamilton Co TN Chattanooga	house for prostitutes
Thomas, Dolly	
"Monday's Court," *CN*, 8 Aug 1910	disorderly house
Thomas, Mary	
"Mayor's Court," *CDC*, 21 Sep 1886	disorderly house
"Mayor's Court," *CDC*, 15 May 1887	house of ill fame
Thompson, Ella	
Chattanooga city directory 1883	boards madam Walker's house 11
Florence	
"Justices' Courts," *CDT*, 22 Nov 1888	house of ill repute
Chattanooga city directory 1889	madam 11 Florence St
"Rasor Talks," *CDT*, 21 Jan 1889	warrant against Cooper's bagnio
"Mayor's Court," *CDT*, 7 Feb 1889	house of ill fame
"Bills Ignored," *CDT*, 19 Feb 1889	house of ill fame
Chattanooga city directory 1889	madam 11 Florence St
Thompson, Ellen (a.k.a. Big Ellen)	
"Woman Assaulted," *CDT*, 22 Mar 1886	in Walker's bagnio
"Mayor's Court," *CDT*, 8 Aug 1886	house of ill fame
"Mayor's Court," *CDT*, 9 Dec 1886	in house of ill fame
"Fight at Bagnio," *CDT*, 8 May 1889	unsavory reputation

"Mayor's Court," *CDT*, 30 Jul 1889	in house of ill fame
Thompson, Lucy	
"Mayor's Court," *CDT*, 15 Nov 1887	house of ill fame
Thompson, Maggie	
"Mayor's Court," *CDC*, 13 Sep 1887	assignation house
Tillett, Lillie (a.k.a. Lillie Raymond) (see Appendix A)	
Chattanooga city directory 1890	207 E Center St
Tillett, Nettie (a.k.a. Nettie Peyser) (see Appendix A)	
"Burglar Caught," *CDT*, 5 Oct 1900	madam resort Penelope St
"Street Identified," *CDT*, 13 Oct 1900	madam
Tillett, Susie (see Appendix A)	
Chattanooga city directory 1891	madam 113 Tenth St
"Lewd Women," *CDT*, 25 Jun 1891	house of ill repute
Chattanooga city directory 1892	madam 8 Florence St
"Lover Business," *CDT*, 30 Aug 1892	house of ill fame
"Day and Night," *CDT*, 31 Aug 1892	house with lover L. B. Moore
"She is Insane," *CDT*, 8 Apr 1893	depraved house
"Circuit Court," *CDT*, 6 Sep 1893	disorderly house
Chattanooga city directory 1894	madam 13 Helen St
"Jack's Version," *CDT*, 1 Mar 1894	proprietress of noted bagnios
"Spencers Arrested," *CDT*, 2 Mar 1894	warm words
"One Saloon Less," *CDT*, 28 Mar 1894	madam
"Caught Fly," *Chattanooga Press*, 22 May 1894	madam
"Local Snap Shots," *CDT*, 9 Jun 1894	madam
"Not Dead," *CDT*, 23 Sep 1894	house of ill fame
"Circuit Court," *CDT*, 31 Dec 1894	lewdness
Chattanooga city directory 1895	madam 13 Helen St
Chattanooga city directory 1896	madam 11 Helen St
Chattanooga city directory 1897	madam 11 Helen St
"At Court House," *CDT*, 14 Oct 1897	house of ill fame
Chattanooga city directory 1898	madam 11 Helen St
Chattanooga city directory 1899	madam 11 Helen St
Census 1900 Hamilton Co TN Chattanooga	madam house of ill fame 11 Helen
"Unfortunate," *CDT*, 26 Nov 1901	house on Helen St
Chattanooga city directory 1902	madam 11 Helen St
"Home is Wanted," *CN*, 28 Mar 1902	foundling at house on Florence
Chattanooga city directory 1903	madam 11 Helen St
Chattanooga city directory 1904	madam 11 Helen St
Chattanooga city directory 1905	madam 11 Helen St
"Louis Motz," *CDT*, 20 Mar 1905	place at 11 Helen St
Chattanooga city directory 1906	madam 11 Helen St
"Two Deputies," *CDT*, 4 Sep 1906	house of ill fame
"Cases Dismissed," *CDT*, 5 Sep 1906	proprietor house of disrepute
Chattanooga city directory 1907	madam 11 Helen St
Weidner & Friedman 1908-1912	bawdy house 11 Helen St
"Notoriety," *CDT*, 11 Sep 1908	operates immoral resort
"Warrants," *CStar*, 11 Sep 1908	operates immoral place

"Up to Officials," *CN*, 11 Sep 1908 — operates resort
"Up to Grand Jury," *CDT*, 15 Sep 1908 — proprietress house in tenderloin
"Grand Jury," *CStar*, 6 Oct 1908 — a.k.a. Susie Jack in bawdy house
"Seek Injunction," *CDT*, 11 Nov 1908 — immoral place
"Third Ward Folk," *DC*, 11 Nov 1908 — operates immoral place
Chattanooga city directory 1909 — madam 11 Helen St
"Died from Over Dose," *CN*, 9 Apr 1909 — house at 8 Foster St
"Ed Boydston," *CDT*, 30 May 1909 — noted woman of underworld
Census 1910 Hamilton Co TN Chattanooga 1020 Douglas — house with 5 female boarders
Chattanooga city directory 1910 — madam 1020 Douglas St
"West Siders Indignant," *CDT*, 15 Jul 1910 — owns place of prostitution
"Cited," *CN*, 17 Oct 1910 — disorderly house
Chattanooga city directory 1911 — madam 11 Helen St
"Deny Contempt," *CN*, 27 Mar 1911 — house of ill fame Helen St
"Answering," *CDT*, 12 Apr 1911 — house in red-light district
"Guilty," *CDT*, 13 Apr 1911 — house in red-light district
"Red-light District," *CDT*, 30 Sep 1911 — denizen of red-light district
Chattanooga city directory 1912 — madam 132 Foundry Alley
"Immoral Houses," *CN*, 29 Aug 1912 — bawdy house
"Demimonde in Court," *CN*, 30 Dec 1912 — proprietor of resort
Chattanooga city directory 1913 — madam 132 Foundry Allen
"Annie Harper Held," *CN*, 19 Apr 1913 — disorderly house
"Sales," *CDT*, 22 Oct 1913 — "lady of the night"
Chattanooga city directory 1914 — madam 8 Florence St
Chattanooga city directory 1915 — madam 8 Florence St
"Ouster Bill," *CDT*, 6 Feb 1915 women — madam house with 6 other
Chattanooga city directory 1916 — madam 8 Florence St
Chattanooga city directory 1916 — resides 405 1/2 Market St

Travena, Mollie
"Disorderly House," *CDT*, 6 Mar 1880 — disorderly house

Traynor, Melinda
"House on Douglas," *CStar*, 7 Jun 1907 — disorderly house Douglas St
"Foster St Resort," *CDT*, 7 Jun 1907 — disorderly house Foster St

Trenham, Maggie
Chattanooga city directory 1915 — madam 23 Florence St
"Ouster Bill," *CDT*, 6 Feb 1915 women — madam house with 4 other

Turk, Madame
"Good Work," *CDT*, 30 May 1901 — resort on Leonard St

Turman, Mattie
"Liquor Stock," *CDT*, 17 May 1914 — disorderly house in Tenth St Alley

Turner, Annie
"Syndicate," *CDT*, 18 Feb 1917 — house on E Tenth St

Turner, Cora
Chattanooga city directory 1904 — madam 23 Florence St

Walker, Rosa/Rose
 "Recorder's Court," *CDT*, 8 Jan 1882 in house of ill fame
 "Recorder's Court," *CDT*, 10 Jan 1882 in lewd house
 "Recorder's Court," *CDT*, 7 Feb 1883 in house of ill fame
 Chattanooga city directory 1884-85 in madam Walker's at 11 Florence
 "Mayor's Court," *CDT*, 6 Jan 1886 in house of ill fame
 "Mayor's Court," *CDT*, 8 Apr 1887 street walking
 "Mayors Court," *CDT*, 2 Mar 1888 in house of ill fame
 "Justice's Courts," *CDT*, 8 Sep 1888 house of ill repute
 "Circuit Court," *CDT*, 8 Oct 1888 house of ill repute
 "A Sad Case," *CDT*, 13 Oct 1888 bagnio
 "Justices' Courts," *CDT*, 17 Oct 1888 house of ill repute
 "Under the Sod," *CDT*, 1 Nov 1888 funeral in bagnio on Florence St
 "Red Ellen Dead," *CDT*, 5 Jun 1890 dive on Florence St
Walker, Susan E. (a.k.a. Mrs. T. F. Walker)
 "Circuit Court," *CDT*, 6 Dec 1881 bawdy house
 Chattanooga city directory 1882 madam house Florence St
 "Recorder's Court," *CDT*, 8 Jan 1882 in house of ill fame
 "Recorder's Court," *CDT*, 10 Jan 1882 in of lewd house
 "Recorder's Court," *CDT*, 1 Jul 1882 house of ill fame
 "Circuit Court," *CDT*, 19 Jul 1882 disorderly house
 "Recorder's Court," *CDT*, 26 Oct 1882 in house of ill fame
 Chattanooga city directory 1883 madam 11 Florence St
 "Recorder's Court," *CDT*, 7 Feb 1883 in house of ill fame
 "Damsel's Heart," *CDT*, 4 Apr 1883 bagnio
 "Brutal Assault," *CDT*, 10 Apr 1883 bagnio on Helen St
 "After the Women," *CDT*, 13 Jun 1883 bagnio on Helen St
 Chattanooga city directory 1884-85 madam 11 Florence St
 "Fickle Floyd," *CDC*, 16 Mar 1885 madam
 "Circuit Court," *CDT*, 26 May 1885 disorderly house
 "Order Given," *CDT*, 19 Jul 1885 lewd house
 "Disgrace," *CDT*, 29 Jul 1885 bagnio on Helen St
 Chattanooga city directory 1886 madam 11 Florence St
 Chattanooga city directory 1887 madam 11 Florence St
 "Mayor's Court," *CDT*, 19 Jan 1887 lewd house
 "Mayor's Court," *CDT*, 29 Jan 1887 house of ill fame
 "Justices' Courts," *CDT*, 27 Oct 1887 house of bad repute
 "Mayor's Court," *CDT*, 15 Nov 1887 house of ill fame
 "Mayor's Court," *CDC*, 25 Dec 1887 house of ill fame
 Chattanooga city directory 1888 madam 11 Florence St
Wallace, Alice
 Chattanooga city directory 1888 madam 107 W White St
Ward, Bertie
 "House Raided," *CDT*, 4 Feb 1912 disorderly house
Ward, Jessie
 "Indictments," *CDT*, 13 Jul 1907 woman of underworld
 Chattanooga city directory 1911 madam 17 Helen St

Weidner & Friedman 1908-1912	in bawdy house
"Demimonde," *CN*, 30 Dec 1912	woman of demimonde
Chattanooga city directory 1913	madam 101 Helen St
"Night Time," *CDT*, 22 Oct 1913	lady of the night
Chattanooga city directory 1914	madam 17 Penelope
Chattanooga city directory 1915	madam 11 Helen St
"Ouster Bill," *CDT*, 6 Feb 1915	madam with 5 women
Ware, Lula	
"Hulbert and Cain," *CN*, 15 Jan 1917	disorderly house
Warren, Canada	
"Justice Jottings," *CDT*, 30 Sep 1886	disorderly house
Warren, Della	
"Justice Jottings," *CDT*, 30 Sep 1886	disorderly house
Warren, Mary	
"True Bills," *CDT*, 12 Jan 1917	disorderly house
Warren, Maude	
Chattanooga city directory 1902	madam 302 W Ninth St
Chattanooga city directory 1903	madam 320 Tenth St
Chattanooga city directory 1904	madam 633 Ninth St
Chattanooga city directory 1905	madam 406 Tenth St
Chattanooga city directory 1906	madam 408 Tenth St
Chattanooga city directory 1907	madam 322 E Tenth St
Waterhouse, Mollie/Millie	
"Recorder's Court," *CDT*, 12 Mar 1899	disorderly house Chestnut St
"Good Work," *CDT*, 30 Mar 1901	den of iniquity Broad St
"Evidence," *CDT*, 31 Mar 1901	disorderly house
"Wild Chase," *CN*, 19 Oct 1901	"notorious
"Arrests," *CDT*, 27 Mar 1905	disorderly house
"Waterhouse," *CN*, 21 Apr 1905	house of ill fame
"Docket," *CDT*, 19 May 1905	disorderly house
"Boys Whipped," *CN*, 20 Jul 1905	star attraction of tenderloin
"Madison's Speech," *CN*, 21 Sep 1905	madam
"Five Years in Pen," *CN*, 29 Sep 1905	house of questionable repute
"Holy Terror," *CDT*, 30 Sep 1905	in dangerous precincts E Ninth St
"Banished," *CDT*, 28 Jun 1906	madam 22 Penelope St
"Cleaning Up," *CDT*, 29 Jun 1906	notorious on Penelope St
"Where Will She Go?" *CDT*, 16 Jul 1907	unsavory character of Penelope St
"Indictments," *CDT*, 13 Jul 1907	immoral resort
"Nobody Will Rent," *CDT*, 22 Jul 1907	dive-keeper
"She Stole Stranger," *CDT*, 29 Oct 1907	house of ill repute
"Two Cases Tried," *CN*, 6 Jul 1909	house of ill fame
"Persistent Offender," *CDT*, 17 Apr 1910	disorderly house
Census 1910 Hamilton Co TN Chattanooga Garfield	house with 2 female boarders 24
"Grand Jury," *CN*, 15 Nov 1912	bawdy house
"Seven Counts," *CDT*, 15 Nov 1912	bawdy house
"Grand Jury," *CDT*, 17 Apr 1915	disorderly house

"Jail Prisoners," *CN*, 6 May 1915	bawdy house
"Proprietor," *CDT*, 14 May 1915	disorderly house
"No Lack of Work," *CDT*, 20 Sep 1915	bawdy house
"No True Bills," *CN*, 15 Jan 1916	bawdy house
"Grand Jury," *CDT*, 2 Nov 1918	prostitution
"Two Murder Cases," *CDT*, 22 Nov 1918	prostitution
"Bugle Call," *CN*, 6 May 1919	runs house of "open doors"
"Names Mixed," *CN*, 7 May 1919	disorderly house
Waterhouse, Willie	
"Miller Acquitted," *CDT*, 9 Oct 1915	disorderly house
Waters, Mary	
"Jail Jottings," *CDT*, 28 Feb 1885	disorderly house
"Circuit Court," *CDT*, 28 May 1885	disorderly house
"Police Court," *CDC*, 7 Sep 1886	in house of ill fame
"Mayor's Court," *CDC*, 22 Apr 1887	street walking
"Circuit Court," *CDT*, 5 Jun 1887	house of ill fame
"The Courts," *CDT*, 21 Sep 1887	house of ill fame
"Mayor's Court," *CDT*, 22 Mar 1888	in house of ill fame
Watkins, Edna	
"Police Docket," *CN*, 28 Apr 1913	disorderly house
"Charged," *CDT*, 28 Apr 1913	disorderly house
Webb, Lucy	
"Circuit Court," *CDT*, 18 May 1897	house of ill fame
Wells, Ella	
"Mayor's Court," *CDT*, 25 Apr 1888	house of ill repute
Wenzel, Louise	
Chattanooga city directory 1915	madam 20 Penelope St
West, Ella	
"Police Pickings," *CDT*, 2 Aug 1886	street walking
"Mayor's Court," *CDC*, 29 May 1887	maison de joie
"Jail Arrivals," *CDC*, 1 Jun 1887	lewd house
"The Courts," *CDC*, 10 Nov 1887	boards Cooper's maison de joie
"Mayor's Court," *CDT*, 15 Nov 1887	in house of ill fame
"Mayor Nicklin," *CDT*, 3 Jan 1888	in house of ill fame
"Mayor's Court," *CDT*, 2 May 1888	in house of ill fame
West, Mary	
Chattanooga city directory 1895	madam 11 Florence St
Chattanooga city directory 1896	madam 11 Florence St
"Notorious Dive," *CDT*, 6 Feb 1896	dive on Florence St
Chattanooga city directory 1897	madam 11 Florence St
"Circuit Court," *CDT*, 29 May 1897	disorderly house
"Warm Time," *CDT*, 5 Sep 1897	madam
Chattanooga city directory 1898	madam 12 Penelope
Whaley, Mrs. John	
"John Whaley," *CN*, 31 May 1905	disorderly house
Wheeler, Sue	
"City Court," *CDT*, 4 Apr 1882	in house of ill fame

"Circuit Court," *CDT,* 19 Jul 1882 — disorderly house

Whitehead, Mamie
 "Before Recorder," *CDT,* 1 Jun 1893 — in house of ill fame
 "Before Recorder," *CDT,* 23 Sep 1893 — disorderly house
 "Hiding Place," *CDT,* 27 Oct 1893 — house of ill repute

Whitlock, Annie
 Chattanooga city directory 1899 — madam 204 E St

Wilbur, Annie
 "Policemen," *CC,* 24 Mary 1886 — disorderly house

Williams, Eliza
 "Justices' Courts," *CDT,* 23 Oct 1888 — lewd house

Williams, Jessie (a.k.a. Big Jessie Williams)
 "Says He Was Touched," *CDT,* 4 Sep 1909 — proprietor red-light district
 "Lackeye," *CN,* 4 Sep 1909 — in resort 1011 Douglas St
 "Labor Day," *CN,* 7 Sep 1909 — woman of E underworld
 Census 1910 Hamilton Co TN Chattanooga Pine — boards E Fulgham's house 108
 "Found in Bed," *CN,* 11 May 1914 — 309 E Tenth St
 "Murder Verdict," *CN,* 17 Aug 1914 — 309 E Tenth St
 "Jealous Negro," *CDT,* 17 Aug 1914 — 309 E Tenth St
 "Syndicate" *CDT,* 18 Feb 1917 — E Tenth St

Williams, Lena
 Chattanooga city directory 1909 — madam 1302 Fairview Av

Williams, Nell/Nellie
 "Judicial Tree," *CN,* 28 Jul 1910 — disorderly house
 "Few Drunks," *CDT,* 10 Jan 1916 — in disorderly house
 "Women Fined," *CN,* 6 Apr 1915 — soliciting on the street
 "Trickster," *CDT,* 16 Jun 1915 — prostitute
 "Grand Jury," *CDT,* 12 Feb 1916 — in house of ill fame
 "Usual Woman," *CDT,* 22 Aug 1916 — in Laura Hines' disorderly house

Williams, Rosa/Rose
 "Letter to Editor," *CN,* 25 Apr 1913 — resort
 "Sales," *CDT,* 22 Oct 1913 — lady of the night

Williams, Rosalee
 "Negro Doped," *CDT,* 4 May 1916 — disorderly house

Willis, Emma
 "Not Much Like," *CN,* 17 Apr 1912 — disorderly house

Willis, Minnie
 "Resort Raided," *CN,* 28 Dec 1910 — disorderly house Foster St

Wilson, Elsie
 "Hulbert and Cain," *CN,* 15 Jan 1917 — disorderly house

Wilson, Mollie
 "Mayor's Court," *CDT,* 8 Feb 1888 — drunk and disorderly
 "Recorder's Court," *CDT,* 13 Jul 1890 — house of ill fame

Wood, Jessie
 "Additional Bonds," *CN,* 29 Sep 1911 — owns resort red-light district

Woodford, Maggie

"Disorderly House," *CN*, 6 Aug 1914 disorderly house Ninth St
Woods, Emma
 "Hulbert and Cain," *CN*, 15 Jan 1917 disorderly house
Woods, Mary
 "It's Unjust," *CDT*, 28 Jan 1913 disorderly house
 "J. W. Green," *CDT*, 12 Feb 1913 disorderly house
Woods, Betty
 "House Raid," *CDT*, 6 Nov 1917 maintains disorderly house
Woods, Madeline
 Census 1910 Hamilton Co TN Chattanooga boards Sue Green's house 118
 Pine
 Weidner & Friedman 1908-1912 in bawdy house
Wooten, Beckie
 "Three Penny Row," *CDT*, 5 May 1915 disorderly house
 "Jail Prisoners," *CN*, 6 May 1915 disorderly house
Wooten, Frankie
 "Three Penny Row," *CDT*, 5 May 1915 disorderly house
 "Jail Prisoners," *CN*, 6 May 1915 disorderly house
Wooten, Rachel
 "Three Penny Row," *CDT*, 5 May 1915 disorderly house
 "Jail Prisoners," *CN*, 6 May 1915 disorderly house
Wright, Anna
 Chattanooga city directory 1883 madam 409 Broad St
Yeager, Maggie
 Chattanooga city directory 1894 madam 10 Porter St
Younger, Annie L.
 Chattanooga city directory 1902 madam 510 Market St

INDEX

References to illustrations are in italics. The Appendixes (A and B) are not included in this index.

Bishoff, Frank, 111
Bishoff, George, 111
Bishoff, Julia A., 111-13
Bishoff, Julia Anna (Echmeyer), 111
Bishop, May, 150n435
Bishop, Pearl, 151n444
Blythe, Willie, 150n435
Bork, Joseph J., 81
Bouley/Boully, Annie, 87, 150n435, 151n444
Bowers, Lillian, 121n54
Boyd, M. W., 140n295
Brake, R. L., 30
Brandt, Francis America, *212*
Brandt, Franklin G. "Frank," 62-63, 78, 109, 221, 145-46n363
Brandt, Nettie. *See,* Tillett, Nettie America
Bratt, Jefferson, 69-71
Bratton, Sophia, 2, 3, 115n5, 220
Braxton, Belle, 14, 123n67
Breck, Daniel, 116n6
Bre(e)zing, Belle, 14, 19-20, 23, 107, 127n115
Brickman, Isadore, 53-54, *190*
Brock, May, 150n435
Browne, W. H., 72
Brownell, Claude S., 64, 146n366
Bryson, Thomas M., 130n137
Buckner, Simon, 12
Burton, Annie, 150n435
Butler, Babe, 58
Butler, Robert T., *204*

Callaway, Elizabeth, 25, 222
Cameron, Goldie, 20
Carmichael, Lena, 41
Carpenter, Dolley, 72
Carpenter, Fred, 72
Carr, Claude, 16-17
Carr, Laura, 16
Chambers, Liza, 150n435
Chapman, Harry, 42
Chevalier, Louis, 72
Childers, Ella, 19, 125n103, 126n111
Chinn, Asa Coleman, *195, 200*
Clark, Alice, 123n67
Clark, Eva, 85
Cleveland, George, 118n28
Clift, J. W., 137n244
Coleman, J. Winston, 153n484

Collis, George, 108
Collis, James, 108
Conley, Morris, 131n153
Conner, John Emory, 48, 138n257
Conway, George, 140n288
Cooper, Alice, 37, 40, 58, 136nn221-22
Courtney, Nora, 20
Cowan, Kate, 37, 150n435
Cox, Herbert, 73
Crawford, Pearl, 20-21, 126n111
Cronin, John, 121n55
Cronin, Lucy E., 121n55
Cross, Viola, 150n435
Crow, Mamie/Maggie. *See* Whittenberg, Mrs. Ed
Crutcher, Hazel Madeline, 65, *198*, 222
Culver, Ada, 84, 85, 87, 150n435
Cummings, J. Walter, 83
Curd, Permelia, 220
Cushman, Frank, 70-71
Czajkowski, Maryan. *See* Lester, Harry

Dale, Violet, 71, *203*
Darnell, Edna, 83
Davis, Jefferson, 128-29n129
Davis, John Timothy, 25, 129n130
Davis, Lizzie, 37
Davis, Malinda, 24-25, 128n126, 129n133, 222
Davis, Sallie, 43
Davis, Sarah. *See* Russell, Sarah
Davis/David, Morgan, 25
De la Perrière, Angeline, 25
Dearinger, Anna Louise (Lane), 117n18
Dearinger, Emily Susan, 108, 115n3
Dearinger, Eugene Lewis, 156n535
Dearinger, Gracie. *See* Jack, Winnie Grace
Dearinger, John Arthur, 105, 117n21, *217*
Dearinger, June Lewis, 102-05, 108, 109-10, *212*, 220, 222
Dearinger, Loralie Frances, 108
Dearinger, Paul Oliver, *212*
Dearinger, Rosalie, 102, 154n512, *212*
Dearinger, Ruth Ann, 156n535
Deas, Julia Inez, 31
DeTrickey, Coy, 72, *203*
Dewey, May, 150n435
Dobbs, Joe, 50
Doty, Arthur, 58
Dunlap, Joe, 73

Goggan, George Beauregard, 78, 221
Goggan, Lillie. *See* Tillett, Lillie Marshall
Gormley, Charles, 156n533
Gormley, Julia, 156n533
Granert, Louis, 56, 77, *164, 180, 188, 189, 193*
Graves, Maud, 127n117
Green, Hosea J., 83
Green, Sue, 10, 11-13, 19, 20, 37-38, 78, 85, 87, 90, 121n55, 123nn67-68, 123n73, 127n115, 136n221, 150n435
Grey, Nellie, 150n435
Griffing, Nellie, *212*
Grizard, Mary, 2, 220, 116n12, 116n14
Grizard, Polly, 116n14
Grizard, Sarah, 116n14
Grow, Flora Mary, 220
Gunby, Rowena, 131n155
Gunn, William Adams, 142-43n320

Hall, Bert, 80
Hamilton, John M., 126n113
Hamilton, Lillie. *See* Tillett, Lillie Marshall
Harris, Blanche, 78, 87, 150n435
Harris, Lucius John, 222
Harris, Lula. *See* Jack, Tallulah H. "Lula"
Harvill(e), Isabella E. "Belle," 30-31, 33, 112, 133-34n185, 222
Harvill(e), Lucinda (Sanders), 30
Harvill(e), William Henry, 30, 132n167
Heinl, Albert M., 145n358
Heiny, Erhart, 42, 43
Henderlight, Ollie, 150n435
Hickey, Andrew F., 145n358
Hicks, Mary E. "Mollie," 37, 83, 137n239, 150n435, 151n453
Hill, Fannie, 126n105
Hill, Fred, 42, 57
Hill, Jennie, 7
Hines, Laura, 150n435, 151n444
Hood, Hallie, 83, 150n435
Howard, Linza C., 145n354
Howell, Emily Brook, 115n3
Hughes, Margaret, 121n54
Hughes, Melvina, 96
Hunt, Jane, 221

Ingram, Lucy, 150n435
Irish Moll. *See* Hicks, Mary E. "Mollie"
Irvin(e), Mollie, 19-20, 21
Ivie, Theophilus H., *174*

Jack, Angeline. *See* de la Perrière, Angeline
Jack, Archie W. *See* Jack, William Arthur
Jack, Arthur. *See* Jack, William Arthur
Jack, Belle. *See* Harvill, Isabella E. "Belle"
Jack, Columbus Lafayette, 25
Jack, Doctor Franklin, 25, 26
Jack, Etta (Bagwell), 222
Jack, Francis Marion (1840-1901), 25, 26-27, 50, 128n126, 130n137, 132n167, 140n295, *172*, *173*, 222
Jack, Francis Marion (1882-1929), 30, 65, 144-45n345, *176*, *198*, 222
Jack, George Washington, 25, 26, 27, 29, 128n126
Jack, Gracie. *See* Jack, Winnie Grace
Jack, Hazel Madeline. *See* Crutcher, Hazel Madeline
Jack, James Russell (1867-1938), 26, 28, 29, 31-32, 53, 55, 65, 131n151, 133n182, *185*, 222
Jack, James Russell (ca. 1836-1865), 25, 26, 129-30n136
Jack, James, 128n128
Jack, Josephine. *See* Wall, Josephine
Jack, Julia A. *See* Bishoff, Julia A.
Jack, Leila Mary (Park), 222
Jack, Lillis (McAdoo), 128n128
Jack, Lula. *See* Jack, Tallulah H. "Lula"
Jack, Malinda. *See* Davis, Malinda
Jack, Patrick, 25, 128n128
Jack, Roberta Lee, 26, 28, 29, 131n151, 222
Jack, Sophia. *See* Rucker, Sophia W.
Jack, Susie. *See* Tillett, Emily Susan
Jack, Tallulah H. "Lula," 25-26, 28, 29, 131n151, 222
Jack, Wade Hampton, 26, 28, 222
Jack, Will. *See* Jack, William Arthur
Jack, William Arthur
 affair with Lillie M. Faulk, 55-56
 affair with Nellie Spenser, 45-50, *187*
 ancestry, 24-25, 222, 128nn128-29
 appearance, xii
 baseball and, 28-29, 50
 birth of daughter, xii, 56-57, 141nn307-08, 155n524, *192*
 birth of son, 30
 birth, 26, 27
 bowling and, 65-66, 145n349
 Brickman's Saloon, Montogomery, Alabama, and, 53-54
 burial, 108
 Chestnut Street, Lexington, Kentucky, property, 60-62, 95, 98, 101-02, 104-05, 108, 142-43n320, 156n533, *194*, *204*, *210*, *211*
 Civil War and, 27-28, 130-31n149
 Criterion Bar & Café, Lexington, and, 62-63

Kearns, James E., 62, 67, 145n358
Keith, Broadwell William, 22, 127n117
Keith, Marville Louis, 127n117
Kelley, Nora, 20
Kennedy, Mollie/Molly, 10, 12, 19
Kennedy, Robert, 145n349
Kerr, Matt, 145n349
Kinkead, George B., 75-76

Lambert & Pierce, 71
Lanham, America Susan, 2, 3, 4, 6, 15, 18, 38, 115n3, 116-17n16, 117nn18-19, *163*, 220
Lanham, Eleanor, 2
Lanham, John, 2, 220
Lanham, Leah P., 2
Lanham, Mary. *See* Grizard, Mary
Lanham, Polly, 116n14
Lanham, Sarah, 116n14
Lanham, Stephen, 2
Lanham, William L., 2, 5
LaRose, Frank, 72
Latimore, Thomas, 86
Latta, Samuel S., 220
Lawshe, George P., 29-30, 31-32, 132n162, *174*
Lawshe, Will, 28-29, 30
Lee, Alice, 83, 84, 150n435
Lester, Harry, 73, *202*
Linnig, Edward J., 75-76
Lister, Mollie, 136n221
Love, Pearl, 150n435
Lowe, Ethel, 150n435
Luigart, Gus, 125n101

Macdonald, Henry, 138n258
Maddox, Mary, 75, 76
Maguire, John, 100
March, Ernest, 100
Marks, Joseph, 156n533
Marlowe, Mary, 75, 76
Marsh, Francis, 126n108
Marsh, John R., 126n108
Marshall, Frances "Fannie," 19
Massie, Mollie, 58
Mays, Florence, 150n435
McAdoo, Lillis, 128n128
McBee, Besssie, 150n435
McCay, M., 120n40
McConnell, Thomas H., 87, 89-90

McCormick, Ellen, 60, 142-43n320
McDermott, Mary, 150n435
McElhinney, Thomas, 56
McGarvey, J. W., 126n109
McGinniss, Asa, 62
McKee, Fred D., 55, 56
McKee, Mrs. Thomas, 50
McKenna, Frances, 96
McMahon, James, 81-82
McMahon, Thomas, 86
McRohan, John D., 75
Meenach, Walter, 14
Meiler, Anthony, 64, 65, 144n334
Miller, Georgia, 83
Miller, Ida, 85
Miller, Pauline, 150n435
Mitchell, Carlton, 28-29, 131n155
Mitchell, Cullen Calhoon, 21
Mitchell, Henry C., 131n155
Mitchell, Margaret, 20, 126n108
Mitchell, Rowena (Gunby), 131n155
Moore, Charles Chilton, 121n53
Moore, L. B., 40
Moore, Madge, 151n444
Moore, William P., 116n6
Morris, Mary, 37, 40, 42
Morton, Jeremiah, 131n153
Morton, Lucille, 150n435
Moss, A., 151-52n458
Mullen, James, 119n34
Mulligan, Dennis, 118n30
Munnell, C. W., 70
Munroe, Jack, 66
Murray, John J., 18

Nesbit, Malinda. *See* Davis, Malinda
Nesbit, William, 129n133
Nickoson, Taylor B. "Nick," 101, 154n512, *210*
Nome, Robert, 76

O'Connor, M. E., 5, 118n30
O'Connor, Mary, 118n30
O'Connor, R., 5, 118n30
O'Day, Alma, 117n18
O'Hare, John B., 221
O'Hare, Nettie, *204*
O'Hare, Sarah, 220

Ohls, Samuel W., 151-52n458
Olden, Emma, 45, 138n245
Oldham, Abner, 4
Oliver, Mary, 19

Park, Leila Mary, 222
Parks, Joseph S., 2, 3
Parks, Sophia. *See* Bratton, Sophia
Parsons, Horace R., 151-52n458
Pattron, Dinah, 58
Peyser, Nettie. *See* Tillett, Nettie America
Plimpton, James L., 131-32n160
Pollard, William M., 71
Pooler, Otis E. "Dick," 78-80, 83, 85, 87
Powell, Annie, 151n444

Ramsey, Kitty. *See*, Tillett, Nettie America
Ramsey, Layton, 22
Ramsey, Louis H., 66-67
Randall, Zella, 40-41
Rawson, Sidney J., 131n153
Raymond, Lillie. *See* Tillett, Lillie Marshall
Reed, Daniel, 18, 221
Reif, Charley, 53, 140n286
Rice, Viola, 150n435
Richardson, Thomas A., 51, 139-40n283
Rose, John, 16-17
Rose, Wilson, 16-17
Rowden, Thomas M., 57, 142n312
Rucker, Elizabeth. *See* Callaway, Elizabeth
Rucker, Gideon Pope, 25, 222
Rucker, Sophia W., 25, 27, 28, 222
Russell, B. H., 76
Russell, Jessie, 76
Russell, Nellie, 76
Russell, Sarah, 25, 129n130
Ryan, Nick, 67
Ryne, Lucy, 151n444

Sanders, Lucinda, 30
Santfords, The, 72
Sauceman, Manda, 58
Sauer, Matt, 67
Schlegel, Louis, *166*
Schmedling, Marcus E., 77, *180*, *184*, *213*
Scott, James, 68, 145n349
Sebastian, Jessie K., 221

Seibold, James, 145n349
Selby, Eleanor, 2
Shannon, James T., 62
Shultz/Schultz, Mattie, 37, 42, 135n211
Smith, Georgia, 58
Smith, Grace, 142n319
Smith, Joseph, 131n159
Smith, Perritt A., 83
Smith, Sallie, 150n435, 151n444
Spahr, Otto, 31
Spain, John 74
Spencer, Edward, 45-50, *187*
Spencer, Nellie (Robertson?), 45-50, 112, *187*
Spencer, Silas, 47-49, *187*
Stagg, Walter W., 221
Steeves, Thomas J., 69-72
Sterling, Lillian, 83, 87, 150n435
Stern, Sue, 121n54
Sternberg, James, 145n349
Stockwell, Viola, 150n435
Stone, Osceloa G., 93
Stone, Robert R., 69
Strader, George B., 145n358
Stratton, Alza, 99
Street, John, 78
Stuart, Glynn, 104
Sullivan, J. J., 140n288
Sullivan, Michael, 69
Swartz, Frances, 71

Taurman, Randolph, 33
Thompson, John, 83
Thompson, Manlius V., 4, 220
Thompson, Mary Belle. *See* Tillett, Mary Belle "Mamie"
Thompson, Vertner Matlock, 4
Tillett, Abner Oldham, 3, 4, 38-39, 221
Tillett, America Susan. *See* Lanham, America Susan
Tillett, Annie B., 3, 5, 15, 18, 38, 117n19, 118n28, 220
Tillett, Charles Selby, 3, 5, 15, 117n20, 220
Tillett, Emily Susan "Susie"
 ancestry, 1-3, 115n5, 116n10, 220
 appearance, xii
 birth of daughter, xii, 56-57, 141nn307-08, 155n524, *192*
 birth, 1-3
 brothels managed by, 10, 18-19, 39, 54. *See also street names*
 burial, 110
 census of 1880 and, 5

331

Tillett, Nancy, 3, 220
Tillett, Nettie America, 3, 15, 18-19, 22, 38, 43-44, 52-53, 57, 78, 109, 117nn19-20, 125n98, 127n117, *167, 180, 181, 182,* 221
Tillett, Permelia (Curd), 220
Tillett, Samuel (1865-1944). *See* Tillett, John Samuel
Tillett, Samuel W., 2, 3, 4, 15, 18, 38, 116-17n16, 117n19, 220
Tillett, Sarah (O'Hare), 220
Tillett, Sophia. *See* Bratton, Sophia
Tillett, Susie. *See* Tillett, Emily Susan
Tillett, Waller Bullock, 3, 38-39, 117n20, 221
Tillett, William Colby, 3, 220
Tillett, William, 15
Tincher, Eulalia, 99

Venable, Charles, 28-29
Vivians, The Two, 72-73
Vogt, Lillian, 121n54

Wall, Josephine A., 25
Walsh, Annie, 135n211
Ward, Bessie, 120n40
Ward, Jessie, 150n435
Warnock, Almeda, *212*
Warnock, Annie B. *See* Tillett, Annie B.
Warnock, David Wesley, 15, 18, 118n28
Weathers, Roberta Lee. *See* Jack, Roberta Lee
Weathers, Wesley Park, 222
Webber, Mamie, 123n67
Weidner, M. G., 83
West, Hazel, 150n435
West, Mary, 42
Whitcomb, Hank, 72
Whitcomb, Lottie, 72
Whiteside, James L., 82, 86
Whittenberg, Mrs. Ed (Maggie/Mamie Crow), 42, 79-80, 87, 136nn220-21, 150n435
Wiggington, Silas, 118n28
Wiley & Wiley, 71
Williams, Ella, 95, 153n484, 117n18, *205*
Williams, Tom, 138n245
Winshipp, W. H., 83
Woods, Madeline, 150n435
Woods, May, 150n435
Wooten, May, 151n444
Wright, Joseph W., 156n534
Wright, Sarah, 156n534
Wurlitzer, Rudolph, 70

ACKNOWLEDGMENTS

Without implying any guilt by association, I wish to thank those who have been of tremendous help—actively, passively, posthumously, or otherwise—in this book's progress, from foundation to finish: my grandmother Gracie W. (Jack) Dearinger; my parents, John Arthur Dearinger and Anna Louise (Lane) Dearinger; my aunts Sue (Dearinger) Howell, Loralie (Dearinger) Howe, and Ruth Ann (Dearinger) McMenema; my sister, the incomparable Pamela Sue (Dearinger) Hutton; my cousins, Lillian (Goggan) Keller, Barbara (Keller) Hammack, Kenneth F. Keller, and Kenneth Andrew Keller; my forever friends Hina (Hirayama) McConnell and William F. Watts; and my spouse, Darrell S. Ung, to whom this work is dedicated.

I have been fortunate to benefit from the professional expertise of Mary Lee Rice, a genealogist specializing in the records of Tennessee, including Chattanooga, and that of the indispensable librarians and archivists at the Kentucky Department of Libraries and Archives, Frankfort, and the Margaret I. King Library, University of Kentucky, Lexington.

It has been a pleasure to work with Ali de Groot, Megan St. Marie, and the rest of the staff at White Poppy Press, an imprint of Modern Memoirs, Amherst, Massachusetts, and I thank the late Joyce M. Bowden for inspiring me to contact the firm about the publication of this work.

Finally, I am especially grateful to my brother, Kevin Lane Dearinger, who patiently and enthusiastically read multiple drafts of this book as they slowly emerged. His advice about historical sources, context, grammar, and syntax, and his unflagging encouragement were much needed and are deeply appreciated.

ABOUT THE AUTHOR

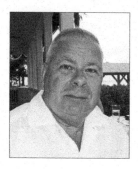

David B. Dearinger was born in Woodford County, Kentucky, where his ancestors settled in the late eighteenth century. After graduating from the University of Kentucky in 1972, he moved to New York City to work for TWA as one of the first men hired by the airline industry into the previously all-female ranks of flight attendants. In 1975, he was promoted to the position of Flight Service Manager. While continuing to fly both domestically and internationally, he began graduate work at the Graduate Center of the City University of New York in 1982, eventually earning an M.A. in American Studies and an M.Phil. and Ph.D. in art history.

Dearinger subsequently taught art history in New York at Hunter College, Queens College, Brooklyn College, and, for over twenty-five years, at the State University of New York's F.I.T. in Manhattan, where he was a tenured adjunct professor. He joined the curatorial staff of the National Academy of Design in New York in 1985 and served as that institution's Chief Curator from 1995 to 2004. In the latter year, he was named the Susan Morse Hilles Curator of Paintings and Sculpture at the Boston Athenaeum in Boston, a position he held until his retirement in 2018.

He has received grants from the National Endowment for the Arts, the National Endowment for the Humanities, the Luce Foundation, the Florence Gould Foundation, and the Lucellia Foundation. He is the author of books, articles, and exhibition catalogues on the history of American art and has lectured widely in the field.

Dearinger began researching his family's history at the age of fifteen, and genealogy has been his avocation ever since. Having been a resident of New York City for nearly forty years, he and his spouse, the architect Darrell Ung, now live in Richmond, Virginia.